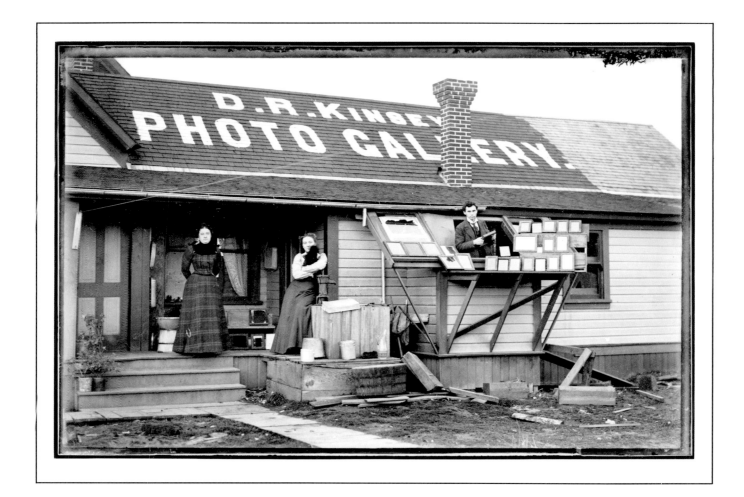

Solar printing at Sedro-Woolley, c.1902.

DRKinsey Photog.

A Request

Friends companions Schoolmates dear.
All your names are welcome here.
All who love me I invite.
In this little book to write.
All some fragrant leaf entwine.
In this rememberance book of mine.

Tabitha May Pritts

Workiachk City
February the 2 1891

Nooksack, Wash..
December 21", 1895.

Friend 'Bitha —

When the leaves of this Album
Are yellow with age,
And the name that I write here
Is dim on the page,
Then think of me kindly
And do not forget
That wherever I am I remember you yet

Very Sincerely Darius Kinsey

Nooksack *Reporter*, Friday, October 9, 1896:

"Married. Thursday, October 8th, at the residence of the bride's parents at Nooksack, by the Rev. J. L. Parmeter, Miss Tabitha M. Pritts of Nooksack and Mr. D. R. Kinsey of Snoqualmie.

"The bride, who is one of the most popular belles of the Nooksack Valley, looked very pretty in old-gold cashmere tastefully trimmed with silk and ribbons. The groom, well known as the Lake Shore photographer, was handsomely attired in regulation black.

"The wedding day was the 42nd anniversary of the marriage of the bride's parents, Mr. and Mrs. S. A. Pritts. A wedding breakfast followed the ceremony; and the friends accompanied the happy couple to the Lake Shore depot, where they started for a tour of the Sound cities, under the usual sendoff of rice, old slippers, etc. They received numerous handsome and useful presents. Besides the parents of the bride there were present—John Pritts and family, Mr. and Mrs. Jess Tucker, A. M. and D. L. Germain and families, Mr. and Mrs. John Berg, Mrs. Lee, Mrs. S. Berg and sons David, Jacob and Aaron, Mr. and Mrs. Butterfield, Mrs. P. Gillies, Jr., Miss Selma Swanson, Mrs. Sleasman and Mr. L. Bushby."

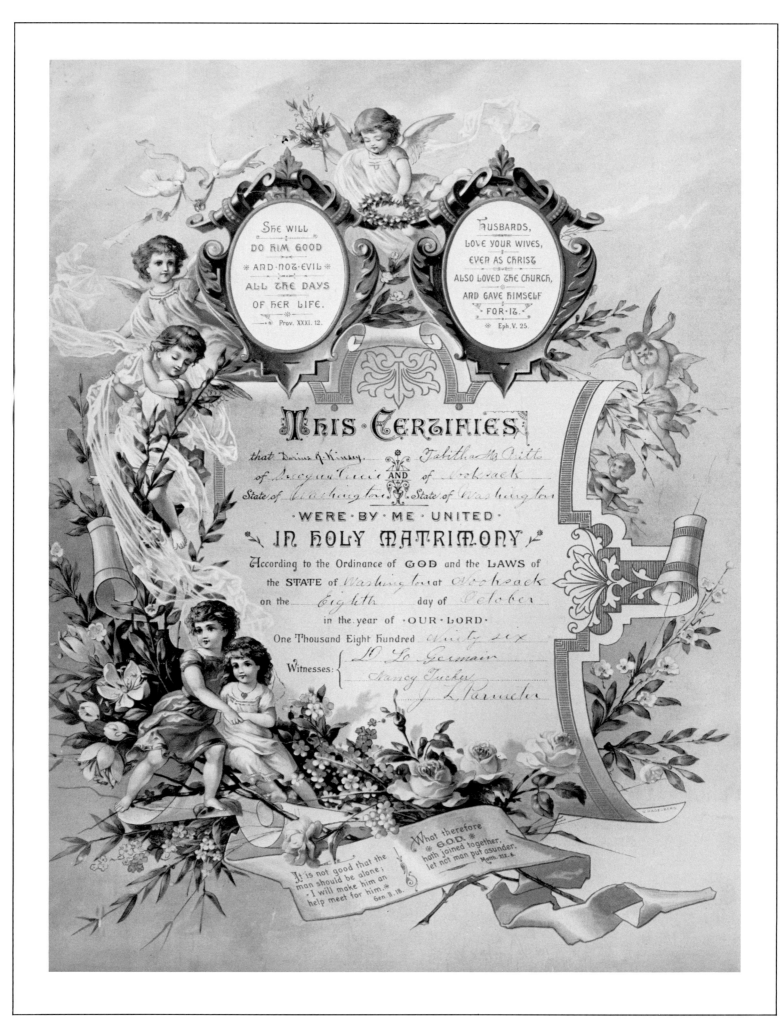

She will
DO HIM GOOD
· AND · NOT · EVIL ·
ALL THE DAYS
OF HER LIFE.
Prov. XXXI. 12.

Husbands,
LOVE YOUR WIVES,
EVEN AS CHRIST
ALSO LOVED THE CHURCH,
AND GAVE HIMSELF
· FOR · IT ·
Eph. V. 25.

This Certifies

that _Darius A. Kinsey_ _Tabitha M. Critt_

of _Acquatici_ AND of _Nooksack_

State of _Washington_ State of _Washington_

· WERE · BY · ME · UNITED ·

IN HOLY MATRIMONY

According to the Ordinance of GOD and the LAWS of

the STATE of _Washington_ at _Nooksack_

on the _Eighth_ day of _October_

in the year of · OUR · LORD ·

One Thousand Eight Hundred _Ninety six_

Witnesses: _D. L. Germain_
Nancy Tucker
J. L. Parmeter

It is not good that the
man should be alone;
· I will make him an
help meet for him. ·
Gen. II. 18.

What therefore
· G.O.D. ·
hath joined together,
let not man put asunder.
Matth. XIX. 6.

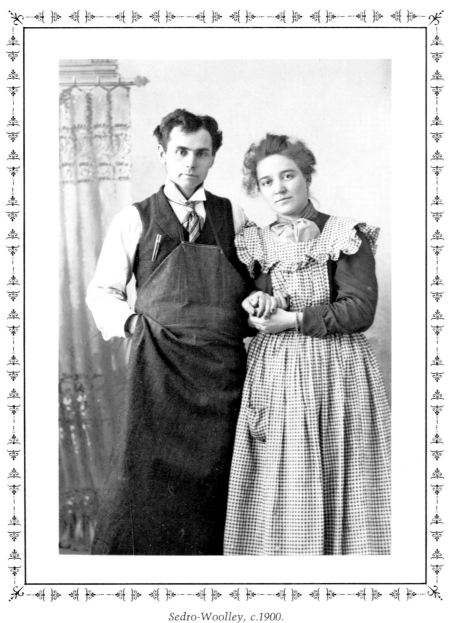

Sedro-Woolley, c.1900.

PHOTOGRAPHER

A half century of negatives by Darius and Tabitha May Kinsey

With contributions by son and daughter
Darius, Jr. and Dorothea

VOLUME ONE

The Family Album

Other Early Work

Produced by Dave Bohn and Rodolfo Petschek

BLACK DOG & LEVENTHAL PUBLISHERS
NEW YORK

Kinsey, Photographer was originally published by The Scrimshaw Press
in 1975 as a two-volume limited edition.

An earlier edition of this book was published in 1982 by Chronicle Books,
under the title **Kinsey Photographer.**

The darkroom timer, reproduced next page, is from the Kinseys' darkroom,
and ticked continuously while Rodolfo Petschek was printing the
photographs for Volumes One and Two.

Unattributed textual material was written by Dave Bohn.

Jacket photograph: "X15. Washington logging camp crew in body
of felled timber which is ready for yarding donkey. Copyrighted
1907 by Darius Kinsey, 1607 E. Alder St., Seattle, Wash."
From an 11 x 14" glass plate.

Published by

Black Dog & Leventhal Publishers, Inc.
151 W. 19th Street
New York, New York 10011

Distributed by

Workman Publishing Company
708 Broadway
New York, New York 10003

Printed and bound in Singapore

ISBN: 1-884822-22-3

h g f e

Library of Congress Cataloging in Publication Data

Bohn, Dave.
 Kinsey, photographer : a half century of negatives by Darius and
Tabitha May Kinsey, with contributions by son and daughter, Darius,
Jr., and Dorothea / produced by Dave Bohn and Rodolfo Petschek.
 p. cm.
 Originally published: San Francisco : Prism Editions, 1978
 Includes bibliographical references.
 Contents: v. 1. The family album & other early work.
 ISBN 1-884822-22-3 (v. 1)
 1. Kinsey, Darius, 1869-1945. 2. Kinsey, Tabitha May, 1875-1963.
3. Photographers--United States--Biography. 4. Lumbering-
-Washington (State)--Pictorial works. I. Petschek, Rodolfo.
II. Title.
TR140.K45B64 1995
770 '.92'2--dc20 95-376
 CIP

the Dedication

Dear Tabitha,

Our sense of wonder at your half century in the darkroom continues to grow. There seems hardly any doubt that some, or perhaps a great deal of the time spent under the safelights was a tribulation to you. And yet, during the three years we have worked with the surviving negatives and contributed material, we have had more than a chance to understand just what you did for Darius.

It seems to us his seeing was that of a genius photographer. But the final *quality of the negatives, from which others could see his work, was increasingly—and finally, totally—in your hands. To say nothing of the hundreds and hundreds and hundreds of prints you shipped to him out there in the woods.*

Again, our sense of wonder at your contribution only continues to grow.

With affection,
Dave and Rudi
Berkeley, January 1974

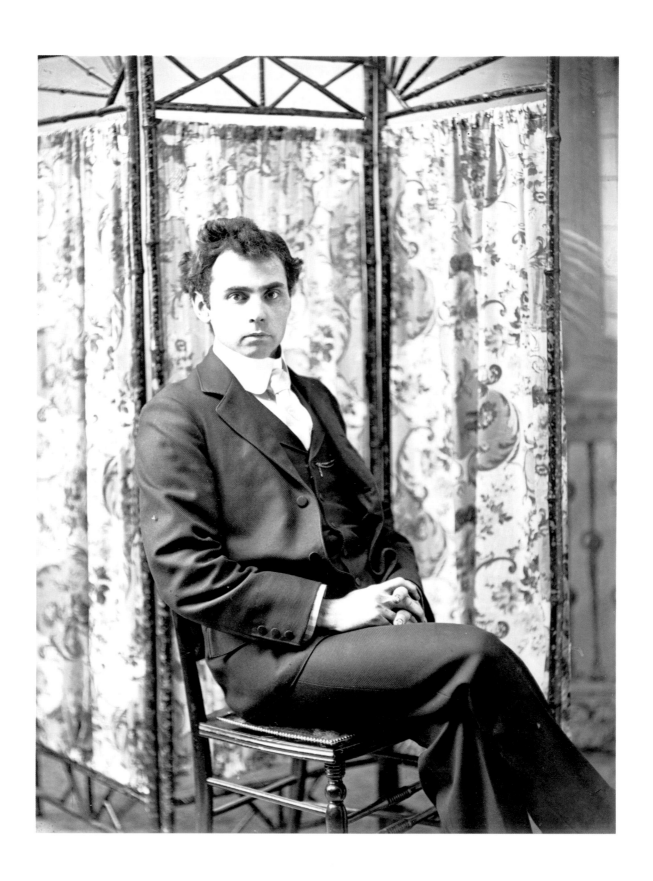

*Darius and Tabitha with
Nettie Brown and Dorothea, 1904.*

the Contents

Darius and Tabitha Kinsey spent most of a lifetime in photography. The surviving negatives—on glass plates and film—number some 4,500 in eleven formats.

These two initial volumes deal with the evolution of Darius' photography, with attention to the elements surrounding that evolution. For example—he was making a living, and without Tabitha in the darkroom he could not have managed the amount of work he did. And because of Tabitha's ever-increasing skill at development by inspection, the great *vision* came through undamaged. Not that such conclusions were sought. They came as a result of interviews and contributions obtained during research, and a thorough knowledge of what is contained in the 4,500 negatives —*all* of them.

Thus, share if you will a journey through two lives in photography, from the Family Album through the gigantic work of the 1910's and 1920's. As for clues to the three hundred and five pages which follow, consider: The work is grouped into sections which reflect divisions strongly represented throughout the Collection; the work is arranged essentially chronologically and Volume One terminates at the end of 1906, when the Kinseys moved from Sedro-Woolley to Seattle; the photographs in Volume One are printed from glass negatives, and are reproduced (peripheral material also) same size; photographs in Volume Two are reduced from 11x14″ film negatives, and exceptions in either volume are noted with the item, as are specific acknowledgments; Dorothea's contribution appears in Volume One, starting on page seventeen; Darius, Jr. holds forth in Volume Two, along with the essay on the Kinseys, notes and bibliography, general acknowledgments, and colophon.

Snoqualmie. Dec. 18, 1889.

Friend Darius,

That you will be successful in your
venture "West" is the wish of—

Your Friend.

John D. Fox
Phoenix. N. Y.

To Dear frind Tabitha

If ever a husband you should have
and he this book Shuld See
tell him of your youthful days
and kiss him once for me
 mate
Your friend and School
Nansey E. Sleasman

May the 11, 1889
Tuxedo

the Recollections of a Daughter

Mother was born in Waverly Mills, Minnesota, on May twenty-fourth, 1875. Father was born in Maryville, Missouri, on July twenty-third, 1869. Mother was the youngest of six children, and when she was a small child the family moved from Minnesota to Pennsylvania, where there were relatives, none of whom I knew. Then they came on a train to the Pacific Northwest and did their own cooking aboard. At first they settled on Fidalgo Island in the San Juans, but soon went to Whatcom County where the two older brothers—William and John—took up homesteads, as did my grandfather, Samuel Pritts. As the other children married they accepted gifts of land, but my mother would have no part of farm life. Although she had her choice of their "old home place" or a small financial dowry, she wanted to go to the city and chose the dowry.

The romance between my mother and father commenced when he was a traveling photographer and went through Whatcom County taking pictures. He called at the Pritts farm and met mother, at that time engaged to be married to a handsome Railroad Conductor who worked the train my father traveled on frequently. Mother told me the story many times—about the railroad man she had thought she wanted to marry and that when he learned of her romance with my father ("that *itinerant* photograph man") he threatened to shoot her new romantic interest. Apparently there were many days of great concern.

Father was very religious, so read his Bible frequently, as did my mother. I still have their personal Bibles and they certainly indicate extensive, daily reading. It was obligatory for us to have prayers every night, kneeling beside our chairs before bedtime. Father always said that he knew what he was doing when he "found" my mother at Nooksack, as he took pride in the fact that along with his biblical name of Darius, mother's given name was Tabitha, also a biblical name. Her middle name was May, for the month in which she was born.

Mother's parents were Samuel and Elizabeth Pritts—from Pennsylvania. I don't think that I ever knew why they were at Waverly Mills, where mother was born. My grandfather Pritts was an extremely like-able person and was especially fond of children. He passed away before I was born, as I recall—or at least I do not remember ever having seen him. But mother used to tell me about all the children scrambling around when Grandpa Pritts was available, because he always had round peppermint drops in a sack in his coat pocket and generously shared them with his little friends. Likewise my grandmother Pritts was a jewel. Always ready to bring out of her small leather satchel interesting objects. It was a sewing kit, purse, miscellaneous bag of sorts, and she was always willing and able to mend or patch, which she used to lovingly do for us.

And she used to wear red woolen underwear and sometimes the long sleeves crept below her sleeve "wrappers," as she used to call them. Grandma Pritts' hair was black, real black, except for a slight graying around the temples. She lived until her late eighties but I still remember that her hair never did turn all gray—or all white—and those were the days before a little help from the beauty parlor. In later years she fell on the ice and broke her hip, requiring the use of a crutch until her death, but she remained cheerful and was the greatest grandmother anyone could ever have. She made beautiful patchwork quilts so mother must have inherited her needlework capabilities.

Although grandmother Pritts shared her time with her other daughters living in Whatcom County, it seemed that most of the time she lived with us, no doubt because mother's life was so completely filled with helping my father in all facets of his photographic work. So Grandma Pritts took care of me most of the time, and my recollection of her is one of the most wonderful childhood memories. I can still see and feel that warm, cozy kitchen in the rambling house in Sedro-Woolley with the old-fashioned black kitchen range with hot water reservoir, and the aroma of homemade bread being baked. Grandma loved to cook!

My grandfather Kinsey was unknown to me and I didn't know my grandmother Kinsey very well. I know that she used to scold me, and am sure I must have deserved it, but she did not visit with us very often and passed away early in my childhood.

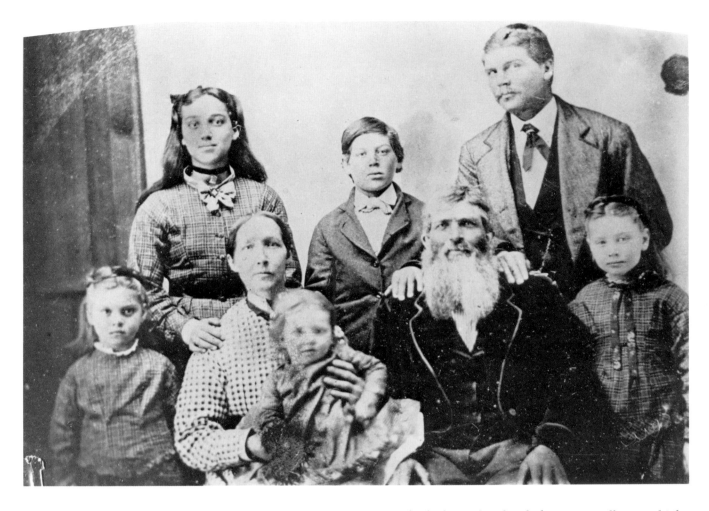

The Pritts Family. Samuel A. and Elizabeth (Berg) with Tabitha; Mary, William, and John standing behind, Nancy and Ellen, c.1877. From copy negative. Courtesy Ada Pritts Brown.

Mother and father had been married for about five years before I came along, and apparently there was great joy in the Kinsey family in Sedro-Woolley. Mother had always wanted a little girl, and when I arrived she said there wasn't a baby buggy in town good enough, so my father made a special trip by train to Seattle to bring home the biggest and best buggy from Frederick and Nelson, a huge wicker affair with a massive colored umbrella with ruffles.

My father's interest in taking pictures was by no means confined to members of the public. Mother told me many times that he was insistent on having me prepared for showing at the family home at the earliest possible moment after my birth. In fact, the first picture was taken when I was seven hours old and weekly thereafter for many, many weeks [fifty-two to be exact]. It is nostalgic to look at these pictures now and see the long, handsome, lace-trimmed, elaborate handmade dresses that mother made for me. Also, I can remember mother telling me that she had the tops of my white kid shoes dyed to match my pink and/or blue dresses. Mother had idiosyncracies that I seem to have inherited, one of them that "everything must match." And mother would never go anywhere without gloved hands, so she

used to be teased that every time "Tib" went on a picnic she wore gloves. Well one reason she wore gloves was because she wanted to cover her fingers, stained yellow because of the developer they used in those days, and she was also afraid someone would think she smoked.

During the time we lived in Sedro-Woolley, mother and father decided on an extended trip across the United States. They were gone for four or five months, taking many pictures which were made into stereoscopic views. This proved to be a very tiring experience for mother, and when she returned one eyebrow became snow-white. In later years, I can remember that whenever the doorbell rang, the first thing she would say was, "Is my eyebrow alright?" She loathed the idea of anyone seeing her with one brown and one white eyebrow. Her eyebrow pencil was about the only cosmetic she used, plus Cuticura soap. She would have been an excellent ad for that firm as she had beautiful skin all her life and many times, when asked, she would say she had used that soap since she was sixteen years old, giving credit to soap!

Also during our Sedro-Woolley residency, mother and father, with a group of other mountain climbers,

took a trip to Mt. Baker. She told me the story of that climb—all tied together of course—and there was a terrible avalanche. Fortunately it passed them by inches and no one was lost, but never again did she go on a mountain climbing trip with my father, his main reason for it all being "more pictures," as she used to say.

Another memory that comes to mind is father's horse and lightweight wagon that he used during photographic trips he made in the Whatcom County area. The wagon was made something like those old Jewel Tea Company wagons, and it was specially built with compartments where he stowed away his equipment. "Slim" was the horse's name, and father used to let me drive, but he would always take over when an automobile came by. However, in those days one only saw about two automobiles per day. It was great fun being able to drive and I felt pretty important when he permitted me to take the reins. Of course mother thought he exercised very poor judgement in even allowing me to take *hold* of the reins in case Slim decided to run away after seeing a car, but father seemed to think he had everything under control and at no time were there any problems. Sometimes that old horse used to gallop and I suppose that was the scary part—when mother saw that galloping horse coming down the road with me in the driver's seat.

———◈———

The Sedro-Woolley house had been remodeled so that father's studio and gallery could have special lighting (skylight), and this business area was accessible from the living quarters. At that time father was engaged in taking portraits of people who came to the studio, and I remember I always wanted to see what was going on but was never permitted to go into the studio during a sitting. To alleviate my unhappiness, father carved out an area in the door, similar to a mail chute, so that I could stand and peek through. He often told me later on that he frequently looked over and saw nothing but two big eyes staring at him. This was always a very entertaining time for me and I can recall an endless procession of people who wanted to have their pictures taken.

We moved to Seattle when I was about five years old. Father had planned extensively for this new home, "just a mile and a half from Pioneer Square." He had visions of Seattle becoming quite a metropolis and wanted to be close-in. He had a twelve-room house built, complete with gallery, developing room, etc., and the then-modern conveniences in connection with his photographic work. This area was on the first floor just off the huge kitchen. Father's work at that time no longer consisted of portraiture inside the premises. He had decided to go out to various logging camps, to take pictures of the loggers, and while in the vicinity to photograph anything and everything in the nearby forests that appealed to him—when the "light was just right." Then he would bring the negatives home, have them developed by my mother and processed by the two hired girls that they employed. Usually it was one of my mother's nieces and a friend, and we were all just one big family. There were bedrooms all over that house and many times they were all filled with visiting relatives from Whatcom County, which mother loved. Father wasn't so pleased about all the visitors although he did not make too much of an issue since mother seemed to have no objections. But mother never had invited guests when father was home, and when anyone came unexpectedly to visit, he would hurry off into his darkroom and busy himself with pictures. He used to have a couch in one of the photographic rooms and he would lie down so mother could say he was taking a nap, for there were never any untruths spoken in that religious household! So when I think about artistic temperament beneath his good business head and sense of organization, I well remember his annoyance when he was interrupted in his work. He just did *not* want interference from *anyone*. He was building his future and their security, things he mentioned often.

As my brother and I grew older we were told that there were to be no playing cards in our home, and I remember one of the hired girls bought a box of White King Laundry Soap, and when father saw the picture of a playing card on the front, he immediately dumped the contents in the garbage can and burned the box. Also in those early days my father would not permit any cooking on Sunday. The girls used to prepare chicken fricassee in heavy aluminum cooking utensils with a clamp-on lid. The chicken was cooked on Saturday and then placed on a round soapstone affair at the back of the stove. Then on Sunday, when the family came home from church services, the chicken was ready to serve. We had to walk to the First Methodist Episcopal Church at Fifth and Marion, which was quite a trek from Sixteenth and Alder, for father would not permit us to ride a streetcar on Sunday. He did not believe in the streetcar operators having to work on Sundays. We had to leave very early in order to be there in time for the first Sunday School services, and we didn't ever get home until around 1:00 P.M. I remember that sometimes my brother and I didn't have time to eat breakfast because we didn't get up when called. On one occasion we were sitting in church next to my father—mother sang in the choir for years—and I thought I noted an unusual odor. I looked over toward my small brother and he was pulling wieners, all linked together, out of the leg opening of his knickers.

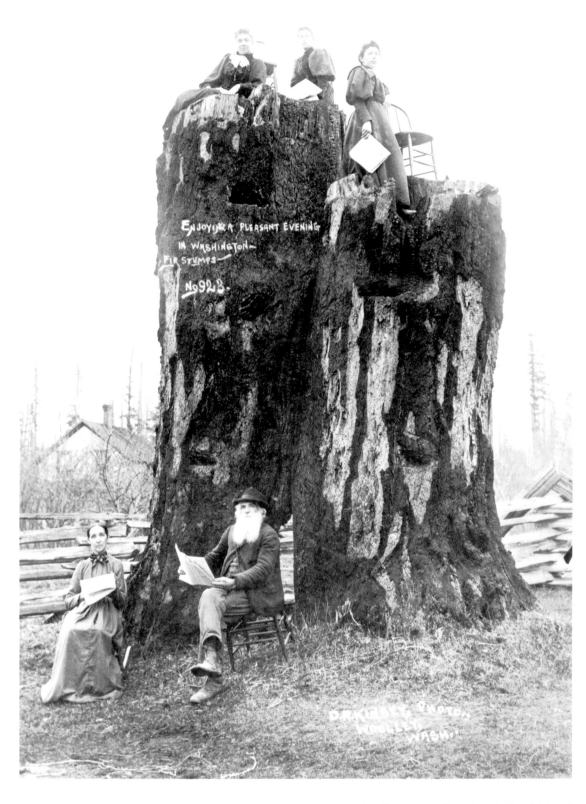

*Samuel and Elizabeth at the Nooksack homestead, with Tabitha (left) and
friends on top, c.1895. From copy negative. Courtesy Mrs. Nels Hansen.*

In the developing area of our first Seattle home there was a large window facing east. Father had a specially designed "door" made to cover that window—in two sections, comparable to a Dutch door, and whenever mother was developing negatives the light had to be shut out, but tightly, and then no one under *any* circumstances could go into the room while operations were going on. I think if someone had hollered FIRE! mother would have stayed at her post until the project of the moment was finished. In the house at 5811 Greenwood Avenue, where we moved about 1919, the enlarging room was under the eaves of the house, on the north side of the finishing rooms, and one had to stoop over to get into the back part. That is where father did all his enlarging, and as I look back now I don't see how he ever on earth enlarged pictures as big as the one we have here, of the oxen [31x55″]—but he did, and was apparently a master at making such enlargements. But I don't think he ever thought very much about it—just part of a day's work. The problem was that he spent so *much* time in connection with every facet of picture-making and it used to trouble my mother that there never seemed to be an end to it. She would finish off one batch of pictures and before you knew it another big order would come in. Father must have been a pretty good salesman to have obtained the hundreds and hundreds of orders he sent in. And father was also an excellent organizer. He had everything filed away in order and would spend hours dreaming up some new scheme so his work would be improved by perfecting the detail by which the films, extra pictures, etc., would be catalogued.

One of the work projects assigned to me on many occasions at Greenwood Avenue was this business of washing the printed pictures by moving them from one tray to another. There were huge trays, each filled with clean, cold water, and the pictures had to be swished around in each water very carefully so as to get that "awful yellow developer off. I don't want any of *my* pictures turning yellow in later years." Father set up a special routine for me as he wanted me to keep close track of the number of washings. It had to be SIXTEEN and not one washing less! He gathered up pebbles from his garden which were placed in an old Mason jar lid, and each time I moved a batch of pictures over into the next tray, a pebble was placed in another Mason jar lid. Somehow I occasionally picked up a couple of pebbles too many and would get through quicker than he figured I should. He then decided on a new scheme as he felt I was fudging a little. He cut out large numerals from a calendar, mounted the sixteen numbers on pieces of cardboard, and placed them on a specially made little rack so that each time I washed through a batch of pic-

tures I had to move over the proper figure. When I moved number sixteen and all the numbers were on the right, I was through. But even then he used to time me.

Other memories of the processing operations bring to mind mother's insistence that the names of the men who ordered pictures be written in a legible manner. Usually she wrote up the names on all the big 13x18″ envelopes, especially if the girls' handwriting was not to her liking, and occasionally I got a crack at it. But I had to promise to write large—and plainly—and to this day I note my handwriting is usually a bit oversize. Mother was meticulous about every detail, which is what father expected of her.

As I grew older father wanted me to become interested in the business, but I wanted no part of it. It seemed to me that all it amounted to was work, work, work. However, he decided that I should be taught how to paint so that I could tint the pictures he took. He paid for about a dozen lessons in advance, at $5.00 each, and bought all the oil paints anyone ever needed. He went all out for me to become an artist. But I just didn't like it. Too confining. So after only a few lessons he decided it was a lost cause. He then talked my mother into taking over the remaining lessons and she painted those pictures with the greatest of ease and from then on she was the family artist. She even taught one of her nieces, Alfreda Kinsey, to paint pictures too.

When we went on various camping trips in the old Ford, my father had a carrier built to fit on the side of the car. This carrier was of heavy sheet metal, and constructed to exact size. It was a compartment for food, and every jar and/or container had been meticulously measured so that they could be stowed away. He had a place for everything and everything *had* to be in its place. We could load and unload the food items in minutes, it seemed. The lid or compartment covering was made in such a way that stilts held it up so it could become a table. Each of us had our own camp stool and we had an operation going which was almost like an assembly line setup. My mother, brother, and I knew exactly what we were supposed to do. And we did it. No fooling around. But mother did not enjoy those everlasting camping trips, although that is what we were supposed to do in the summer months. My last camping trip with them was the one with those awful ants in Yosemite. We drove down there in father's new Franklin. The tent was pitched in a certain area so father could be at the right place at the right hour in the early morning, when the light would be just right to take pictures of Yosemite Falls. The camping spot he chose was anything but right, however, as mother and I awakened during the night and were literally covered with

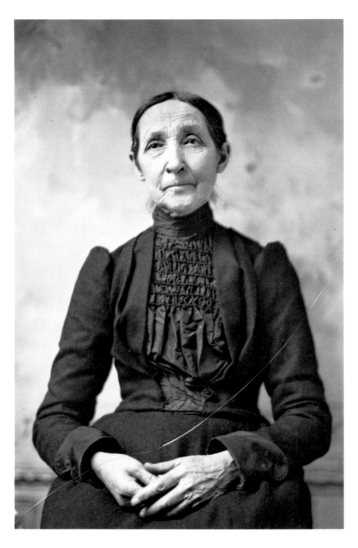

stantly trying to improve his work. He spent hours on detail that to me often seemed useless effort; he would enlarge a picture and if it didn't come out just right he would do it all over again. He wanted everything to be as nearly perfect as possible. I never saw any instruction manuals in his possession and his big rolltop desk contained no such items that I know of. He was self-taught and had a great and gifted talent for what he was doing. He loved a real challenge and there were certainly many of them since he worked out his photographic problems all by himself, for which he surely deserves a great deal of credit.

Although mother did get pretty tired of it all, I never heard her complain. And father used to say that never once did mother fail him in all those years, and that is quite a tribute to a country girl who knew nothing about photography, who wanted to move to the city as she didn't want to be cooking for farmhands. But I don't think she ever realized what she was getting into. In fact, neither of them did. It was like a snowball. Father would get started on a project and would throw

tiny black ants. They were even in our hair. That was the last time I would ever go on a location vacation. My father thought he had everything very well organized and he usually did. He was great on detail, but picking out places to camp was something else.

———◆———

Mother learned all her darkroom skills from my father. They were involved in a trial and error approach, although it was father who did most of the experimenting. Mother just went along with whatever he would tell her to do, and I know she used to get pretty fed up sometimes. She would plan something along social lines, and then a project would come up and she would need to do picture work. It seemed that nothing in her life existed except that photographic business. I know she used to get extremely tired and sometimes plagued with headaches, but she would rest awhile and then back again into that darkroom.

I do not remember any pleasure trips they ever took—only those involving more picture work. Nor do I remember any "fun" entertaining in those days. Father never took mother out for the evening, they belonged to no clubs, and the company we constantly had was relatives on both sides of the family. The business was simply an obsession with my father. He was con-

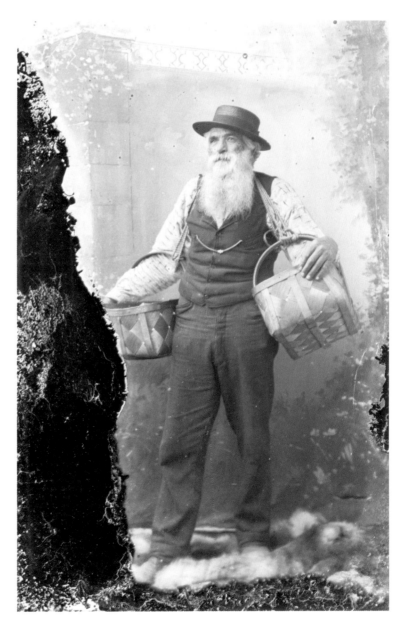

himself into it with everything he had. He absolutely drove himself in everything he did. Just would not stop. I don't think mother thought too much about my father's camera skill in the woods, but she used to be very concerned about all the risks he took to life and limb—trees being felled and sometimes within a few feet of where he would be setting up his camera. He would climb to precarious heights to photograph a scene which he felt would be outstanding. He was constantly on the lookout for something unusual. When vacationing, all of a sudden he would stop the car, climb out, and leave us waiting for the longest times while he prowled around in the woods finding just the right place to get a good shot at something that particularly interested him. Mother used to get impatient with the delays and expressed herself, but that made no difference. The picture just HAD to be taken.

I never did hear mother comment on the type of work father did. She accepted it as a way in which to earn a good living and that was it. I don't think she ever felt she did anything very special, except that she did comment with pride upon the fact that never did she keep my father waiting for a batch of pictures that he wanted on a certain day. She absolutely went all out to accomplish that. She would develop the films, print the pictures, set up the orders in the large envelopes father had printed for the purpose, and dispatch them posthaste. Absolutely nothing was permitted to interfere with getting those finished pictures off to father in some logging camp.

When the pictures were ready for expressing, mother would wrap them in two bundles of nearly equal weight. I can see her yet, tugging and pulling, getting those orders ready and then tying heavy brown twine around, and I thought she could make the neatest looking packages I ever saw. She was very particular about how they looked and how they were addressed, and then she would arrange heavy brown straps around each bundle, and proceed to carry them three long blocks to the Yesler cable car. Sometimes I used to walk with her with one of my playmates. She would rest those huge packages on a small retaining wall at the corner of Sixteenth and Yesler, since it was easier for her to pick them up and get onto the cable car. Sometimes the conductor would get off the car and lift them aboard. Then at the Railway Express, just below the King Street Station, the man would lift the bundles onto the counter for her. He often commented that he didn't see how she could possibly lift them, let alone carry them for about five blocks after she got off the cable car at Third and Yesler. In later years she had a great deal of hip trouble, and one doctor attributed the beginning of that

problem to the carrying of those massive orders constantly being sent to my father.

Father came home sometimes on weekends, because he wanted to see his family and wanted to be able to attend church services. He was an avid gardener when he was home, after we moved to Greenwood Avenue, and he raised all his favorite green vegetables; kohlrabi, Brussels sprouts, cabbage, spinach, and a host of the root vegetables which were "good for us." But when he was some distance away he would spend Sunday at the logging camp quarters. He used to mention that the boys would want him to join in their poker games, but of course he would have nothing to do with such "evil!" To my knowledge he was always treated with great respect and given his meals at the cookhouse. But he had to be careful about what he ate, and the old family doctor book is full of penciled notations. Father used to refer to his dyspepsia and I presume his stomach problems were caused by the unusual hours he kept in taking his many pictures, lack of proper sleep, and irregular meals. However, he seemed to thrive on about four or five hours sleep and he was always up at the crack of dawn doing something about preparation for that day's work. He used to spend hours in that little enlarging room and never stopped until the work was exactly what he wanted. No matter how he felt, there seemed to be sufficient energy left to do something about the picture work.

If father ever gave my mother any special credit for her work in the darkroom, I never heard it. But he was not much on complimenting anyone and neither was mother. In fact, whenever one praised the work she did with oils, even after only a few lessons, she would modestly say that anyone could do it if they took the time and put their mind to it. It just seems to me that neither of these folks ever thought they were doing anything very special and no one else at that time ever thought so either.

Mother's devotion to my father—whom she always called "Dee"—was outstanding, and I admired her for it. In later years I began to understand that father never could have accomplished what he did without mother's loyal support and hard work. But I do not think father ever had any intimations of his own greatness as a photographer. He never did mention anything that would lead me to believe this. Neither did mother. They merely pooled their abilities and resourcefulness and together created something of great historical value. And it was a partnership setup to the Nth degree.

Dorothea Kinsey Parcheski
Seattle
January 1973

The parlor at Sedro-Woolley, Thursday, October 11, 1900.

The organ is by Cornish & Co., Washington, N.J. All other furnishings from Frederick and Nelson, Seattle. Bear rug, Wilton velvet rug, and black rug. Pink flowered wallpaper. Red, green, and yellow fishnet drapery. Shelf drape by Tabitha of green silk, with pink tassels made of taffeta round pieces gathered to make a ball. Mark Gillette's violin. Fungus on shelf painted by Dr. Thompson.

Photographs: Samuel and Elizabeth Pritts on organ; on shelf left to right, Aunt Mary Kinsey, Elmer Bovey, Hattie Nash, Alice Dunmyer; on chair, interior of Presbyterian Church next door.

Identifications by Tabitha Kinsey,
courtesy Dorothea Kinsey Parcheski

Other portraits unidentified. Two of the large prints on shelf are of Devil's Corner on the Skagit River. Watercolors, on organ and floor, are Washington coast scenes, presumably by Darius. Newspaper is Seattle *Post-Intelligencer* of above date, and since Clark Kinsey was visiting Sedro-Woolley at the time (see p. 42), he was almost certainly behind the camera for this photograph of the partnership.

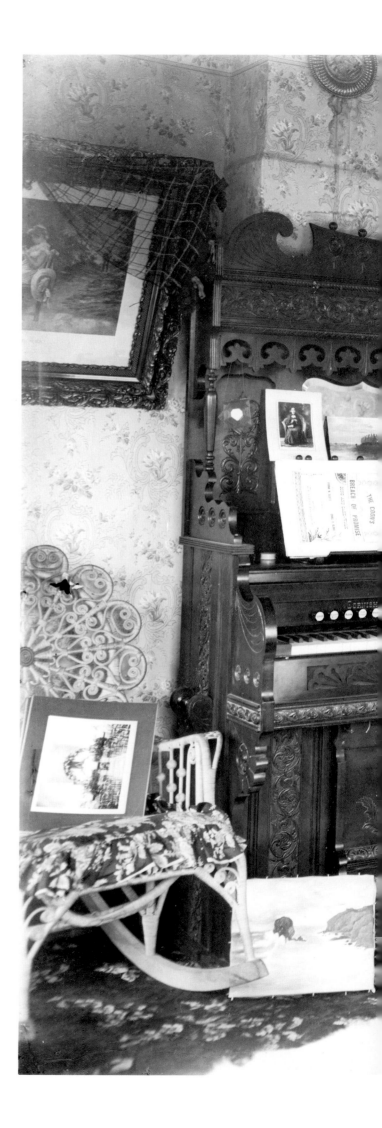

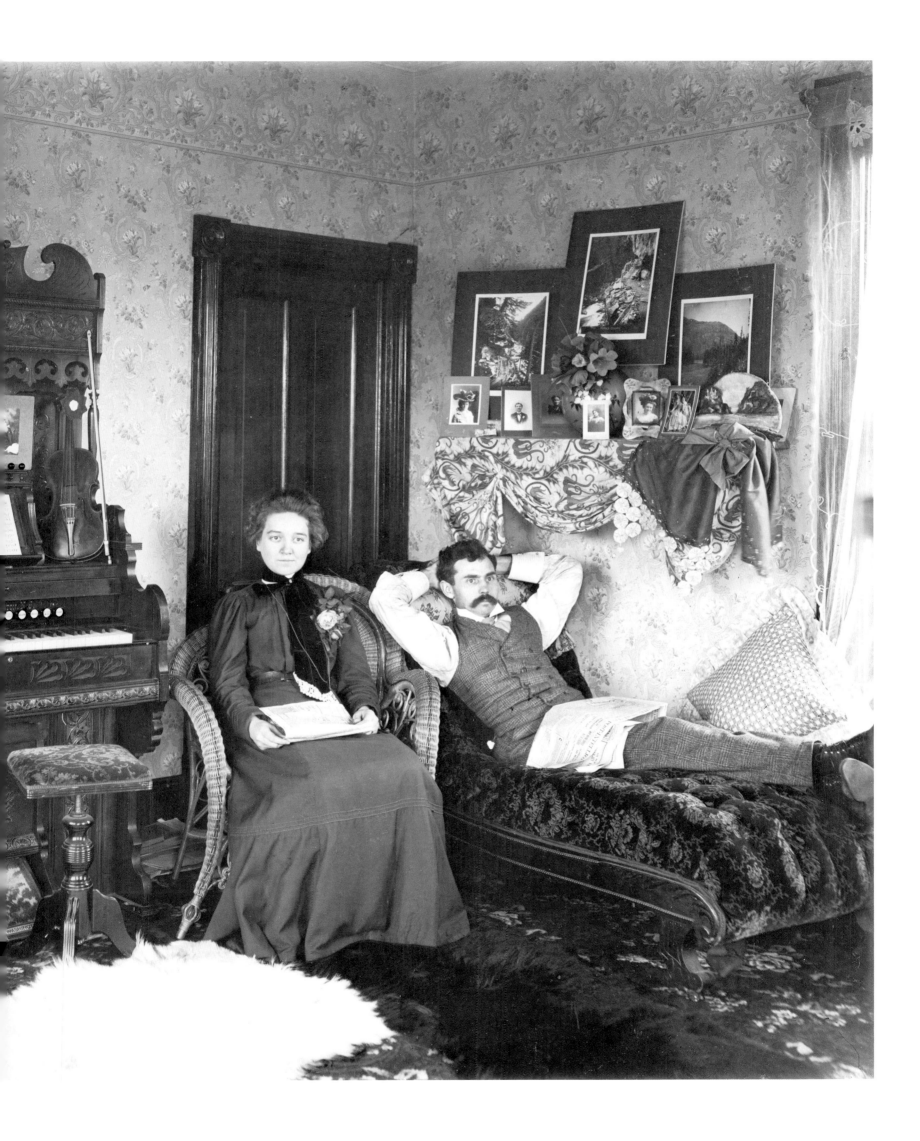

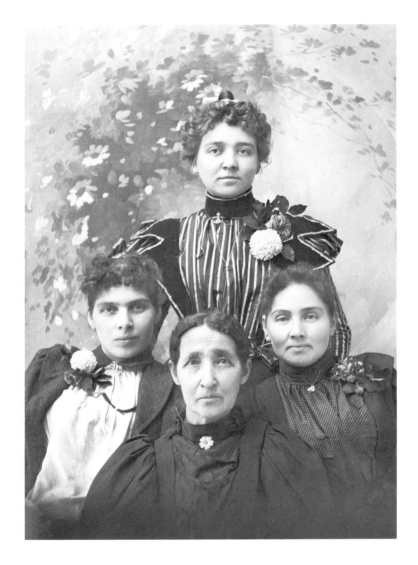

Elizabeth Pritts with daughters
Nancy, Tabitha, and Ellen, c.1898.

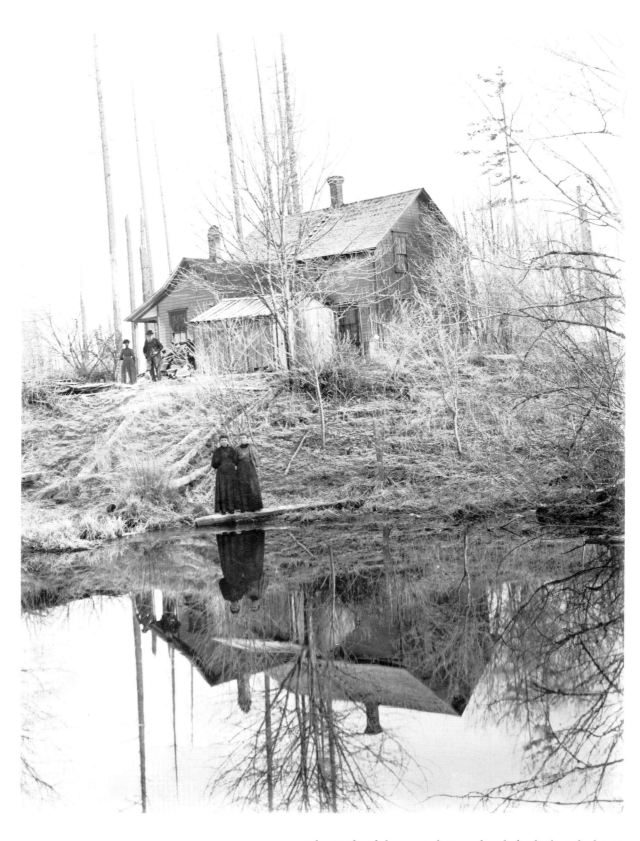

*The Nooksack homestead. Samuel and Elizabeth at the house,
Tabitha and friend by the water.*

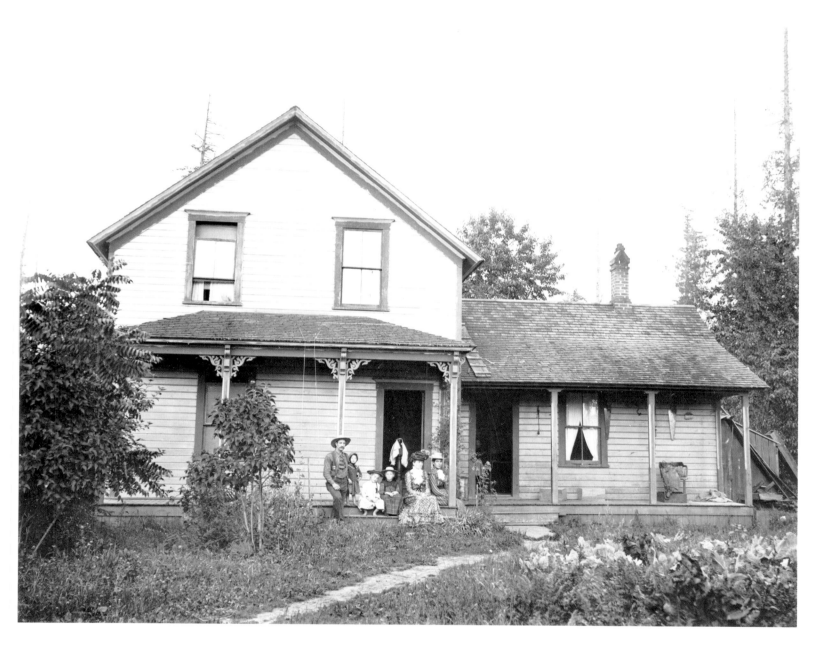

The Nooksack homestead. Jess and Nancy (Pritts) Tucker
and children, with Tabitha, c.1900.

My father's folks took up, I guess you'd call it a homestead, out there in Nooksack, and they were living there when Darius and Tabitha met. He was a photographer then and came through the country taking pictures and he met my aunt there [1894] and fell in love with her and he just never gave up.

Ada Pritts Brown
Interview
November 1972

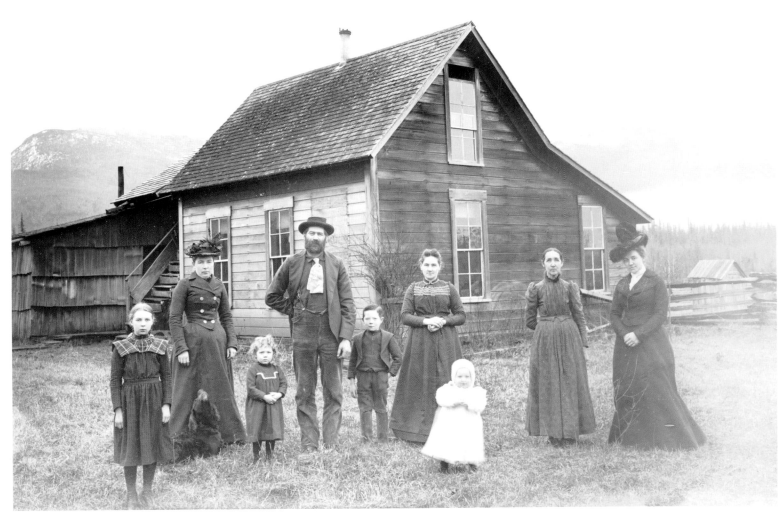

William and Lou Pritts at left with daughters Ada and Eva.
Ellen Pritts Germain with son George and daughter Arvilla.
Elizabeth Pritts and Tabitha. Photograph by Darius.
On the next page, the photograph was taken by Tabitha. C.1900.

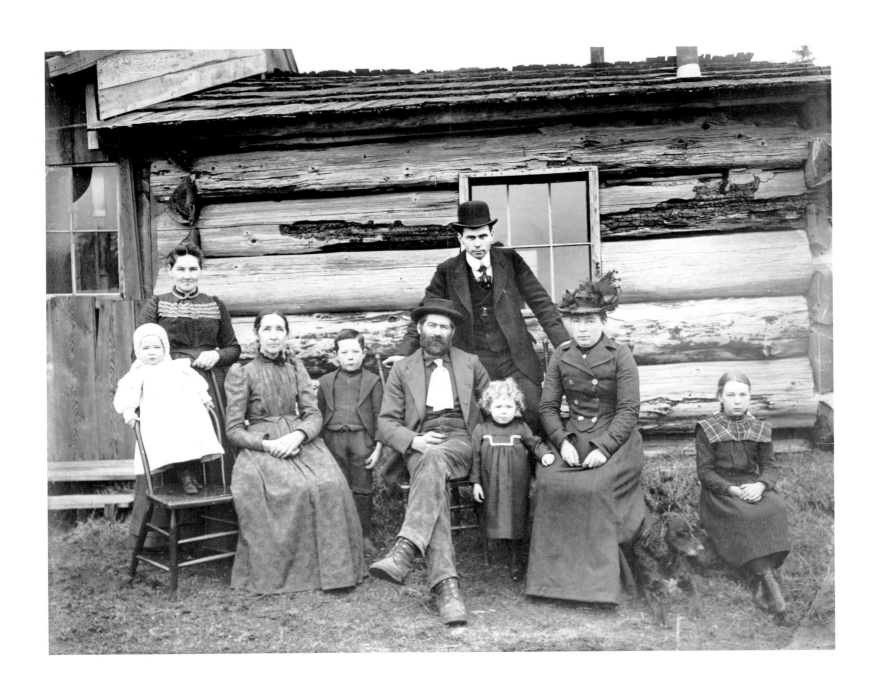

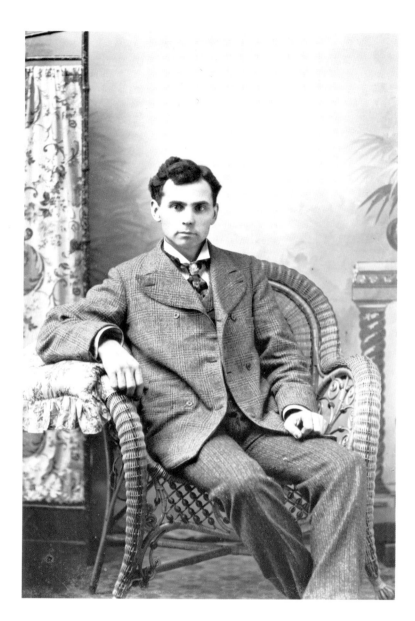

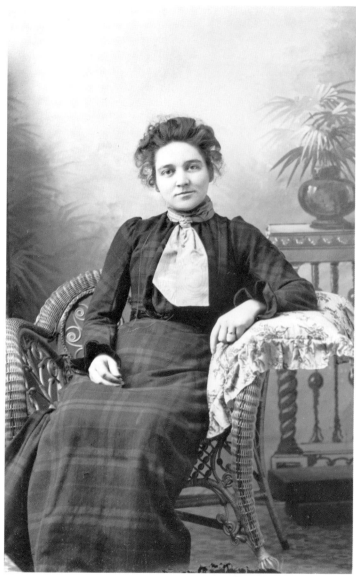

At Sedro-Woolley, c. February, 1901.

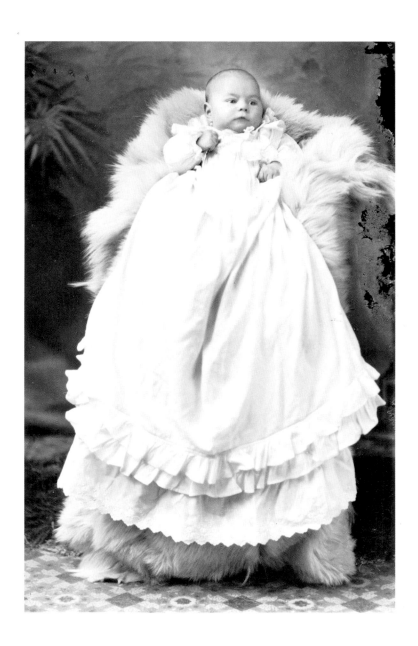

Dorothea Kinsey was born at Sedro-Woolley on August 30, 1901. Darius photographed her at seven hours of age, at least once a week for the first year of her life, and regularly thereafter for almost a decade.

"Yes, my birth date was August 30, 1901, and I think I told you father was Superintendent of the Methodist Sunday School and had a large dollar-size button made which he clipped under his coat lapel, containing that picture of me at the tender age of 5 hours. And when asked about the new arrival, he'd flip over that lapel."
Correspondence, February 13, 1974.

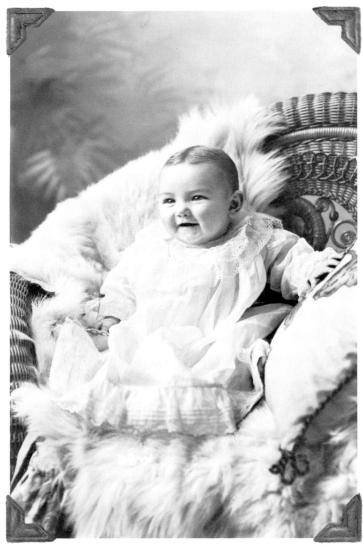

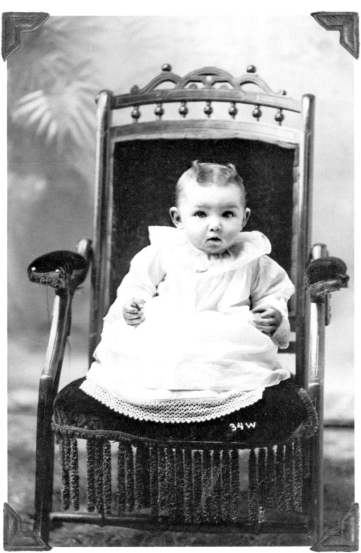

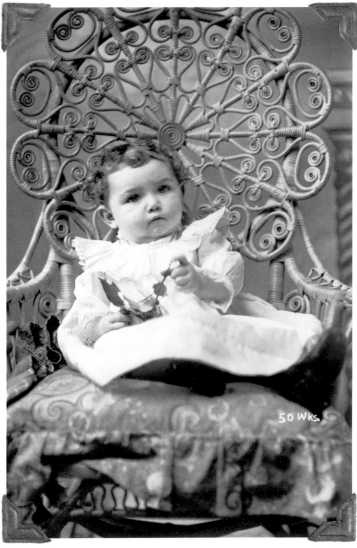

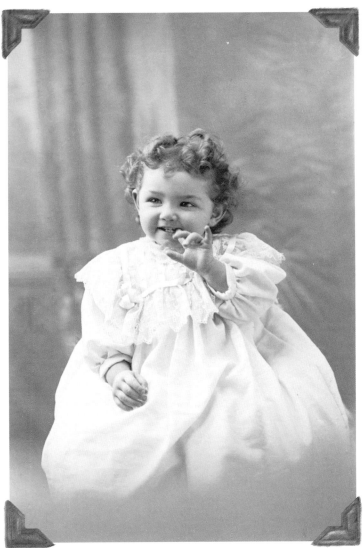

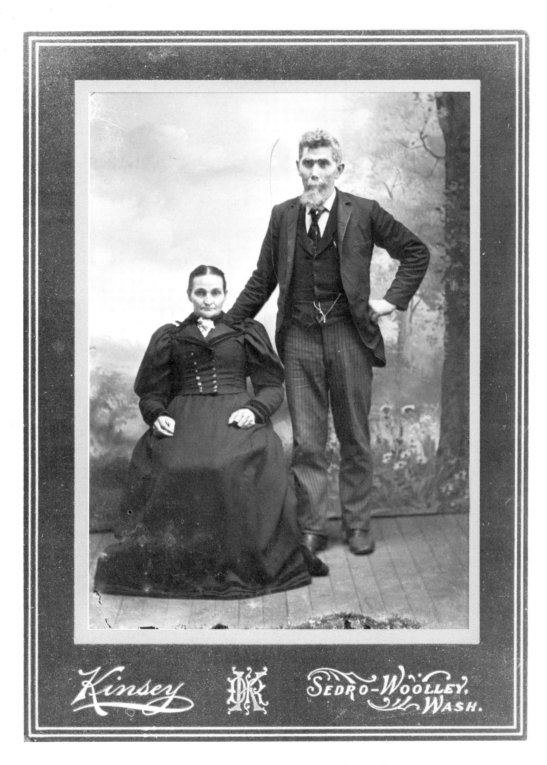

Kinsey

SEDRO-WOOLLEY, WASH.

Darius' father and mother, Edmund John and Louisa (McBride) Kinsey, c.1896.

the Kinsey side of the Family

INHABITANTS in *Grant Township*, in the COUNTY of *Nodaway*, STATE of *Missouri*, enumerated by me on the 19th day of June, 1880.

JOHN B. KILDOW

Kinsey, Edmund J.	35	—		—	Farmer
Louisa	33	—	Wife	—	Keeping House
Alfred	12	—	Son	—	Laborer
Darius	10	—	Son	—	At Home
Clarence	8	—	Son	—	At Home
Emeline	7	—	Daughter	—	At Home
Edmund	4	—	Son	—	At Home
Clark	3	—	Son	—	At Home

The 1880 census (Soundex) is from The State Historical Society of Missouri.

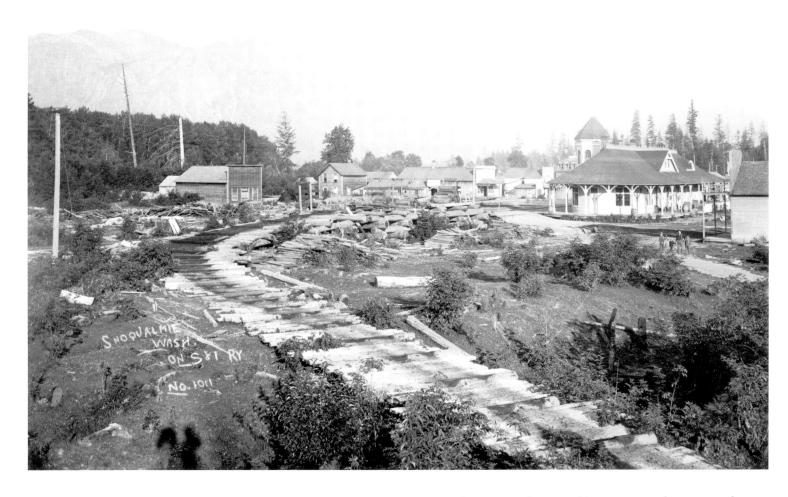

0307. *Mount Si, from Snoqualmie, Washington; Snoqualmie Pass in distance (Snoqualmie, Wash., on S & I Ry. No. 1011 [1897]).* Note immortal shadows of camera, tripod, and photographer. Hotel Kinsey is just visible to left of railroad station roof.

Captions: In the family section, identifications have been added by the authors, with one exception. Through the rest of Volume One, Darius Kinsey typewritten captions appear without parentheses; captions hand-written on the emulsion of the plates appear in parentheses; bracketed dates are inferred from Darius' numbering system (risky) and/or the context of a particular photograph, if applicable. Additions in Roman typeface are by the authors. In most cases, the typewritten captions have been cropped from the bottom of the plate, where they sometimes appear.

Eighty-two Years in the Snoqualmie Valley
Some Memories of the Kinsey Family

My parents moved to Snoqualmie in June, 1890, from Seattle. The railroad had been completed in 1889. I was born in Seattle in 1879, so was old enough to remember a great deal of the early days around the valley. The roads were very poor and there was only one bridge across the rivers. This was a railroad bridge from Snoqualmie to the sawmill on the opposite side. Few people lived in Snoqualmie. The mill workers lived near the mill and several people lived on the hop ranch, now called Meadowbrook, and that is where my folks settled for a year or two.

Among the people who came when we did were the Kinsey family, the Fowlers, Karl Klaus, and Jessie Gordon and family. The Con Fury family came a little later. The Kinsey family settled on a piece of ground across the street from the present *Record* office. The place was covered with stumps and old logs but with five strong boys and one girl they soon built a house and had the ground in good shape and a fine garden.

Mr. Kinsey [Darius' father, Edmund J.] was a carpenter and quite religious. He built the first church and worked alone a good deal of the time. The boys got busy at just about everything. They had a hotel, store, butcher shop, post office, logging camp and livery stable. They furnished driving horses for the traveling men who sold goods to the stores. They also had pack horses for the miners. Two of the boys, Darius and Clark, took pictures of the Northwest and of logging from the beginning when oxen were used to haul logs.

Ed Kinsey was the cattle buyer and ran the pack train. He was a very good judge of horses, as his family had come here from Indian Territory and he had been with horses all his life. Hardly a day passed that Ed didn't trade horses. He would stop the emigrants coming over the mountains with their wagons, and talk trade. Several times there were stories in the Seattle papers about Ed Kinsey and his trading ability. My father told Ed Kinsey one day that he wanted to get a good buggy horse. Ed said, "I know just what you want." In a short time Ed came with a gray mare and my father bought it. It was one of the best we ever had.

Every time the Kinseys butchered a beef, Ed would challenge someone on what it would dress. One time he bet with a man who knew a lot about butchering. They bet quite a sum of money, and a large crowd gathered around. Someone held the stake. They put a good padlock on the door and set a time for the weighing the next morning. The whole town was interested in the betting. When the door was opened the next morning, it was noticed that someone had cut a piece of meat off one quarter.

That ended it.

Dionis George Reinig
Snoqualmie, about 1970

Courtesy of Mrs. Leslie (Reinig) Norton
November 1973

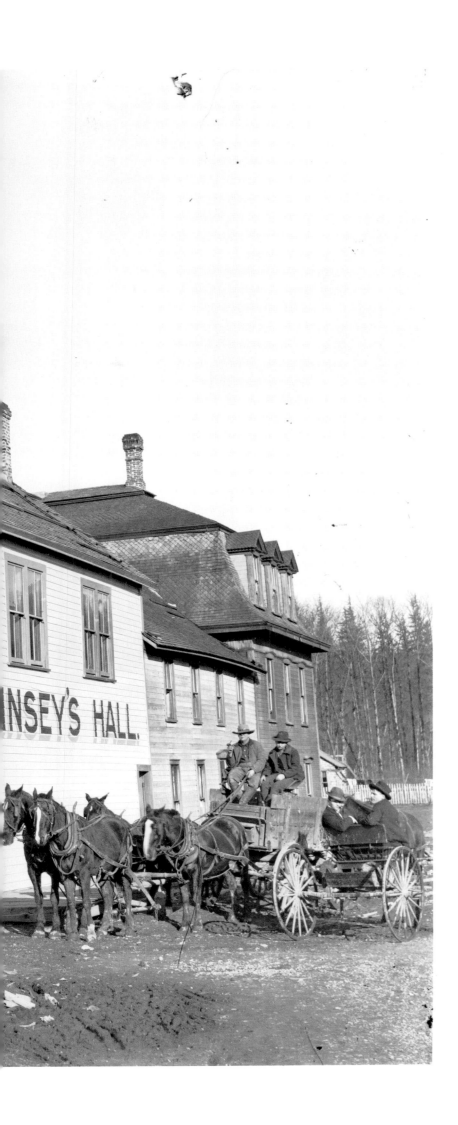

Circa 1902 at Snoqualmie, corner of Front and River Streets. The Post Office far left, dance hall second floor right. Behind the team and wagon, at the next corner, is the actual Hotel Kinsey, which burned in 1902. The Snoqualmie Valley Historical Society has a print showing the front of the Hotel, on the back of which Flora Thaldorf mentions the fire.

On the porch, just to the right of center, are Alfred and Lila Kinsey, with infant Lucile. Alfred ran the store and Lila was postmistress. At the right corner of the building is Sarah Kinsey, wife of Edmund Kinsey, Jr., who is in the left seat of the wagon, with Mark Hanna holding the reins. These identifications are courtesy of Alfreda Kinsey Tiddens.

And finally, at the right corner of the building, relaxing in the sun, is the canine personality known as "Dude."

Louisa Kinsey with sons Darius, Clark, and Clarence.

Judging by dates on a small number of surviving items, Darius and Clark initiated a partnership out of Snoqualmie in 1895, which lasted until spring or summer of 1898 when Clark caught the Fever and rushed to the Yukon—where he and Clarence Kinsey subsequently operated a photographic studio in Grand Forks.[1] Returning to the Northwest in 1900,[2] Clark eventually photographed extensively for the West Coast Lumbermen's Association. Eleven thousand of his 11x14″ negatives were given by his heirs in 1956 to the University of Washington (Special Collections).

[1]*Clark Kinsey obituary, The Seattle* Times, *November 30, 1956, pp. 47, 48. The Skagit County* Times, *June 23, 1904, under* Local News Items.

[2]*The Skagit County* Times, *October 11, 1900. Clark was visiting Darius at Sedro-Woolley.*

Clark Kinsey.

Duplicates of this picture postpaid to any address in the
United States or Canada for 60 cents.

Our Collection of Puget Sound photographic views is more com-
plete than any other Photo Company in the Northwest.
Write us for prices on twenty-five, fifty and
one hundred lots—no two alike.

Kinsey & Kinsey ⁂ Snoqualmie·and····
⁂ ····Nooksack,·Wash.

Official Artists Seattle, Lake Shore & Eastern Railway.

Mary & Millie Adams 1898

The
Little **Trilby** Photo
Was Originated by
Kinsey & Kinsey
Official Artists S., L. S & E. Ry.

*Woolley, Arlington and Snoqual-
mie, Washington.*

Sold for **75 CENTS** a Dozen
And Warranted Not to Fade in Fifty
Years.
Negatives Preserved.

TIMES' Print, SEDRO.

*Kinsey & Kinsey cards courtesy May Tucker Ploeg,
Ed Fleetwood, and Violet Sumner.*

Kinsey & Kinsey *Woolley, Arlington and
Snoqualmie, Washington.*

Official artists S., L. S. & E. Ry.

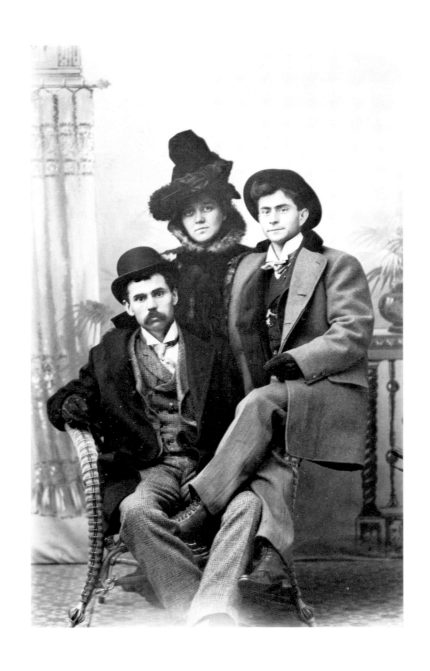

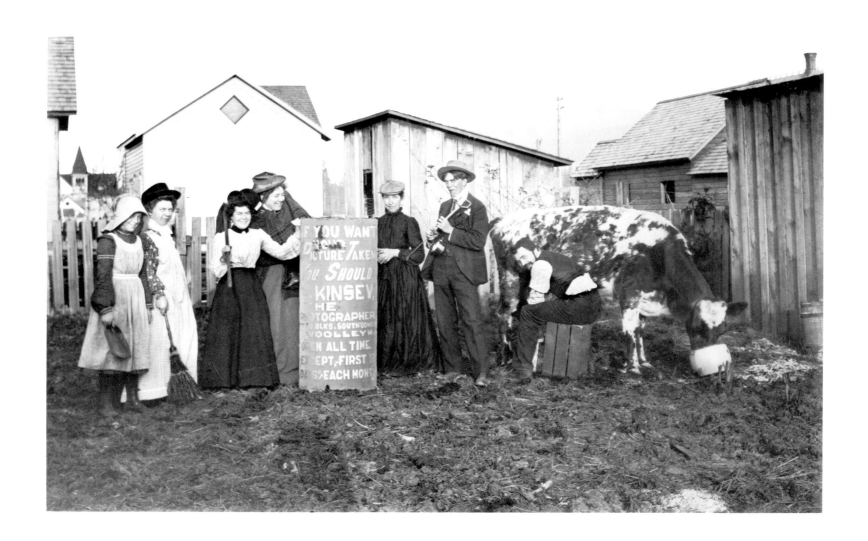

A bunch of jokers, including Grandmother Pritts and Tabitha, with the sign destined for
Metcalf Street, downtown Sedro-Woolley, where it was attached to the corner of the
building across the alley from O. S. Paulson's clothing store. The wall alongside was
plastered with tobacco and plug cut advertisements, and the lower part of the sign was
later changed to read "Open Every Day Of The Year Except Sunday."

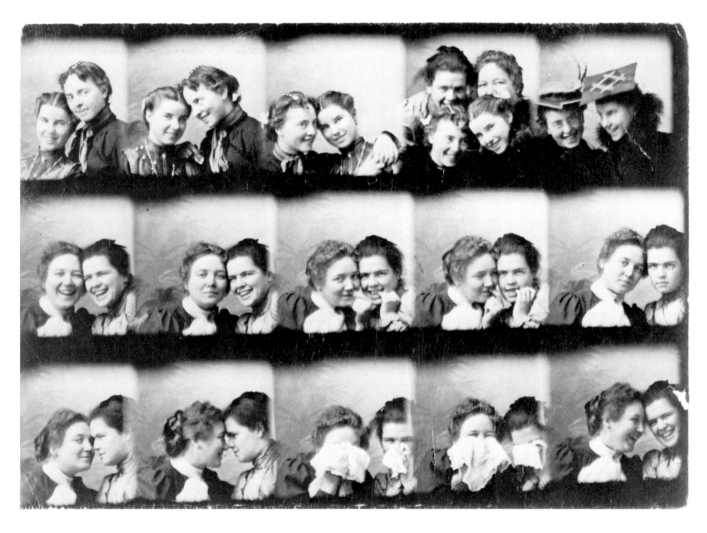

Stamp Photos

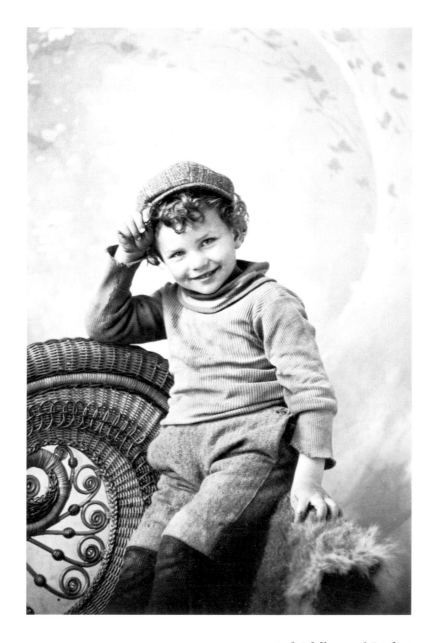

*Earl Odell, son of Emeline
(Kinsey) and Burt Odell.*

POSING is perhaps the most important point in securing a good picture, and it's a point to which we give much care. We study each subject and bring out the character and individuality of the face to the best advantage. The same care is given to every part of the work, to the retouching, printing, toning and mounting, so that the finished picture is a pleasure to you and a credit to us. The Kinsey Studio, Sedro-Woolley, Wash.

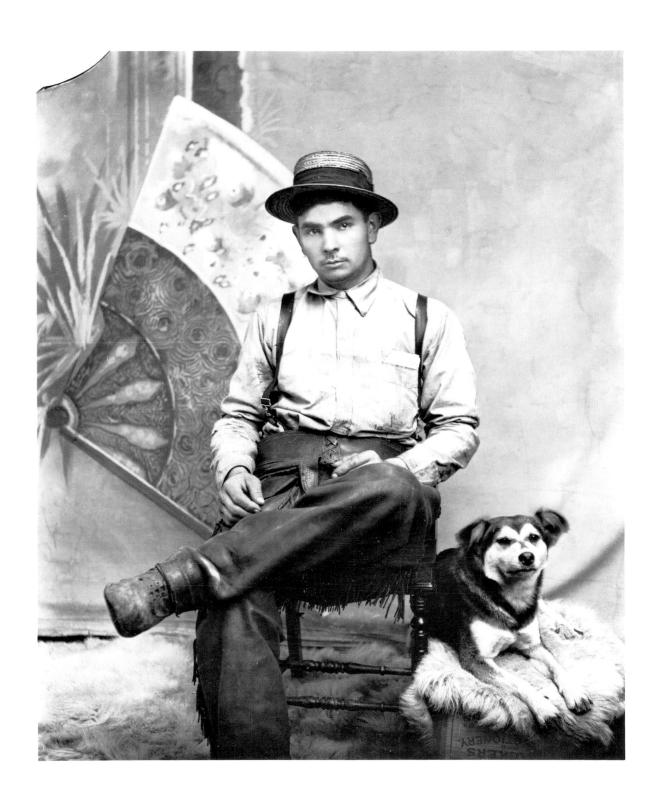

"This is my uncle Ed and I really exclaimed loud and clear when I looked at this picture—
'*That's our dog Dude*!' I hadn't thought of him in all these seventy-plus years. I remember
how kind my father was to him (Mother wasn't too keen about him being in the house, because
of fleas and shedding hair). Dad used to pet Dude a great deal and say to him—
'Good old Dude.' " (Dorothea Kinsey Parcheski on identifying the photograph.)

The Value of a Really Good Portrait is Beyond Estimate.

Its peculiar Fitness for a Holiday Gift

 Is Beyond Dispute. You are Earnestly Requested to Call and Examine our Work

Before deciding upon your Christmas Purchases. Avoid the Holiday Rush by ordering at once. Delay may mean disappointment.

Darius Kinsey, Photographer, Sedro=Woolley, Wash.

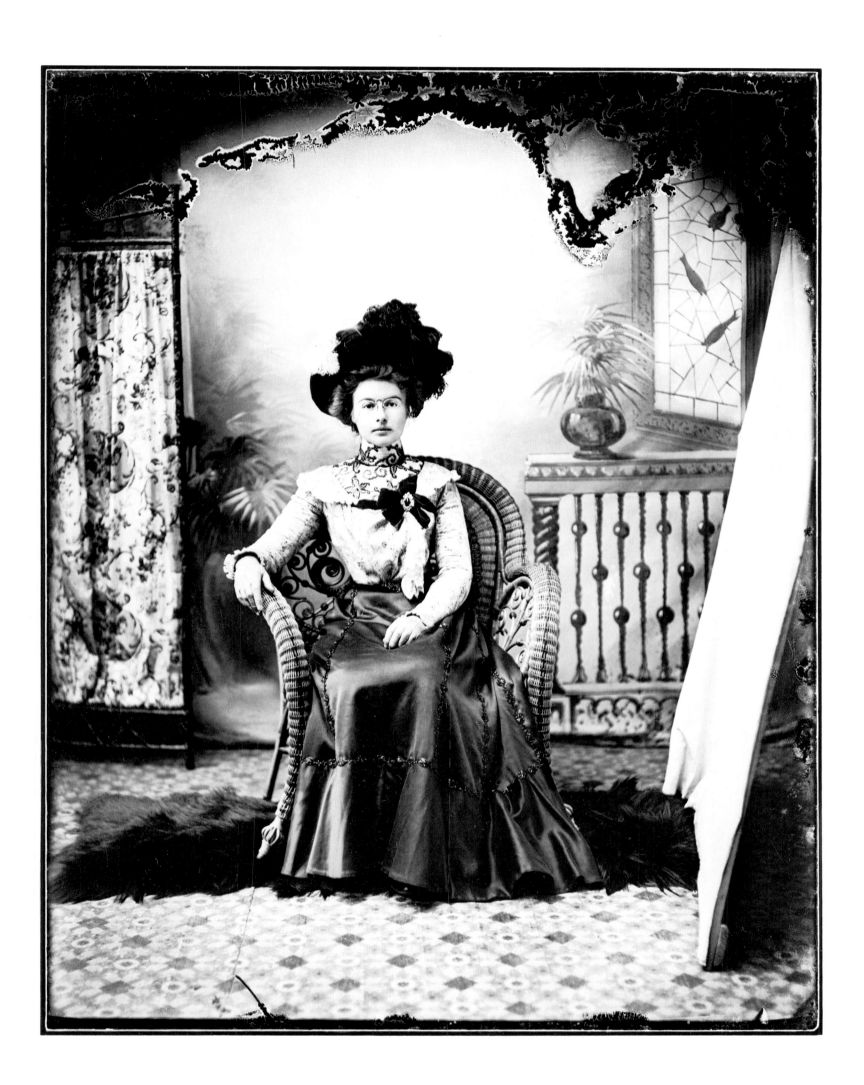

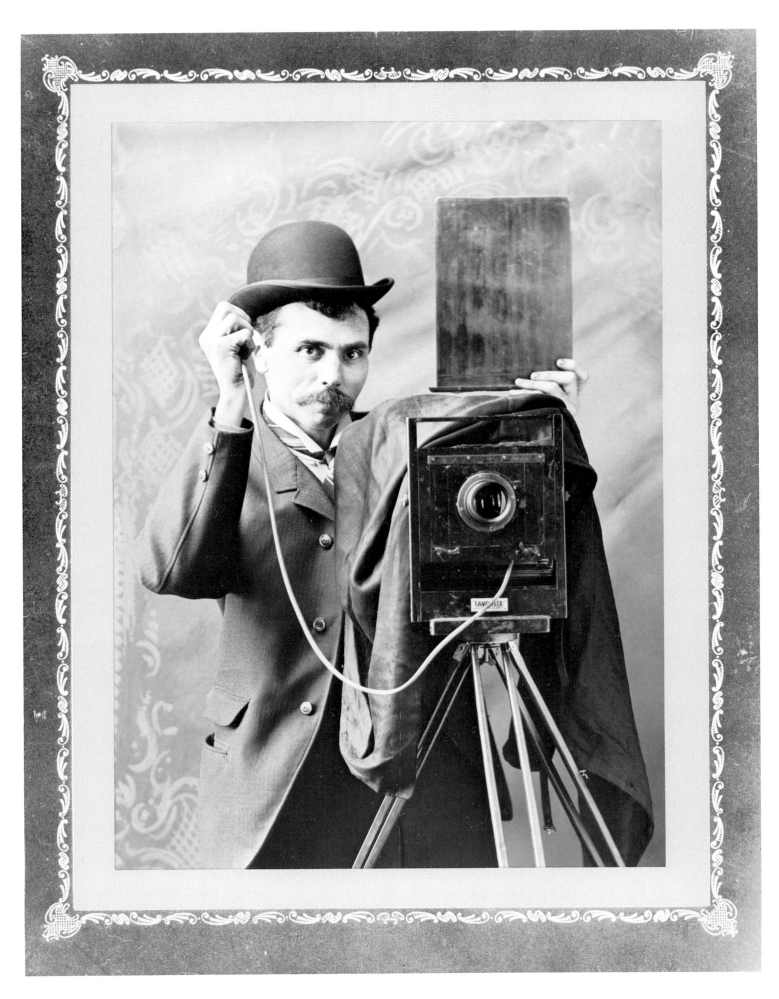

Enlarged from the 4-1/4 x 6-1/2" plate.
"Our One Desire . . ." is from a
7 x 9" manila print envelope.

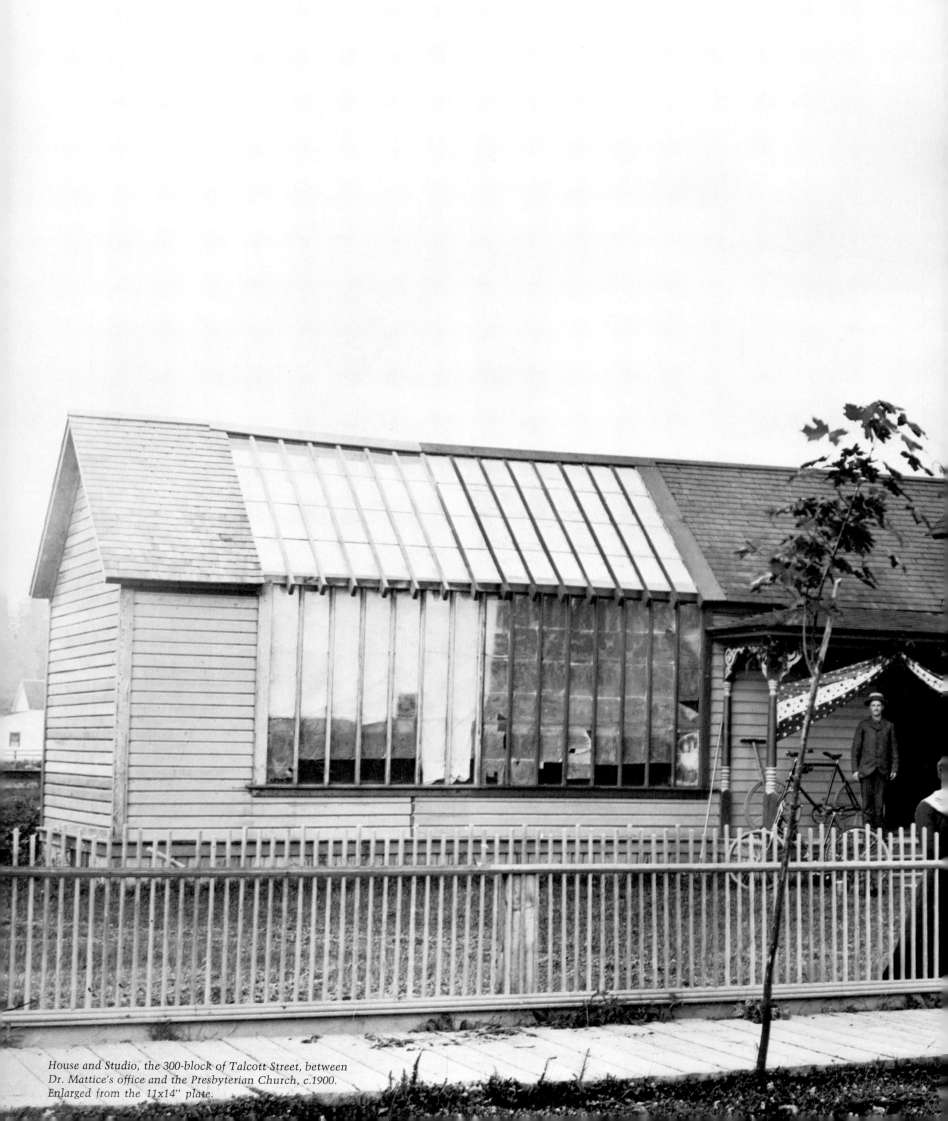

House and Studio, the 300-block of Talcott Street, between Dr. Mattice's office and the Presbyterian Church, c.1900. Enlarged from the 11x14" plate.

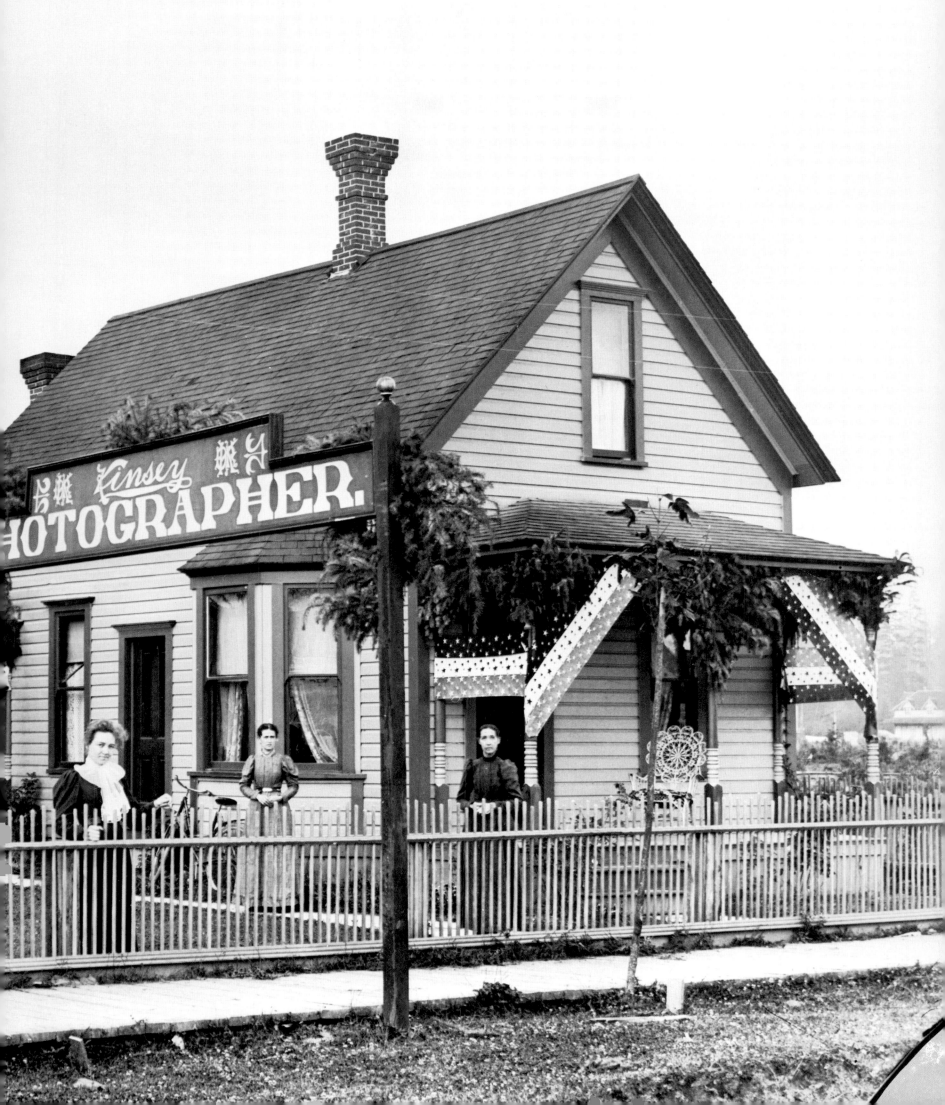

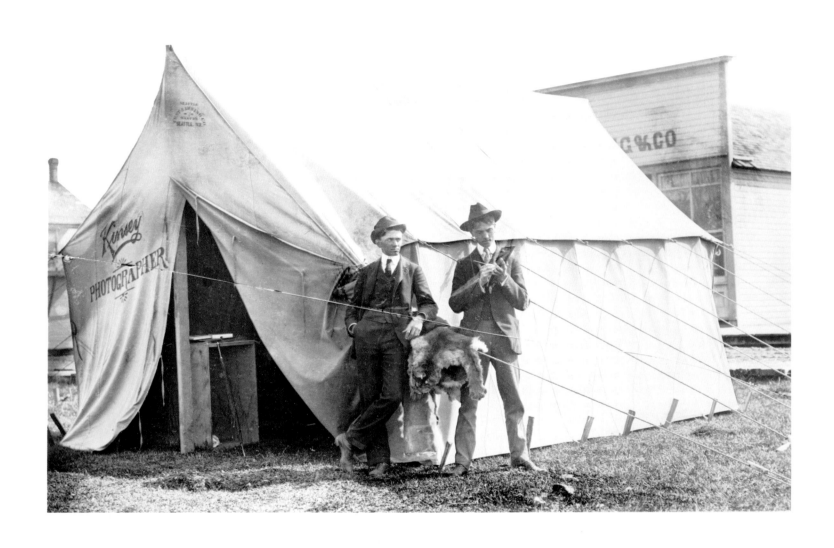

The Skagit County *Times*, August 31, 1899: *"D. R. Kinsey will visit Hamilton on or about September 11 with his tent studio, remaining for a few days only."*

September 7, 1899: *"Fourteen photos for a dozen Tuesday, September 12, in Kinsey's tent studio at Hamilton. Will be opened Monday, the 11th, remaining for a few days only."*

*The Tent Studio. Clark Kinsey far right. Clarence Kinsey
middle row, right. C.1902.*

July 12, 1900: "Kinsey's new studio will be located in McMurry Monday, July 16,
remaining until Saturday, July 21. Fifteen photos for a dozen on Tuesday the seventeenth."

July 19, 1900: *"Kinsey has decided to locate his new tent studio in Clearlake for a few days,
beginning with Tuesday, July 24. Those desiring to have family groups taken, or have not the
time to visit the city studio, should embrace this opportunity. See samples in Clearlake postoffice."*

June 4, 1903: "D. Kinsey, Sedro-Woolley's famous photographer is telling the good people
of Hamilton to 'look pleasant' this week."

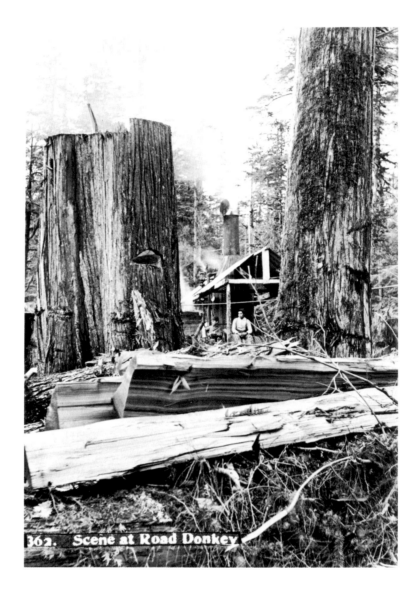

362. Scene at Road Donkey

Enlarged from stereo pair. C.1898.

Thus endeth the Family Album.

We turn now to the woods, the mountains, the streams and glaciers. And since Darius' magnificent fifty-year odyssey in photography started in 1890 with the big trees and the men and horses and oxen underneath them, let us begin there as he sallies forth with his very first camera—the 6½x8½″—relentlessly and singlemindedly pursuing an apparently implacable necessity: namely to photograph. To photograph. Always, to photograph.

43. *Log Leaving Chute [1890].*

Only one glass plate has survived from Darius' first year in photography. "Log Leaving Chute" is dated from a copy negative (in the Collection) of a print on which was written the following: "*65A Log entering river from log chute. Photo by Darius Kinsey in 1890.*" Whereabouts of the print is unknown. Since Darius arrived in Snoqualmie from the east in December of 1889, he did not wait long to begin the great adventure.

"Snoqualmie Mill Company's Slough," which is one half of a 6½x8½″ plate,
is one of two surviving negatives from year two, 1891.

"163. Twelve Oxen Hauling Turn of Logs on Skid Road in Washington [c.1892].”
This is the famous Kinsey photograph of the Bryan and Reid skid road, near Arlington.

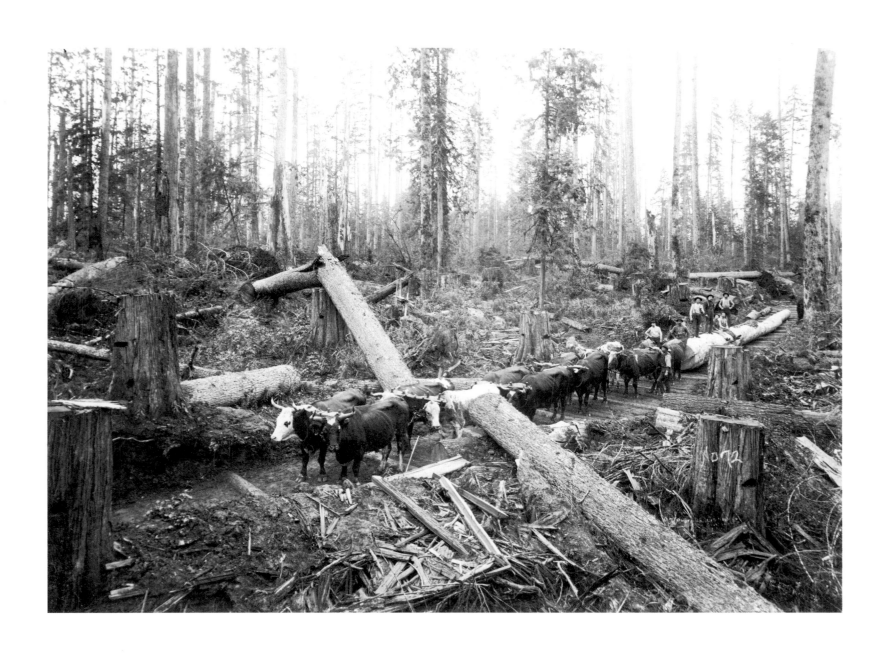

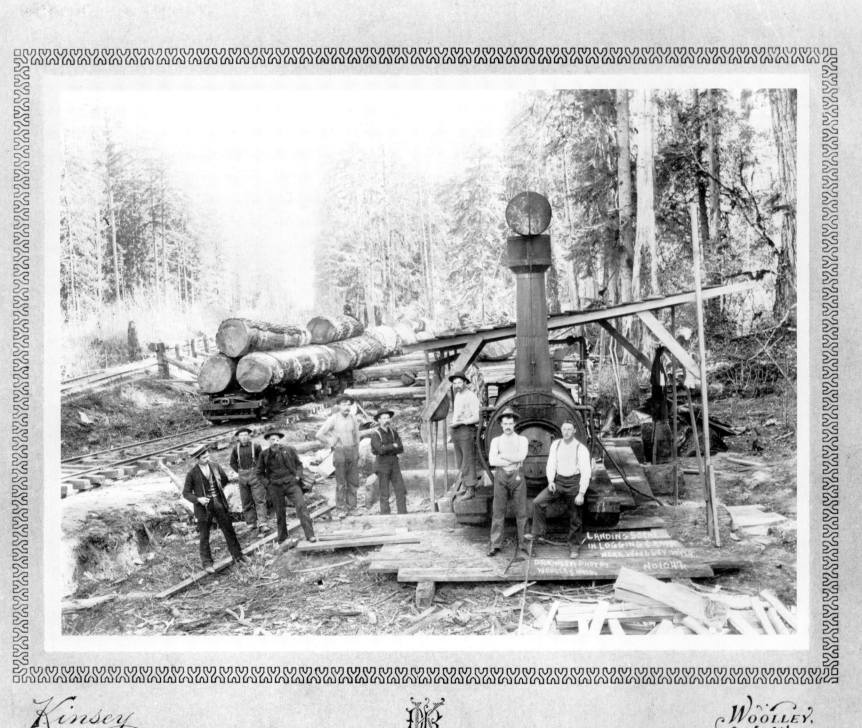

Kinsey

Woolley, Wash.

The year is 1897, and the Photographer Himself is at lower left in working dress, the only known existing photograph of Darius posing on location with the boys. Reproduction is from copy negative of an original 6½x8½″ solar print, and dating is based on the number (1047) and the fact that Sedro and Woolley did not become Sedro-Woolley until 1898.

"Preparing To Fall a Jiant Fir in a Washington Forrest. No. 1030.
D. R. Kinsey Photo., Woolley, Wash."

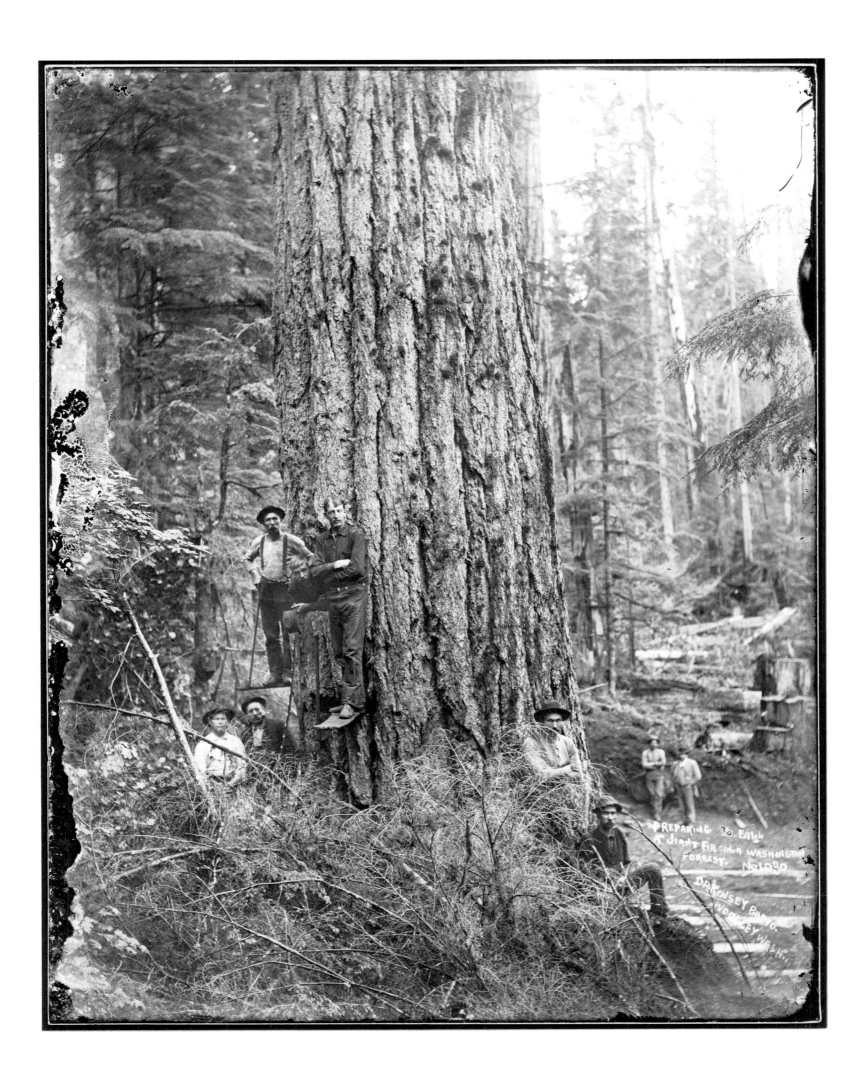

PREPARING TO FALL
A GIANT FIR IN A WASHINGTON
FORREST. No 1030

DARINSEY PHOTO.
WOOLLEY WASH.

Do you want some views of

WASHINGTON FORREST SCENES?

IF YOU DO, remember that we have the best---having
had five years experience making such pictures
in all parts of the Puget Sound Country.

FROM OUR large collection of negatives we have selected
twelve of the best, which represent t e largest trees,
the highest tre s, biggest logs,etc, etc.; also the man-
ner in which the trees are felled, sawed up, hauled
out of the woods, and loaded on the car. Among
this collection is a beautiful picture of the Snoqual-
mie Falls; also, one of Mount Rainier.

ALL OF THEM are the same size as this one and can be
had at the following prices: One, for 50 cents;
Three, for $1; Seven, for $2; Twelve, for $3, prepaid.

Address:

KINSEY & KINSEY,

OFFICIAL ARTISTS S. & I. Ry.,

Snoqualmie, Wash.

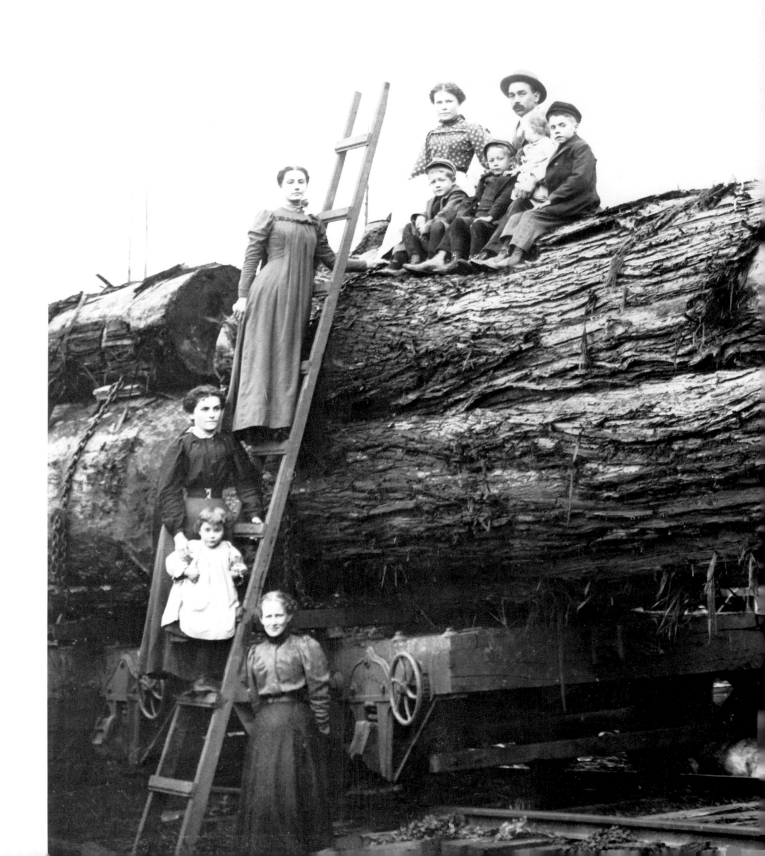

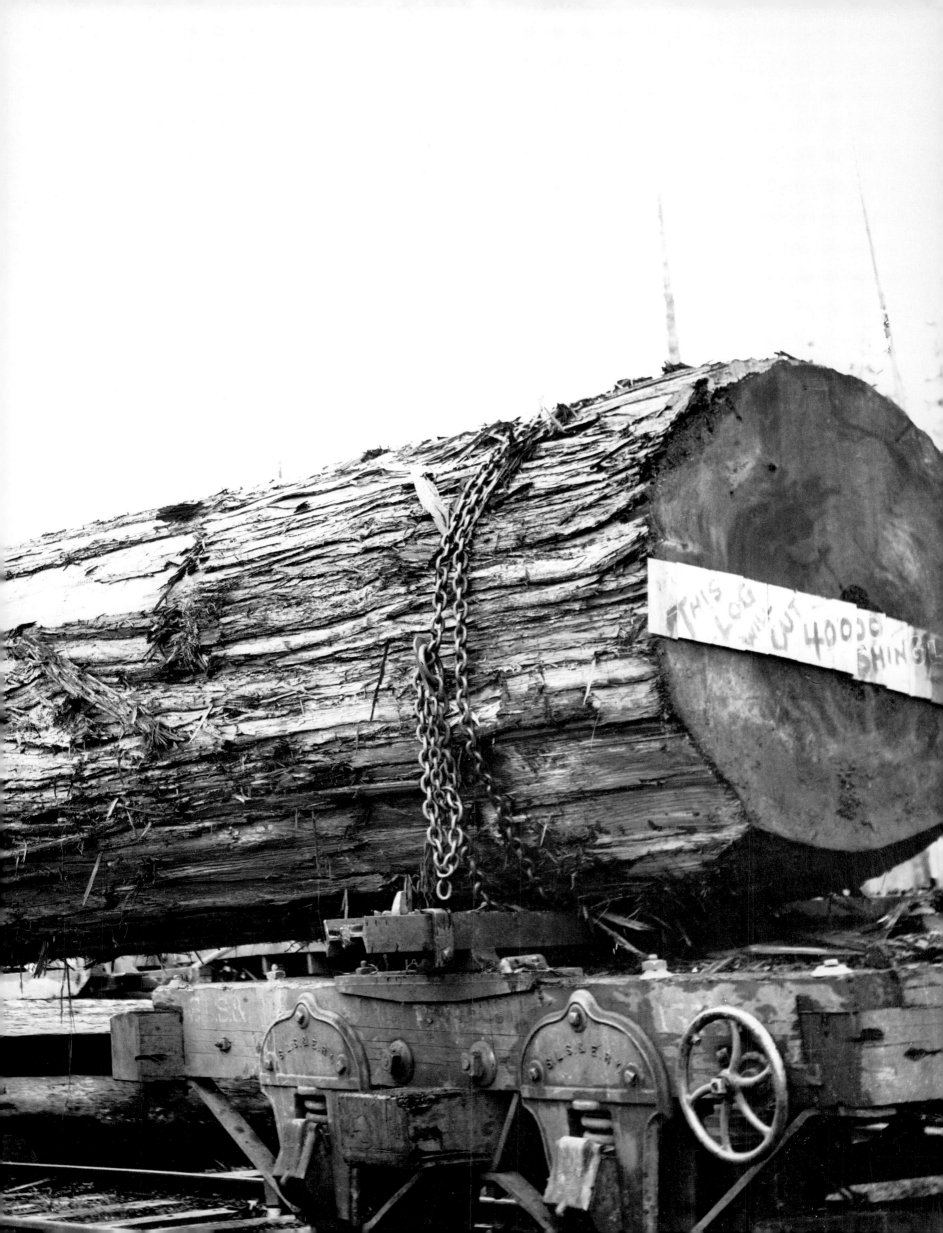
THIS LOG WILL CUT 40000 SHINGLES

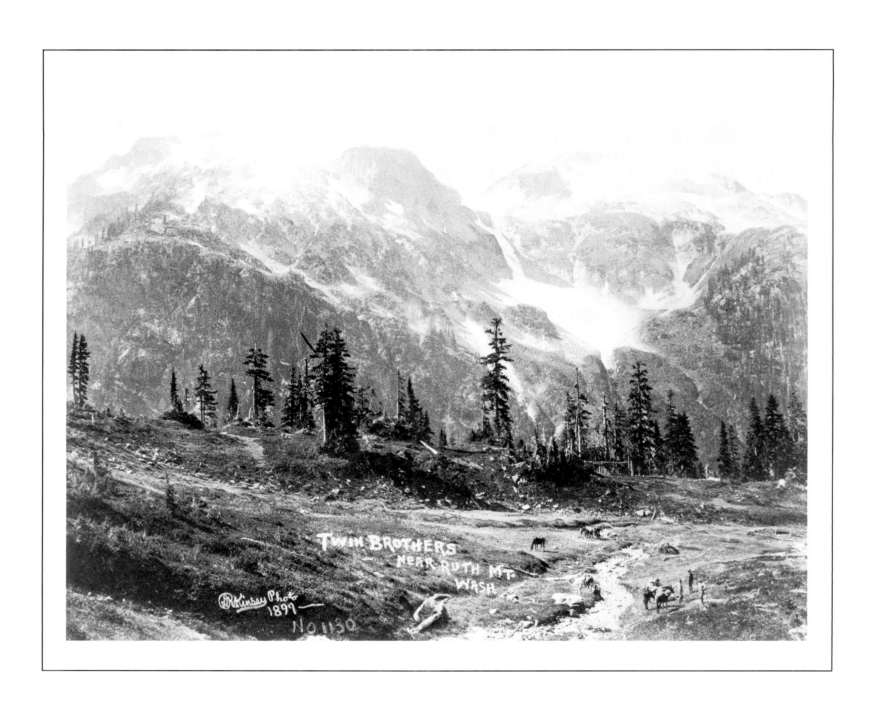

TWIN BROTHERS
NEAR RUTH MT.
WASH.

D.R.Kinsey Photo
1899
No 1130

D.R.Kinsey Photog.
1899

the Expedition of 1897

It must have been the month of August, when the snow is gone from the high country. There were eight or nine horses and five men total. They probably started the plus one hundred mile round trip from Nooksack. Darius took the 6½x8½" (and possibly the stereo), a supply of glass plates, his tripod, and a black umbrella. Three miles out from Deming they picked up the North Fork of the Nooksack River, headed north for five miles and west for almost twenty-five. Then a side trip north, about seven miles up Swamp Creek and over Gold Run Pass to Tomyhoi Lake, which Darius spelled "Tommyhigh." At this point in his first venture into the photography of pure mountain landscape, Darius was only warming up, for the two solar prints that survive are not impressive.

They came back down Swamp Creek and pointed west again, but only for three miles before cutting into the Ruth Creek valley where they were surrounded by the peaks rising abruptly from both sides of the drainage, all the way to Hannegan Pass, the major destination. And now one can almost see Darius up there in his bowler, shading his eyes against the brilliance of the glaciers, scooping a drink from a rushing stream, setting up the tripod again and again, the black umbrella held over the camera— the photographer oblivious to the slightly-perplexed packers who had never before seen a man so obsessed with taking pictures.

By some unlikely miracle eighteen original solar prints from this expedition have come down to us, which combined with the remaining glass plates provide a total of twenty different views. A conclusion is inescapable . . . Darius was in his element. The photographs made as they ascended Ruth Creek and the panorama of eight plates (nearly 360 degrees) taken from Hannegan Pass sing of the Cascades. Granite Mountain, the Nooksack Ridge with Mt. Shuksan beyond, Ruth Mountain, the campfire alongside the packers' tent at the Pass, and the high-mountain photograph that Darius was never to surpass in the forty-three years of camera work ahead of him—"Mt. Tib"—which he named for his bride of one year.

Yes, Darius was in his element. Darius Kinsey, Photographer, in the high country of the Northern Cascades.

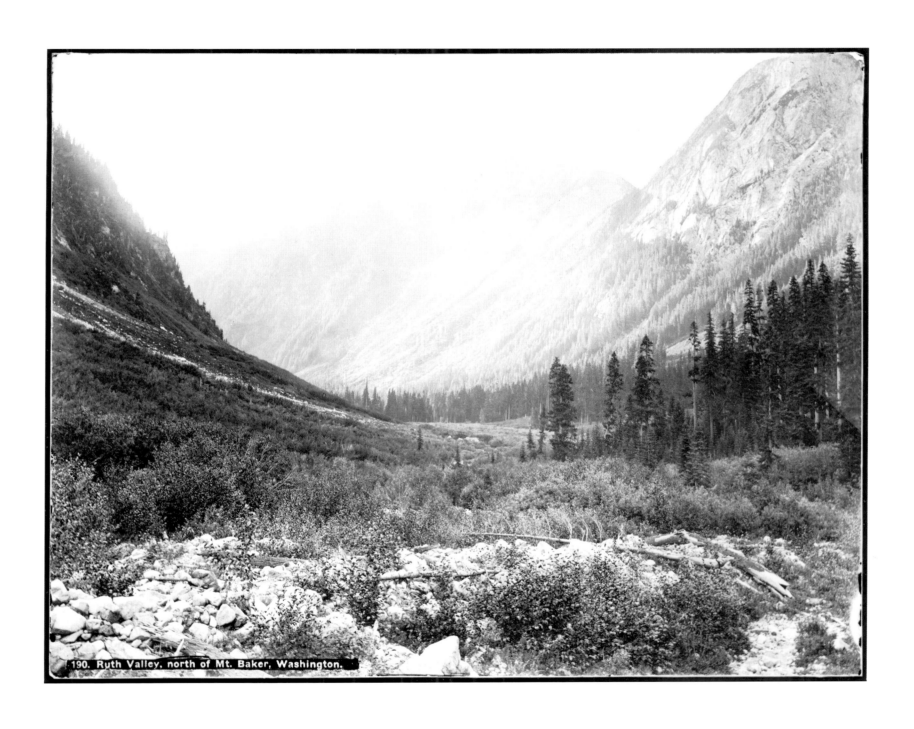

190. Ruth Valley, north of Mt. Baker, Washington.

76

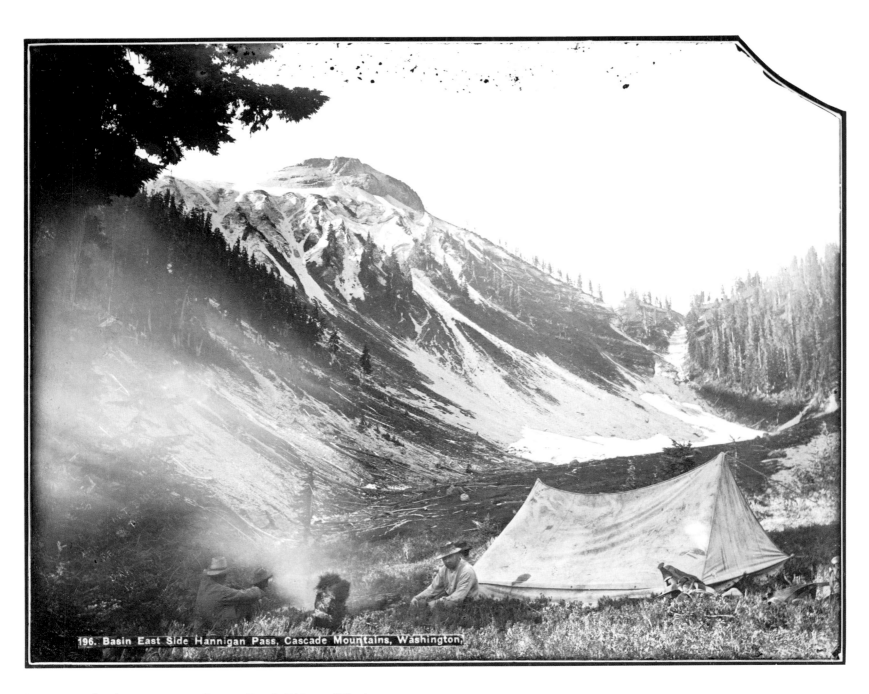

196. Basin East Side Hannigan Pass, Cascade Mountains, Washington,

(Basin East Side Of Hannigan Pass Showing Result Of Snow Slides.)

(Hannigan Pass Wash., From East Side—D.R. Kinsey,
Photo., Woolley, Wash., No. 1116.)

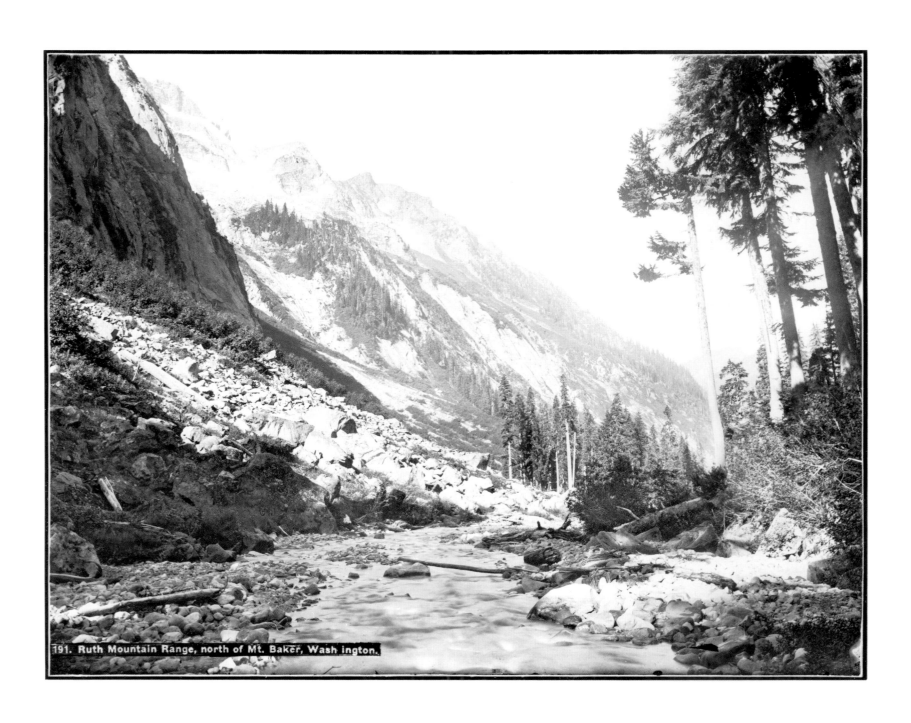

191. Ruth Mountain Range, north of Mt. Baker, Washington.

78

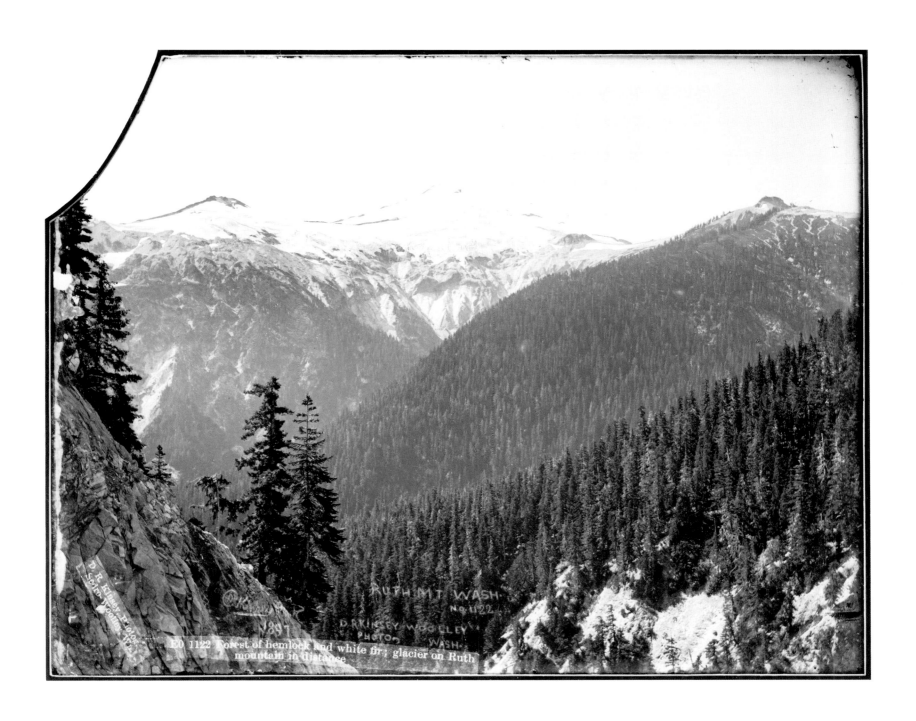

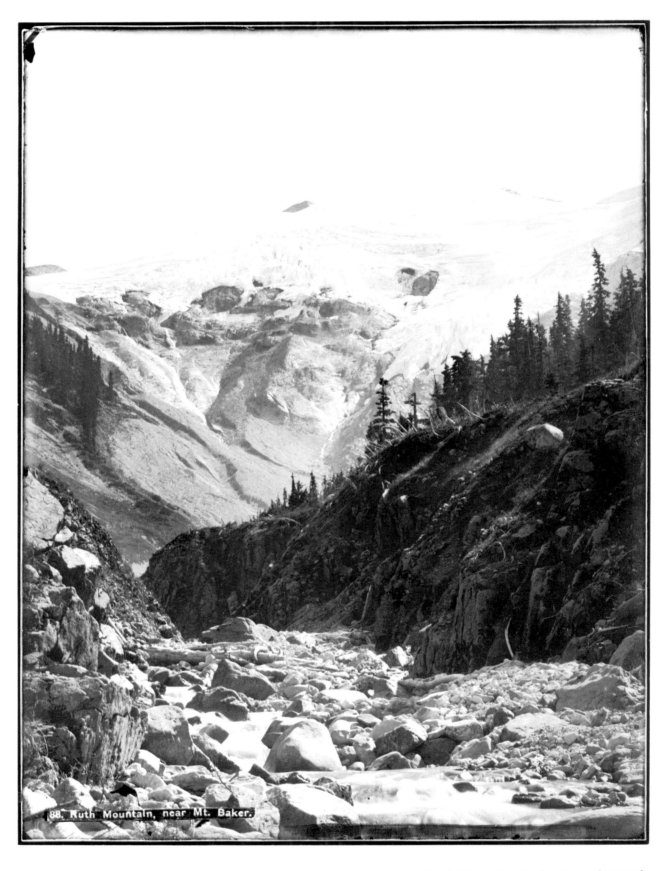

88. Ruth Mountain, near Mt. Baker.

(Ruth Mountain, Wash., Copyright 1897 by
D.R. Kinsey, Photo., Woolley, Wash. No. 1124.)

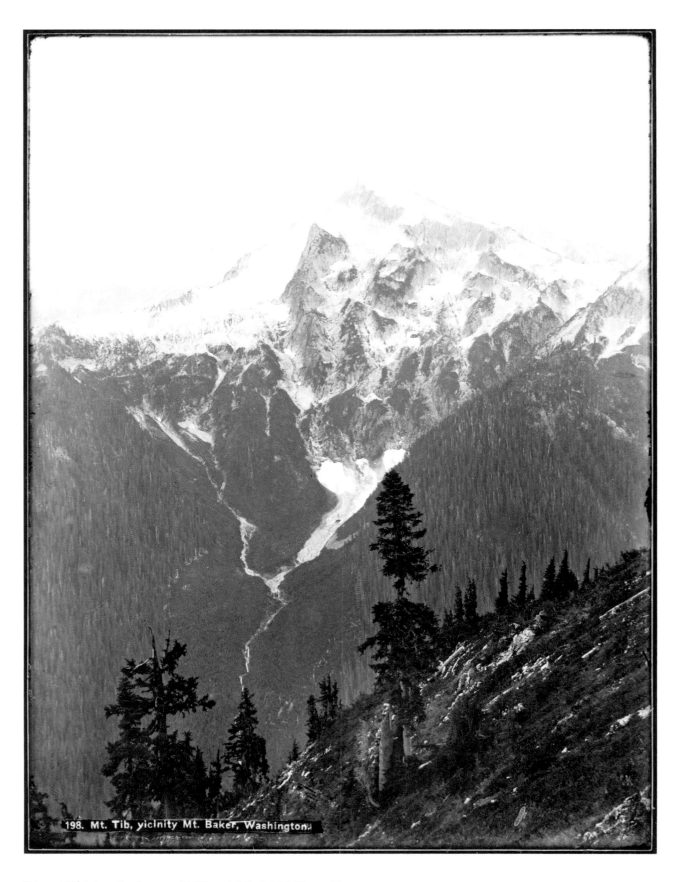

(Mount Tib Near Headwaters Chilliwack Wash. DR Kinsey Photo 1897—No. 1123.) This is the north side of Mineral Mountain.

Sedro-Woolley at the Turn of the Century

The Skagit County *Times*, April 14, 1904: "*The City Census*—The census just taken by H. L. Devan for the purpose of advancing the town of Sedro-Woolley to a city of the third class shows that upon the actual town site, there live, breathe and have their being sixteen hundred and eighty-seven persons. When the towns of Sedro and Woolley were consolidated it was found necessary to omit a portion of each, as the law governing municipal bodies of that class does not allow them to contain more than a certain area within their limits. It is estimated that there are from eight hundred to nine hundred people living in this adjoining territory, which would make the real population of Sedro-Woolley about twenty-five hundred."

The Skagit County *Courier*, September 25, 1902: "Kinsey, the Sedro-Woolley photographer, will again be in Sumas October 29 and 30 and will occupy King's Photograph Studio. Mr. Kinsey is considering the proposition to open a permanent gallery here, expecting to visit here two or three days each month. Mr. Kinsey is perhaps the best photographer on the coast so the people of Sumas will, by patronizing him, get as good results from sittings as can be had in the larger cities. Sumas *News*."

The Skagit County *Times*, September 28, 1899, under *City and County News*: "D. R. Kinsey, Sedro-Woolley's photographer, has been requested by the World's Fair commission to furnish photographic views of Washington scenery, particularly forest and logging scenes, for exhibition at the Paris Exposition of 1900. This action is in recognition of the great superiority and excellence of Mr. Kinsey's work as an artist and is in itself no mean reward of merit."

The Skagit County *Times*, June 28, 1900, under *Nearby Towns — Hamilton*: "Talk with Kinsey if you want a Kodak. Our price same as the east. Instructions free."

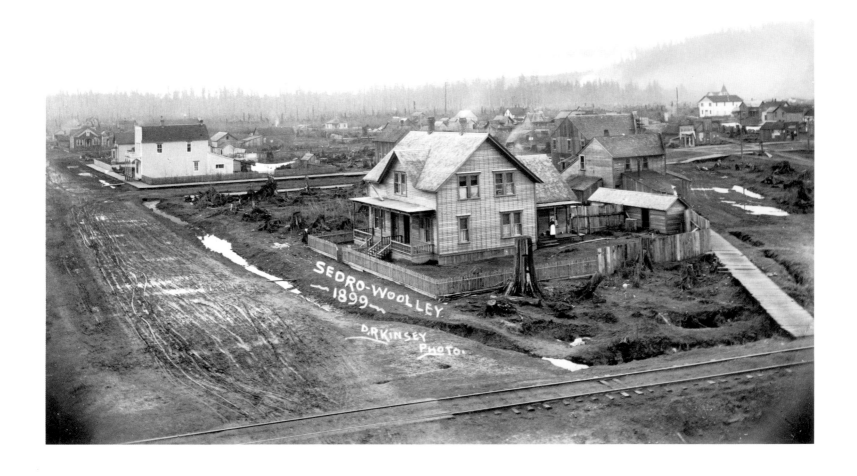

"The pioneer town builder did not arrive until 1884. This was Mortimer Cook, a somewhat eccentric man . . . Mr. Cook's great ambition was to bestow upon the new town a name such as no other town in America should have . . . He eventually concluded to name the place 'Bug' . . . About this time some one suggested that the syllable 'hum' would probably be affixed by outsiders in jest; furthermore, Mrs. Cook and other ladies interested strenuously objected to the undignified name, and the founder of the town was prevailed upon to accept the name Sedro, a corruption of the Spanish word for cedar . . . But while all these developments were in progress in Sedro, a rival for the trade of the surrounding country had been springing up, one destined to handicap for a time the development of the pioneer town, but later to join with it in the outworking of a nobler destiny than either could hope to have achieved alone. This was Woolley . . . Woolley postoffice was

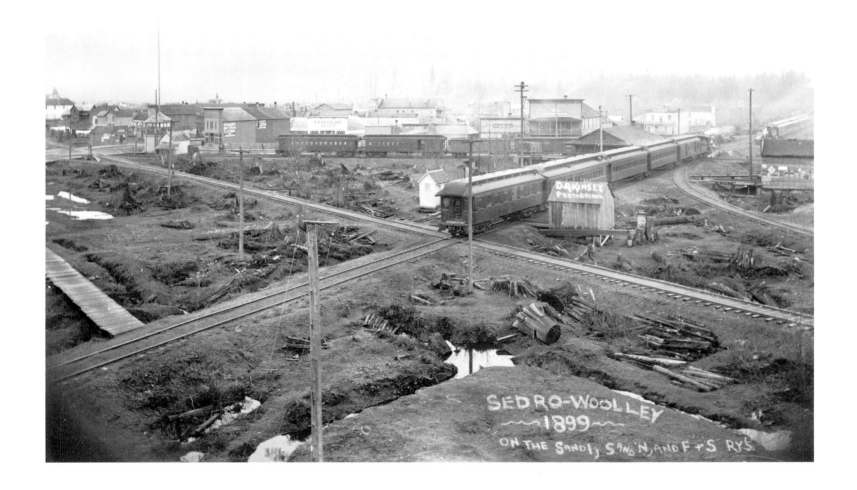

SEDRO-WOOLLEY
~1899~
ON THE S^AND I., S^AND N., AND F.+S. RY.S.

established about August 1, 1890, the mails at first being carried up from Sedro on the backs of Mr. [P. A.] Woolley's sons . . . but as time went on it became apparent to the discerning that the best interests of both [towns] would be better conserved by mutual cooperation and a less active indulgence in the ignoble passion of jealousy . . .

"December 6, 1898, a petition asking that steps be taken toward union was presented to the county commissioners . . . An election was then held . . . which resulted in favor of the union and incorporation, so the two towns were duly incorporated by the commissioners December 19, 1898, under the name of Sedro-Woolley."

from *An Illustrated History of Skagit and Snohomish Counties*, Interstate Publishing Company, 1906

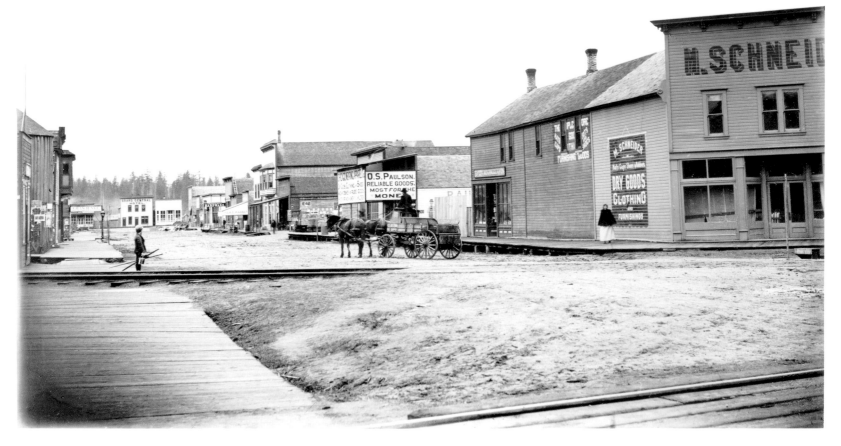

Metcalf Street at Northern Avenue (above), and Northern Avenue (p. 87), c.1899.

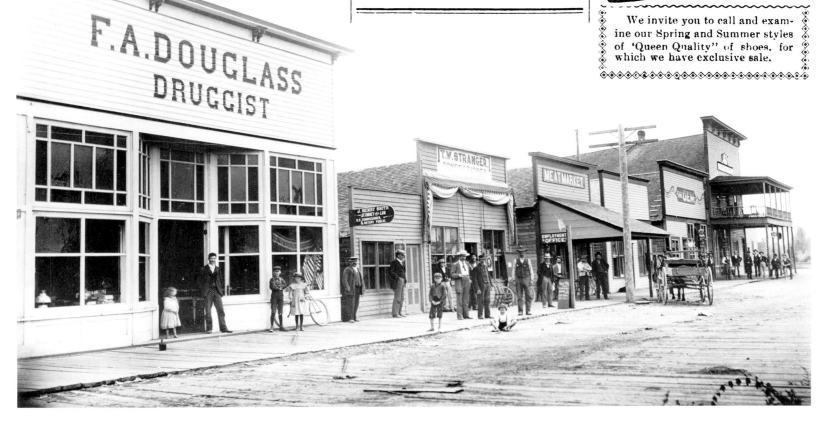

The Skagit County Courier.

OFFICIAL PAPER OF SKAGIT COUNTY.

VOLUME II. SEDRO-WOOLLEY, WASHINGTON, JUNE 19, 1902. NUMBER 6

A FAIR PROPOSITION.

A Plan for a Waterworks System for Sedro-Woolley.

The city council met in special session at the city hall last Monday evening to consider the different waterworks proposition which have been offered to Sedro-Woolley. As mentioned in these columns last week the council had invited the projectors of the different propositions to be present and prepared to explain their plan fully. In accordance with this request Mr. Lamb and Mr. Hill were present. The former represented the company which is now actively engaged in installing a water system in Mt. Vernon, while the latter represented private p rties.

After considerable informal discussion among the different members the council finally asked Mr. Lamb to state definitely his plan, which he did, substantially as follows:

The company had in view two different water supplies either of which would furnish an abundance of water but by the one which he would probably utilize they would be able to furnish the city with 800,000 gallons of water in twenty-four hours. He said that, when the company had decided on the source of its supply it would submit a sample of the water to the chemist at the Washington university for a test and would guarantee good, pure water for domestic use. He would not bind the city to take a single hydrant and the corporation could have the privilege to purchase the entire system at the expiration of ten, fifteen or twenty years at its then cash valuation.

In connection with the water system the company would also put in an electric lighting and power plant, the idea being to furnish power for manufacturing purposes, and also both arc or incandescent lighting for the city and prichte individuals. In this case also he did not ask the city to bind itself to take a single light, nor did he want a guarantee for a certain number of lights from the business men. He was willing to come here and put in the lights and was satisfied that they would be used when once the people saw their utility. In other words his company was willing to come hereon provide it at its side wholly depend

SEDRO-WOOLLEY WINS.

Takes a Game from Arlington by a Score of 7 to 1.

Sedro-Woolley 7; Arlington 1.

Well, say, wasn't it a corker.

It was the opening of the new ball park and the first time that the complete team had appeared before the home people.

But it didn't take the crowd long to find out there was something doin' last Sunday shortly after Uncle Guy Beck sent the first ball over the plate.

But, say Mister, wasn't it that Arlington bunch a sassy lot when they hove into town and pranced jauntily out to the ball park? The yellow and green of Arlington had become slightly soiled by the clouds of dust which "got action" over on the ball ground and the tin horns of the Arlington crowd had become so badly choked by Sedro-Woolley dust that they wouldn't blow worth a copper.

But how about the crowd? If anybody ever entertained the idea that the national game was on the decline in popular interest he should have 'happened around in the vicinity of the park last Sunday. Over 1000 packed themselves in the grandstand and swarmed over the right and left foul lines. They came from Arlington in a special train, 375 strong; they came from town and vicinity and they planked down their two-bit pieces at the gate with a persistency that made a bland smile overspread the angelic features of Manager Shrewsbury. It was Sedro-Woolley's first experience with "pay-to-see" base ball and I guess they like it. The crowd saw a fine game. They saw a man in the box who was well-nigh invincible. Beck held the Arlington sluggers down to three little, scattering scratch hits that never would have been scored as such had the grounds been in good condition. As it was thirteen Arlington men punched gaping holes in the atmosphere and spent most of the time on the bench, while those who did hit the ball never got it outside the diamond

innings and only five saw the color of first bag.

The home team made but one error and that was excusable, owing to the condition of the ground. Beck had the Arlington men completely at his mercy and Daviscourt's throwing to bases was almost perfect.

The big crowd went away satisfied that they had witnessed a ball game.

The score.

ARLINGTON.

	AB	R	1B	SB	PO	A	E
Plymate, lf	3	0	0	0	1	0	0
McLaughlin, ss	4	0	0	0	2	1	1
L. Barnum, rf	4	0	0	0	1	0	0
Finchcb, p	4	0	1	0	0	7	0
Caswell, 1b	4	0	1	0	2	0	0
Biddle, 3b	4	0	1	0	2	2	1
Peterson, 2b	4	0	0	0	0	0	0
Warren, cf	3	0	0	0	3	0	1
H. Barnum, c	3	1	0	0	13	5	1
White, c	2	0	0	0	1	3	1
	31	1	3	0	24		

SEDRO-WOOLLEY.

	AB	R	1B	SB	PO	A	E
Beck, p	3	1	0	0	0	7	0
Jolly, 2b	3	1	1	0	2	3	0
Dolly, lf	3	1	1	0	0	0	0
Davscourt, c	4	1	1	0	13	0	0
Alexson, ss	4	0	1	0	1	0	1
Mullen, cf	4	0	2	0	1	0	0
Graham, 3b	4	1	1	0	2	1	3
Daviscourt, 1b	4	1	1	0	8	1	0
Phillips, rf	2	1	1	0	0	0	0
	31	7	8	4	27		

ARLINGTON......3 0 0 0 2 0 1 0 0 0—1
SEDRO-WOOLLEY..3 0 0 2 0 1 0 1 x—7

Summary — Earned runs, Sedro-Woolley 3; struck out by Beck 13, Bases on balls, off Caswell 11; by Beck 3. Wild pitch, by Finchet 1.

ANOTHER SATURDAY NIGHT SALE

June 21

OUR SALE of a week ago was a great success. Our customers wynt away loaded with bargains. This sale will be equally as good. Following are the good things we will nearly give away.

Ladies' Wrappers,

The "Banner Brand," large assortment of colors, all with inside fitting waist linings, sizes from 32 to 42, regular worth is $1.00, Saturday night after six, each...... **75c**

Chrystal Silks

so suitable for Children's dresses, Regularly sold at 50 to 60 cents, Saturday night after six, per yard...... **35c**

Bleached Turkish Towels

One lot Bleached Turkish Towels, worth 50c a pair anywhere, go Saturday night after six at per pair...... **35c**

Crash Skirting

A few pieces of Crash Skirting (make the finest kind of Outing Skirts) regularly sold 17½ to 20c. yd. Saturday night after six, per yd... **12½c**

Do you need a **Rug?** We just received a new lot of Axminsters, Moquettes, and Smyrna rugs and can give very low prices on them.

Coddington & McGowan
Sedro-Woolley
Opposite Fritsch Bros.

and the water company would be enjoined their franchise would be good and in force until the injunction was dissoved, even if it required ten years, and the city's water system would be tied up for that length of time. Mr. Lamb stated, however that his company would agree to begin work on the plant within fourteen days from the date of the granting of the franchise and push the work to completion. It is the intention of the company to operate their electric light plant by water power which would be generated at the source of the city's water supply. Mr. Lamb also stated that the pressure would be more than sufficient for all purposes as he would have a fall of over 400 feet from the source of supply to the city limits.

Mr. Hill was asked if he would agree to, and meet all the conditions proposed by Mr. Morgan and stated that he would.

As the council could not grant a franchise at a special meeting, the city attorney was instructed to draft an ordinance in compliance with the wishes of the council, and submit same to both Mr. Lamb and Mr. Hill for their approval and that the matter be finally settled at the regular meeting next Monday evening.

The Courier believes that the proposition made by Mr. Lamb is in good faith and we understand his company is provided with ample funds to do as they agree. Let us all hope that the day is not far distant when Sedro-Woolley shall have what she so badly needs—a first-class water system.

take the game away from them. But they're good losers and it's a pleasure to have 'em come. A big crowd will always turn out here to see Arlington play ball.

The association will have an addition to the grand stand built at once. A string of "bleachers" will also be built. It is the purpose of the management to provide seats for all who attend the games, if the lot is big enough.

'Twas the first time during all these years that Sedro-Woolley ever vanquished Arlington, and no wonder the rooters "hollered."

J. F. Mott & Co. offer the best hat obtainable to the first man making a home run on the local grounds.

Now, get in line for the next.

He's Away Off.

The following clipping is taken from last week's LaConner Mail:

Sedro-Woolley was at bat, two men were out and Beck on second. The latter, owing to a clever trick perpetrated by Smith, was put out while stepping off the bag, which made the side out. Beck however did not relish being caught at his "own game," so consequently he raised the point that Pitcher O'Laughlin had made a balk, which was entirely wrong, as the latter was not in the box at all when the play in question was made. Sedro-Woolley said that Beck had to be placed at third or nothing; so the game ended right then and there as Umpire Valentine refused to reverse his decision, which was honestly given, namely: that Beck was put out at second, thus retiring the side.

To a man up a tree, it would look like they were afraid that LaConner would win out in their half: hence their refusal to continue to play, made them certain of not sustaining defeat.

To judge by the above the editor of the Mail knows about as much about the ball game in question as a resident of the Feegee islands. The fact of the matter is it was the LaConner team which refused to continue the game and left the grounds. A number of the LaConner players recognized the justice of the claims made by Sedro-Woolley and wanted to proceed with play but a couple of the former clubs hot head d players refused to see it that way and like spoiled babys left the ground. The umpire then gave the game to Sedro-Woolley. These are the facts in the case as the LaConner editor could easily have ascertained had he cared to print the truth.

ager Shrewsbury is due much of the credit.

The story of the run getting is as follows:

Arlington went to bat first, and Plymale was the first man up. He waited for four wide ones—found them—and trotted down to first. He stole second, went to third on the only passed ball charged to Davis-court during the game. McLaughlin and L. Boursaw meandered up to the rubber but they both failed to land and retired. Old "Prunes" Frazier, after a couple of tries lammed out a safe single between third and short which brought Plymale home. "Prunes" died at first, however, for Caswell tipped up a nice little one to Beck, who gathered it in and the stuff was off.

In Sedro-Woolley's half Beck was given a pass to first, but was thrown out at second by Caswell's fielding of Joch's infield punch. The latter went down to second on a passed ball, stole third and scored on another passed ball. Mr. Caswell presented Jolly and Starks with free transportation to first and they scored on errors and Mullen's long drive to center for one base after Alverson had sawed three holes. Harry couldn't get any further, however, for H. Boursaw caught him napping at first and sent a quick one down there which did the business.

In the second and third the locals failed to score, but in the fourth they added two more to the total and it happened in this way:

Alverson walked to first, went down to second on Mullen's hit and stole third. He came home and Mullen went to second on Graham's sacrifice. Mullen scored a moment later on Davis-court's single. Phillips went out from Caswell to first and Beck flew out to McLaughlin, retiring the side.

In the sixth Daviscourt picked out a safe single, was advanced to second by Caswell's gift of first to Phillips and scored on the throw in of Beck's high fly to deep center.

In the seventh the locals drew another blank, but in the eighth Graham scored on his hit, a passed ball and Phillips' sacrifice.

After the first inning the visitors went out in one, two, three order, only one man getting to second during the eight

The "Hard Times Sports" base ball club of Sedro-Woolley. c.1901. Reduced from the 8x10" plate.

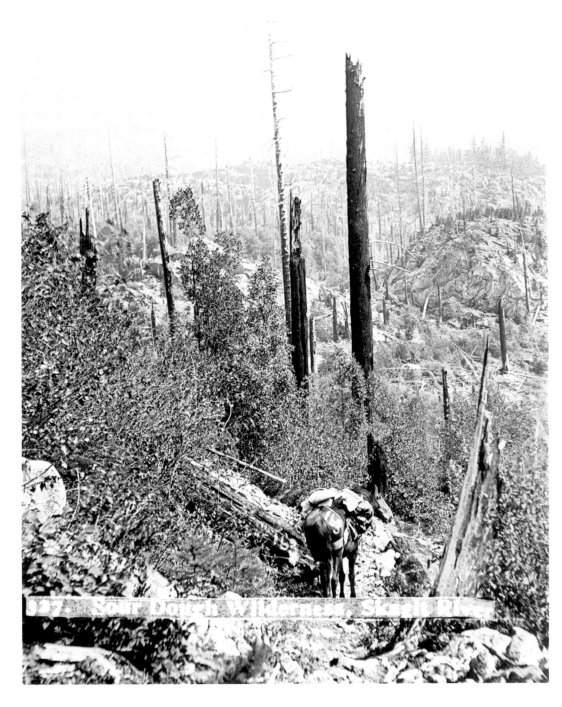

The trail crossed over Sourdough ridge
at middle skyline.
Enlarged from stereo pair.

the Expedition of 1900

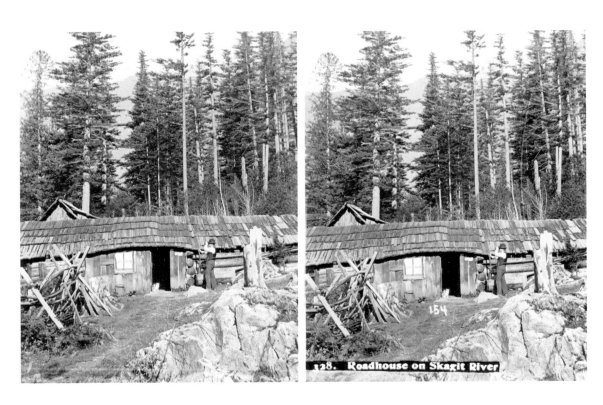

328. *Roadhouse on Skagit River.* Seneca Ketchum standing.
This is Goodell's Landing.

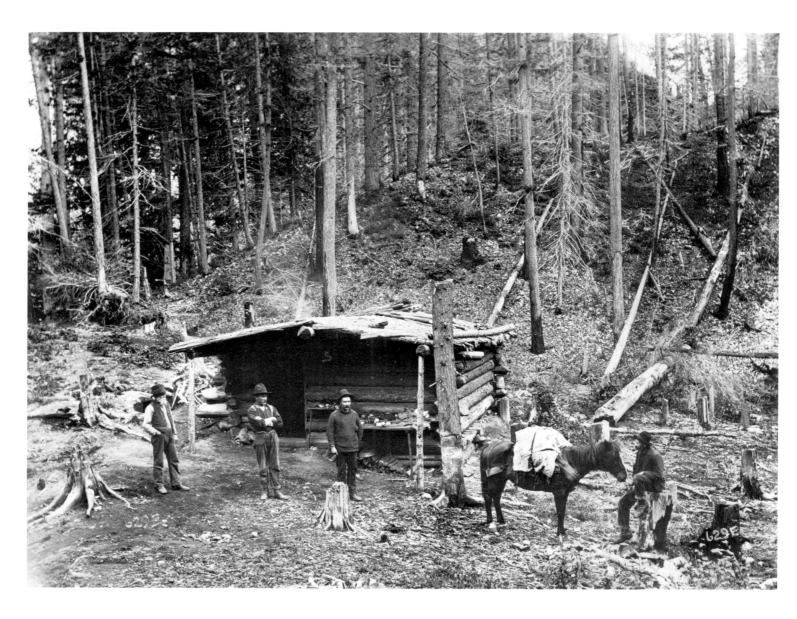

244. *Smoky Cabin—Road House, entrance of Slate Creek Canyon, Washington.* Wiltz Brown far left, Andy Williams next. Kinsey's and Ketchum's horse.

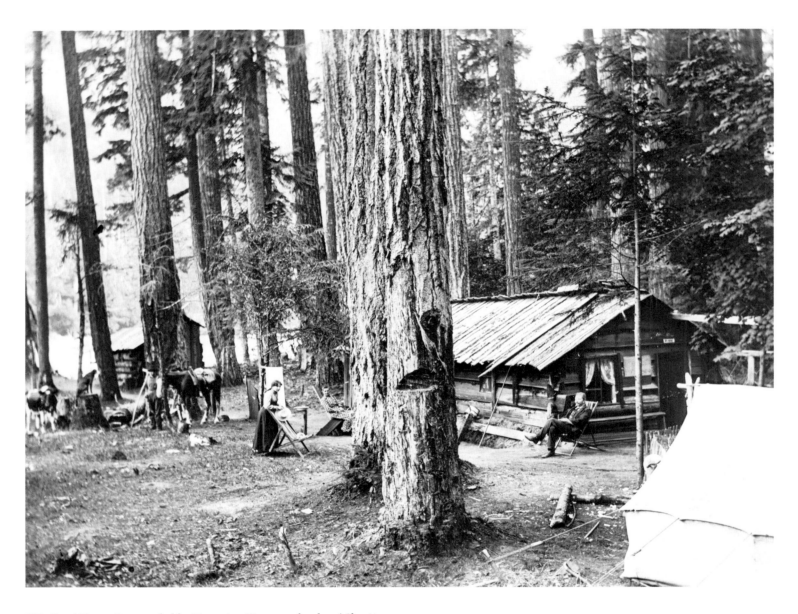

231. *Road House Surrounded by Towering Firs, near banks of Skagit River, Washington.*

Lucinda Davis seated, daughter Dessa with hat, son Glee with horse, Jimmy. Dog on stump is Shep. Seneca G. Ketchum seated in front. Sign over door reads "Hotel Cedar Bar."

In August of 1900, two men and a heavily laden packhorse set out from Hamilton — destination Barron, up in the Slate Creek mining district and not much more than one hundred miles out. It was Darius heading for the mountains again, this time with Seneca G. Ketchum, then editor and publisher of The Skagit County *Times* of Sedro-Woolley.

No small part of the horse burden was cameras. The indefatigable 6½x8½″ was aboard, with a strong supply of glass plates to match. Also aboard was the camera destined to become the indispensable tool in the hands of a genius photographer — the 11x14″ Empire State. Almost certainly this was the first trip for the 11x14″ because the earliest surviving plate in that format is from the Expedition of 1900.

Fifty-one miles from Hamilton — along the Skagit River — Kinsey and Ketchum hit Goodell's Landing and Ketchum was posed in front of the roadhouse. Then another eight miles or so to Cedar Bar, where they hauled up for a day or two. The Hotel Cedar Bar — or the Davis Roadhouse — was run by Lucinda Davis, her daughter Dessa, and sons Frank and Glee. It was a good place to stop, not only for the excellent food but because Glee was an expert at loading horses and the intrepid travelers were not.

In August of 1900, Glee Davis was fifteen years old. Now — December of 1973 — Glee is eighty-nine and willing to reminisce at some length about the Kinsey/Ketchum effort and on Skagit River history in general. Glee recalls that about two weeks after the travelers passed through on the way into the mountains, Darius came down from Barron alone, because Ketchum had decided to walk out to the east . . . "But Kinsey came back and then he stayed with us. And I took him around quite a bit getting pictures, sort of in inaccessible places. He was a very religious man, a Methodist, and one of those days was Sunday. He told my mother, he says, 'You don't need to get any dinner for me. I am going to stay over the day, and I want you to let me have that bunkhouse down by the river, and I want to stay there and I don't want to be disturbed.' And he stayed there all Sunday. Had his Bible with him. Didn't eat any dinner. No, he just wanted to be quiet. He just shut what windows there were and he wanted to sit there and study his Bible.

"When Kinsey left there, he wanted some help going out. The schoolteacher — that was Ruby Smith — had been visiting us up there that summer. She had to go out to her school, so it was up to me to take her down, so the three of us went out together. Well, we went down and tried to get a picture of the Long Bridge from the other side of the river. And we couldn't get where I wanted to. There was no trail over on the other side, in that section. We ran into a cliff that we couldn't get around with his equipment. He had a big camera.

"But he was all tied up in pictures. He wanted a picture of everything. 'Take a picture. Oh, I'll get a picture of this. Well, here's a picture.' I can almost hear him repeating like that as he'd go along. He was quick to spot something that he wanted to take. Only I did kind of wonder why, at Goodell's Landing, why he took that one of Ketchum looking the length of the building. Only showed just that corner, and that didn't represent the building at all.

"Oh yes. He was certainly tied up in pictures. He was going to take a picture, he didn't hesitate if he wanted a picture of something. He was ready to get it in the best shape he could."

Identifications and quoted material from
interviews with Glee Davis, December 1973

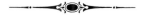

The Skagit County *Times*, September 27, 1900, under *City and County News: "There is on view at the postoffice, what is probably the finest display of scenic photographs ever exhibited on the Pacific coast. There certainly can be no finer. These represent scenes along the Upper Skagit river, recently secured by Mr. D. R. Kinsey, between this city and the Slate Creek mining district, and are splendid examples of the magnificent scenery along the banks of the Skagit and of the artistic skill at the command of the photographer. Mr. Kinsey has the distinction of being one of the very few American photographers whose work was chosen for exhibit at the Paris Exposition, a high honor fully merited."*

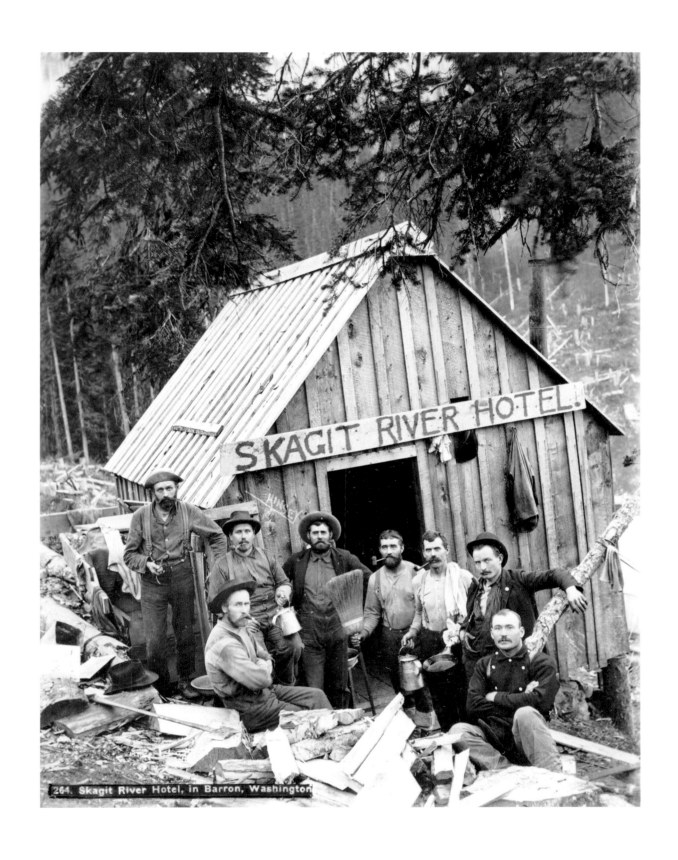

264. Skagit River Hotel, in Barron, Washington

3. *Shake Cabin on New Homestead.*

the Homesteaders

If eloquence, whimsy, documentation, and technical excellence have ever been combined in one photograph, perhaps the homestead fiddler qualifies. Dated 1897 from the nearly-obliterated penciling on the emulsion: *"D. R. Kinsey, Photog. Woolley, Wn. No. 1032."*

0323. A Shake Cottage in Washington; made from
split cedar boards [c.1897].

0322. Bachelor Bolt Cutters at Home in Their Little Shake Cabin
(D.R. Kinsey Photo., Woolley, Wash. [1897]).

"0318. *Early Settlers, near Puget Sound, Washington (D. R. Kinsey Photog.,*
Sedro-Woolley, Wn. [1899])."

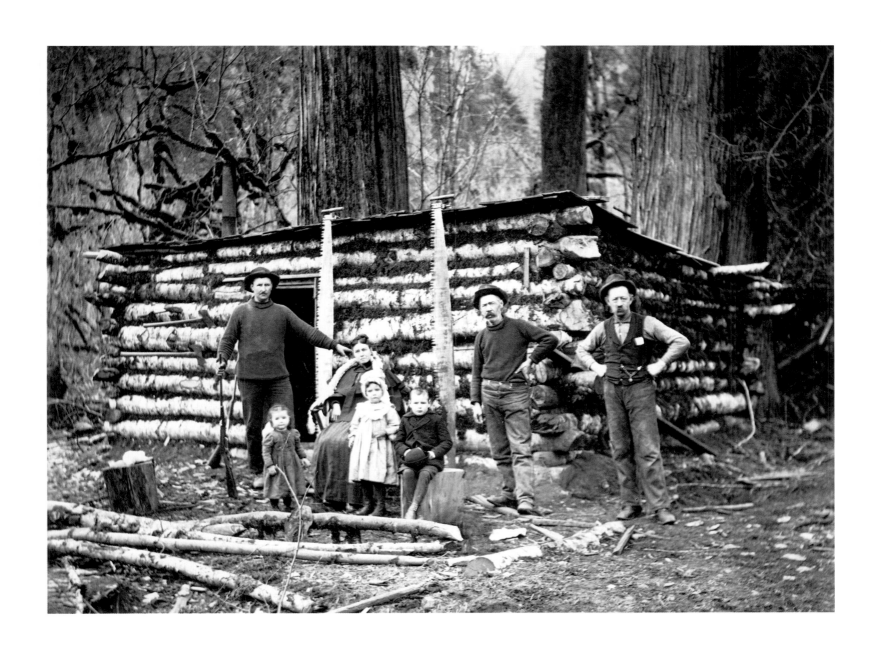

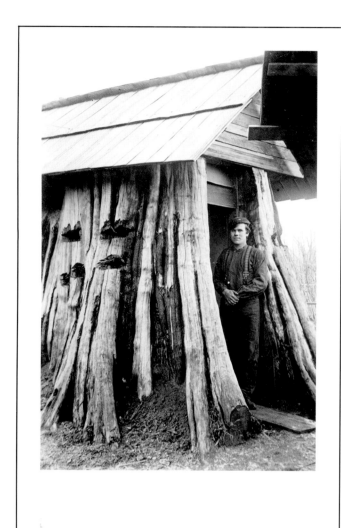

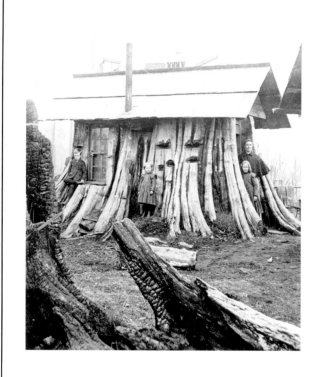

"A Novel & Inexpensive Home. A great Cedar Stump Utilized by Ingenious Washington Pioneer." Reproduction in "Puget Sound Life" (booklet) by John Davis & Co.

The Skagit County *Times*, Sedro-Woolley, January 22, 1903, front page photograph: "This unique residence, made from a cedar stump, is in Snohomish County. The outside diameter of the stump is 22 feet. Inside it is one good-sized room, which is boarded up and neatly papered and made as comfortable as any apartment could possibly be made. The walls inside slant inward at the top, which gives one the impression rather that it is an upstairs room, otherwise it is not different from any other room."

March 27, 1902, under *City and County News:* *"Photographer Kinsey has taken a novel and attractive way of advertising his views of Washington scenery by having a picture of a stump residence, that was taken in Snohomish County. printed on his stationery."*

The Skagit County *Courier*, Sedro-Woolley, December 24, 1903, a solitary block ad including photograph, centered on a blank page: "Cedar Stump Residence, 22 feet in diameter, copyrighted 1902, by Darius Kinsey, Sedro-Woolley, Washington—Stereoscopic views of this picture 17¢. Unmounted, 6x8 inch Photos, 25¢; 11x14, 60¢; 20x24, $2.25. Postpaid anywhere."

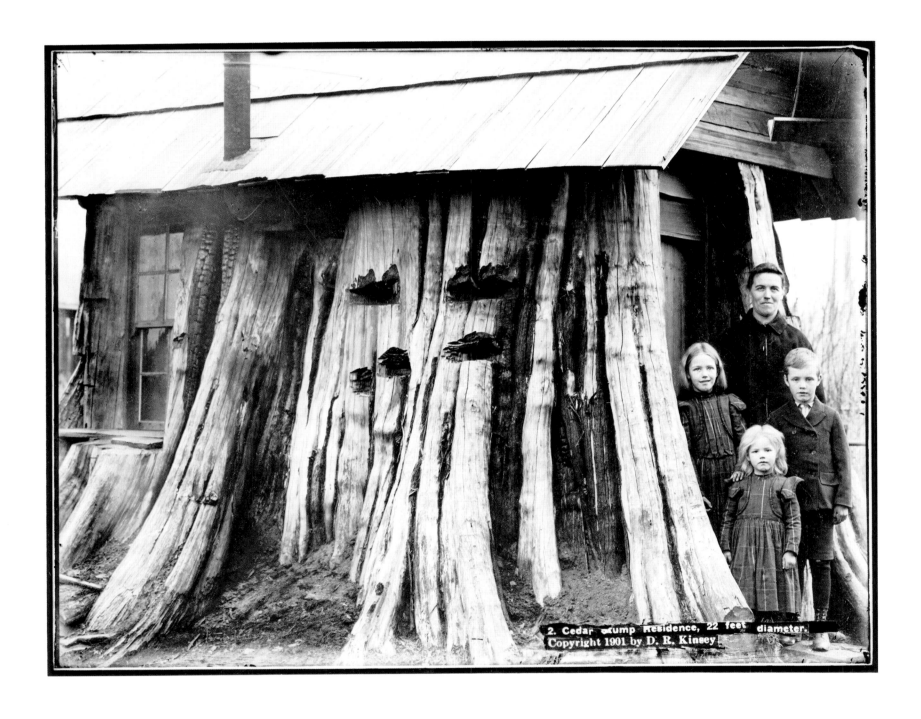

2. Cedar Stump Residence, 22 feet diameter.
Copyright 1901 by D. R. Kinsey

Cedar Stump Residence

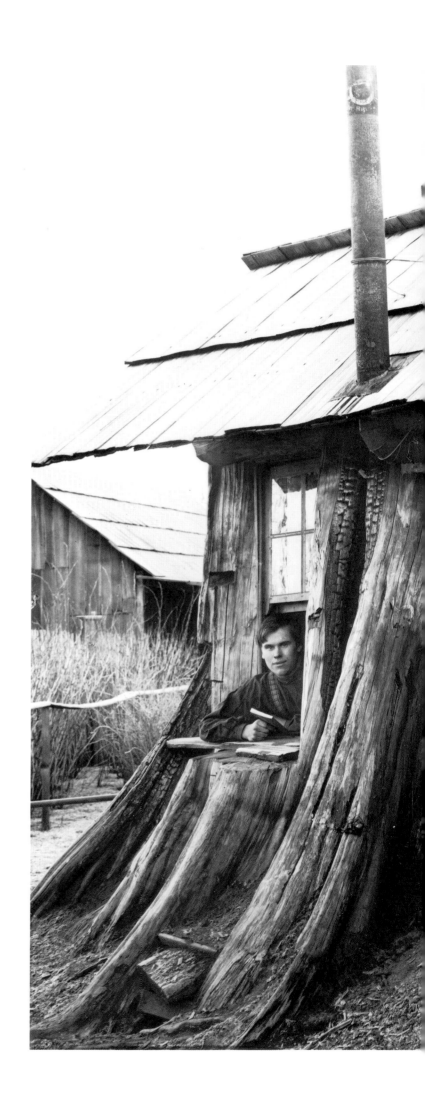

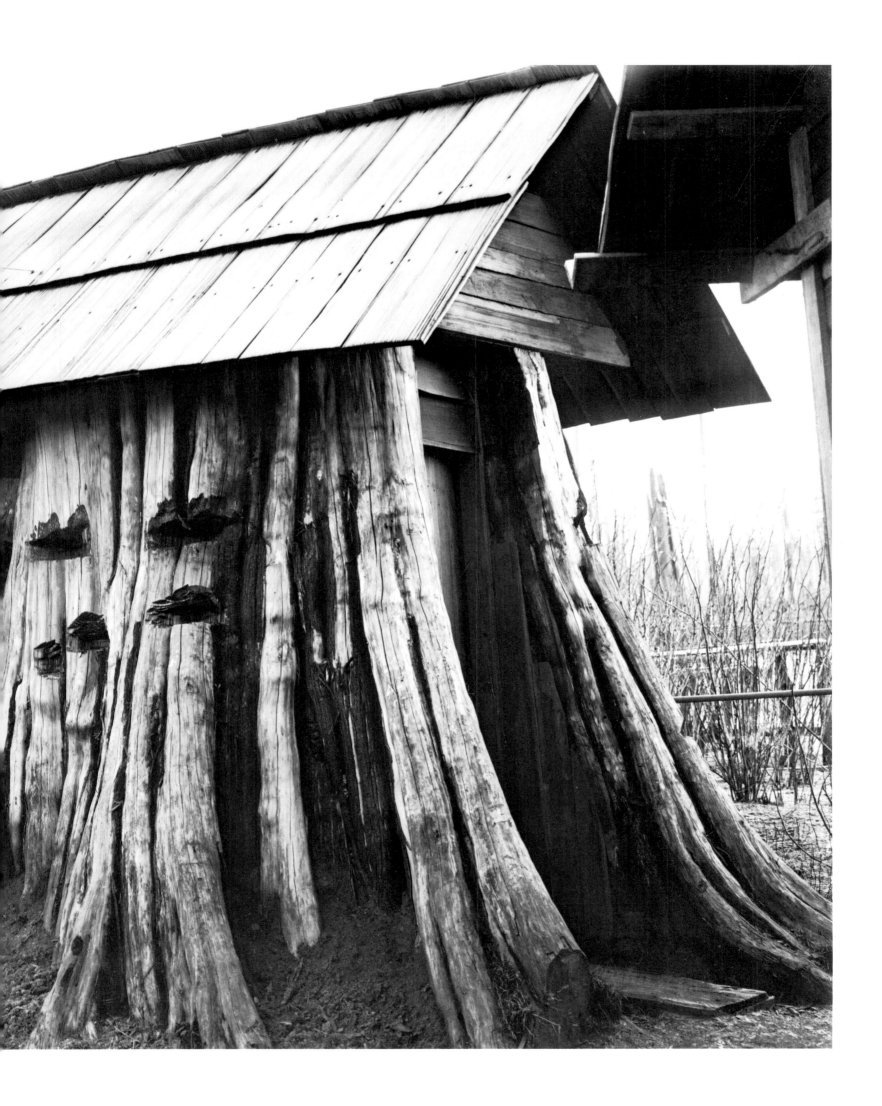

0351. South from Camp of Clouds, on Mt. Rainier, Wash.
Copyrighted 1903.

the Seattle Post-Intelligencer

Have Narrow Escapes
Two Photographers Come Near to Death on Mt. Rainier

July 21, 1903: "A night spent in a driving blizzard, 8,000 feet up the side of Mt. Rainier, at the 'Camp of the Clouds,' and a narrow escape from instant death from an avalanche of rock constitute a part of the experience of Darius Kinsey, of Sedro-Woolley, and his assistant, John Zetterlund, who went up into the Paradise Valley country last week to secure some stereoscopic views of that section.

"Mr. Kinsey and his party claim to have been the first to reach the 'Camp of the Clouds' this year. It took them ten hours to cut the trail out from Longmire Springs to Paradise Valley. According to the story told by Mr. Kinsey on his return to Seattle, their trip must have been one continuous chapter of accidents. He said:

'Accompanied by my assistant, John Zetterlund, I left Seattle Thursday, July 17, for the Paradise Valley country of Mt. Rainier for the purpose of obtaining some stereoscope views of the Nisqually Glacier and other points of interest in this section.

'In the first place, we had a hard time reaching Paradise Valley, as we had to cut the trail out from Longmire Springs to the "Camp of the Clouds." It took us more than ten hours to accomplish this task.

'No sooner had we prepared to make camp on arriving than a most terrific snow storm swept down the valley amounting to nothing short of a blizzard. The snow fell in sheets and the wind blew for hours. We were 8,000 feet up the mountain side, and snow was already thirty feet deep beneath us. For, according to Cain Longmire, the proprietor of Longmire Springs Hotel, this year has seen one of the greatest snowfalls on record in that section.

'Zetterlund, who has recently come to this country from the east, was unaccustomed to the rigors of the condition to which the elements subjected us, and came near perishing with the cold. We were soaked to the skin and could not light a fire. Several times Zetterlund gave up and lay down in a roll of the tent, but I aroused him each time and made him keep moving around.

'After several hours work, by reaching up as far into the dry limbs as we could we were at last able to get a fire started. Soon the storm ceased and from then on we had beautiful weather.

'We had no guide and the next day when we started out to photograph the Nisqually Glacier we came near having a fatality. While taking the picture I noticed pebbles falling from the rim of the glacier. No sooner had I taken the camera on around to get a view from another quarter when a great mass of boulders came crashing down where we had stood but a moment before.

'Another thing which I would advise people to be careful of is attempting to wade the Paradise River. I attempted it and came near losing my footing as the water looked to be no more than a foot and a half deep, but I found it to be over three. It was only owing to the fact that I had a good Alpine stock that I was able to retain my footing on the slippery rocks on the bottom of the swiftly flowing stream.' " [Also to be found in The Skagit County *Courier* and The Skagit County *Times* for July 23, 1903.]

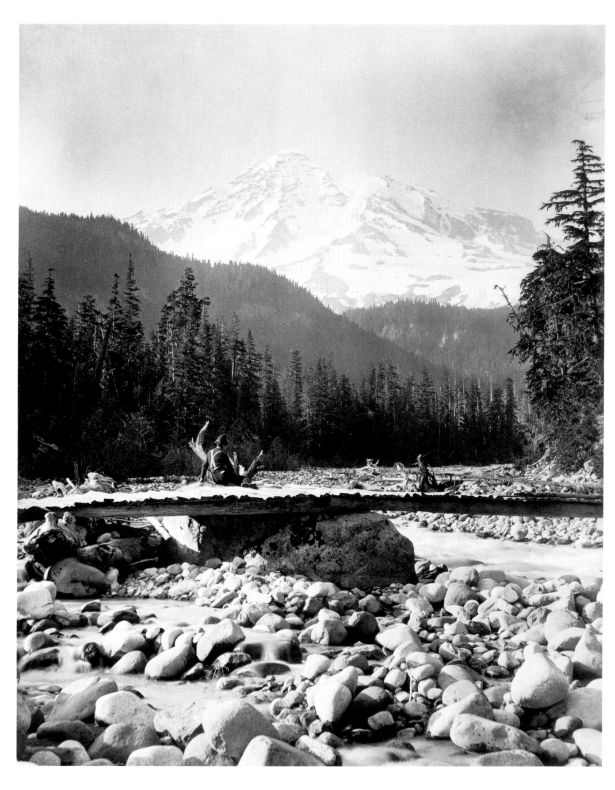

0343. Mt. Rainier, Washington, 14,526 feet high,
from Nisqually River. Copyrighted 1903.

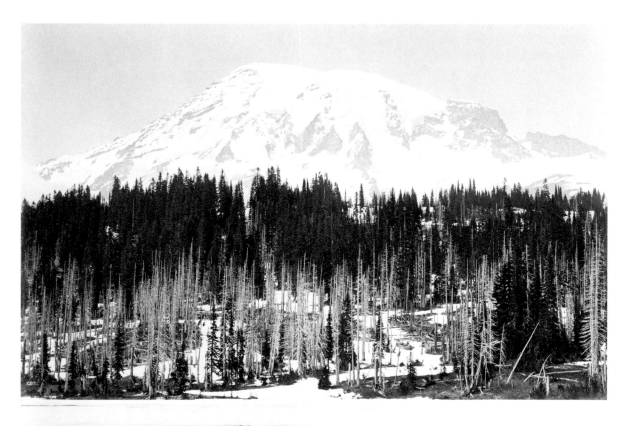

0344. Mt. Rainier, Washington, 14,526 feet high,
from Reflection Lake. Copyrighted 1903.

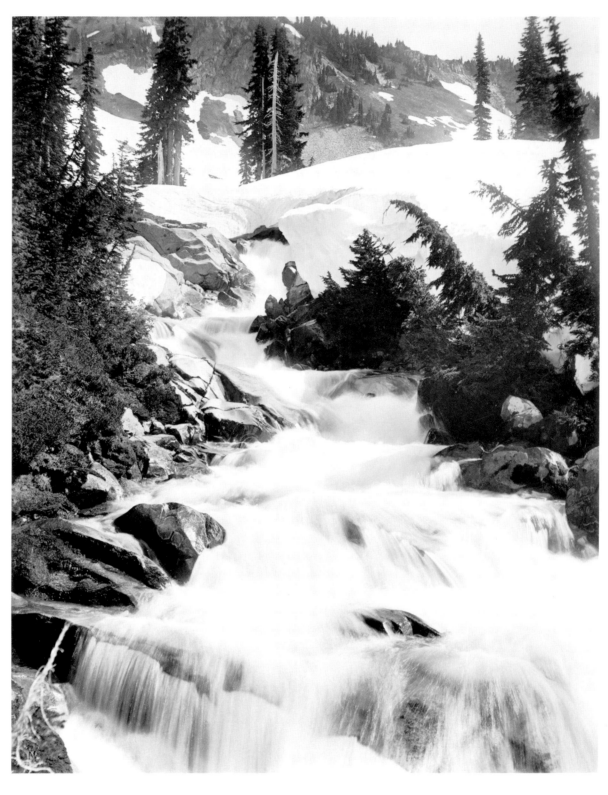

0353. Rapids Along Banks of July Snow,
Paradise River, Wash. [1903].

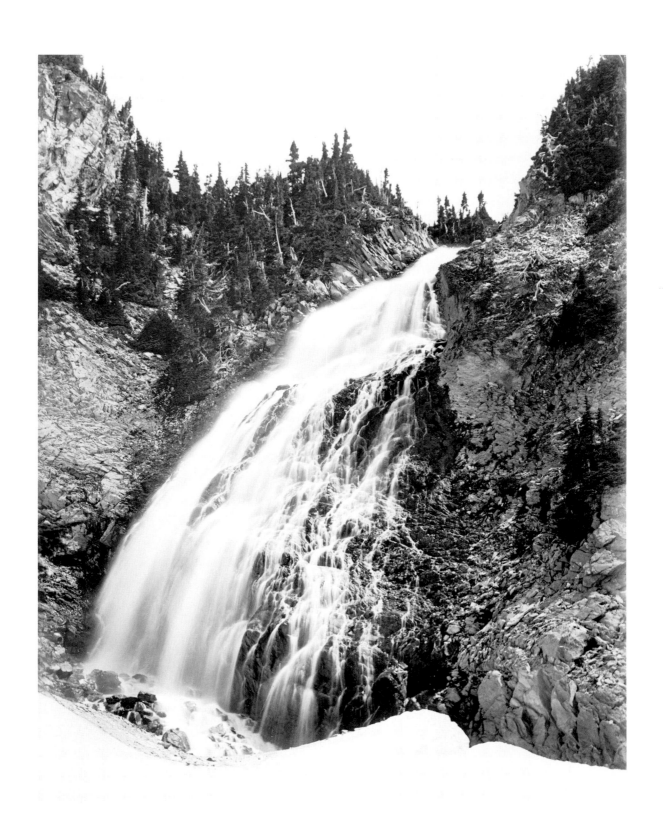

0354. *Sluskin Falls, Washington, 300 feet high,*
on Mt. Rainier [1903].

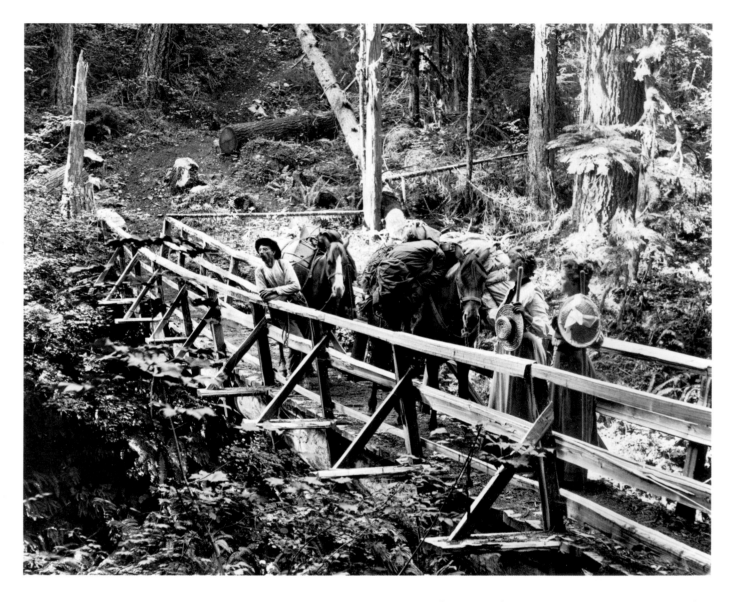

0363. Pack Horse Walking a Log Over Canyon near Mt. Baker, Wash. Cropped from the enlarged 6 1/2 x 8 1/2″ plate.

This photograph probably shows the start of the ascent of 1903. The plate number fits and so do the hats. Tabitha and Phronia Farnsworth on the bridge with Ed Barnes (?), the packer. The horse at the rear is laden with at least three camera cases.

the Ascent of Mt. Baker, August 1903

Sunday [Seattle] *Post-Intelligencer*, September 13, 1903: "*Almost to the Summit of Mt. Baker*—A party of Sedro-Woolley people numbering three, besides the guides, ascended almost to the summit of Mount Baker, but were forced to return without reaching the highest elevation, by the mighty crevasses which rend the mountain top, and by the great banks of snow which at frequent intervals tear down the mountain side, sweeping all before them in their path . . . Pictures of the great snow caverns and glaciers and the other wonderful natural sights were taken, and the collection Mr. Kinsey now values almost above price. Telling of the difficulties encountered, of the pleasures of the trip and of the journey, Mr. Kinsey said:

'Miss [Phronia] Farnsworth, Mrs. Kinsey, and myself left Sedro-Woolley August 4 and reached Baker, on the Great Northern Railroad, at the junction of Baker and Skagit Rivers, that afternoon. We then walked to Jackman Canyon, where the scenery is fine. There we either had to wait for the pack train a day or to walk eighteen miles to the fish hatchery.

'We preferred to walk, so began our tramp early the next morning along Baker River through dense woods, and arrived at Baker Lake Fish Hatchery late in the evening. Henry O'Malley, the superintendent of the fish hatchery permitted us to occupy a shake cabin for the night.

Beautiful Baker Lake

'Baker Lake is a beautiful body of water a mile wide and two miles long, bounded on all sides by towering mountains, among which are Mt. Baker, Mt. Shuksan and Baldy. The mountains are reflected in the clear, beautiful water almost as in a mirror. We had a most pleasant time canoeing and fishing. At one point on the lake is a double echo. A mammoth canoe dug out of a large cedar log and rigged for a sail boat is a feature of enjoyment on the lake.

'Monday morning we began the ascent of Mt. Baker. Henry Edgar, our guide, and Ed Barnes, the packer, completed our party. Crossing Baker Lake, we found a good trail for the first two miles, but the remainder of our journey lay through virgin forest. Logs, windfalls, devil clubs [sic] brush, deep canyons and rocky ledges lay before us on the steep mountain side. One deep canyon was bridged by an uprooted fir. We climbed over the roots of this and crossed high above the tops of trees. We frequently walked logs and windfalls twenty feet from the ground.

'We reached the timber line about six o'clock in the evening, having had packs on our backs almost continuously for ten hours. Our tent was pitched on a narrow backbone, on both sides of which are glaciers. Mr. Edgar and I took a reconnoiter, with gun and stereoscopic camera, after making camp.

Start for the Summit

'Intending to reach the summit and return to camp the same day, we arose at four o'clock the next morning in order to get a very early start. The whole eastern side of the mountain, our route, is obstructed with crevasses. Some of these are less than twenty feet apart, and they frequently parallel each other several hundred feet.

'When crevasses were close together in these steep places the danger can better be imagined than

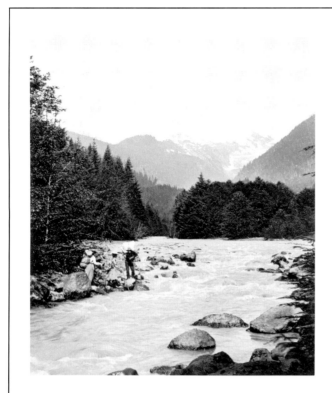

461. *Mt. Baker, from Park Creek, Washington, 11,500 feet.*

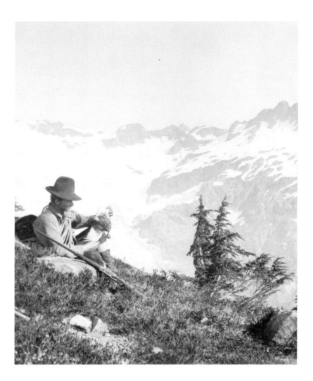

465. *Park Creek Glacier. Mt. Baker.*

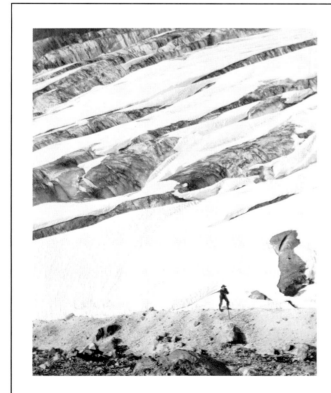

469. *Birdseye View of Crevasses on Mount Baker.*

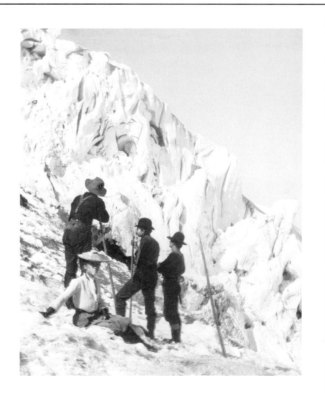

478. *Cliffs, Snow and Ice, 300 feet high. Mt. Baker.*

Photograph by Tabitha. Darius second from right.

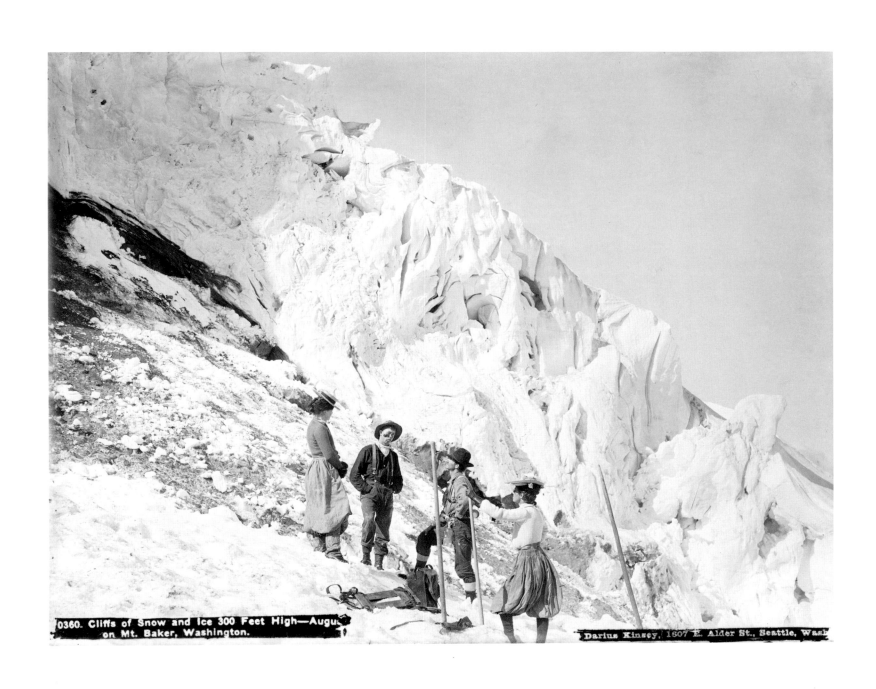

0360. Cliffs of Snow and Ice 300 Feet High—Augus on Mt. Baker, Washington.

Darius Kinsey, 1807 E. Alder St., Seattle, Wash

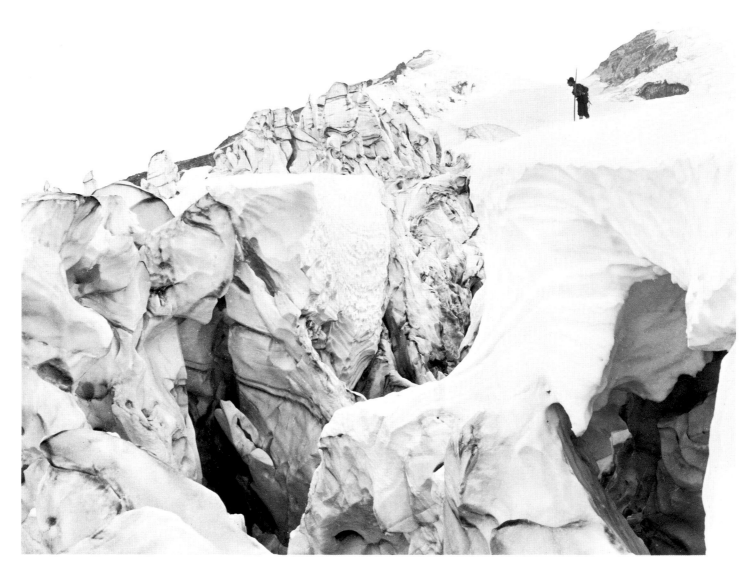

0361. *Large Crevasses in August on Mt. Baker, Wash.*

described. We could not see bottom in some of the great rents in the ice. At one point the snow and ice had formed into shafts twenty-five or thirty feet high, resembling monuments. In another place there are odd shaped shafts resembling totem poles.

'While resting in what seemed to be a flat field of snow, Mrs. Kinsey's Alpine stock was lost. Before any of us realized what had happened, it was going over the ice like a thing of life, soon disappearing forever in a seemingly bottomless pit. This was a great loss, but we could not think of turning back. After giving my Alpine stock to Mrs. Kinsey we continued our climb.

'About a quarter of the distance from the snow line to the summit we came to a grotesque image of rock, about forty feet high. This figure was part of a ledge resembling Gibraltar on Mt. Rainier. We named it Frightened Devil's Ledge. His Satanic majesty was staring toward the crater of the mountain. Near the summit a large snow slide had occurred a few days previous, exposing a hundred feet or more of perpendicular rock. Out on the top of this a stream of water gushed from high snow and ice cliffs. Mr. Edgar decided to make a dash over the snowslide and secure some water, as our supply had given out early in the day and we had not been able to get any more on account of numerous crevasses between our route and the perpendicular rock ledges.

Slide Follows Slide

'Immediately after Mr. Edgar reached the waterfalls, one of these small slides occurred. He ran for his life and succeeded in getting some distance from the foot of the falls before the rocks and ice struck the steep incline, although bowlders and missiles flew all around him, he was not hit. Individually I was getting somewhat shaky.

'A short time previously we had crossed a double crevasse which was formed by the snow and ice sliding from the upper crevasse into the lower one, leaving a sharp ridge one hundred feet long. There was no way around, so we crossed using the life line. When about half way over Barnes slipped, going his length into one of the crevasses. Miss Farnsworth had the presence of mind to throw herself across the ridge between crevasses. Barnes got back again as he retained his hold on the life line, which was securely anchored in ice with our Alpine sticks.

'Beneath the south peak was a great mass of ice and snow, apparently three hundred feet high, which leaned slightly and extended past the saddleback under which we were standing. We were all looking at a small snow-slide, several of which had occurred within an hour,

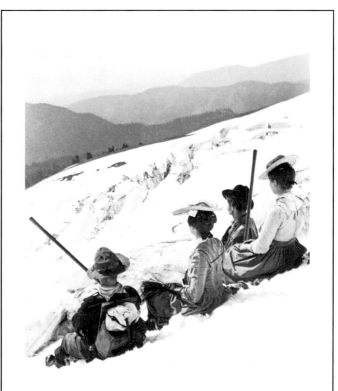

470. Near Crevasses 100 feet deep, Mount Baker.

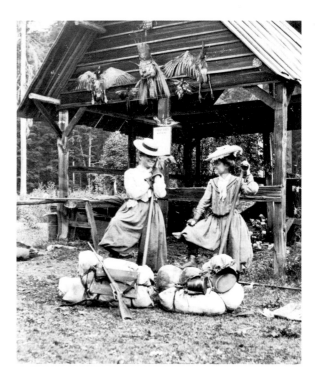

479. Just Returned from near Summit of Mt. Baker.

when the whole south peak seemed to be giving away. The break began about eight hundred or nine hundred feet from us and extended to within one hundred feet. The whole avalanche went thundering down the mountain, causing the snow and ice beneath us to tremble. Large chunks of ice thirty or forty feet square went rolling down the mountain. This slide was plainly heard at Hatchery, nine miles distant.

'Owing to the lateness of the hour and the probable changes slides might have caused on the mountain side we decided to descend. We were within less than one hundred feet of the lowest point between the two peaks and could easily have made the rest of the climb in an hour.

Smoke from the Crater

'The crater is between the peaks, and was emitting gases that smelled strongly of sulphur. Mr. O'Malley, at the Hatchery, reports at one time seeing black smoke come out of the crater. Before we had passed the last crevasses on our return down the mountain, it was quite dark. Several times in the uncertain light we lost our trail, which could be distinguished plainly in the few inches of soft snow when the light was good. One of these side trips led us into a very dangerous place. I had carefully worked my way out to this particular point in order to get a view. We were on this dangerous place between two yawning crevasses, and the wonder is that it did not give way.

'Through lack of food we could not attempt to climb the following day. We remained several days longer in Baker Lake vicinity. The rarefied air on the trip caused the skin on our faces to peel and our lips to swell.

'Many have attempted to make the summit of Mt. Baker, but only a few have succeeded. So far as we could ascertain, no woman has ever stood on the summit.' " [Also articles in The Skagit County *Courier*, September 17, 1903; The Skagit County *Times*, August 20, 1903.]

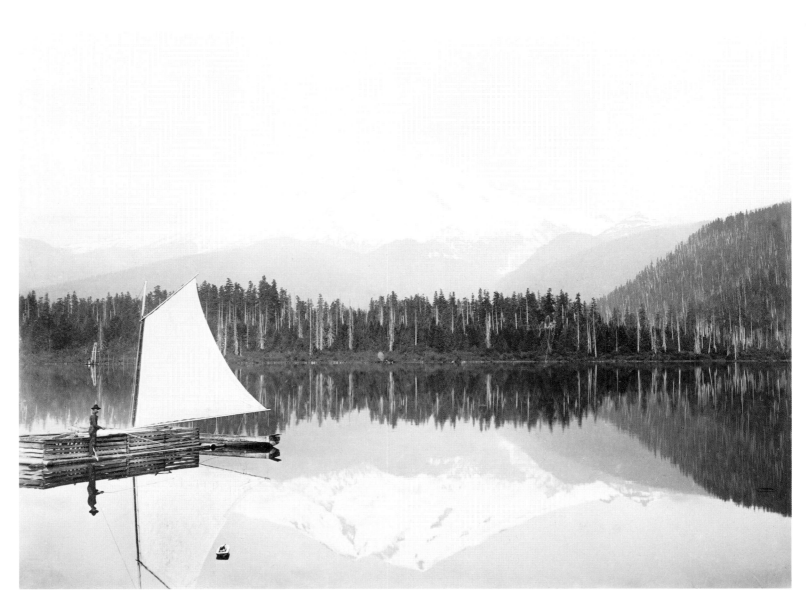

0357. *Mt. Baker, 11,500 feet high, from Baker Lake, Wash.*
Copyrighted 1904.

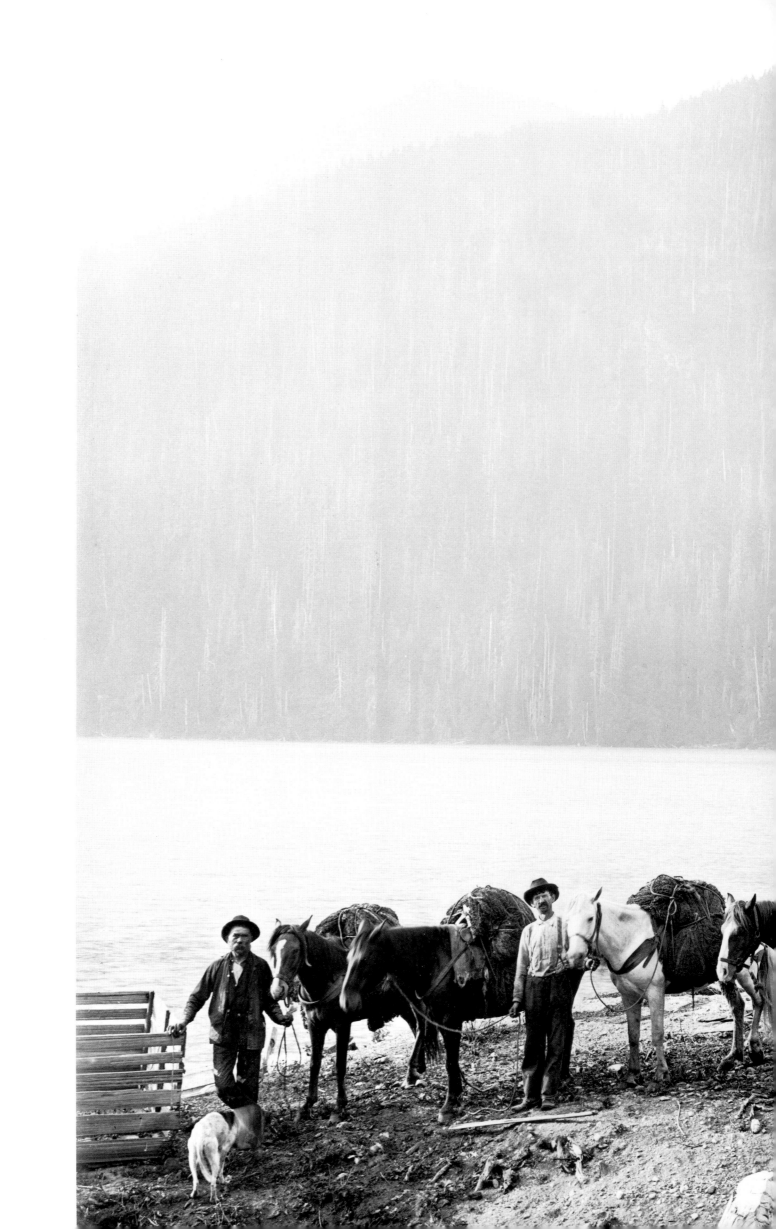

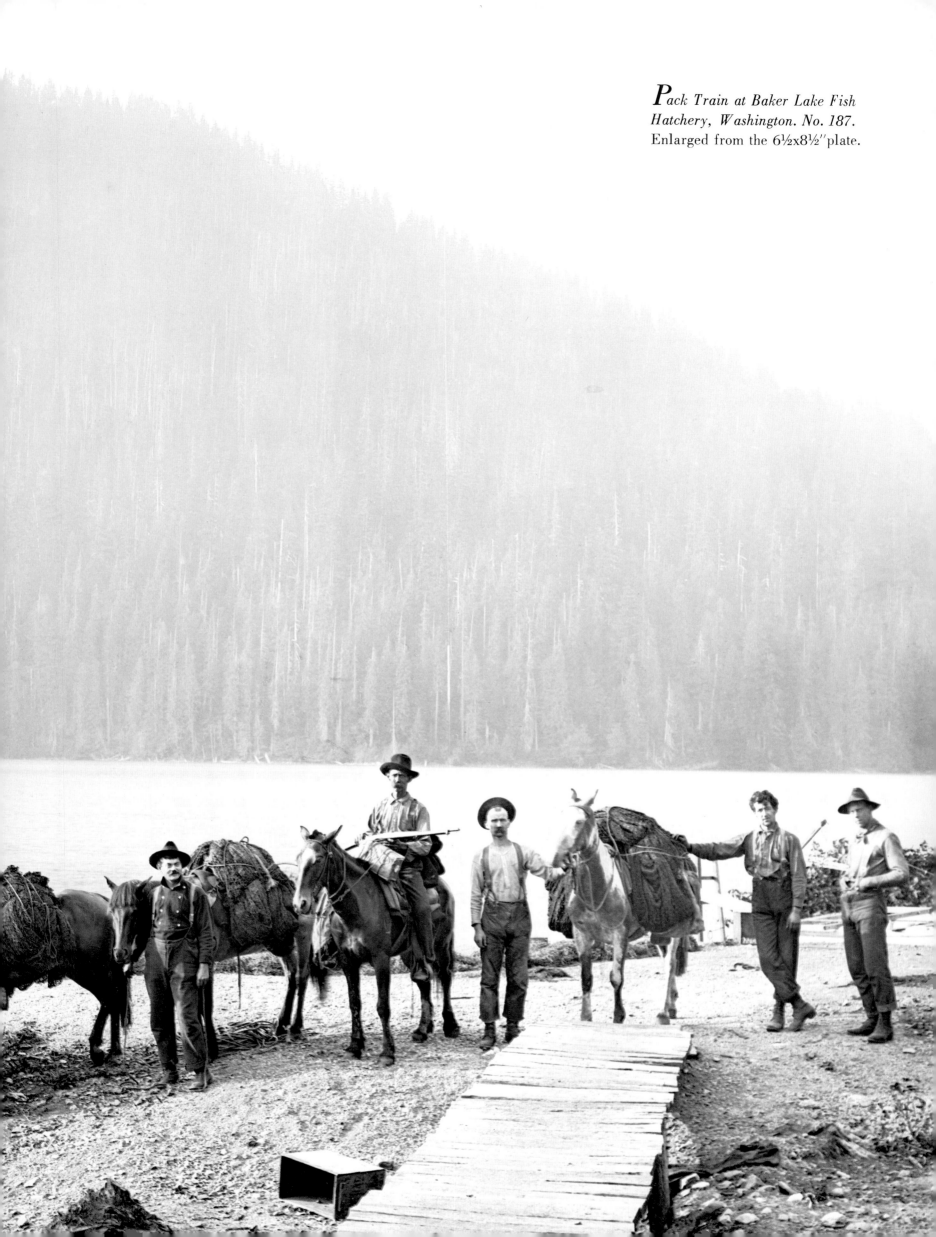

Pack Train at Baker Lake Fish Hatchery, Washington. No. 187. Enlarged from the 6½x8½″ plate.

And now back to logging. The Big Trees, the shingle bolts, the men and their equipment, the logging locomotive—which was to become an important segment of Darius' work with the 11x14″ camera—and always the group portrait in the woods.

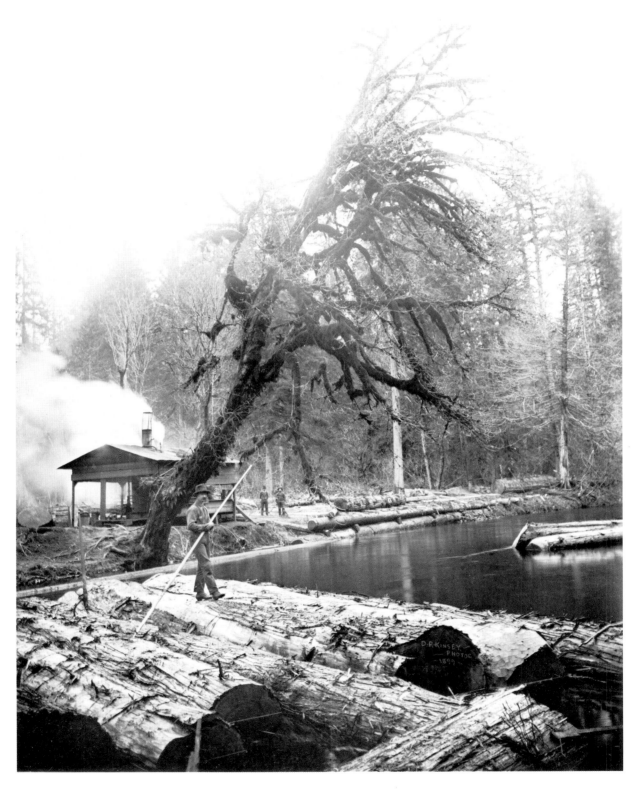

151. *Landing and Boom Logs on Pilchuck, near Pilchuck, Wash. (D.R. Kinsey,*
Photog. 1899 No. 1205. Hiatt and Bryan [?] Pilchuck, Wash.).

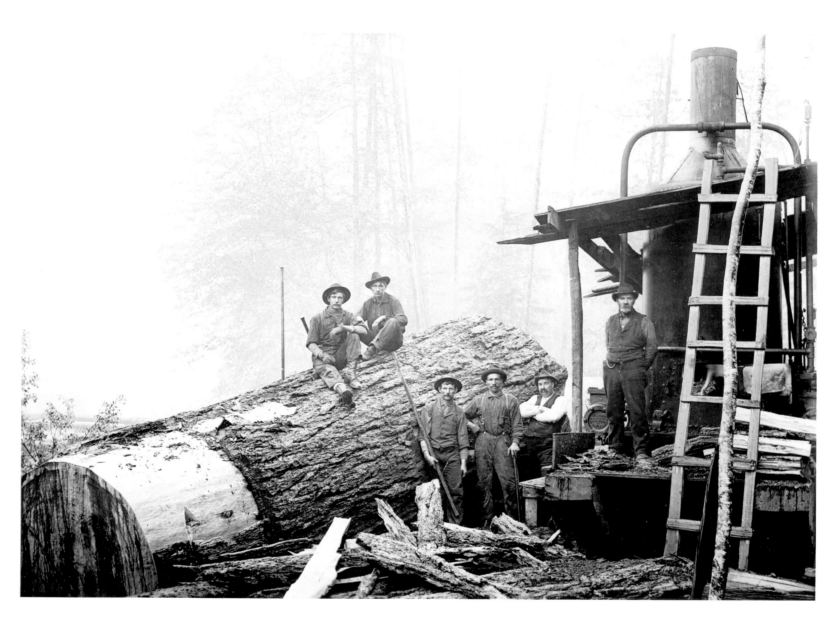

152. *Fir Log 10 Feet in Diameter, at Landing Donkey on Skagit River, Washington.*

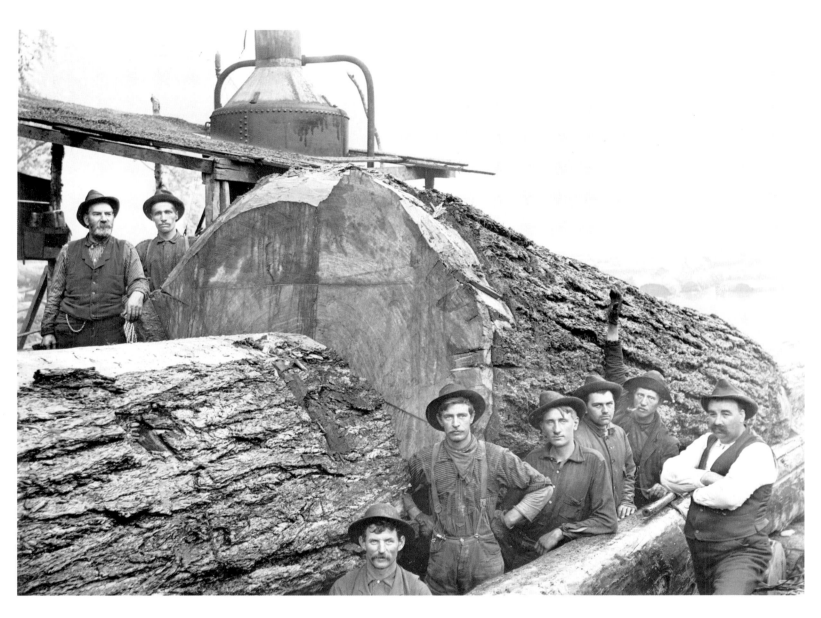

25. *Turn of Logs at Landing Donkey.*

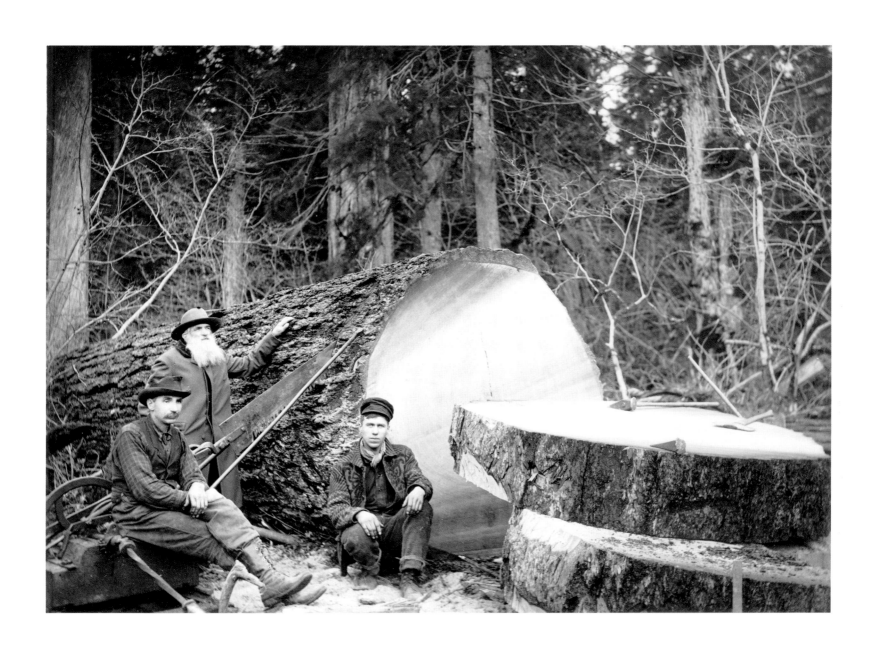

"*136. Method of Cutting Stove Wood in a Washington Forest* [*c.1900*]." And on the back of an original solar print: "Tib Kinsey, My Father with a beard."

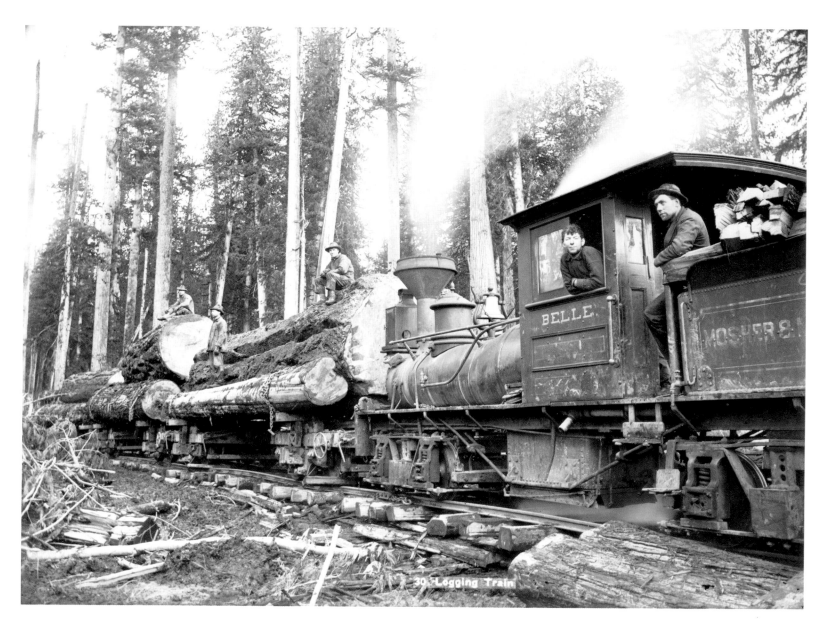

30. *Logging Train.*

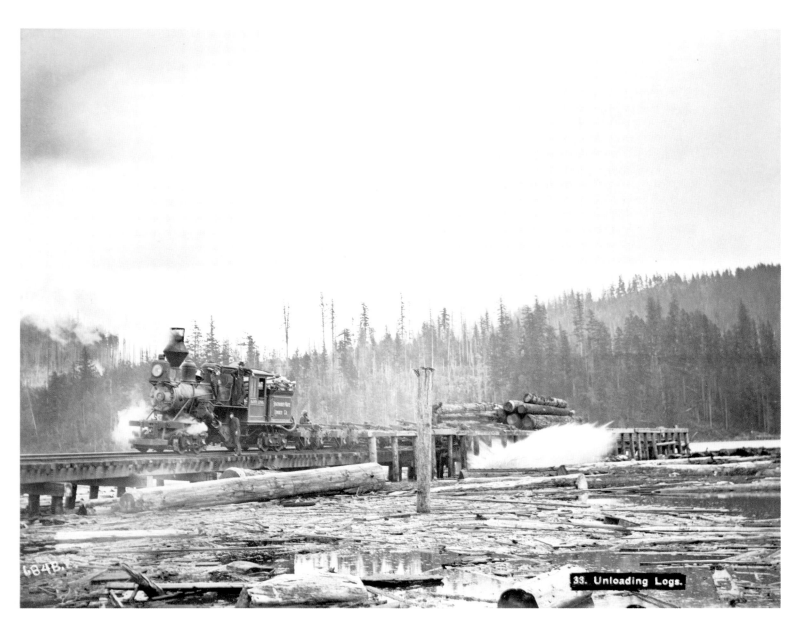

33. Unloading Logs.

"173. Boom of Shingle Bolts on Stillaguamish River, Wash."

"55. Shingle Bolts on Bank of Stream."

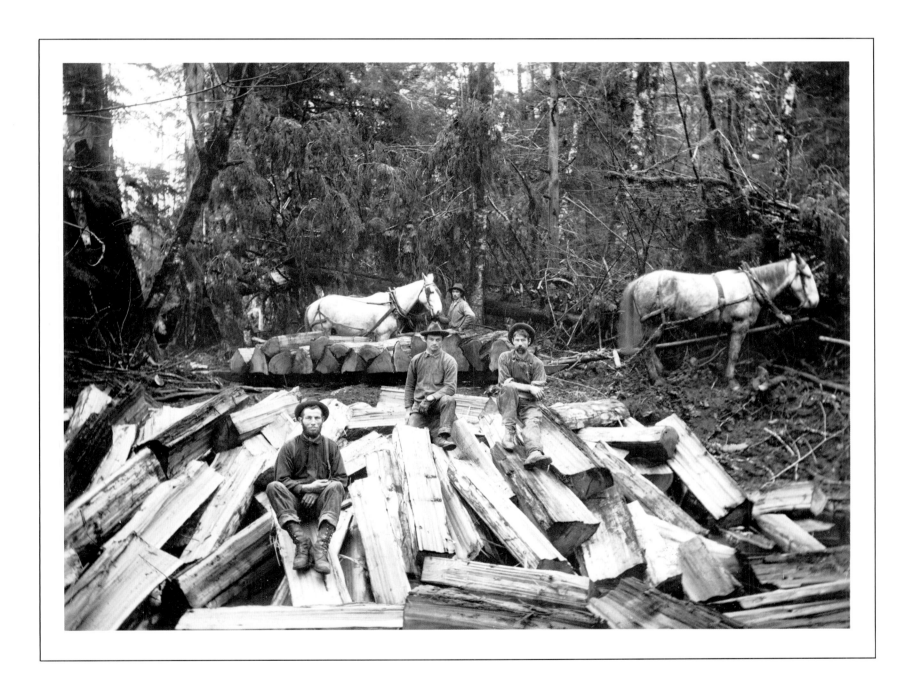

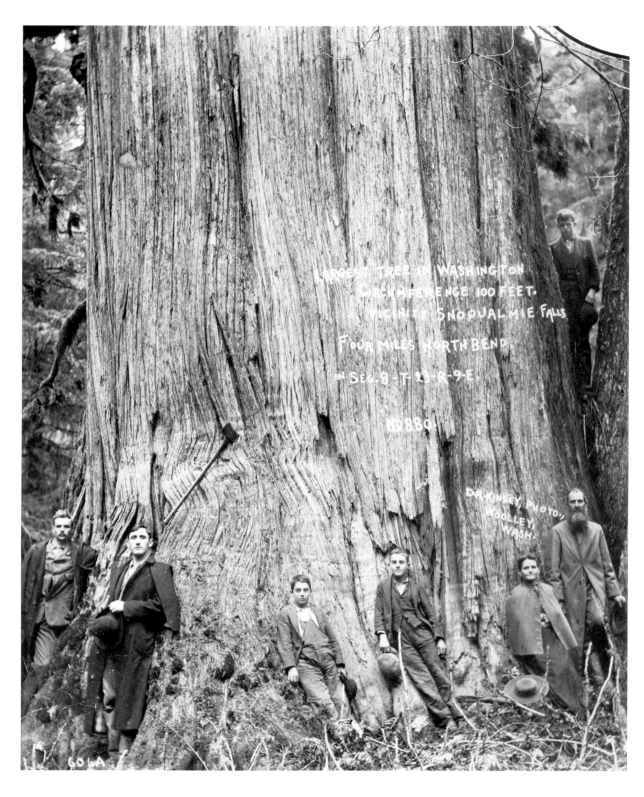

61. Largest Cedar in Washington; circumference 100 feet at ground [1897].

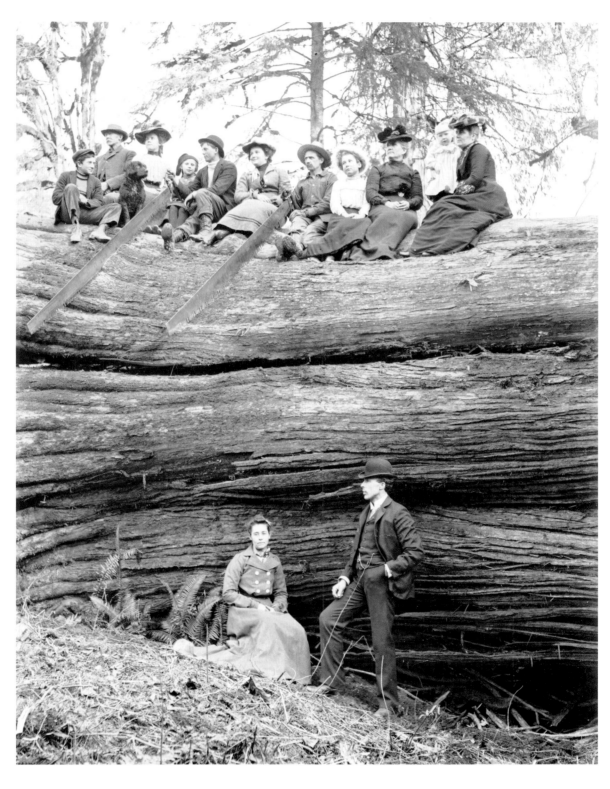

138. *Picnic Party on Cedar Log 17-1/2 Feet in Diameter, in Washington.* Copyrighted 1905.

These three plates (see pg. 139) are undated, but judging from format are early examples of Darius' genius with the group portrait. Above, Darius accidently loaded the plate incorrectly and photographed the boys with emulsion facing away from the lens. Thus, a reversed image is obtained when a contact print is made . . .

Now the loading error has been corrected and the camera moved back. But the format is too tight and the men seem to slide off the picture . . .

So the camera back is switched to vertical and the central character is asked to move to the center. Finis. (The sequence is suggested and cannot be proven.)

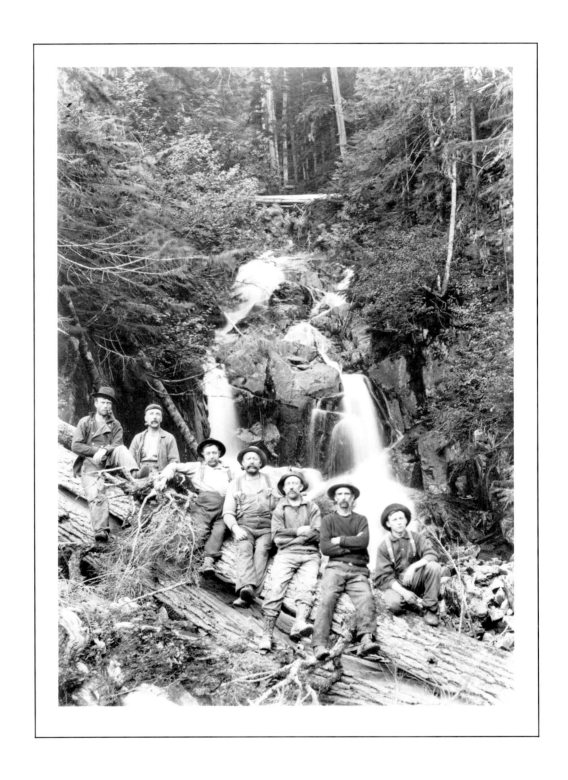

"*120. On the Spring Boards and in the Undercut. Washington bolt cutter and daughters. Copyrighted 1905.*" Cropped from the enlarged 6½x8½″ plate.

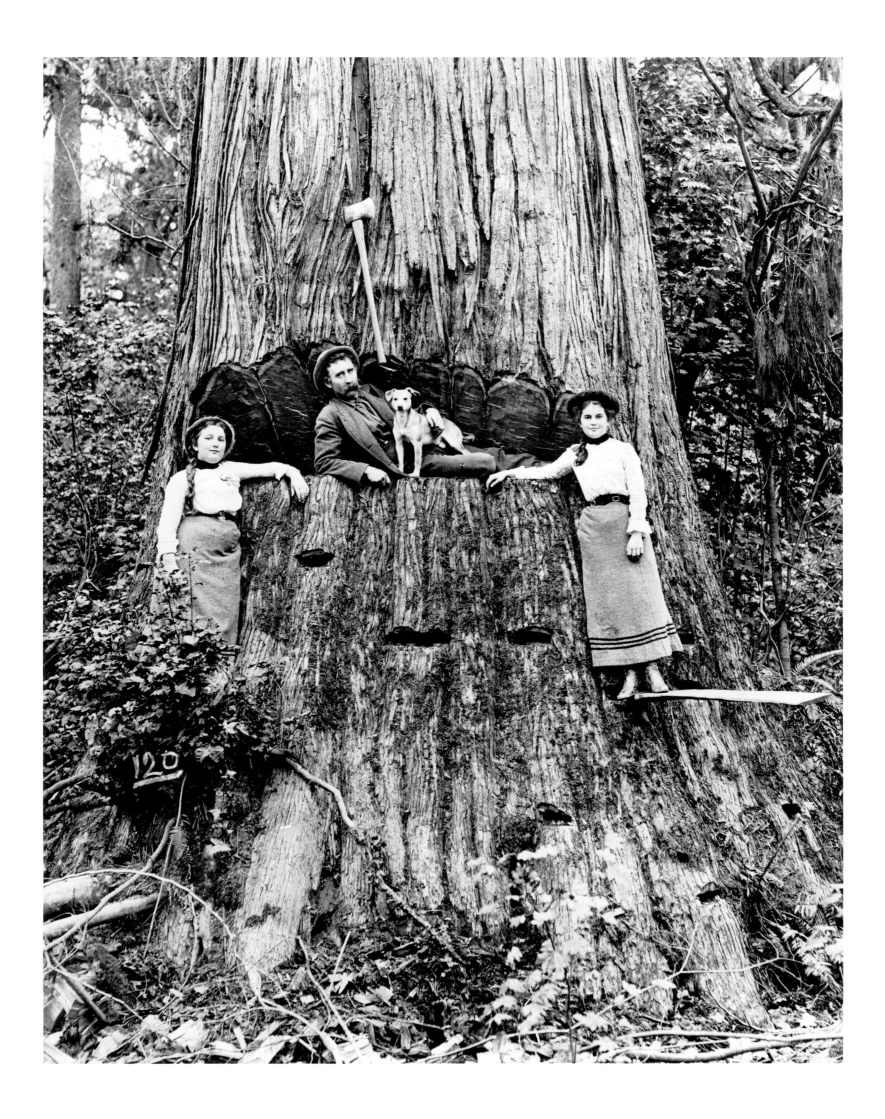

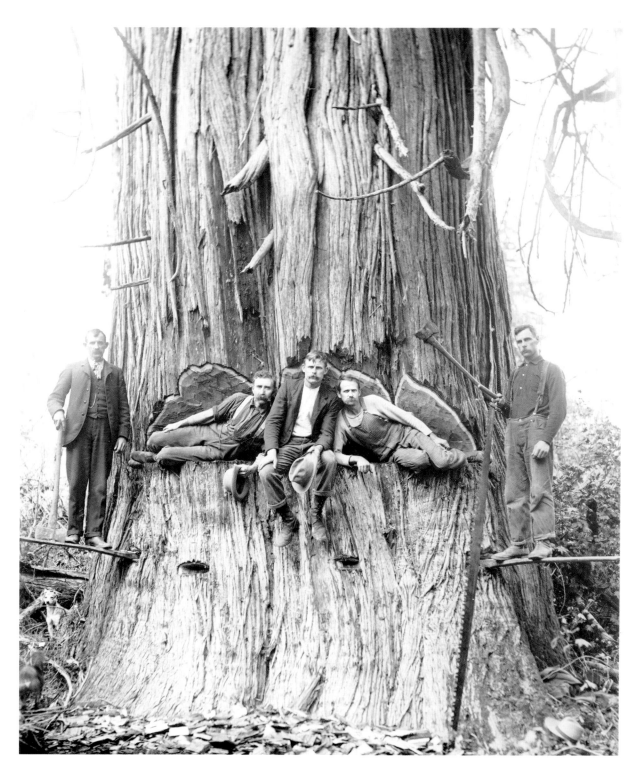

Three Men in undercut—Cedar in Washington [1905].

The year is 1905 and a significant shift has occurred in the way Darius Kinsey saw and arranged the Big Trees. Presumably the change began in 1900 when he started working with the 11x14″ camera, and then the 20x24″, the first evidence of which is 1902. By 1905 the difference was showing on the smaller plates, as in the group portraits on pages 135, 141 and 142, all dated that year.

But analysis is abhorrent, speculative, and usually unrelated to the photographer's thinking. Darius was almost certainly thinking only of photographing, and then photographing some more. Yet . . . could we not say that the Big Trees have now become the Classic Big Trees?

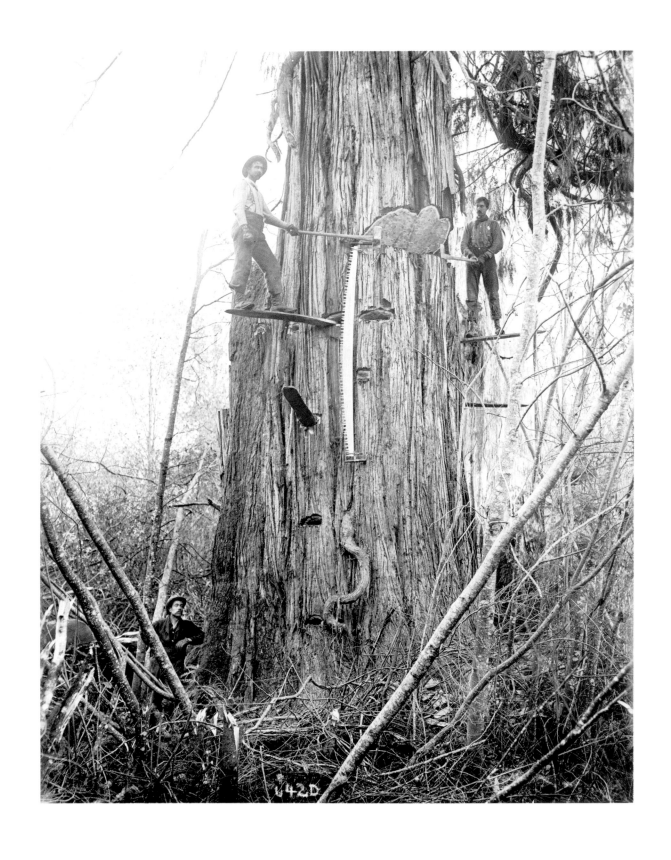

"*114. Felling Cedar Tree 20 Feet from Ground, in Washington* [1905]."

"122. *Seventy-five Feet to First Limb, 300 Feet High—Average timber in Washington* [c.1905]."

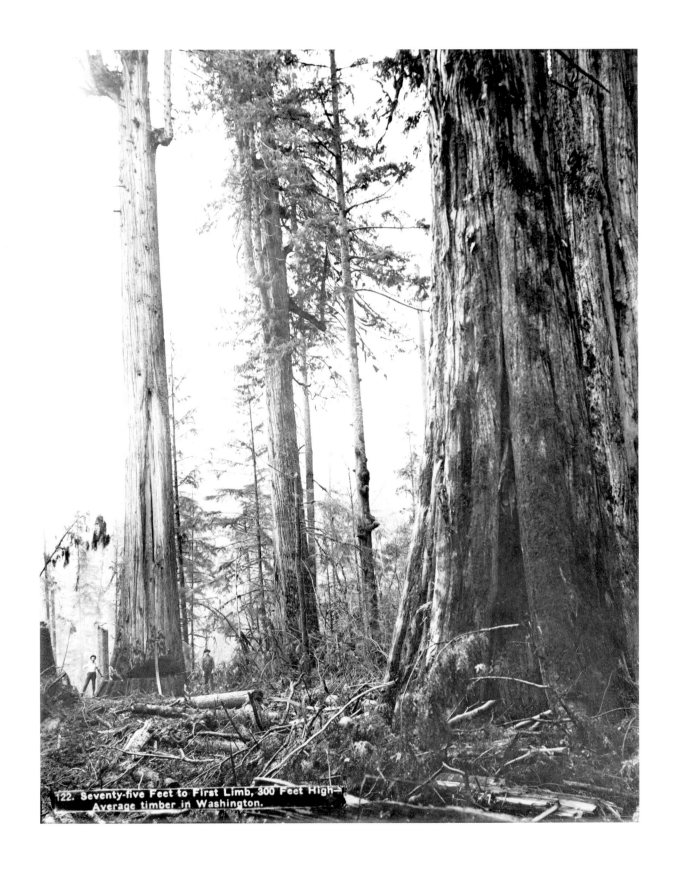

122. Seventy-five Feet to First Limb, 300 Feet High—
Average timber in Washington.

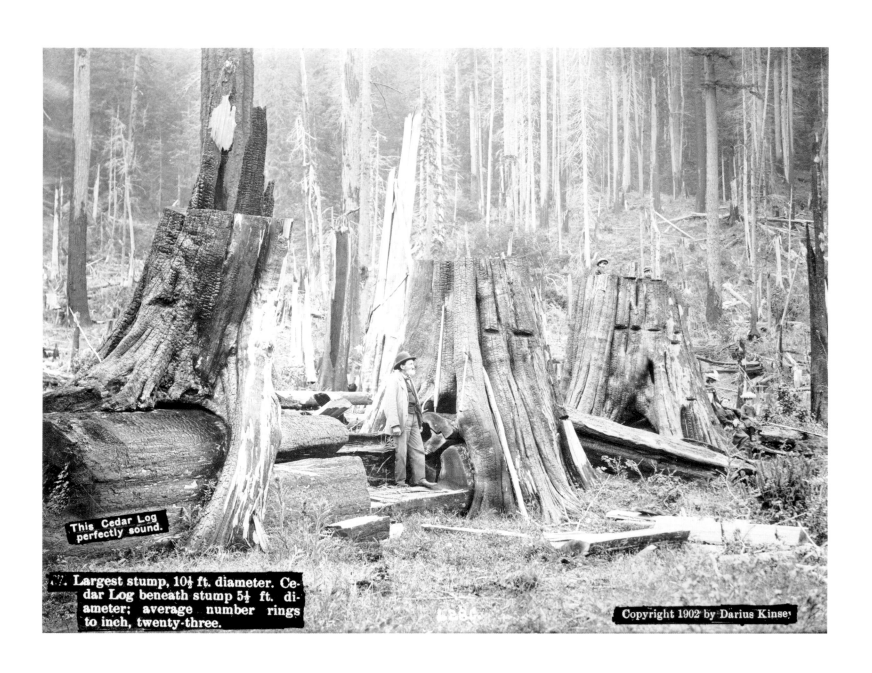

This Cedar Log perfectly sound.

Largest stump, 10½ ft. diameter. Cedar Log beneath stump 5½ ft. diameter; average number rings to inch, twenty-three.

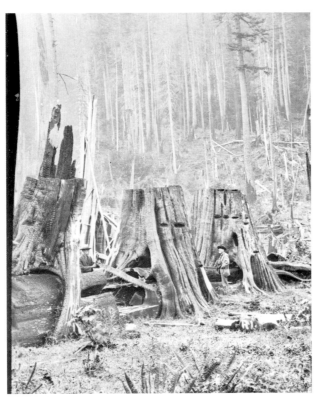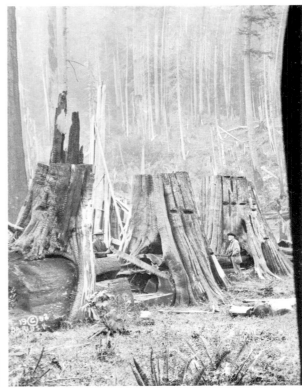

(19©02 Darius K)

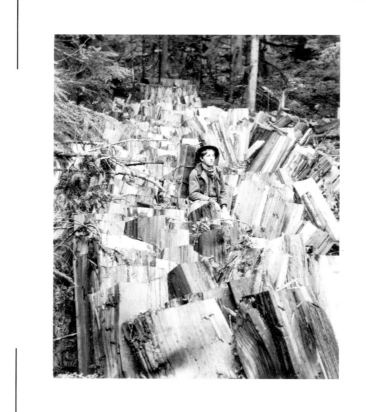

Unidentified helper with a case of
20x24″ glass plates on his back.
From stereo pair.

the Great Glass Plate

In December of 1972 it was established that *one* 20x24″ plate had survived the years, was part of the Collection until about 1960, but was then passed on to a collector in Portland, Oregon. Name of the recipient was unknown. Since the Portland area houses some 750,000 souls, the chances of tracing the Great Plate and *then* finding it intact seemed nil.

But the Plate was found, and not only was it found, it was intact, safely stored in Darius' enormous contact printing frame. Further, not only was it intact, it was in the hands of a very special collector—a gentleman, a trader (!), a man desirous of seeing the Great Glass Plate reunited with its lesser brethren after thirteen years.

Finally, a year later there occurred the incredible coincidence of finding the newspaper paragraph which mentions the very tree, that day seventy-two years ago when Darius and his helpers dragged one hundred and fifty pounds of equipment into the woods to . . . well, what else? To make a photograph, of course.

The Skagit County *Courier*, May 8, 1902: "Mr. Kinsey is securing some very fine negatives with his large camera. Notwithstanding the weight which, with case, etc., is 150 pounds, he makes trips very much the same as with an ordinary camera. The pictures in the postoffice [Sedro-Woolley] represent a trip of one mile through the woods up a mountain side. Two men were employed for this trip which consumed the greater part of one day. The 16-foot tree in one of the pictures is the largest known fir tree in the state; it was undercut especially to be photographed."

0398. *Felling Fir Tree 16 Feet in Diameter, 350 Feet High, in Washington. Copyright 1902. Reduced from the 20x24" plate.*

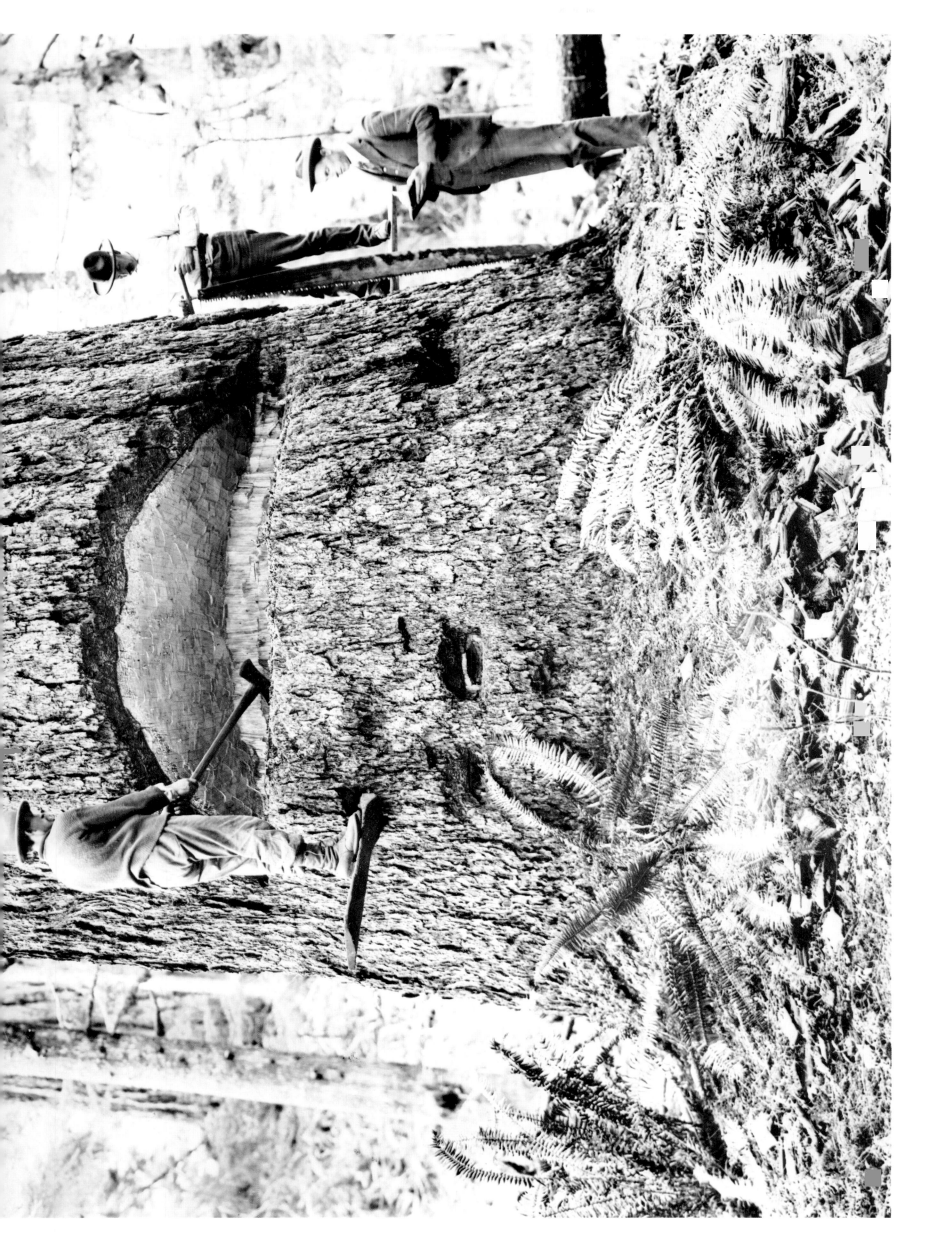

The Skagit County *Courier*, March 6, 1902, under
News of City and County: "D. R. Kinsey was a
passenger for Nooksack yesterday where he went on
a picture taking expedition. There is an immense log
nearly 100 feet long across Breckenridge Creek, and
Mr. Kinsey will take a picture of it with his big camera.
It is his intention to invite all the school children in
the vicinity to take their position on the log while
he takes a picture of it."

July 17, 1902, under *News of City and County*:
"Mr. and Mrs. D. R. Kinsey left Tuesday morning
for Monte Cristo and Silverton where they will remain
for a two-week's outing. Mr. Kinsey took along his large
camera for the purpose of taking some of the many
views for which the above places are noted. During their
absence the gallery will be in charge of Miss Jennings,
who thoroughly understands photography, having
learned the art under one of the leading photographers
of Oregon."

November 13, 1902: "D. R. Kinsey, the photographer,
has recently placed in the postoffice some fine views of
the country tributary to Sedro-Woolley and also of
Monte Cristo and vicinity. The views were all taken by
Mr. Kinsey's immense camera, 20 by 24, the largest
in the state, and are triumphs of the photographer's art.
The local views will prove quite an advertisement of
this section showing, as they vividly do, the immense
timber and other resources of the upper Skagit valley."

The Skagit County *Times*, April 2, 1903, under *Local News Items*: "As a photographer Darius Kinsey has a national reputation. He has just received orders from Savannah, Ga., Southern Pines, N.C., and St. Paul, Minn. Mr. Kinsey's fame as an artist helps to advertise Sedro-Woolley far and near."

July 28, 1904: "*M.E. Church Notes* — Mr. Darius Kinsey, our faithful efficient Sabbath school superintendent has gone to Yellowstone Park to rusticate a couple of weeks. Brother Kinsey has been at the head of our Sunday School for five years, and has succeeded in building up one of the largest and best schools in the county. During his absence Mrs. Warren Bagly, his able assistant, will have charge . . . "

October 27, 1904, front page: "*Have Returned* — Mr. and Mrs. D. Kinsey returned home from their eastern trip last Friday. While away [about six weeks] they visited many points of interest, their travels taking them to Washington, D.C., New York City, and many historical places in the eastern states, in addition to their visit to the St. Louis exposition. The trip was taken principally for the purpose of securing stereoscopic pictures, and they exposed altogether about eight hundred plates which indicates that they were pretty busy during their seven weeks absence."

July 20, 1905, under *Local News Items*: "D. Kinsey started Wednesday on a trip which will last several weeks, in search of health. He will, of course, take views of all the fine scenery he butts up against while he is absent and will undoubtedly have something nice to show us when he returns."

Snoqualmie Falls, c.1898. Enlarged from stereo pair.

156

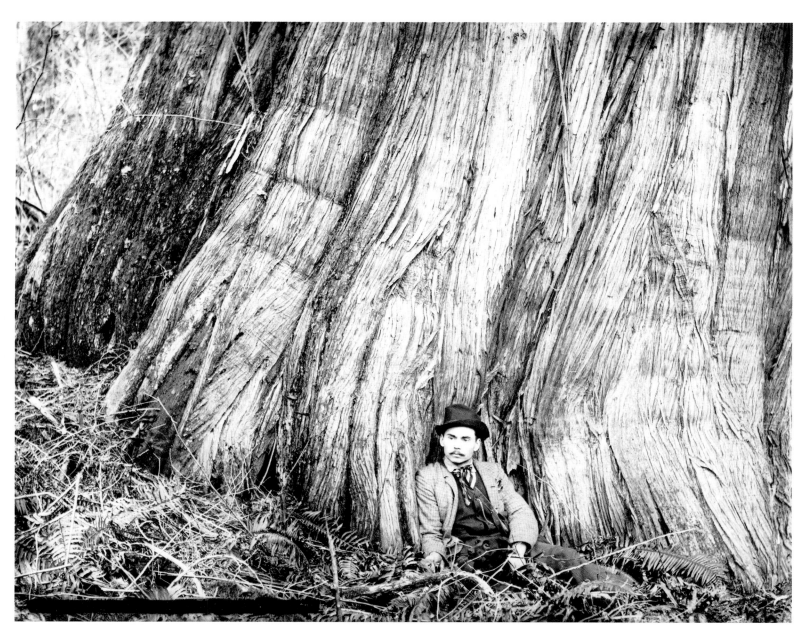

111. At the Foot of a Large Cedar Tree in Washington.

the Skagit County Times

December 20, 1906, front page:

"To Seattle — Mr. and Mrs. Kinsey to make that city their future home. One of the regrettable features preceding the holidays is the departure from this city of Mr. D. R. Kinsey and family, who are leaving us permanently and will make their future home in Seattle. The family is so identified with the town that its departure is like taking away a substantial part of a good foundation. Since its founding the home of the family has been here, and its work has done as much or more than all else in spreading the moral and material fame of Sedro-Woolley. As a testimonial of appreciation, Mr. and Mrs. Kinsey's associates in religious work,

including the entire congregation of the M. E. Church, prepared a surprise for the worthy couple in the way of a reception and handsome gift. The reception at the Church Friday evening was no part of the surprise, but the presentation of a handsome silver cake basket from the ladies of the Aid Society, through Reverend Michener, was an unexpected feature. It was intended as a constant reminder of good deeds done and universal friendship that will live and wait for them in the hearts and hopes of all their friends in their old home place. They expect to leave Saturday."

REMOVED·TO
1607 E. Alder St., Seattle
Phone Sunset East 6778

"There is nothing good or bad
except by comparison

Our pictures are not better than
the best but better than the rest"

This Volume Two opening quote is from a Kinsey manila print envelope, c.1920.

"32. Man lying in the completed under cut of a twelve-foot cedar; wagon load of chips lying on ground. Copyrighted 1906 by Darius Kinsey, 1607 E. Alder St., Seattle, Wash." Glass plate.

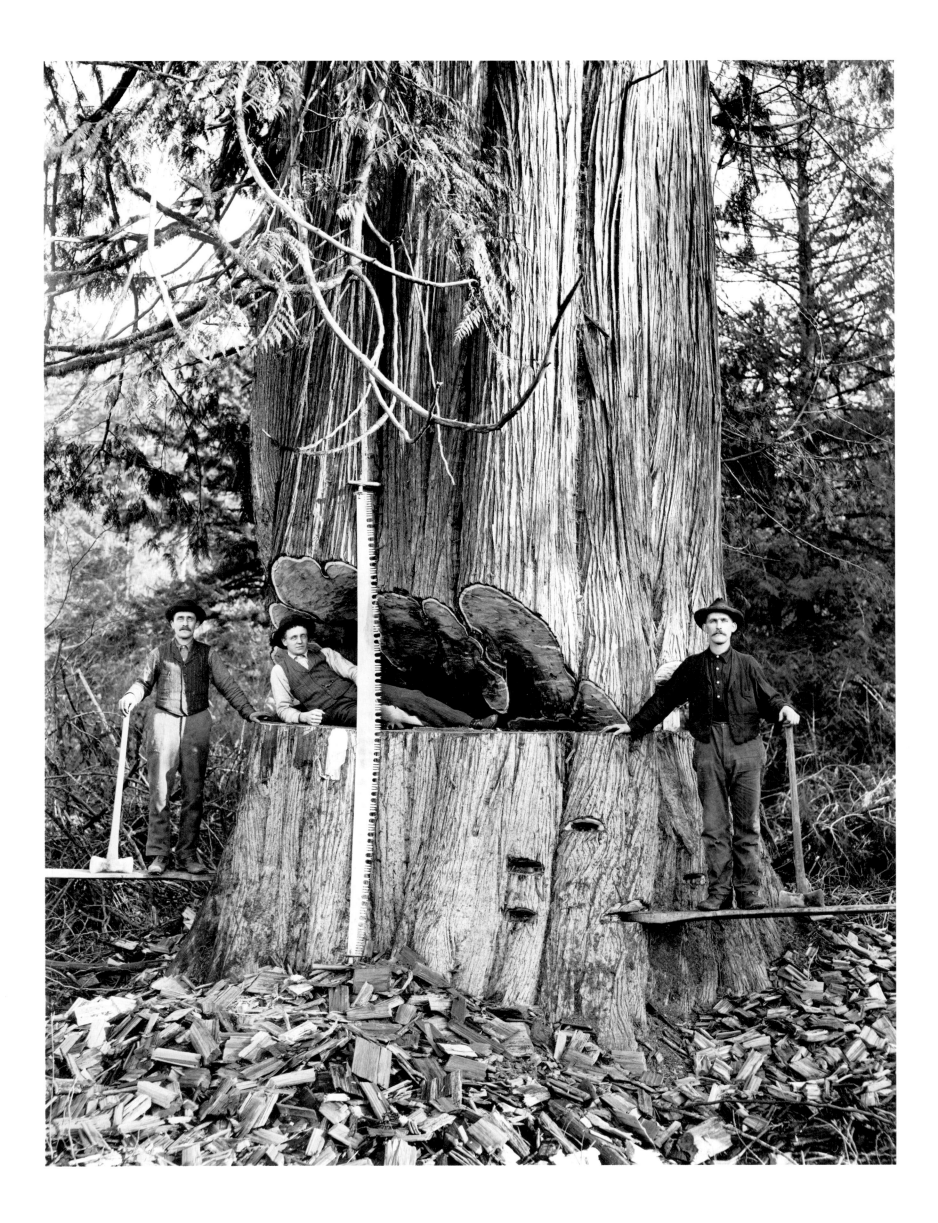

"24E. Pioneer trail winds through moss-hung cedar forests in Washington. Copyright 1906 by Darius Kinsey."

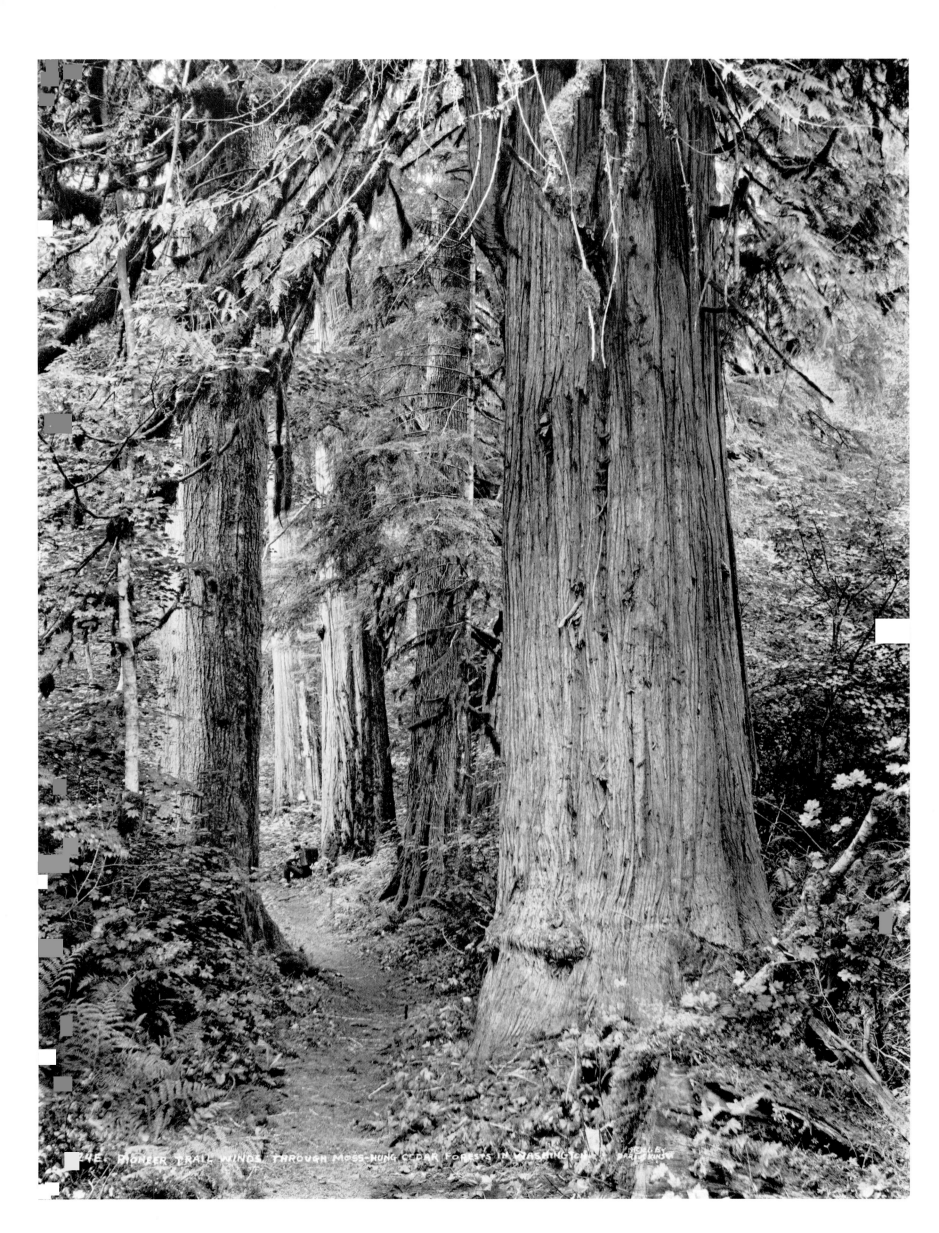

24E. PIONEER TRAIL WINDS THROUGH MOSS-HUNG CEDAR FORESTS IN WASHINGTON.

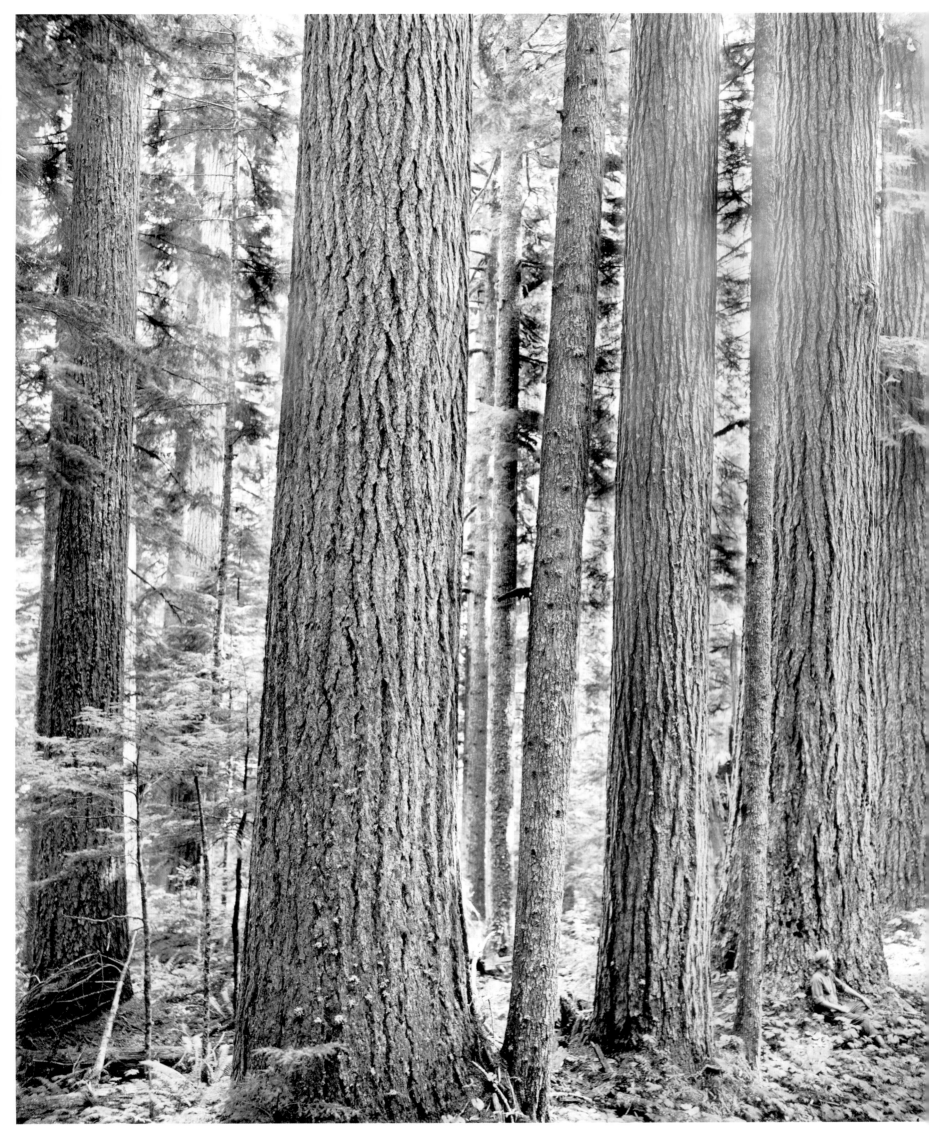

"A8. A dense stand of fine quality fir, five to seven feet in diameter. Darius Kinsey, Seattle, Wash." Glass plate.

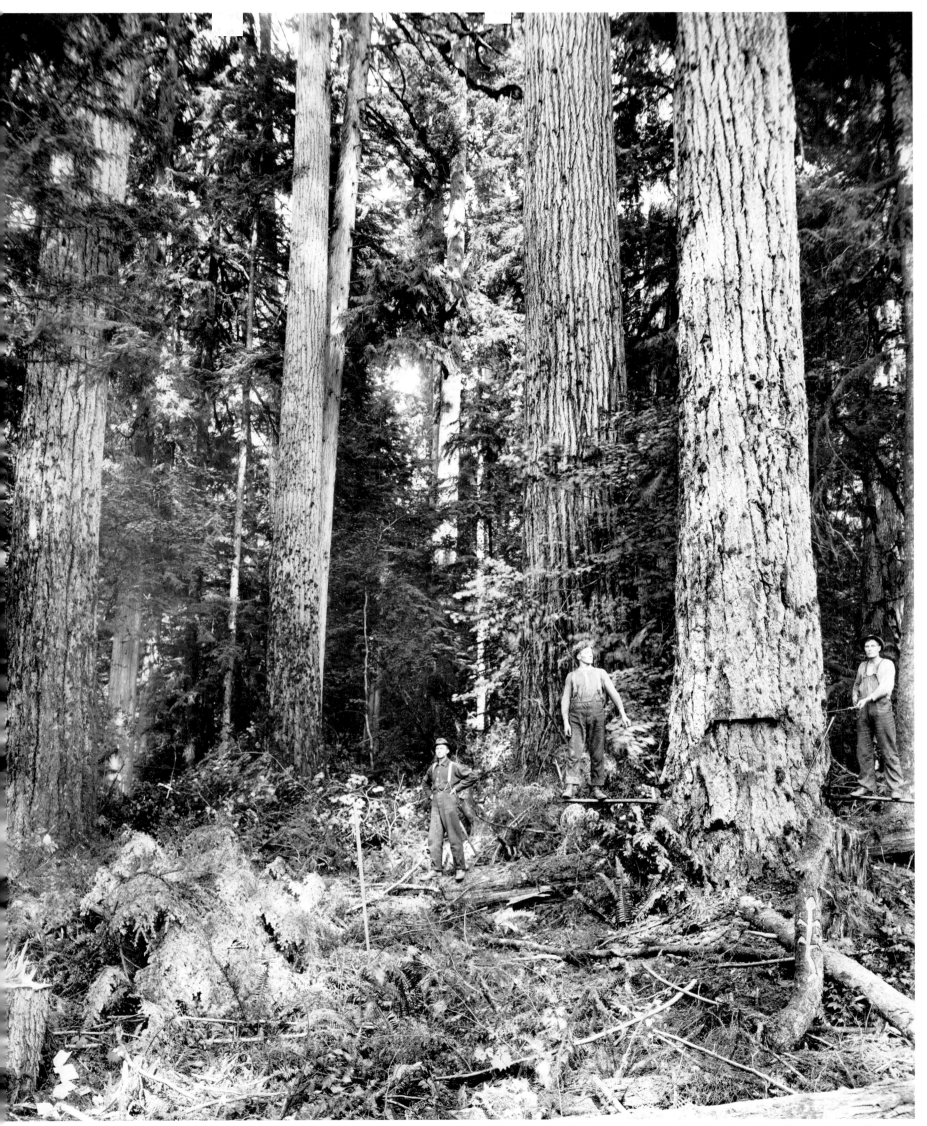

"16. Sawing bottom of scarf, which is the first stage of putting an undercut in a tree. Darius Kinsey." Glass plate.

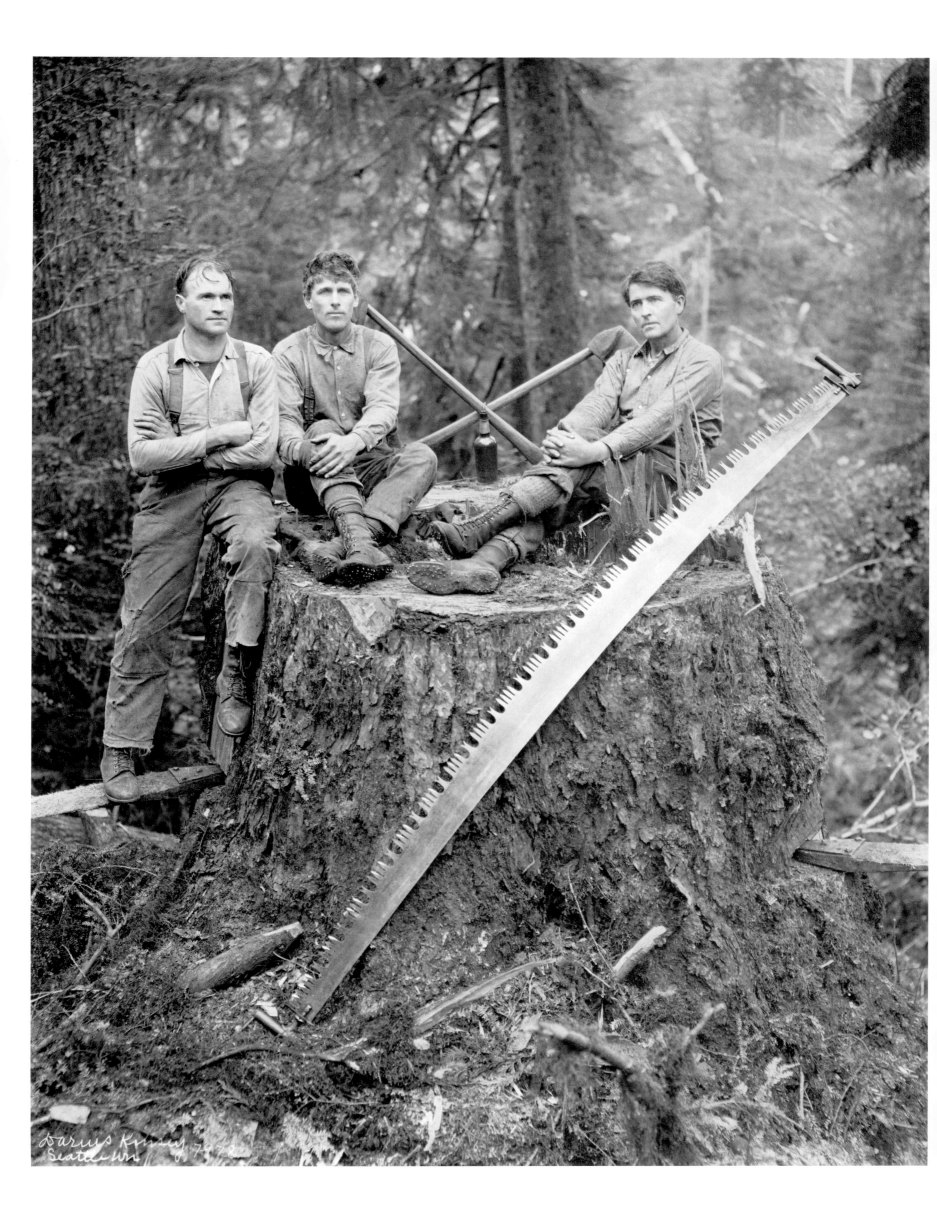

PHOTOGRAPHER

A half century of negatives by Darius and Tabitha May Kinsey

With contributions by son and daughter
Darius, Jr. and Dorothea

Volume Two

THE MAGNIFICENT YEARS

Opening page quote is from a Kinsey manila print envelope, c.1920.

THE CONTENTS

The photographs in Volume Two are from the very end of the Sedro-Woolley decade, and cover the Seattle years 1907-1940. All of them were taken with Darius' big camera—the 11x14" Empire State. Interviews with loggers who remember Darius in the woods, and with members of the Kinsey clan, are scattered throughout. Darius Junior's reminiscences start on page 181, the essay on Darius and Tabitha on page 299, followed by notes and references on pages 312 and 314. The story of the Collection begins on page 315.

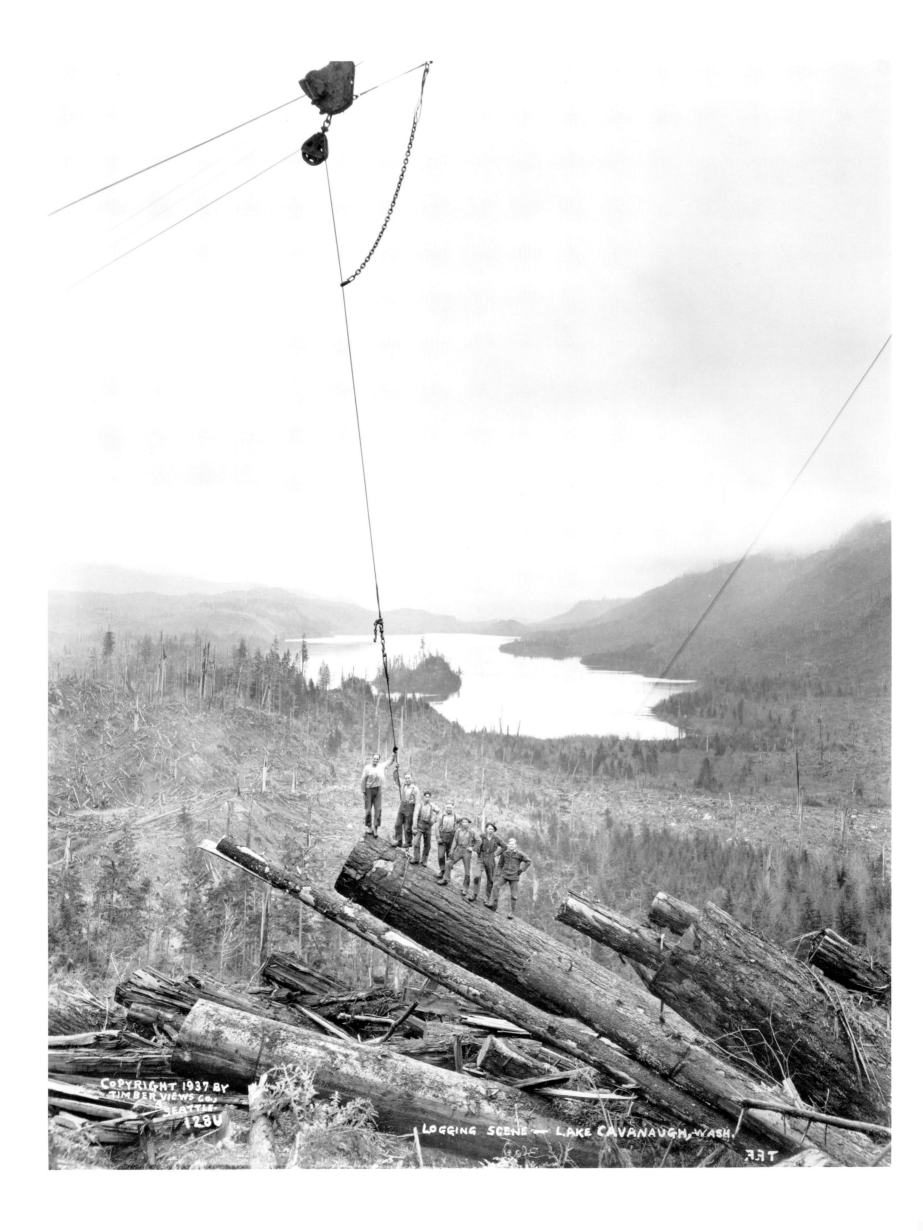

LOGGING SCENE — LAKE CAVANAUGH, WASH.

THE MAGNIFICENT YEARS

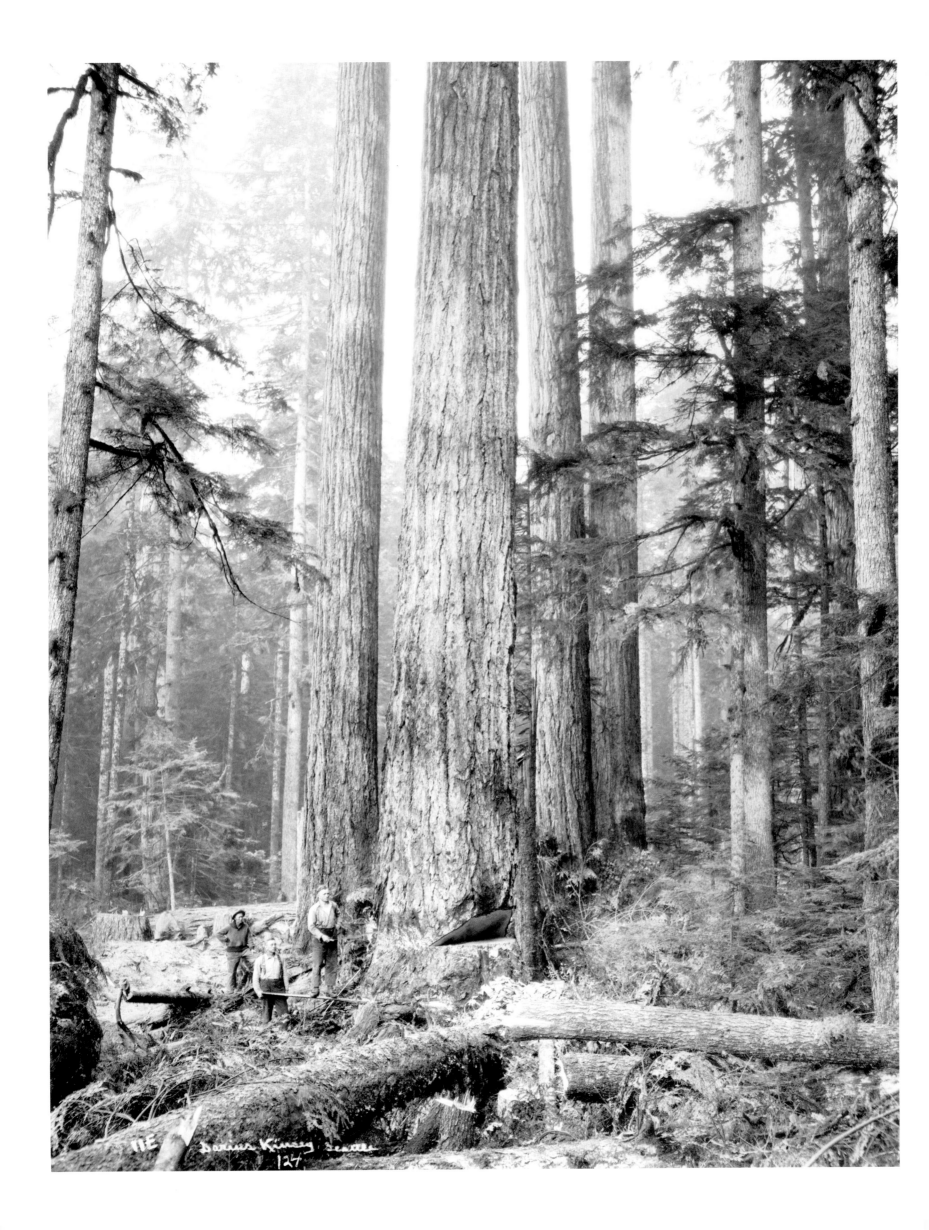

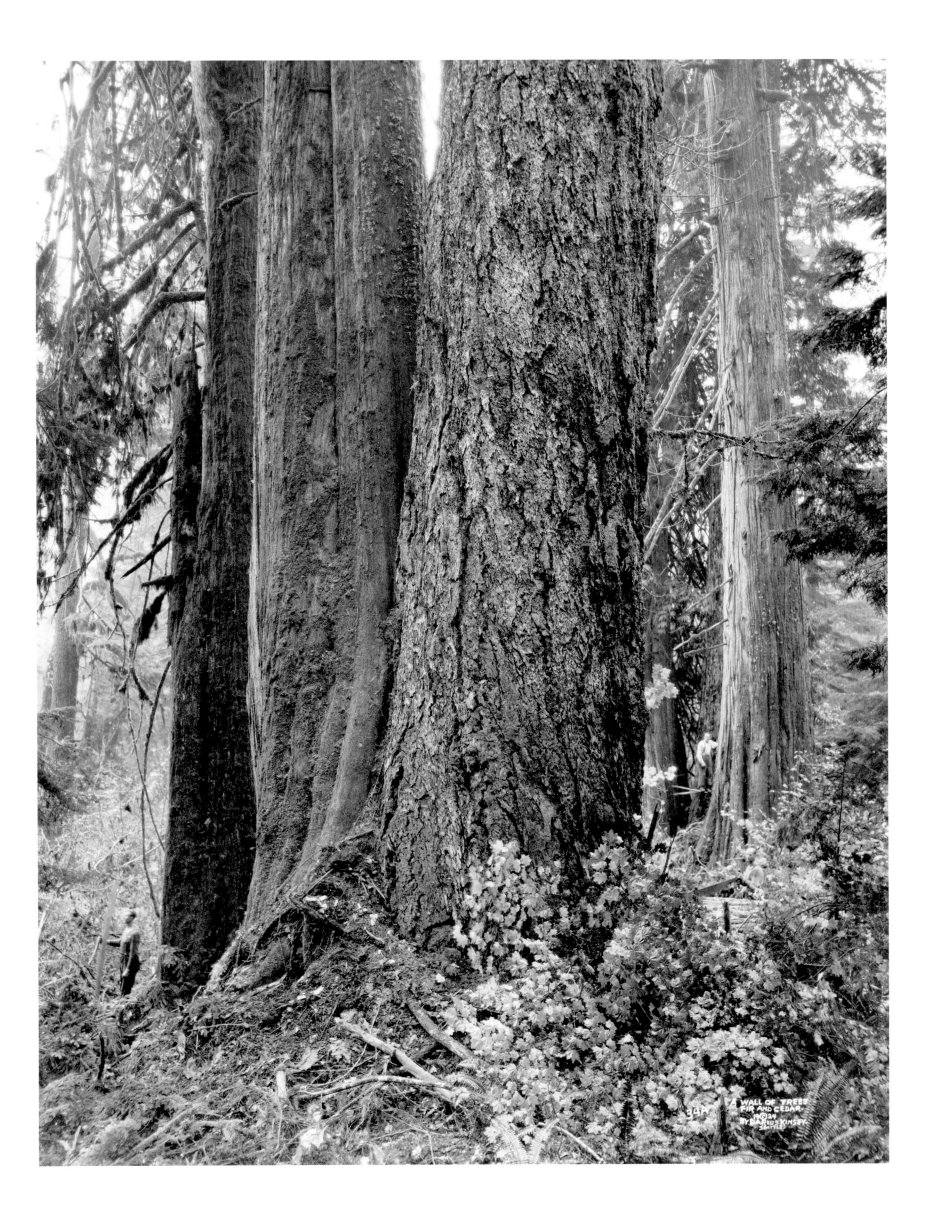

A WALL OF TREES
FIR AND CEDAR.
N°124
BY DARIUS KINSEY.
SEATTLE

"3273. Eagle Falls Logging Co., Index. Undercut 10 feet across, 39 feet around 6 feet from ground. Darius Kinsey, Seattle."

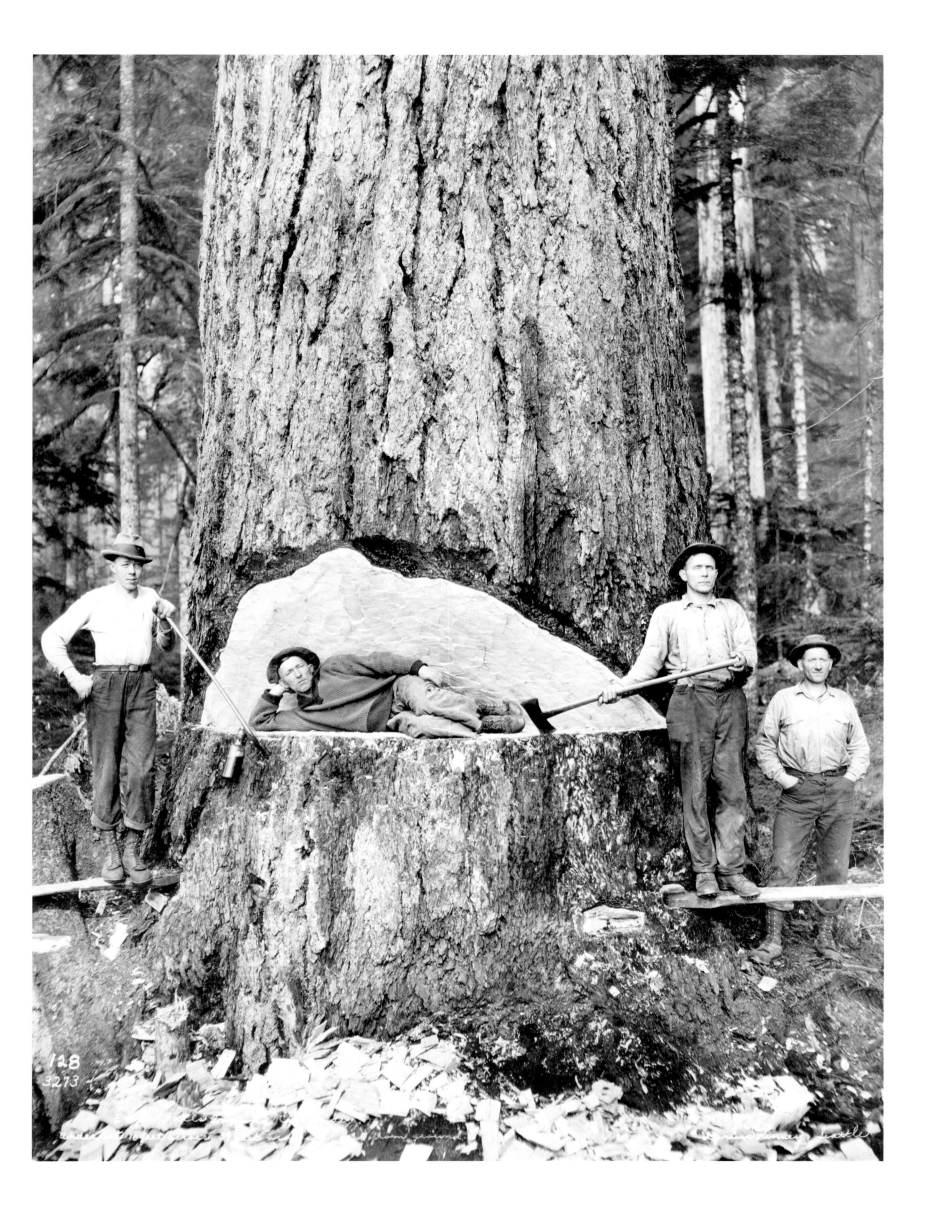

128
3273

"A48. Bucker, beginning a cut on cedar log, 12 feet in diameter. Darius Kinsey, Seattle, Wash." Glass plate.

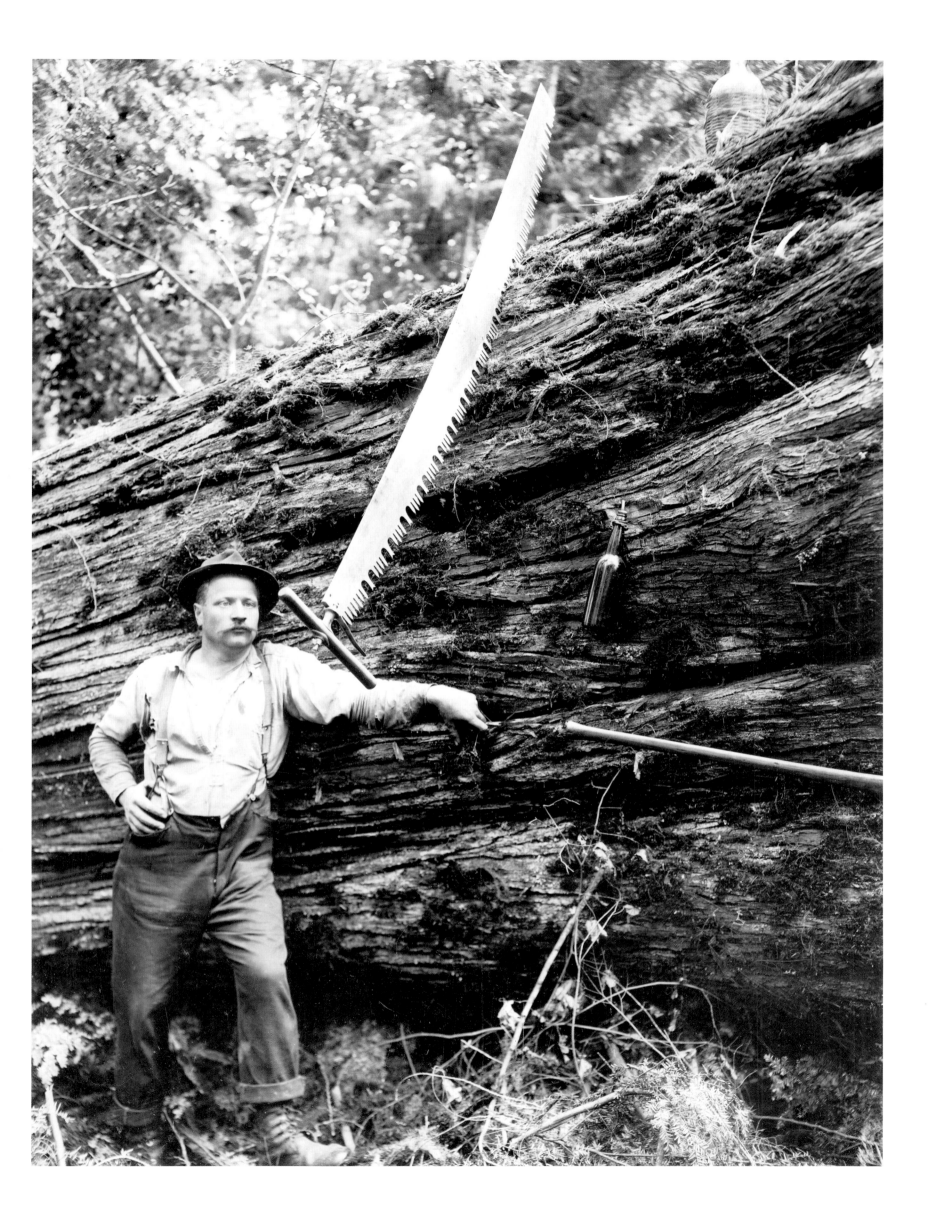

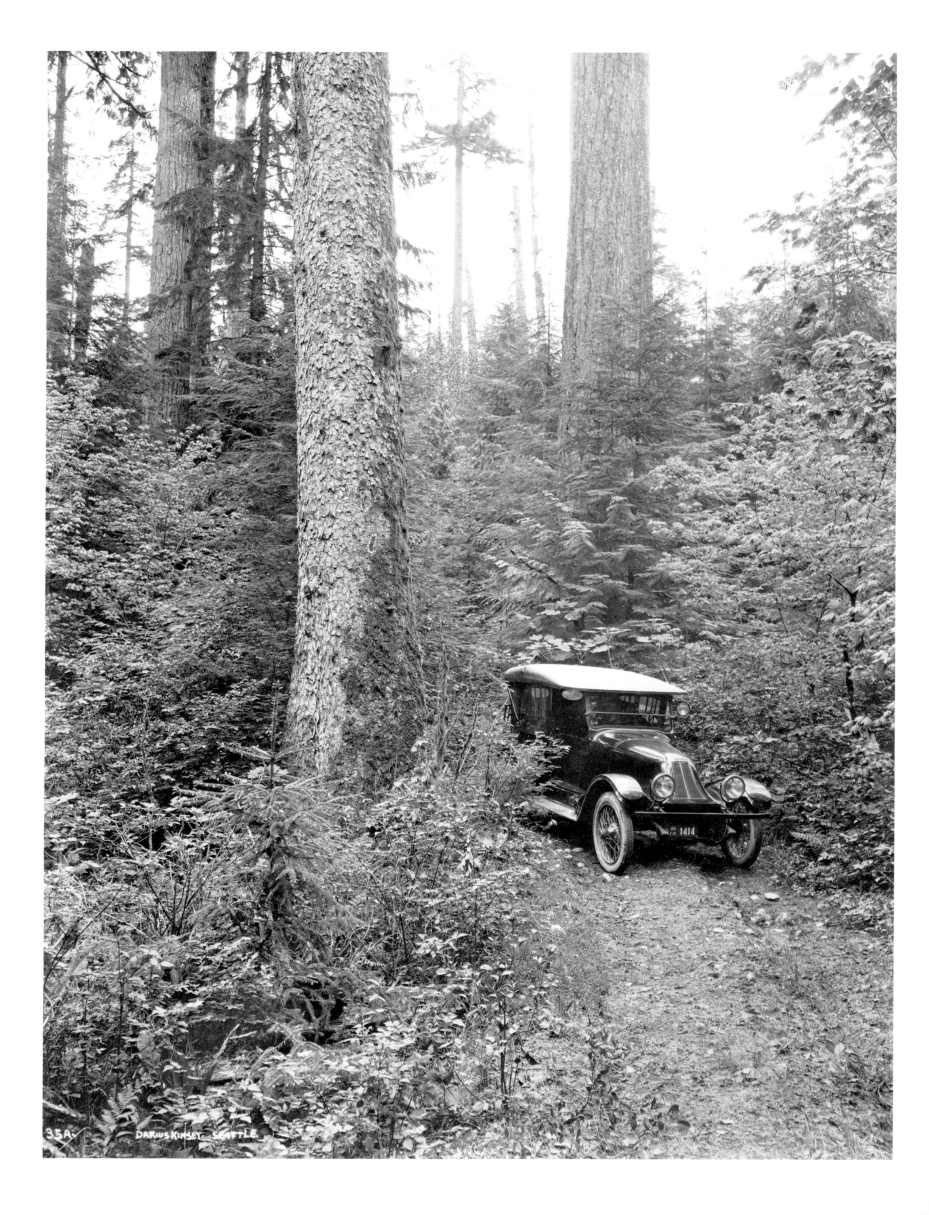

35A DARIUS KINSEY, SEATTLE

Dad called me "old man" from the time I was about five or six years old. I don't know why it was. I think I didn't look too healthy at the time. Anyway, I was called "old man."

He was a hard, hard worker. I remember that very well. Of course, the logging sites were all back in the mountains. I mean, it wasn't a short hike to any of them. And I remember we were up in that logging camp over the weekend, and we had to park our car—we had the old Model-T Ford—we had to park our car down at the railhead. Anyway, he ran out of film, and my Dad and I had to walk down to the car and I think it was fifteen or eighteen miles, one way. It was too much for me. I didn't go all the way, but he went to the car to get film and walked back.

He bought the Model-T Ford in 1913, and before that I know he had a horse and buggy. We got the first Franklin in 1919. But my Dad thought I was too young to drive the Model-T, and I remember he was away from the car one time, and of course I knew exactly how to run it. I cranked the darn thing up and took it out for a ride and came back all in one piece. I don't know if he found out about that or not. But I was driving the Model-T on quite a few of the trips, so I must have been twelve or thirteen then. And then the first Franklin in 1919 and my Dad, like most older people—he was a little bit slow on the mechanical end to get used to a different car, so I was the first one to drive the Franklin. I got a learner's permit and taught him how to drive. But I drove on all the trips I was out on.

I made a glass enclosure for the first Franklin. It had sliding windows. Then, after it conked out, I picked up a secondhand Franklin touring car with a glass enclosure for him, and then later on he had a Franklin

sedan. We had three Franklins altogether. But, you know, he really looked out for me. He thought I wanted to be a photographer and I just couldn't go for it. But I was very mechanically inclined. He realized later that I wasn't going to follow his work, so when he bought the 1919 Franklin, there was a stipulation that later on, when I wanted to, I would be allowed to work in the Franklin garage. I must have started there about 1925.

Yes, he would go any time. I remember one time—you have a picture there of the Franklin in some snow—at Mt. Index. That was taken on a trip when I was on my Easter vacation from school. We went up to Index and stayed in the hotel that night, and gosh, the next morning there was about a foot of new snow. So we took the Franklin and drove up toward the mountain. We had a road that hadn't been ploughed at all. But we managed to go through, up to an area where he could take some pictures, and he got some beautiful photographs of that mountain. A very beautiful trip.

Then I remember a Columbia River Gorge trip. That was one of those deals when just Mother and I went along. And we got so darned impatient. It was a hot day and we were hot, and we had that Franklin touring car. He wanted to take a picture of the river and he went way up in the dry foothills, and there were rattlesnakes up there. I wonder to this day how he ever escaped without being bitten. Anyway, he went up there and he took a panorama picture, and he really got a bird's-eye view. And later, at a high place—a lookout point—the wind blew the top off our car, and we were drinking some milk and it actually blew the milk right out of the cup. Well, that trip down there was made in my last

year of high school, I guess—in 1927—and that was the last trip to the Gorge.

But then the Yosemite trip was made during the summer. That was a wonderful time. Just one trip to Yosemite. Getting back to the old Franklin again, we had that thing so loaded down—and the Franklin didn't have very good brakes at that time. They had a brake on the drive shaft, and the brake would sometimes get a little grease and oil on it. And I remember we had to go over a road from the West, and the hills were so steep that I couldn't hold the car with the foot brake and the hand brake. I just had to keep going. And the hills were so steep going out that we had to get out of the car, and my Dad had to push it, help push to get us up the hill, we were so loaded down. That car wasn't too much for power or brakes.

That small film was before I can remember. Only thing I can remember is when I went out with Dad it was all 11x14" film. School vacation started in June, and we would go out and be out for six or eight weeks. Actually, what happened there, what really turned me sour on that business—there was a lot of hard work and the uncertainty of the whole thing also. But Dad would take me out all during the summer and we would go to these different places; saw mills, canneries, and all that sort of thing. And I would be stuck with helping him to make platforms. It was a heck of a job for a young kid. We had to lift big planks, 2x6's and 2x8's—they are big things—and we had to roll fifty-gallon drums around to make platforms that had to be made pretty safe, of course. All that work and what little did you get out of it.

Well, I will say the meals made up for all the problems I thought I had. We would eat at the logging camps, and of course my Dad was acquainted with a lot of the cooks. Some of the cooks would shift around from logging camp to logging camp, and he would be acquainted with many of them. A lot of the time I would get an extra handout in the

evening. I remember there was a white cake with a white frosting on it that I liked so well. I can taste that darn cake yet, a single-layer deal, and they made them in a platter that must have been four or five feet long and a couple feet wide, and I would just get myself sick, almost, eating that darn cake. It really was a treat. But I would have to get up in the early morning. You had to get up at 4:00 or 5:00 in the summertime. They would have breakfast and go out in the woods. They usually got to the woods on a flatcar hauled by a locomotive, and if you come right down to it, I used to always get a kick out of the locomotives. When they brought the logs down off the mountain, they put a locomotive in front and one in back, you know. And the engineer used to let me ride in the cab and I can just hear that racket when they put air in the cars. Boy, it would make a racket. I sure got a kick out of that.

Of course, Dad was always out there taking pictures. Speaking about taking pictures, I remember one thing about some of those woods scenes that you have. I remember that he would put a time exposure on them. It seemed to me that on one picture—it was in a shaded area in broad daylight, but it was shaded—he had a half-hour exposure. Now could that be possible? And I remember the shutter very well. He had a bulb. There was a lens—a frame about that square that the lens screwed to, and then behind that lens there was a shutter about that square, and then there was a bulb to it. A shutter-control bulb.

I remember so well that developing. We had hired help and my Dad and Mother were both awfully careful how the prints were processed. And Dad was always a stickler to be sure that all the hypo was washed off. They just washed them and washed them. To this day there are prints that haven't faded at all. But it really got Mother down. I will have to say that it was quite an ordeal for her. He would send the negatives in—they would

come special delivery, as I remember—and she had to get to them right now. She would just work like heck to get the negatives developed and the prints made, and then the orders were all put in big manila envelopes and the number of pictures in each one was written on there, and the price and everything. In the meantime, Dad would have taken some more pictures and would be sending some more negatives in from the logging camp. So it was just a round of sending negatives in, developing them, printing them, sending them out. And there would be more coming in.

Oh boy, she just hated it. I remember so well that she didn't like it at all. But she had no alternative, because my Dad had to make a living and she had to do her bit or the thing would have fallen flat. It was a job where they had to work together. He couldn't print the pictures out in the field, so she had to help out. But I will say one thing. We never ran short of help. They would live in the house, they would be regular housekeepers, at least in the early years. So at one time, Mother had nothing to do in the house except to work on the pictures. That was a full-time job for her. And she was always very lucky in hiring people to help her. In the first place, I had a lot of aunts and uncles, and their children wanted to get a crack at coming to the big city. They lived up in Nooksack at the time, and they would work for my folks a couple, maybe three years, and they would marry off and that was the end of that. And then we had to start to canvass around for help, you might say, and when we were out taking pictures Dad would keep his eyes open for prospective workers. So those girls would get to the big city, they got paid well, and had a good place to live in first class surroundings.

You know, Dad wasn't much trying to make headlines. He was very much in the background. I remember Curtis, I think his contemporary you would probably call it. He really made headlines. He really got in with the people who could help him make headlines. But my Dad was one to be quiet and on the sidelines, and the only thing he cared about was just to print, or make pictures that he enjoyed. He tried to make a living by it, but he also had a terrific interest in his work. He didn't care about what other people thought of his work. He just wanted to do what he liked most, and that was it.

And he had been told many times, of course, that those pictures were top pictures. I remember this Vance who built the Vance Hotel in town. He bought Dad's pictures to put in each room of the Hotel, when they first built it. Every room in the Hotel had an 11x14" framed picture on the wall. But as far as the quality of the pictures, I don't think there would have been any question in my Dad's mind about them, because he sure tried hard to take good photographs. It used to be quite annoying to us kids, and my mother too, as far as that goes—we'd go out with him on those trips and boy, he would see a scene that he wanted to take a picture of and he would go out on the hottest kind of a hike up the mountain there, and he would be fooling around there for about an hour and a half and we were sweltering down in the car waiting for him, and we were awfully impatient. But he was just as patient as can be and he liked the work. He took every effort he could to make every negative just right. He really put a lot into it.

The sad part about the whole thing as I look back on it now—for years I have thought that a photographer, a good photographer, can go out now and take a 35mm camera and take negatives that are about yea-high big, and carry it in his two hands and come back with the same quality of picture that Dad took. But you are telling me that Dad's genius, as you put it, would not have come through with today's small equipment, so I guess it wasn't in vain after all. I am glad to hear it.

Darius Kinsey, Jr.
Interviews
Seattle, February and March 1973

Darius Junior and Tabitha with the Model-T.
Date on negative would make the "old man"
twenty-three years old. License plate gives the
correct date—1918.

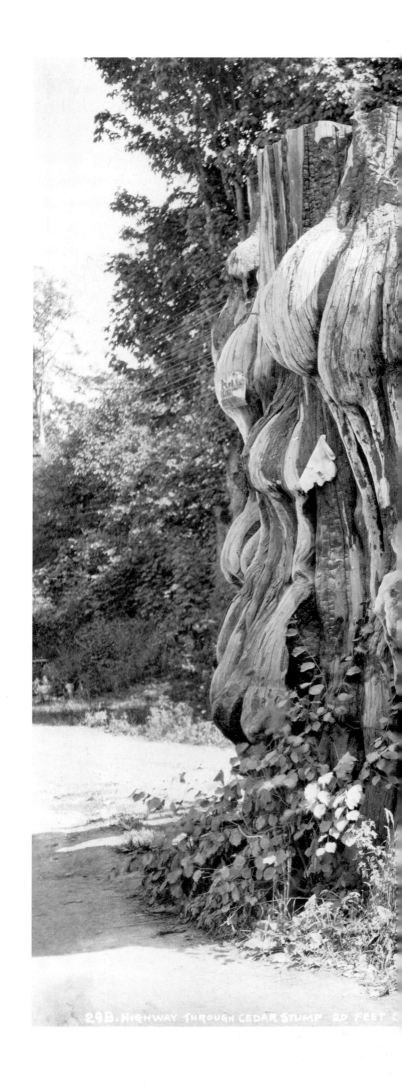

29B. HIGHWAY THROUGH CEDAR STUMP 20 FEET

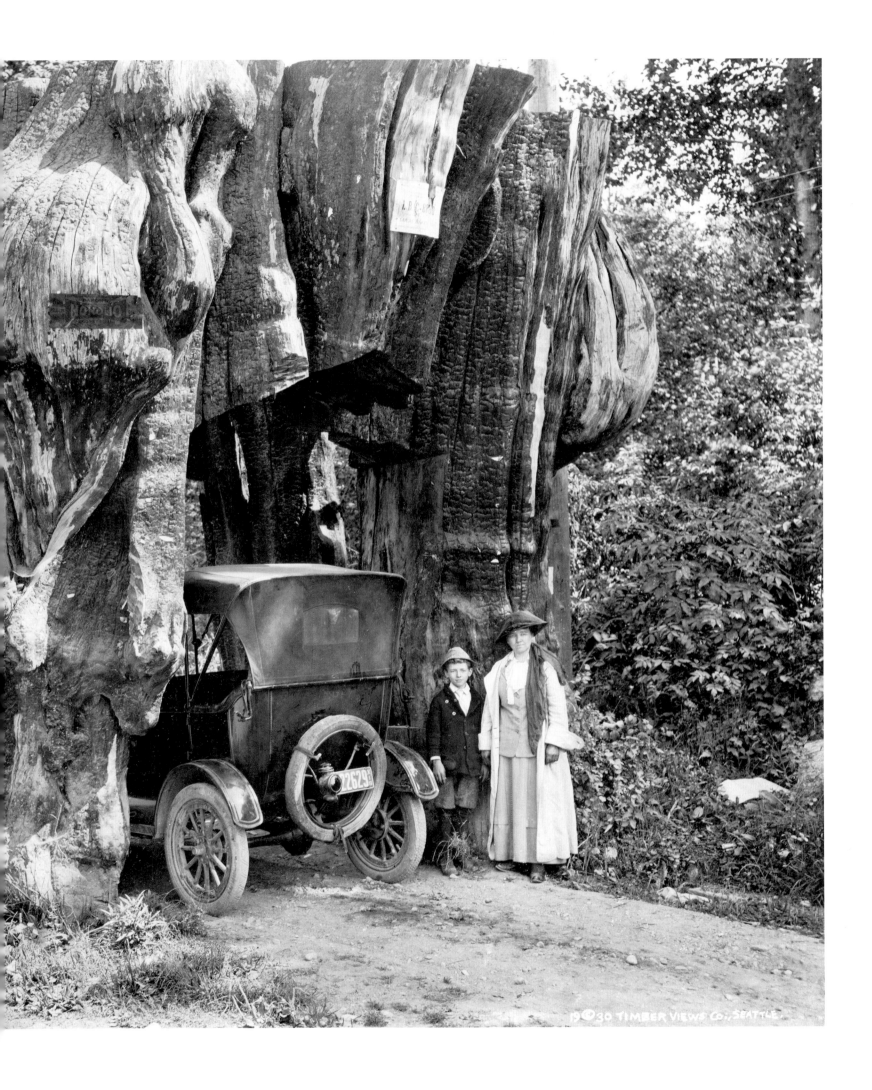

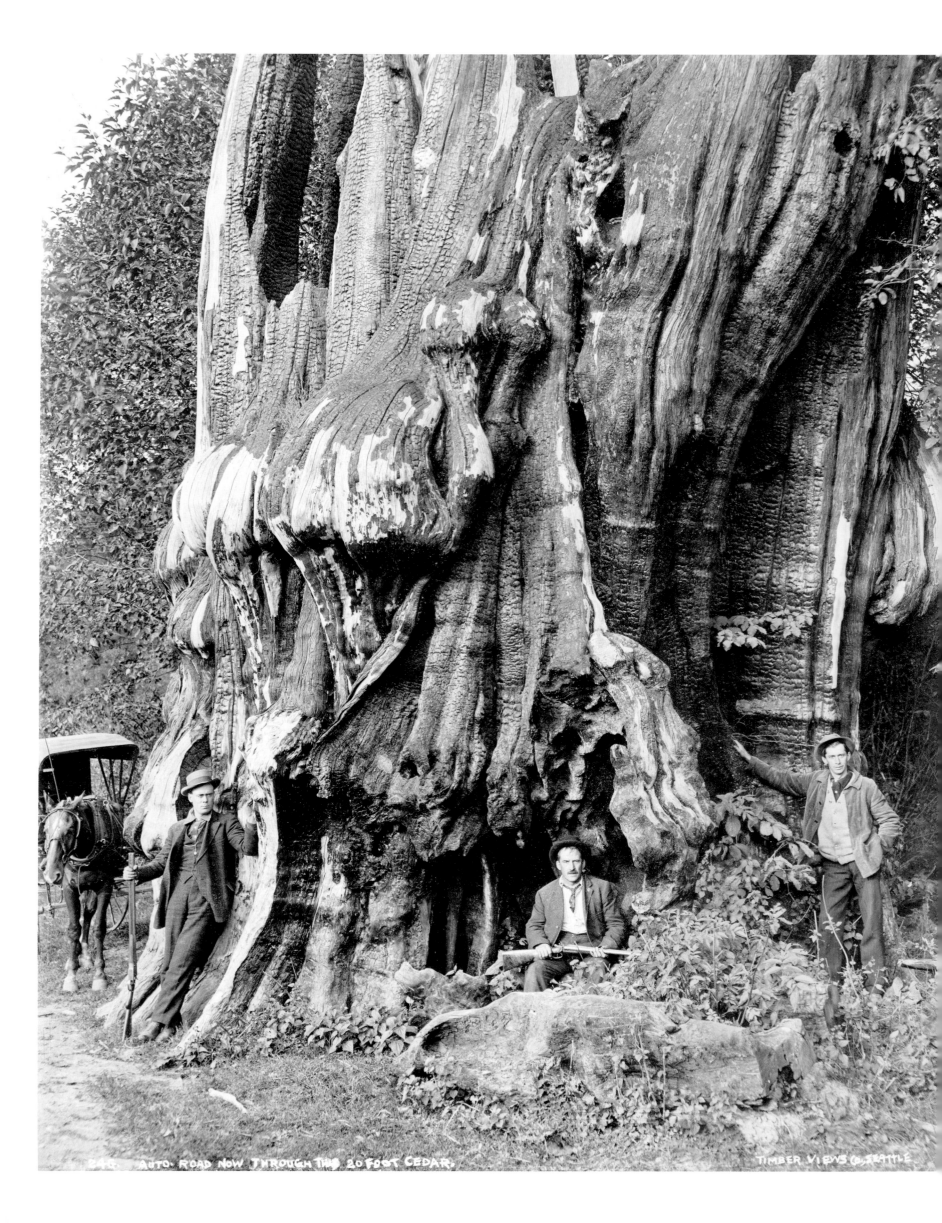

248. AUTO. ROAD NOW THROUGH THIS 20 FOOT CEDAR.

TIMBER VIEWS CO, SEATTLE.

"X173. Storms of more than a thousand winters have left their imprint on this ancient land mark of forest—Washington cedar 20 feet in diameter. Darius Kinsey, 1607 E. Alder St., Seattle." Glass plate.

"*A24. A close in view showing 15 cedar trees, averaging about eight feet in diameter; timber can be seen up to a height of 70 to 100 feet. Copyrighted 1913 by Darius Kinsey." Glass plate.

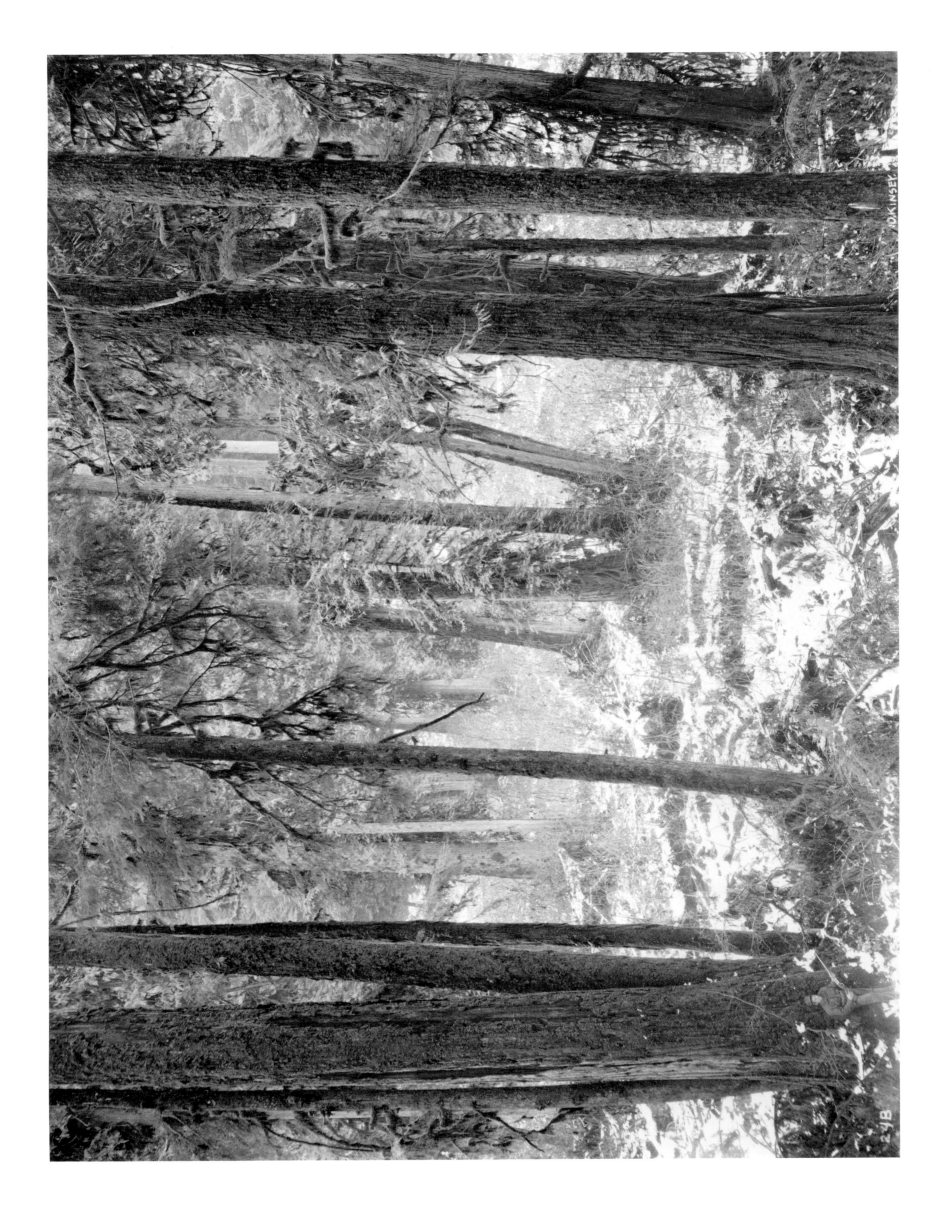

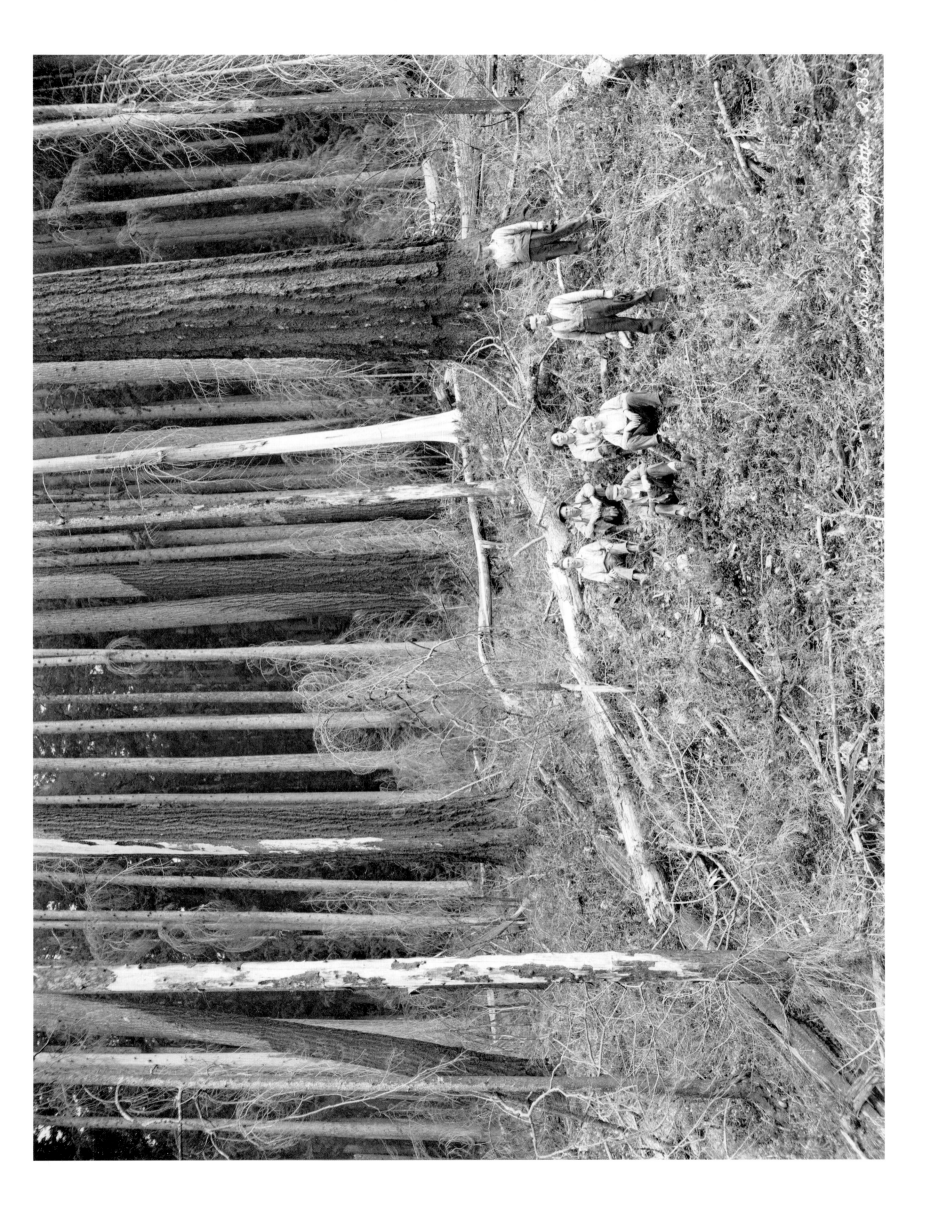

"A7. A nearby view of four big fir trees, standing so close together that they form almost a solid wall. Copyrighted 1913 by Darius Kinsey." Glass plate.

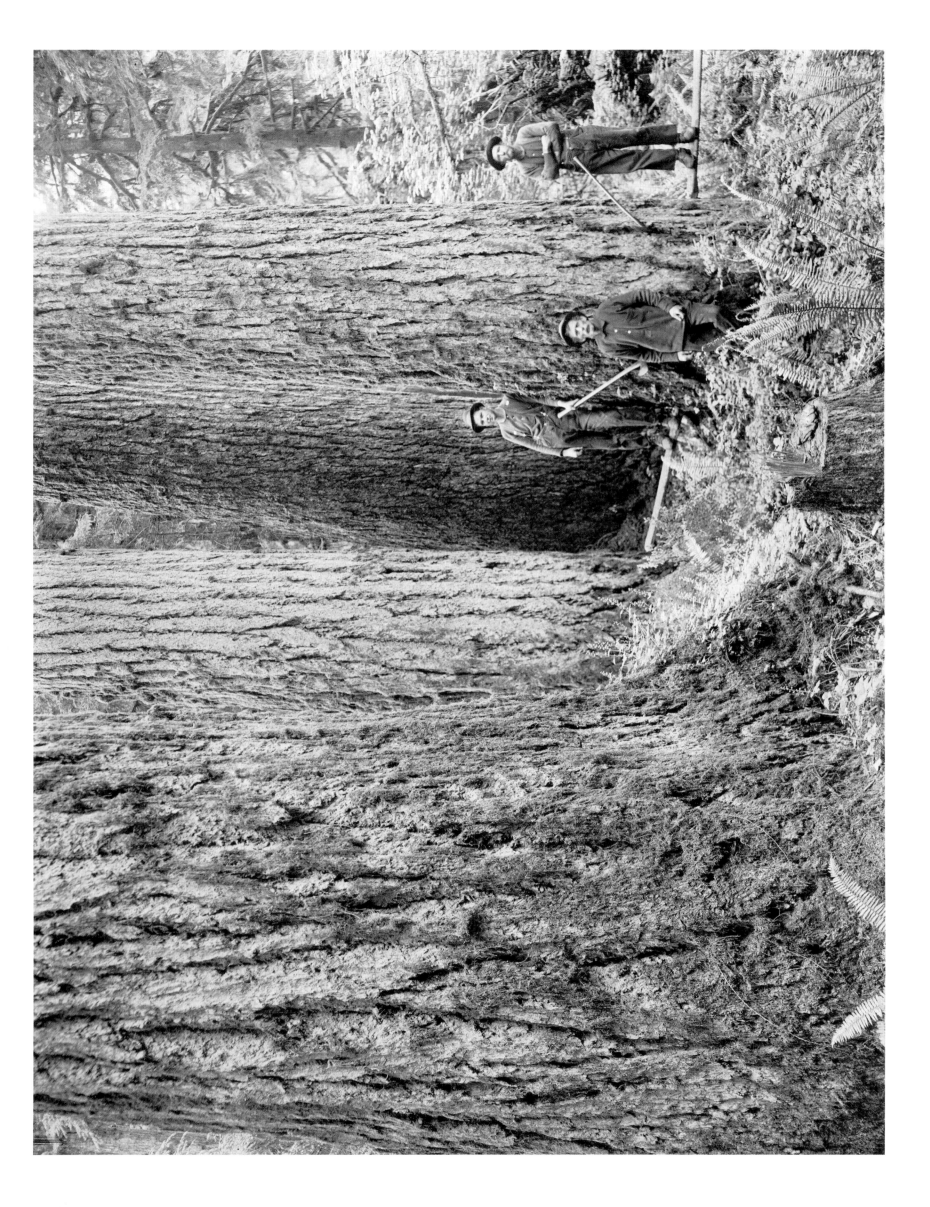

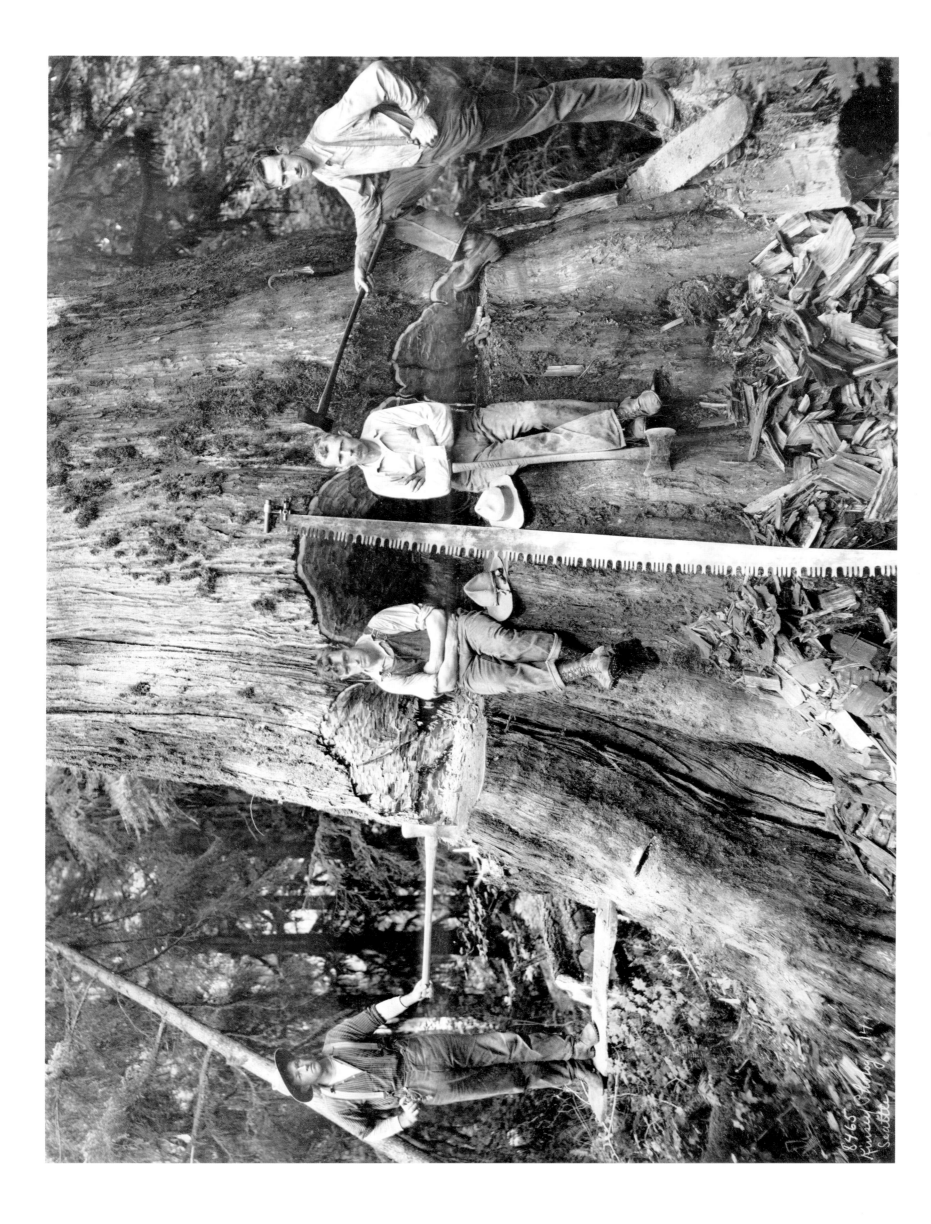

"19. A close in view of a ten-foot fir showing man lying in the completed undercut. Darius Kinsey."

"Felling cedar stumps for shingle bolts."

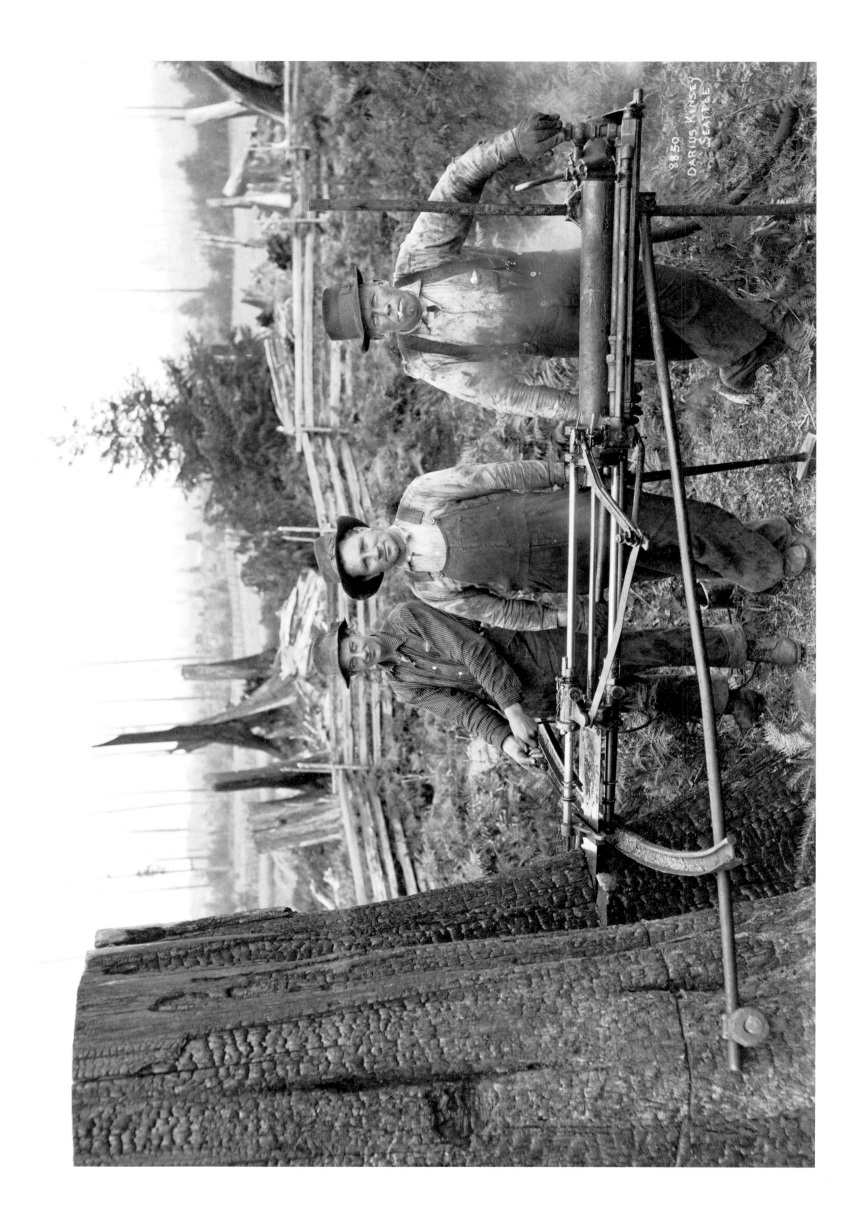

I knew him. Yeah, I remember old Kinsey. Oh, I knew him just about as well as I know any of the fishing gear, because he used to be around in the camps, you know, and I used to help pack his cameras up in the hills.

He'd take those old cameras and up the hill he'd go. He had cameras on legs fifteen feet high. He spent his whole life taking woods pictures, you know. He was offered a job for the steamship companies and the railroad companies, to go around taking pictures, but no sir, he stuck to the woods. He spent pretty near his whole life just taking pictures of woods and timber and stuff. Oh hell, he didn't give a damn where it was. Out in the woods with the fallers and all over the damn woods. Take pictures of all the god-damned operations of logging.

The first picture I saw him take was in '16 or '17, and up to the middle '20's. I was up at Camp Four and up at English's. He'd come in on the trains or speeders. I think he'd stay a night or two. Yeah, he was just like one of the loggers. They'd always give him a bed. Always paid for his meals and everything. Then he'd go up and take a bunch of pictures and in about two

weeks he'd be back with the samples, and the boys would all buy a picture around, maybe. He'd take them on a day like this. God damn, they'd turn out just as bright and pretty. As a rule, he told me he always liked it a little hazy. Does away with a lot of shadows, you know. You look at those pictures and you'll hardly find a shadow in any damn one of them.

That guy sure knew his stuff taking pictures. You look at his pictures and you never hardly see a shadow. And they're so damn plain. Look like some of them pictures you could just pick the bugs off'n the bark of them trees and stuff he'd taken. He was sure a wonderful photographer. A wonderful man, by God.

Frank Maddox
Interview
December 1973, near Sedro-Woolley;
on the banks of the Skagit River,
at B & M Log Boom fishing hole.

199

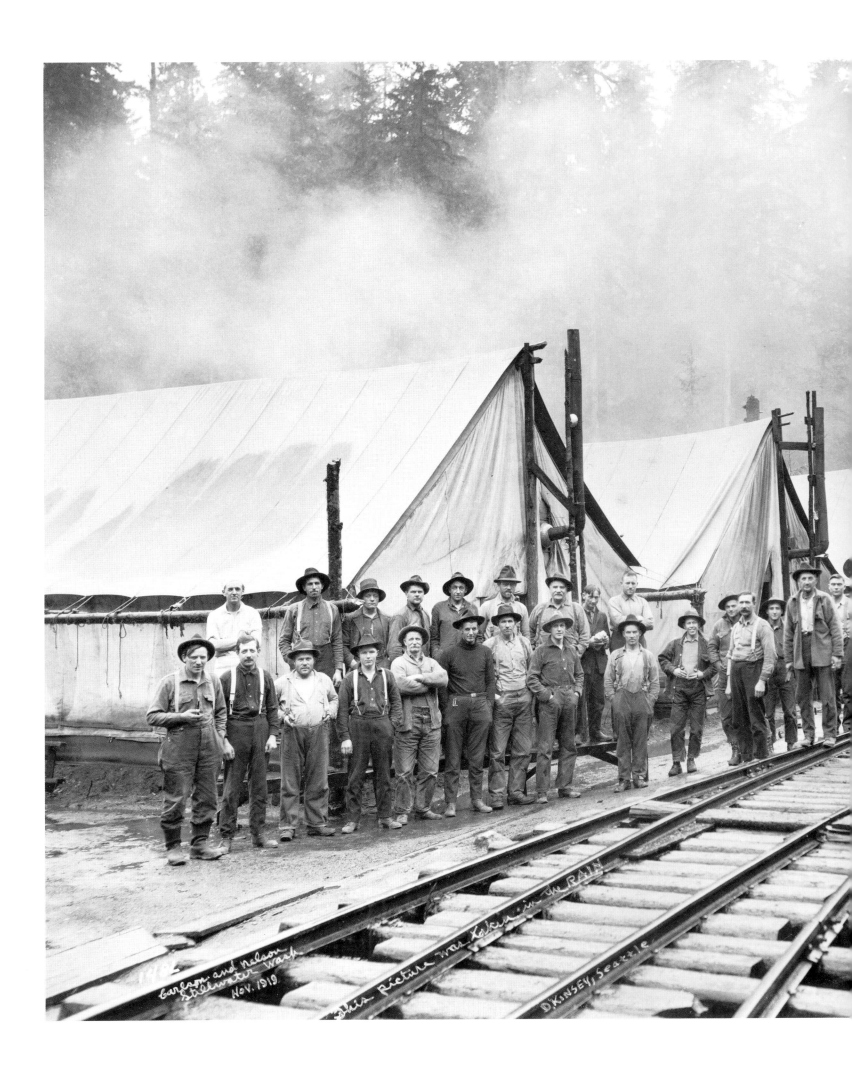

Garcron and Nelson
Stillwater Wash.
Nov. 1919.

this picture was taken in the RAIN

D.KINSEY, Seattle

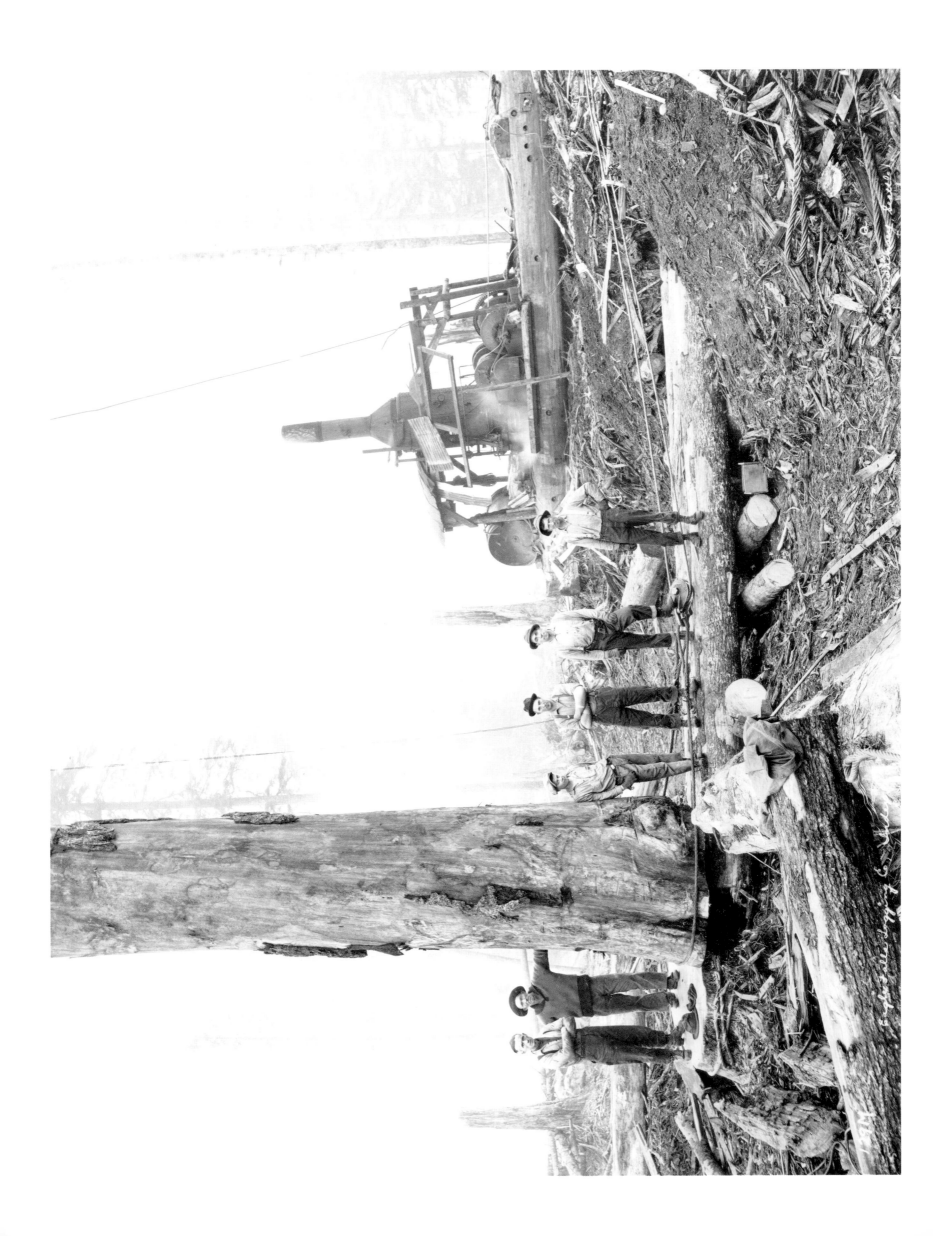

From a glass plate.

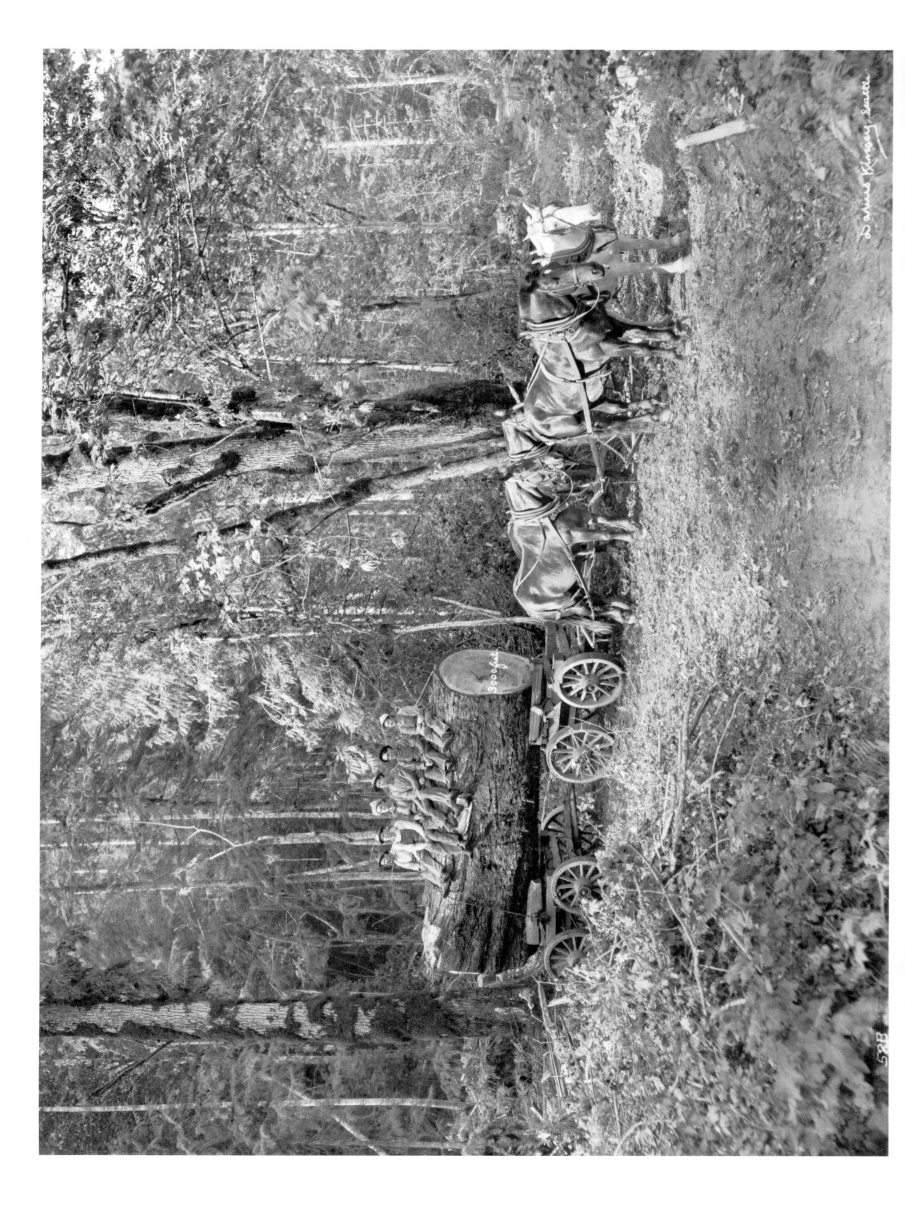

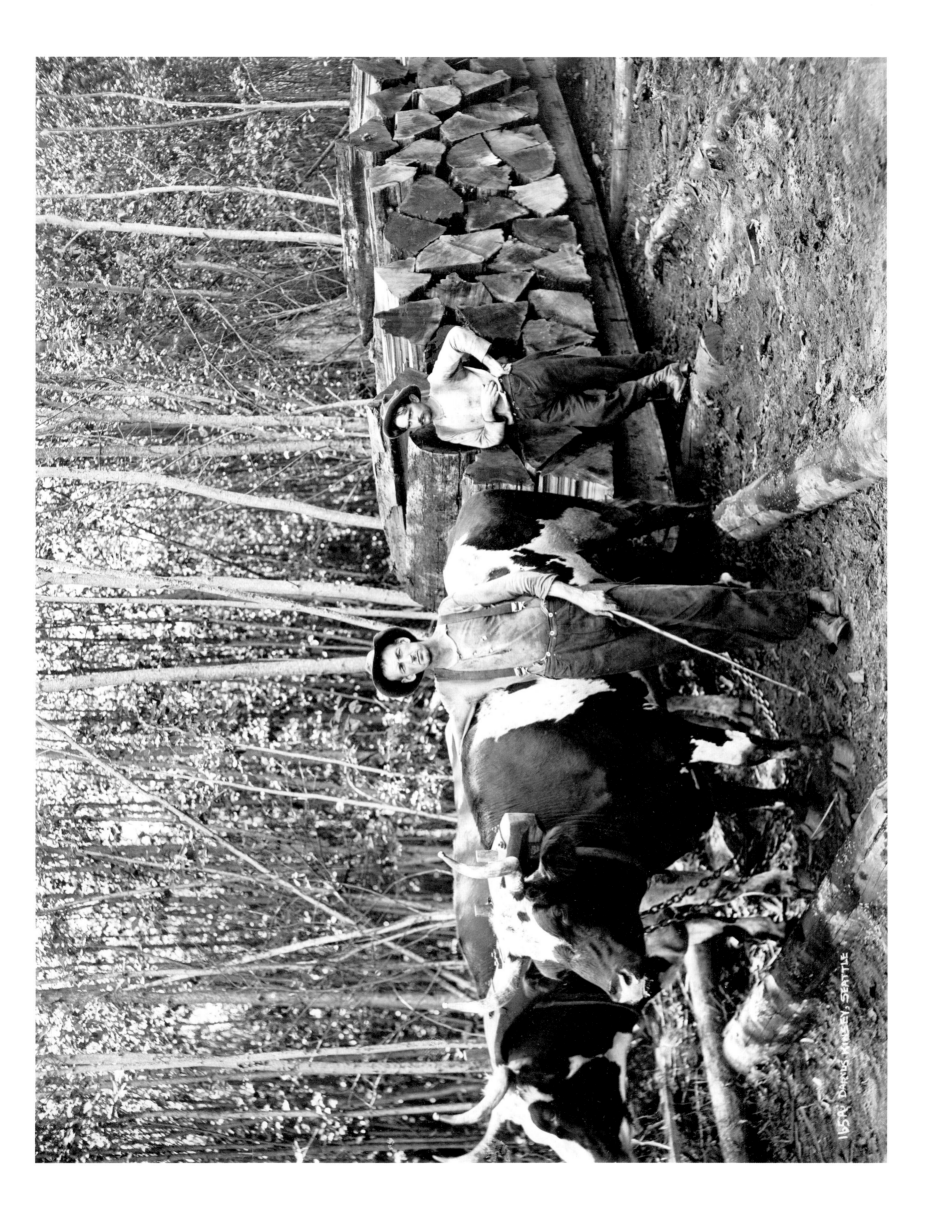

165 A Darius Kinsey, Seattle

"Fordson Tractor converted into a shingle bolt railway locomotive."

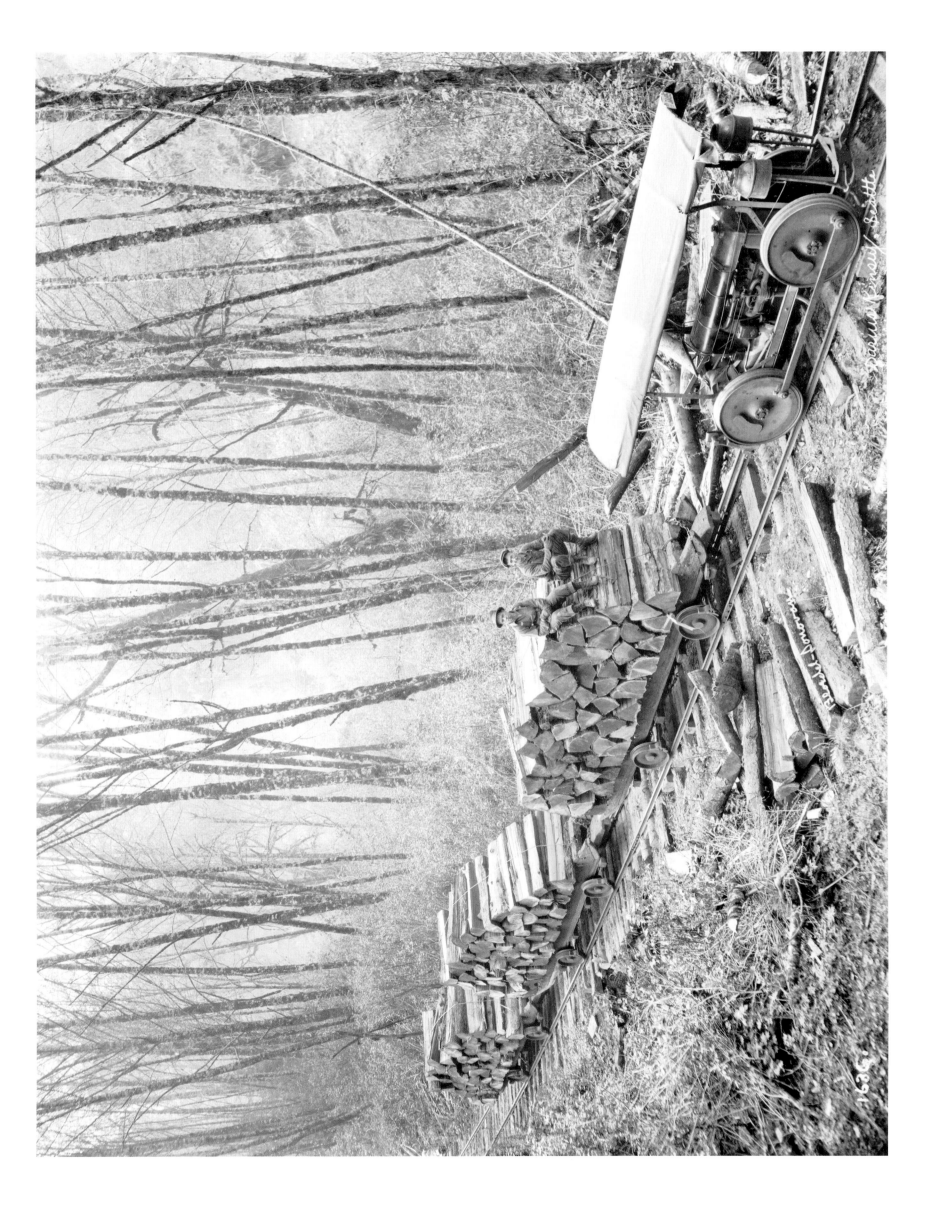

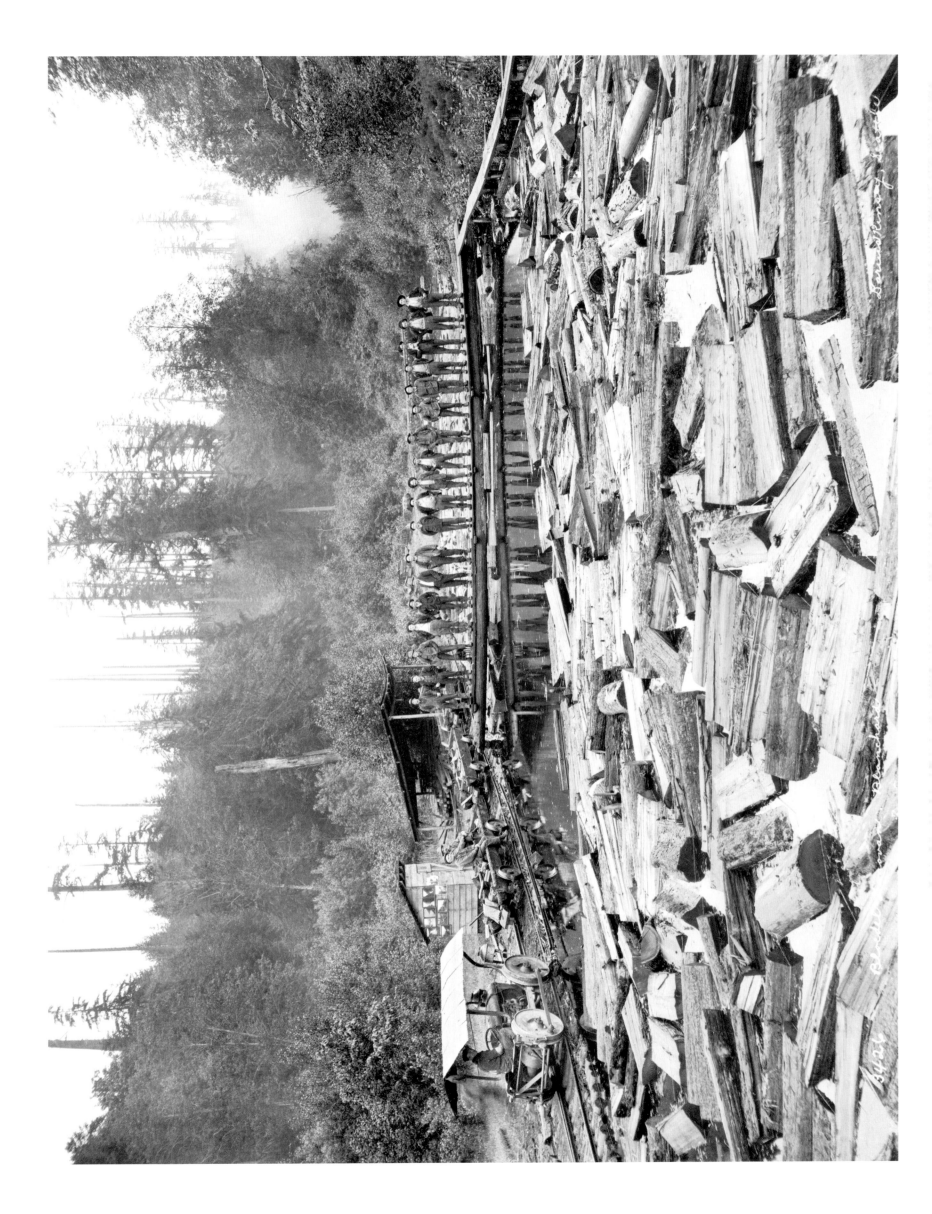

... piles of bolts, bolt cutters and teams." Glass plates of the other two of this three-part panorama have not survived.

Darius Junior on the truck.

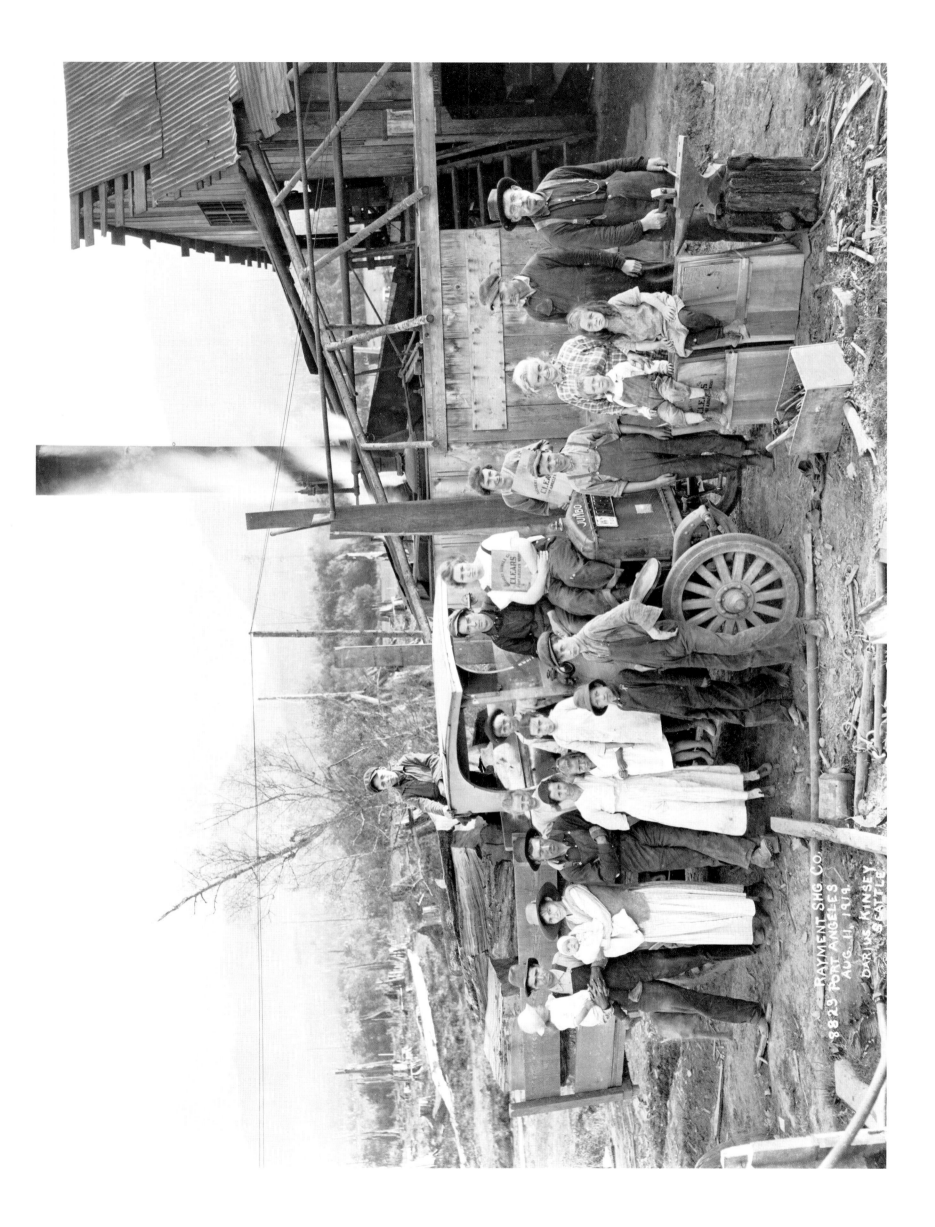

RAYMENT SHG CO.
8829 PORT ANGELES
AUG. 11, 1919.

DARIUS KINSEY
SEATTLE

I became his helper. I was second loading in that camp, and I bought two pictures off of him that time. Somehow I have lost them. One of them was my best one, I thought. I was still logging then, I wasn't driving pilings yet. He had—with those ground glass plates you know, and all his contraption, he had about three or four hundred pounds and he couldn't take it all, all the time.

At that time we were out of Darrington, up the Sauk River about eight miles. And there was no road to us. He had to travel with the logging company train. So he showed up. Of course, by that time we were well acquainted. He showed up like he always did and he said something about he couldn't—he had an old Franklin car. Did you ever see a Franklin car? Well, he couldn't bring that any further than Darrington, see? And they wasn't going to run a locomotive for him out on those side roads. He said something about how he ought to have brought a helper, the way this job looked. "Well," I said, "maybe I can be your helper." So I quit second load and went to work for Kinsey. They put somebody in my place and didn't even dock me in my wages, which I figured they would.

Well, after he took a couple of pictures that he had scheduled, say, we would just take a walk out where I knew some fellows were falling. So I was more or less scouting out prospects for him. We would go out on some railroad spur, or maybe even just a grade if the track wasn't in yet, and he would take a look at it and decide what he needed in the way of a camera. We would do this in the morning, come back and eat lunch, and then go and take pictures. He always seemed to have all the time in the world. He was

very quiet and very intense. And I don't think there was ever a person who could change what he started to do.

I have seen him get all set up with that big, long tripod he had—that was quite a thing—get all set up and a couple of guys had the undercut of the tree and they were going to make the back cut, see? They were on the spring boards and he gets the thing all set up and he had a little gap up in the tree that he had noticed. He hadn't said anything about it, but he had noticed a gap in the foliage, you know, through the treetops, and the sun was over here—it was a bright day—and when the sun got to that gap everything would be just perfect for the shot and that is what we waited for. I suppose probably it took fifteen minutes for that picture.

At the end of that four-day stretch when I was his helper, we had lugged everything down there from the camp, which was probably half a mile, and he was waiting to load it on the locomotive at the railhead, the Sauk River Logging Company. He had a big valise-like thing, portfolio is what you call it. He said take a look in there and if you see anything you would like to have, you can have it. So I saw the picture of Pilchuk Julia and took it out and framed it and gave it to my mother, because she and Julia were friends. Of course Mother is gone now so I have the picture there on the stairway.

Ralph Keaton
Interview
Snohomish, February 1973

Monroe Logging. I was superintendent there, for one. You've got some of those pictures, don't you?

Well, part of the time he could drive right into the camp, and other times we would bring him in — earlier than the road was in, we'd bring him in. We've got pictures from there shortly after the camp was opened up, in 1922, I think. But we'd see that he got out into the woods on the speeders.

He was a quiet sort of fellow. He didn't talk much, just kept to himself pretty well. In the woods, most of the times he took care of himself.

Then in the evenings he'd be in the camp, and he'd go around and take orders and he'd come up a short time later, a couple weeks or so, and bring the pictures up. We'd arrange it so he could have his pay through the office. If the men didn't have the money, why they'd take it off of commissary.

He had a graphic, I think. I don't really remember. But he had a pretty good-sized camera, up on a tripod. He had a dark cloth he put over it. And the men — oh, they thought his pictures were wonderful. You know, you didn't get a photo as good as that in those days, very often. The same pictures, the same background and everything, are good right up to today — taken fifty years ago. Went in there in 1922, that's been fifty-two years. So he did a good job.

<div align="right">

Charles Gemmer
Telephone Interview
Lacey, April 1974

</div>

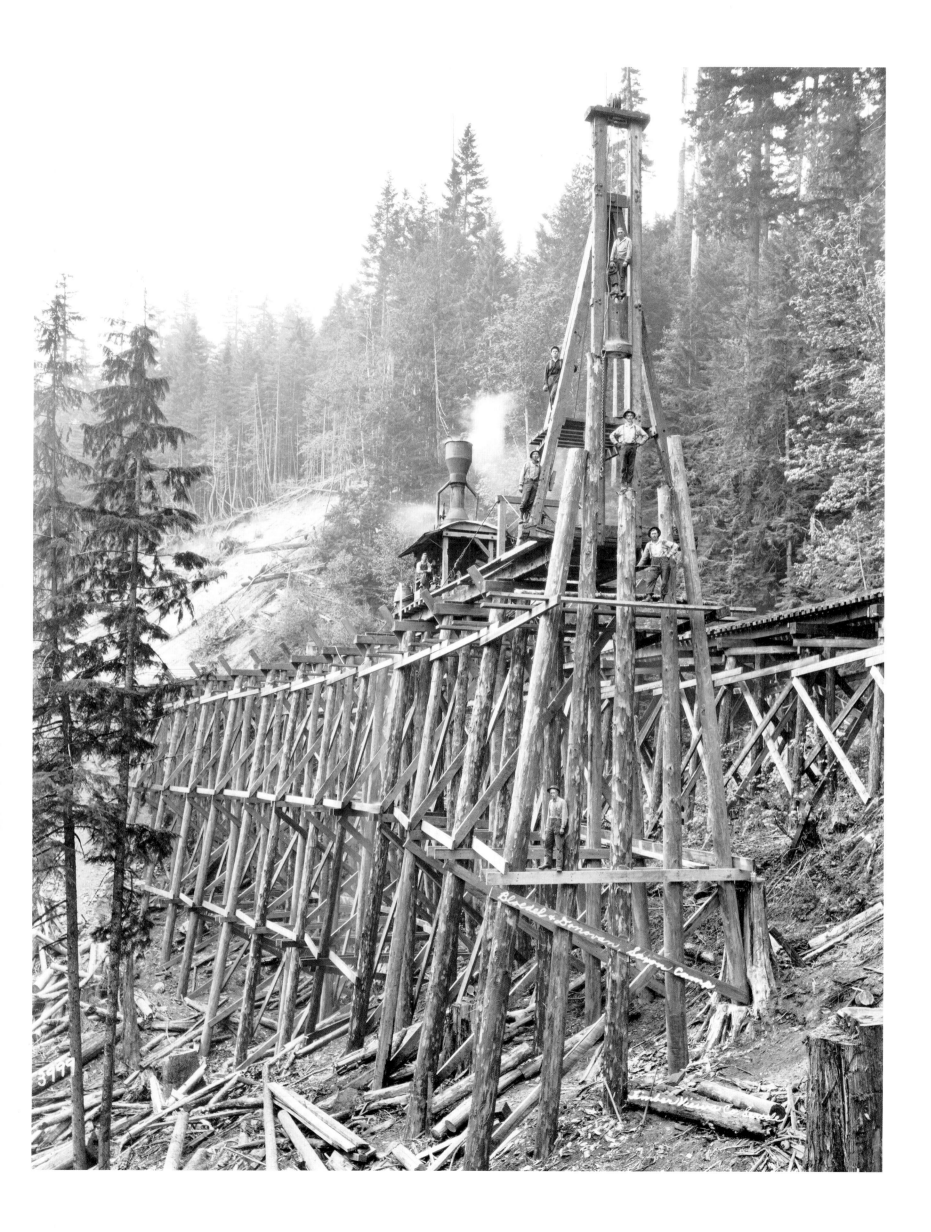

"A105. Building logging railroad bridge over a canyon, using fir bents 100 feet long. Darius Kinsey, Seattle, Wash." Glass plate.

Yeah, he left the car down at the road, and the camp was about a mile and a half up the hill. Of course, we'd haul food in there every morning and at night with a speeder, and I can remember very well—we took him out on the speeder. In the evening after he took his pictures. He had to walk about a mile and a half to that one camp there.

About that old car, well he always had it, and that Franklin car had a wooden frame—oak frame. And I remember he came to show me, and he smiled at the open hood and said, "Look at it, wood frame that car."

Several times he stayed overnight. Always one meal, he never missed that. They never charged him for anything. He stayed in the bull cook shack—it was called the bull cook shack in those days, where they kept the linens, and the bull cook stayed in there. That was the fellow that made the beds and cut the wood for the cookhouse, stuff like that. They had a bull cook in every camp.

<div align="right">
Ed Fleetwood

Interview

Marysville, March 1974
</div>

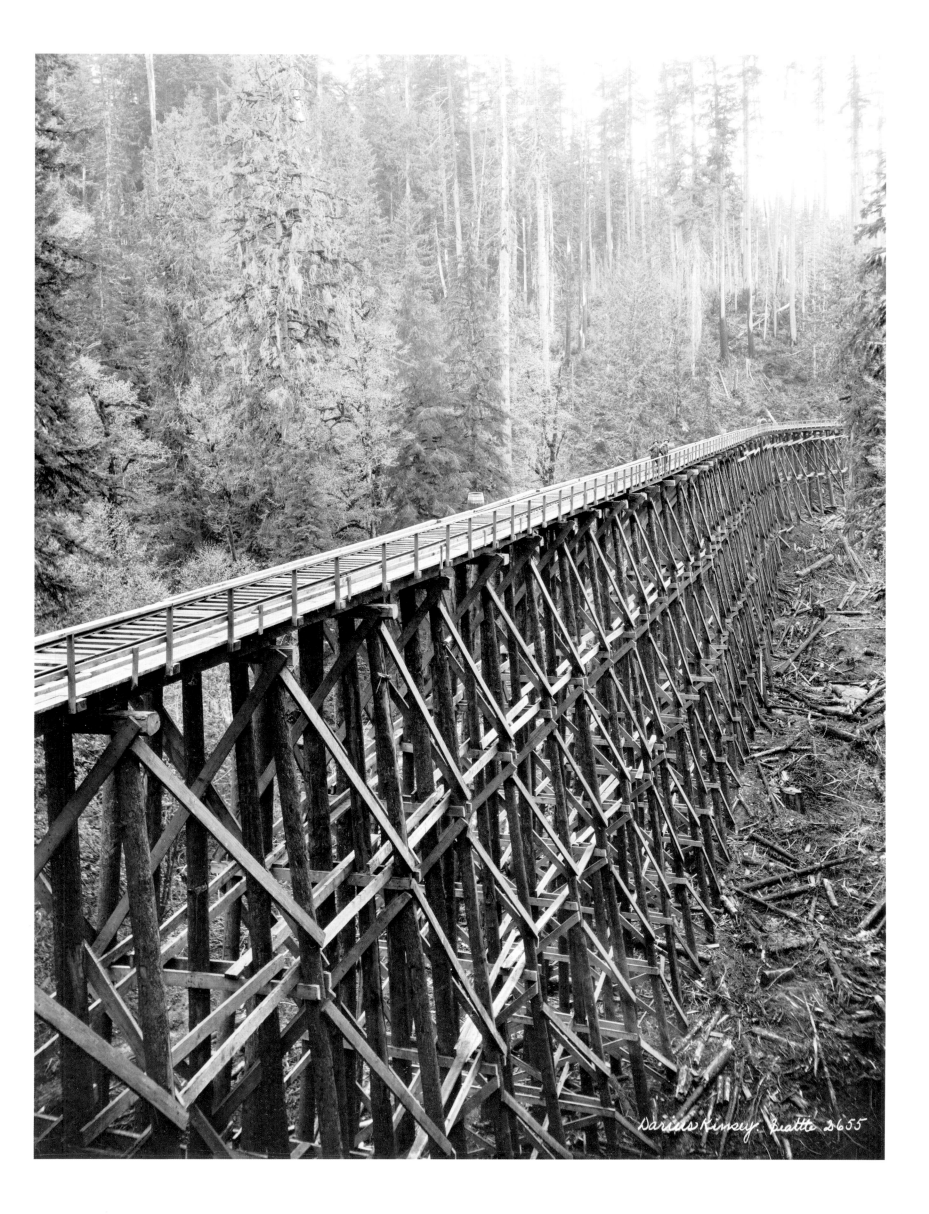

Darius Kinsey. Seattle 2655

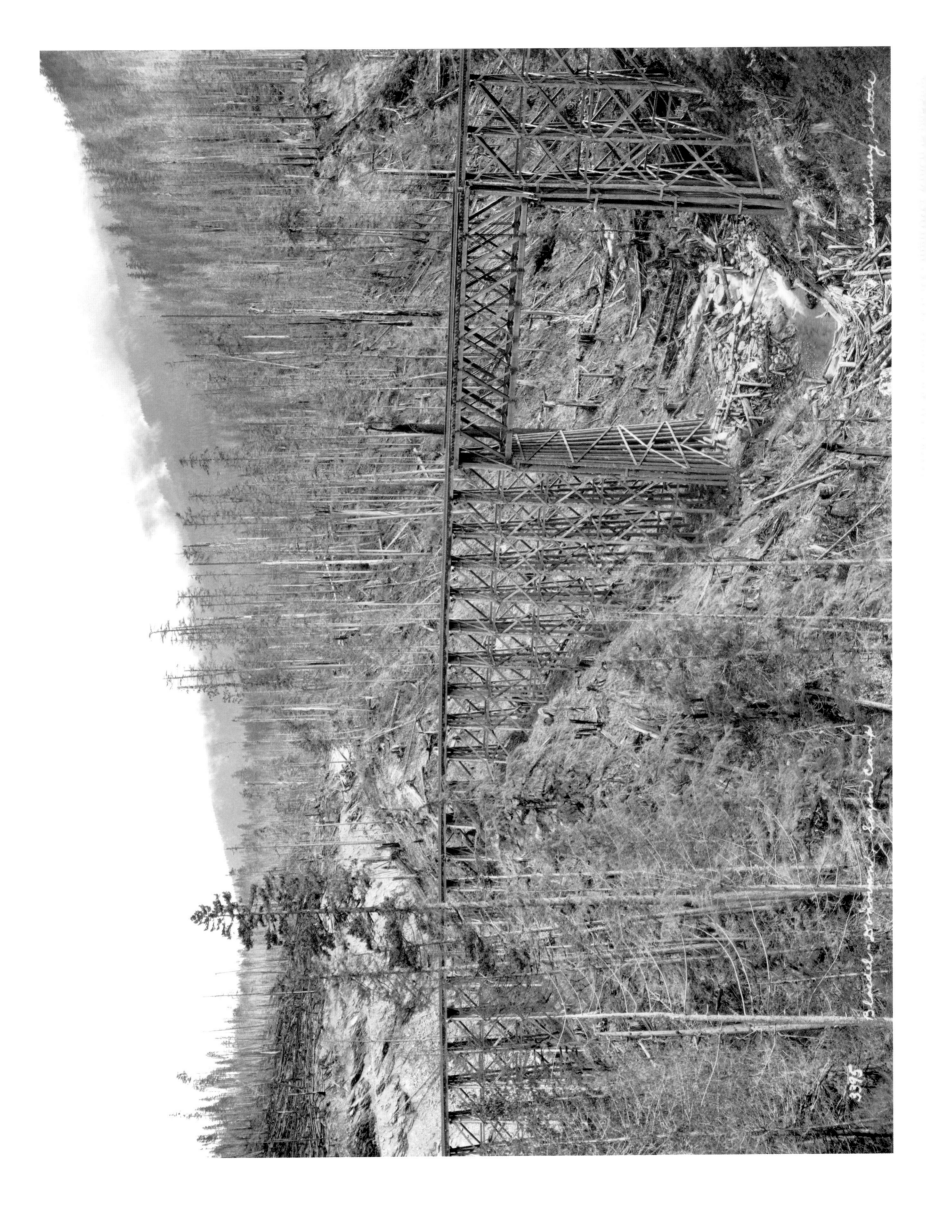

"1103. Trestle nearly 100 feet high over which is passing a logging train. Darius Kinsey, Seattle, Wash." Glass plate.

"A111. Locomotive trailing logs between rails — no cars used on this logging railroad. Darius Kinsey, 1607 East Alder St., Seattle, Wash." Glass plate.

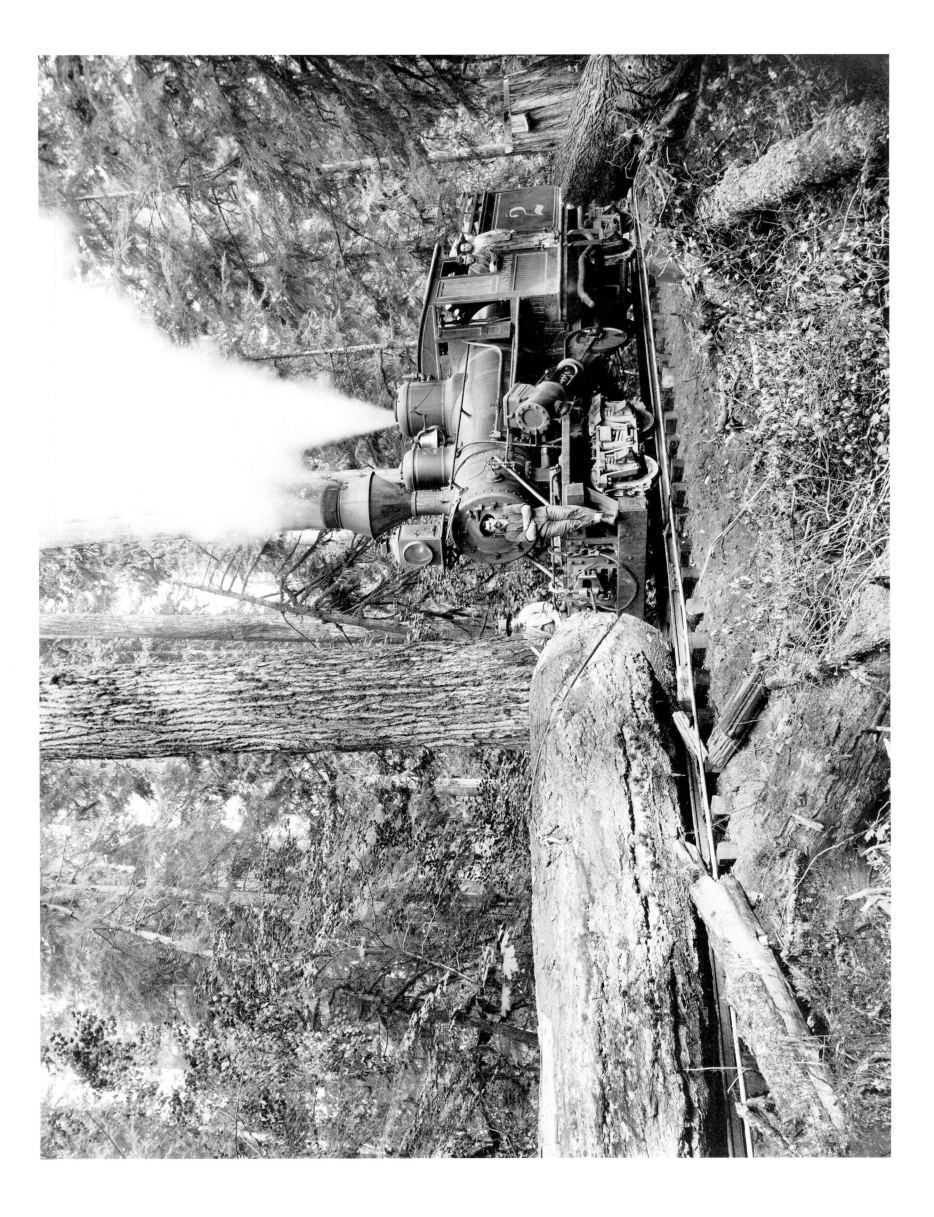

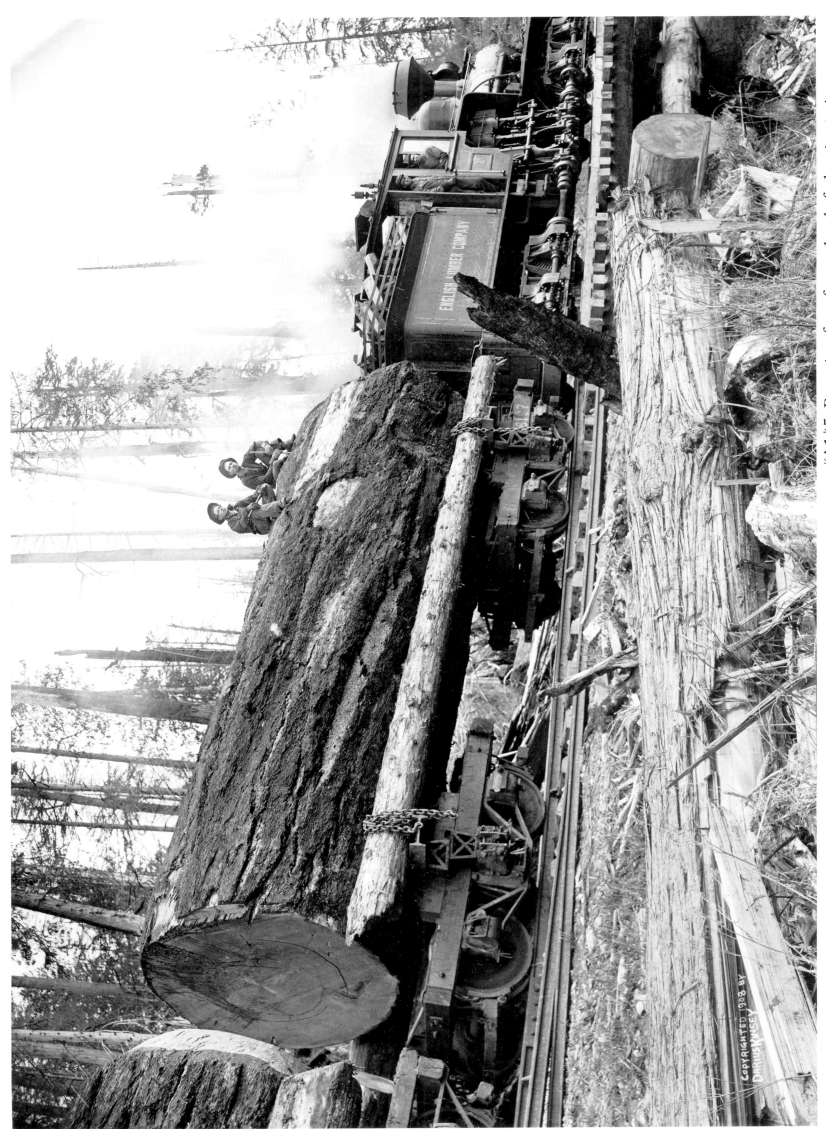

"A145. Rear view from forward end of a logging train, showing a ten-foot fir log and Shay locomotive." Glass plate.

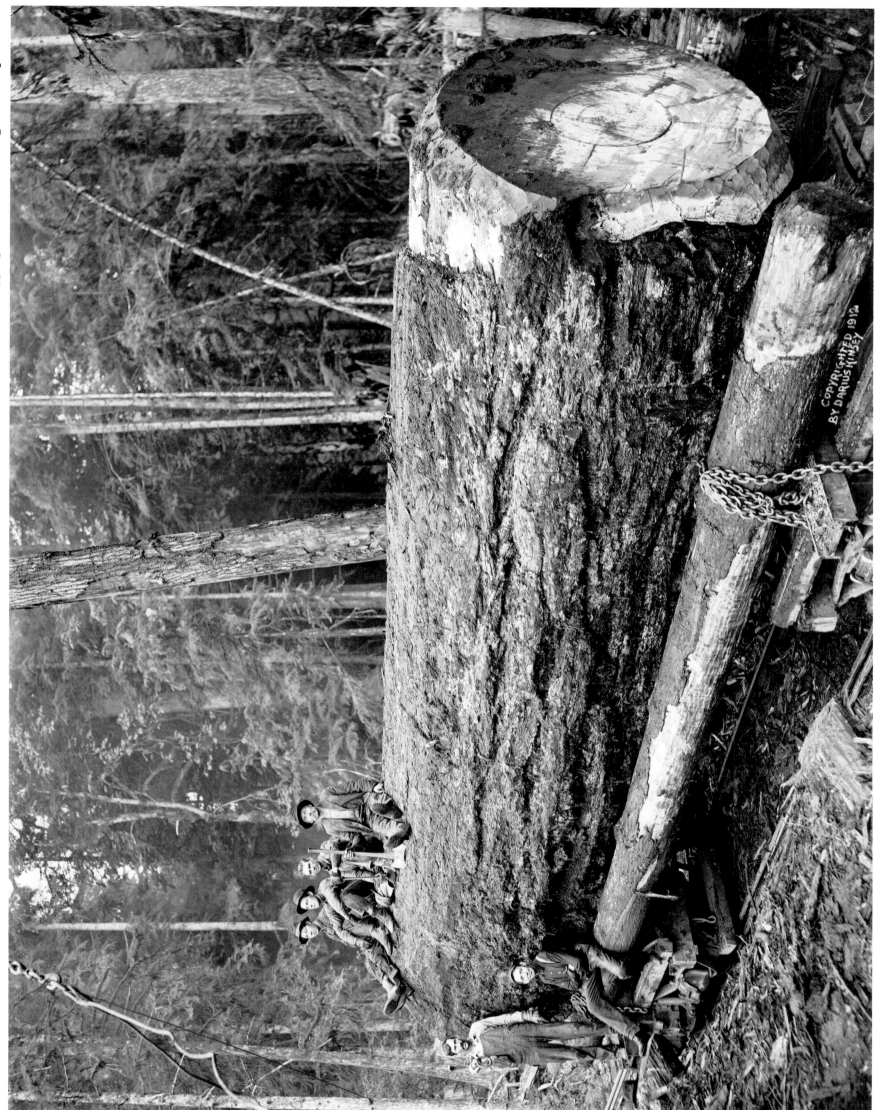

"A122. Fir log, nine feet in diameter, on logging trucks at landing." Glass plate.

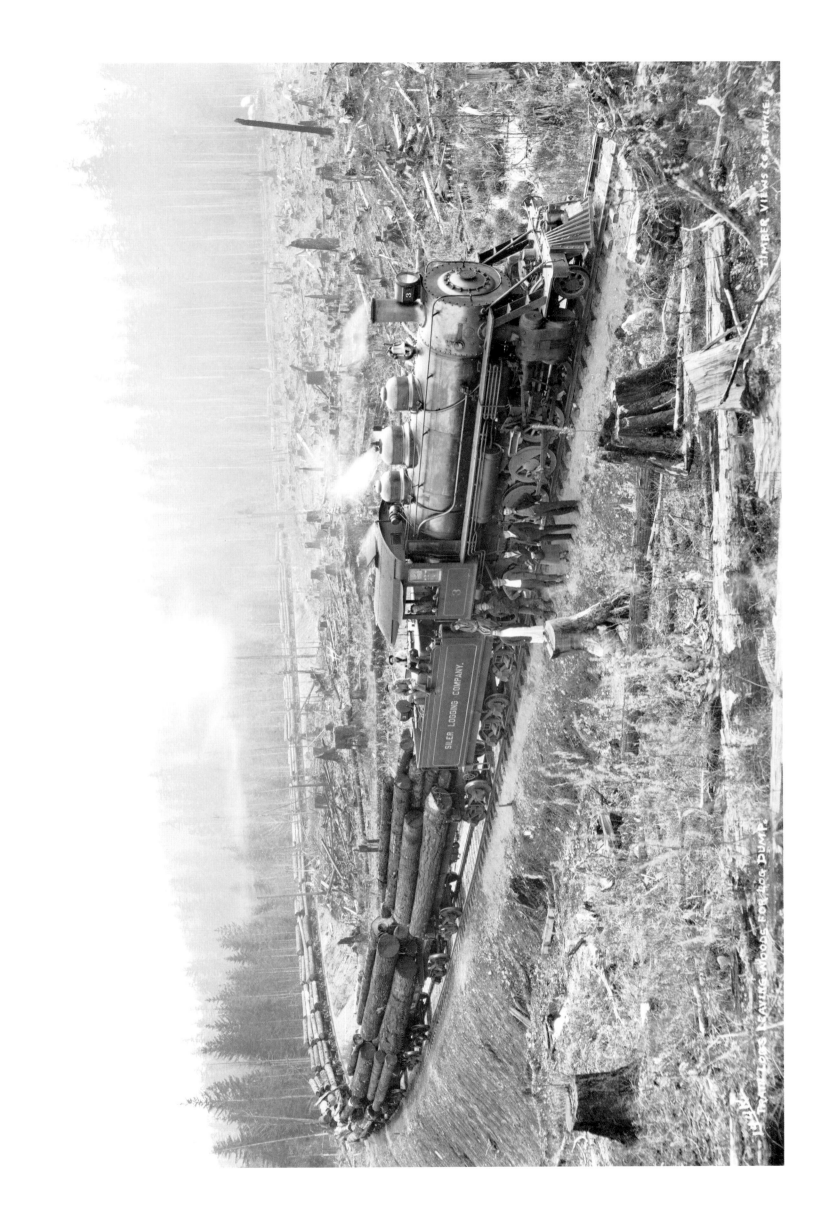

SILER LOGGING COMPANY.

TIMBER VIEWS 50 SEATTLE

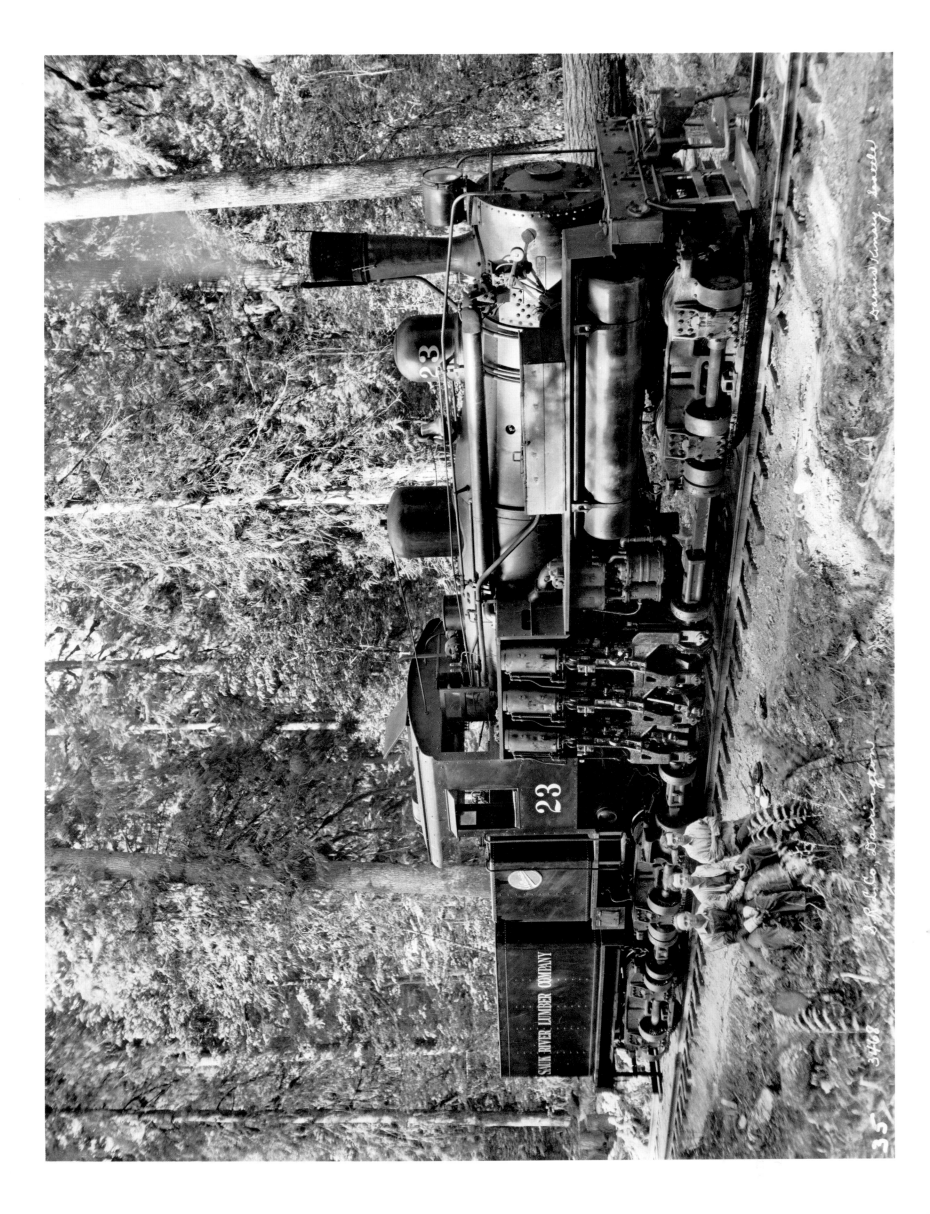

SAUK RIVER LUMBER COMPANY

23

23

S. R. L. Co. Darrington

3468

35

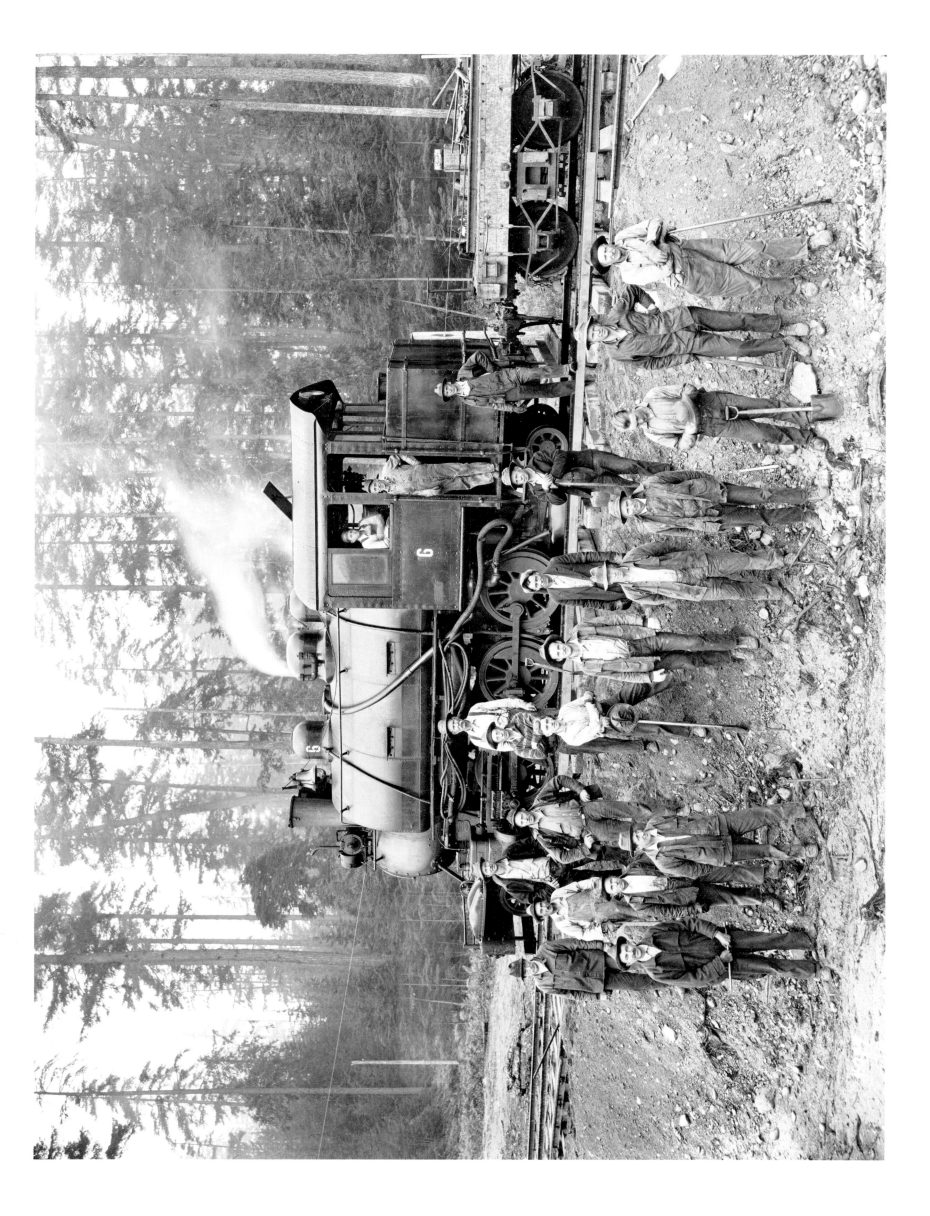

I first became acquainted with Darius Kinsey in 1922 when I was working in the logging camps of the Snoqualmie Falls Lumber Company at Snoqualmie Falls, Washington. Darius Kinsey made several trips during the early twenties when I was employed there. He was not the only photographer who worked the camps, but he was the only one who had the management's blessing and cooperation. The others, and I've long since forgotten their names, are chiefly remembered because they were distinctly persona non grata.

It was the summer of 1922 and slashing fires had plagued us the whole season. Some green timber, too, had been pretty badly singed. It seemed at times as though the whole Tokul Creek watershed was ablaze. Actual logging operations were intermittent, while the crews fought fires night and day. The disposition of the Superintendent, Mr. Cutler Lewis (no relation), was about as dry and brittle as the parched woods. One of the itinerate photographers—not Darius Kinsey—had somehow hooked a ride into camp, about seven miles by rail from the nearest road. This fellow had managed to make some rather spectacular photos of the raging fires. He thought some of his best pictures were of the big steam locomotives, partially obscured by smoke, pumping water to the fire fighters. He was very proud of these. Later he returned, when the fires had partially quieted down, with his proofs to take orders. How he got into camp I don't know— might have hauled him up myself on the railroad speeder I operated. One morning he happened to buttonhole the cook, Chris Lohr, right in front of the camp office, and had barely gotten out his pictures when "The Old Man" (as everyone called Mr. Lewis behind his back), who was in the camp office, overheard the photographer's sales pitch.

" 'Parmer'," he said to me, "who's that feller talking to Chris?"

I told Mr. Lewis he was a photographer.

"Tell him I want to see him in here right away."

I relayed the message and recommended the photographer continue his conversation with the cook later on. Mr. Photographer, thinking he had a prospective customer, approached The Old Man with his samples at the ready. The Old Man was a powerful character, but not famous for his diplomacy, and without any preliminaries he boomed out, "Who are you"? The poor guy wasn't shaken in the least and promptly launched into his sales talk. "I've made some fine pictures of the forest fires here and would like to . . ." He never finished. The Old Man cut him short. "These God damn fires! I've seen all I want of them without looking at any damn pictures of them. How did you get into this camp?" Before Mr. Photographer could get his mouth open to reply, Mr. Lewis turned to me. "Did you bring him up here, 'Parmer'?" And before I could answer, he opened up again on the photographer. "Now get out of here and stay out. Nobody gave you permission to come into this camp and I don't want to see you again, ever. Get your stuff together and beat it." There followed a few moments of embarrassing silence while the poor man eased his way out of the office. "Now 'Parmer'," The Old Man said in a voice with the volume turned down, "Don't ever let no more photographers into this camp except Mr. Darius Kinsey."

I didn't know of or about Mr. Kinsey at that time, but later on he arrived in the camp. I could tell by the way he was greeted by the camp foreman, Mr. Helmar Hegness, and some of the old-timers that Darius Kinsey was greatly liked, well-known, and respected. I was told by the foreman to look after Mr. Kinsey, take him on the speeder wherever he wanted to go. In a quiet way, Kinsey evidently had the faculty of generating confidence. He never seemed hurried or excitable. As I remember him, he was a man with great patience. He evidently had a considerable understanding of human nature — knew how to handle people. The mysteries of photography were apparently no mystery to him, for he always seemed decisive, knew what he was about, and didn't waste time. Having dabbled for years in photography as a hobby, I am often undecided as to where to set up my tripod to obtain the best angle or view of the subject. This fellow Kinsey didn't seem to be bothered that way. On one occasion, I remember, he was photographing the crew of a "side" with the yarder in the background, while I waited with the speeder. Kinsey quickly sized up the scene, picked a fairly high stump (with one set of springboard notches) on which to set up his camera — with a little help from me. No standing around for Kinsey pondering over the best location. When the donkey puncher, Keith Lord, blew the noon whistle, the crew at the landing was shortly joined by the hook tender, Claude Suits, and his rigging crew. They were bunched around the spar tree, anxious to climb aboard the speeder and head for camp and a good dinner. Kinsey kidded them a bit and motioned them to relocate themselves so as to show up to the best advantage. He got off several exposures and had his pictures. No commotion, no excitement, and everyone jovial and happy.

Darius Kinsey would later return with his sample prints and take orders from the men. Most of the crew lived in the camp, and Kinsey would visit the men in their bunkhouses during the evening. I believe we even made some payroll deductions for some of the men who didn't happen to have any cash in their pockets, although I'm not sure about that. If I remember correctly, the ordered prints were sometimes sent to the camp office and I undertook to see they were correctly delivered. Other times, Kinsey brought the ordered prints to camp and personally delivered them.

Kinsey usually spent a night or two on each visit and probably slept in one of the bunkhouses where there was an unused bed. He and one of the log scalers, Axel Nordmark, became good friends, and as I recall, Kinsey was later put up in the scalers' shack, which wasn't really a shack but a combination office and comfortable bedroom.

Darius Kinsey appreciated my running him around on the speeder and helping him where I could, although he knew it was part of my job. I occasionally prompted him on the names of some of the men who bought his pictures, although he seemed to know quite a few of them whom he had met earlier in other camps. By way of expressing his thanks, he gave me some of the prints I fancied and I have a few of them yet — reminders of the days fifty years ago when I was a kid of eighteen or so, trying to learn the lumber business.

Palmer Lewis
Mercer Island 1972

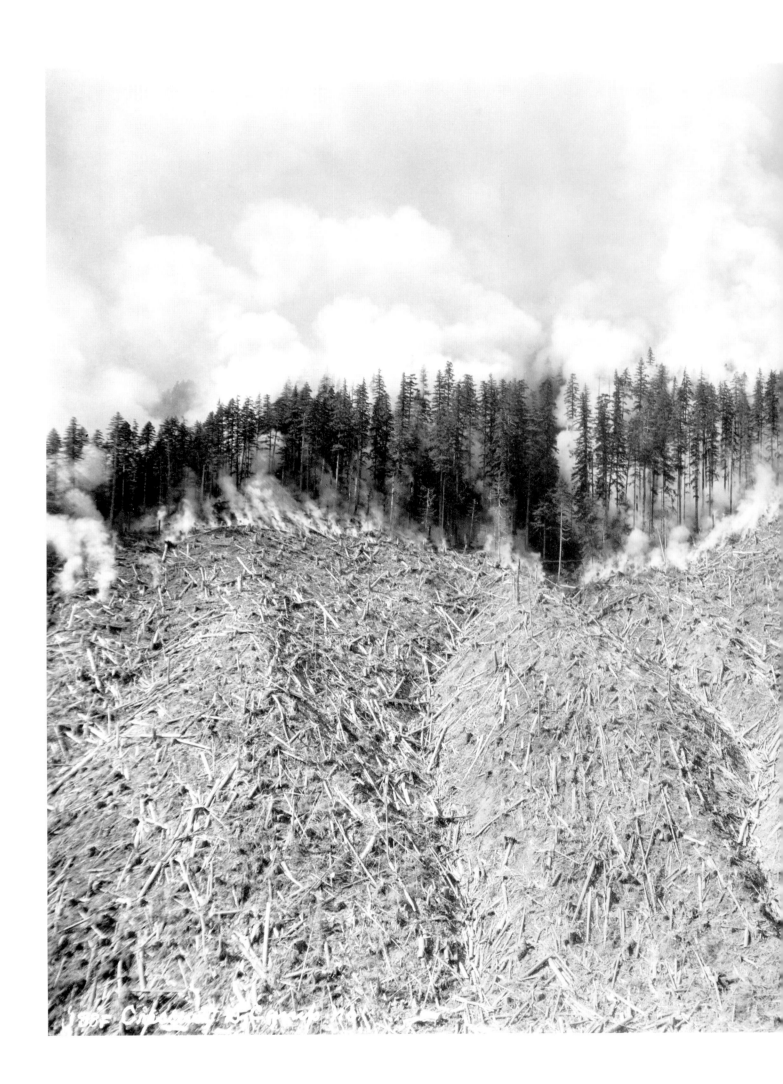

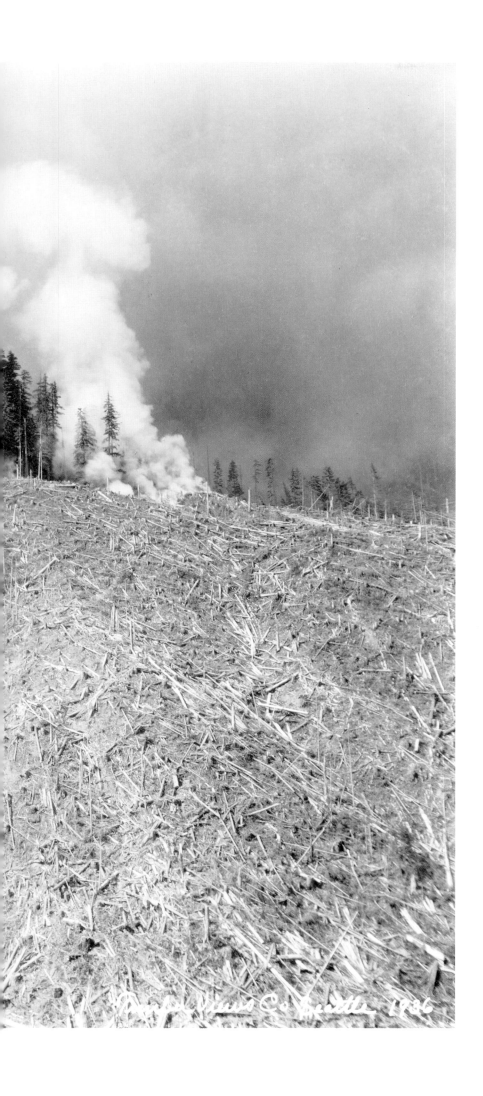

Douglas Views Co. Seattle, 1936

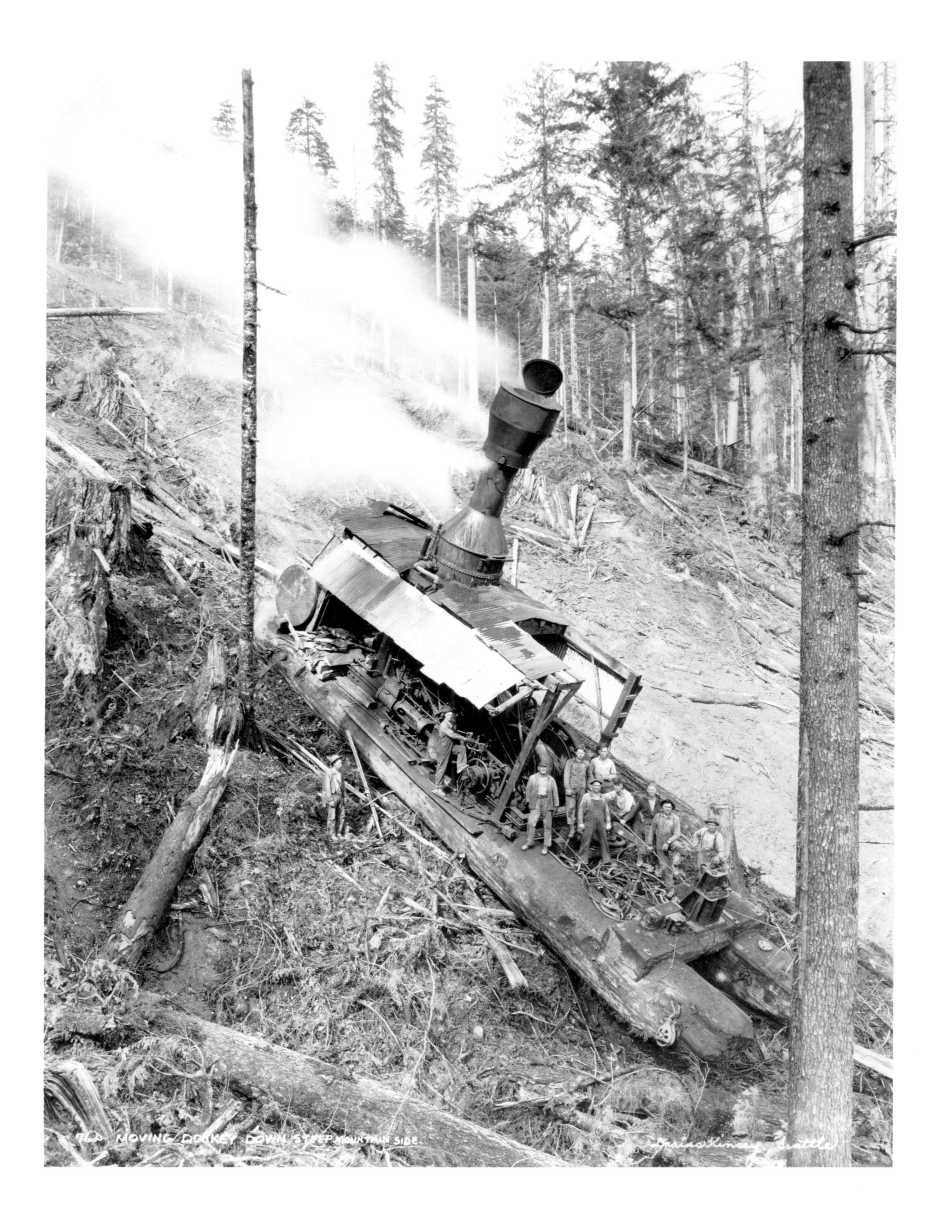

MOVING DONKEY DOWN STEEP MOUNTAIN SIDE.

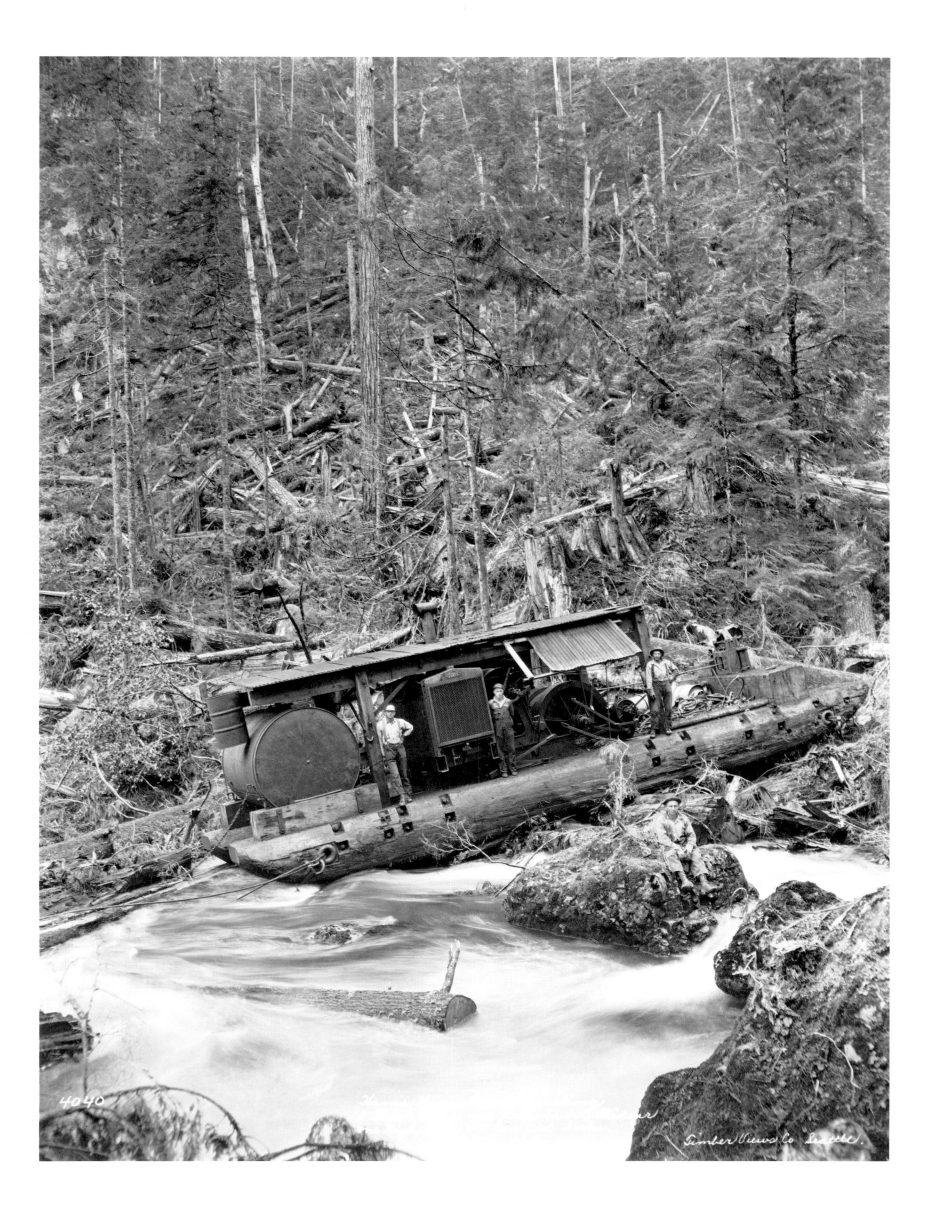

4040

Timber Views Co. Seattle.

The first time I saw Darius Kinsey I was a pretty small boy. My father had a little camp up here, about where Lake Shannon is at now. And I cannot remember if he came up there in a car or not. My brother, Frank, thinks Kinsey came up in a rented buggy and had a man helping him. But I remember him having his tripods and taking his pictures around there. And he took a group picture of the crew in that camp. The main thing I remember that struck me so funny was that he had those great big, long-legged things so he could get up high and take a picture.

Years later I worked in the Ford garage here in Concrete, and Kinsey came up with a Model-T Ford, and then later he came up with a Franklin. I have a vague memory of doing something on the Model-T, very vague, but I definitely remember fixing some tires for him and maybe changing the oil for him on that Franklin. I remember the Franklin quite well, because we didn't see many of them. There was one here in town, but when Kinsey came in with his, he pulled into what we called the "new garage."

Of course, you wouldn't know, but one of the tricks of those Franklins was when you started climbing hills, which Kinsey did a lot of, and it started heating, you didn't have to stop it. You shifted down to low gear and opened her wide, and those air fans cooled it off. You see, you go lugging in high and second, it would heat up. But if it started to do that you shifted it down and speeded the engine up, and it would cool right off. This is kind of strange to a guy who's never run one.

Of course, you know what he looked like. Kind of short, very quiet man, never had much to say. If you asked him anything, he just gave you a very brief answer. He didn't start describing the whole business like these people do nowadays — "I've got a problem . . . ," and it takes a half hour before they get around to telling you they've got a slow leak in the rear tire.

Gordon McGovern
Interview
Concrete, December 1973

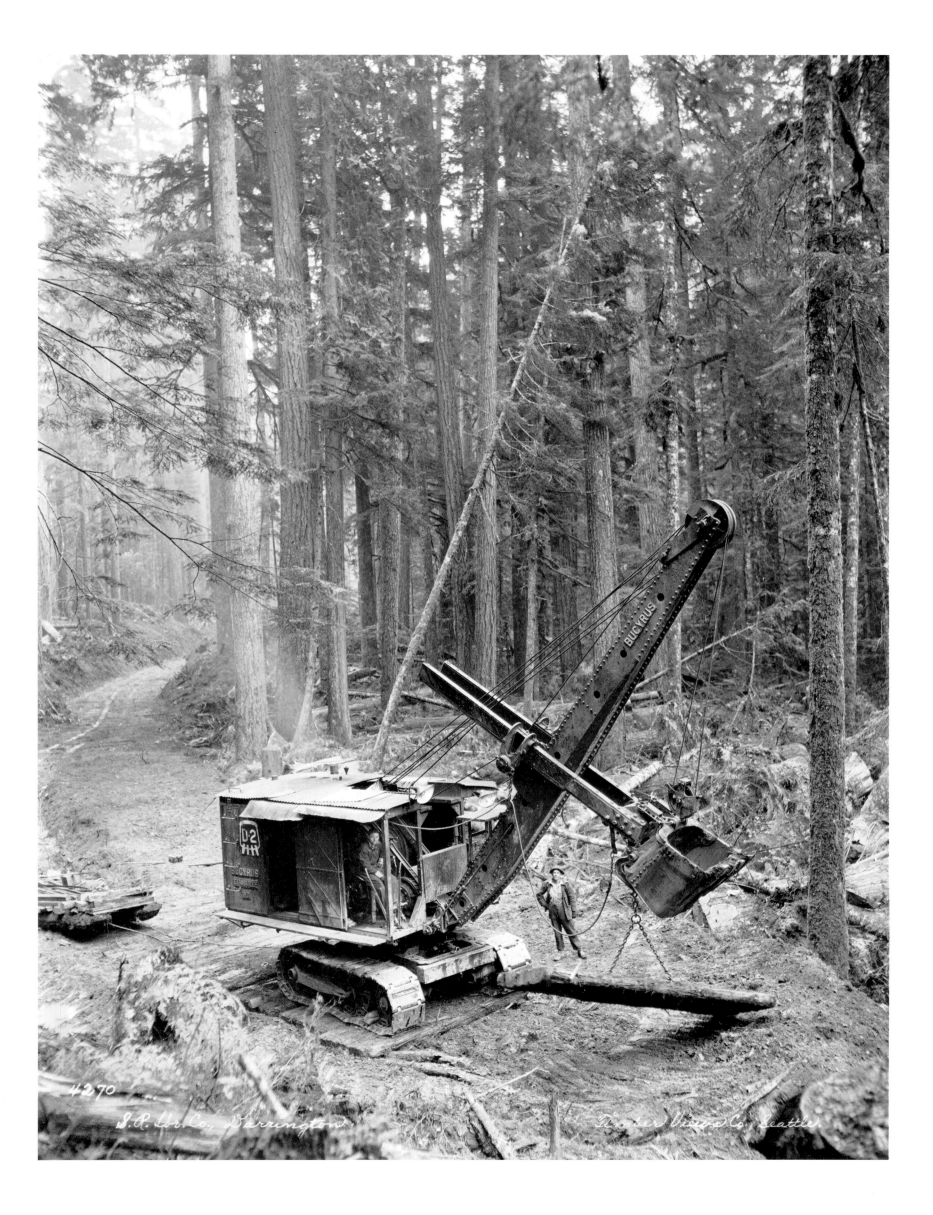

4270

S.R. Lbr. Co., Darrington Timber Views Co., Seattle

The last time I was with Darius was in Vale, in 1935. He'd come into the headquarters camp, and then the speeders would haul him from there.

I was a donkey doctor in those days. Took care of all the machinery for Weyerhaeuser Company at Vale. I had a speeder and hauled the men out of the woods and did all that kind of work, and I took all the visitors in. When Darius came, I took him to the various camps on a speeder. Of course, we helped him with his stuff, and loaded him on the speeders, but ordinarily I don't think Darius had much help in the woods. I don't think they put anyone with him, is what I mean. So I'd take him into the different camps and the foremen would take care of him from there on. Showed him what trees, and there were certain things that were too dangerous for him to be around. Such things as that.

He'd come in the bunkhouse at night, when the men were there, and show them the pictures and what they would look like, and tell them all about the pictures. I think he charged four bits for those. If it was a group picture, he'd sometimes send one to all the men in the bunch and they paid him through the office. If it was a group picture. But if it was an individual picture, like certain ones he'd made before — I have some of them yet, in there — why they'd pay him right there, or anyway, I always did. He'd send them by mail, you know, and they'd come through the company commissary. They were all in big, brown envelopes, and they were all addressed to each person.

<div style="text-align: right">

L.A. Stephenson
Interview
Marysville, March 1974

</div>

238

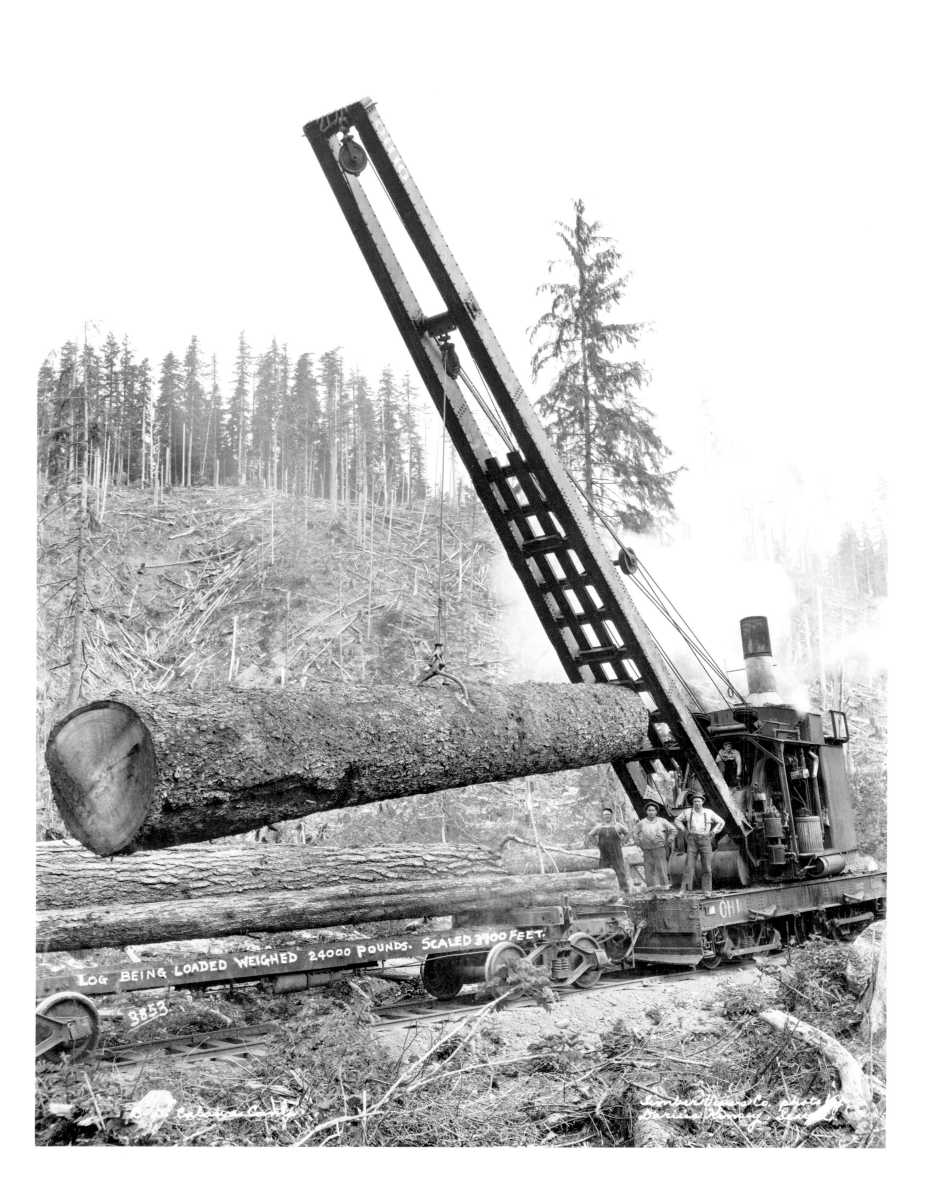

LOG BEING LOADED WEIGHED 24000 POUNDS. SCALED 3100 FEET.

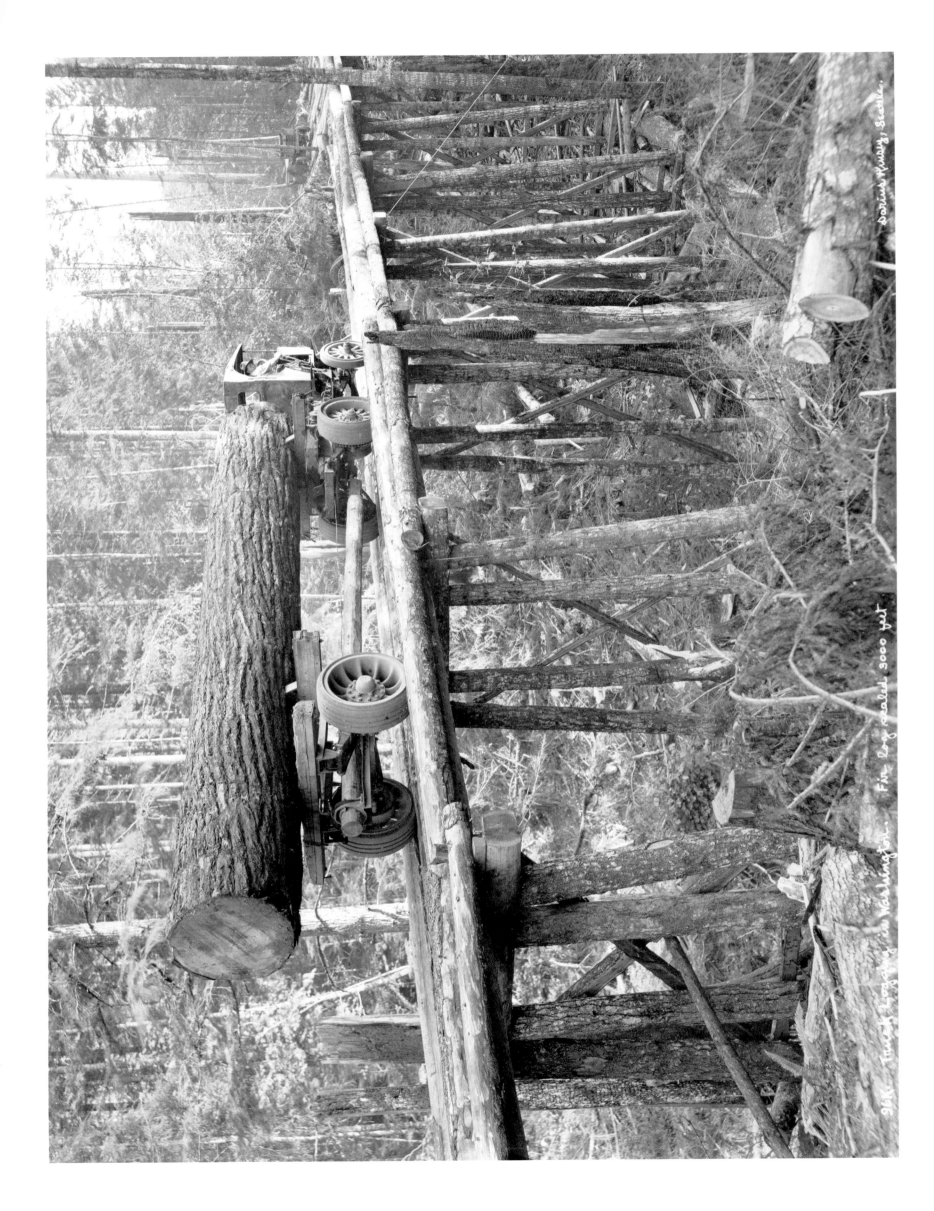

Fir. Log scaled 3000 feet

Truck Logging in Washington.

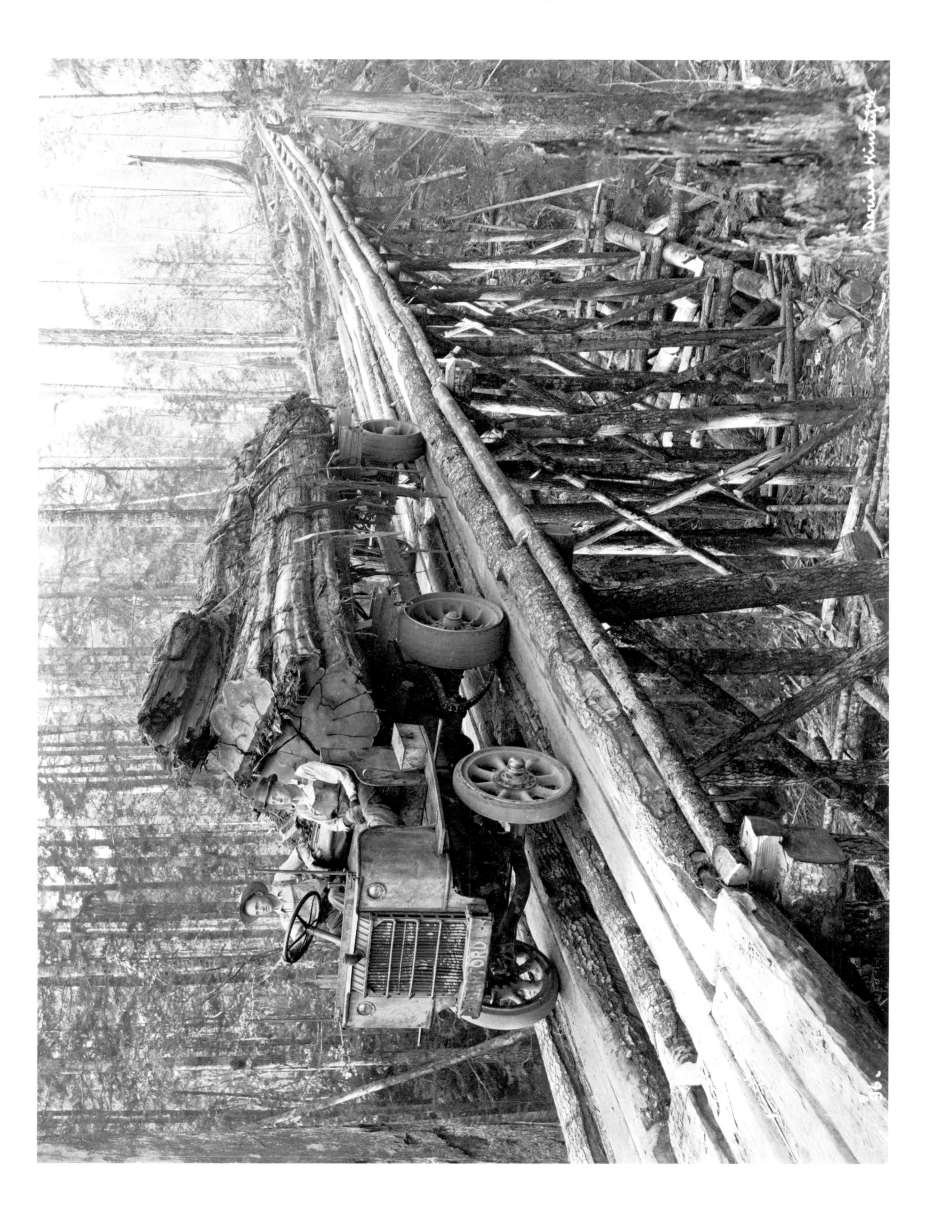

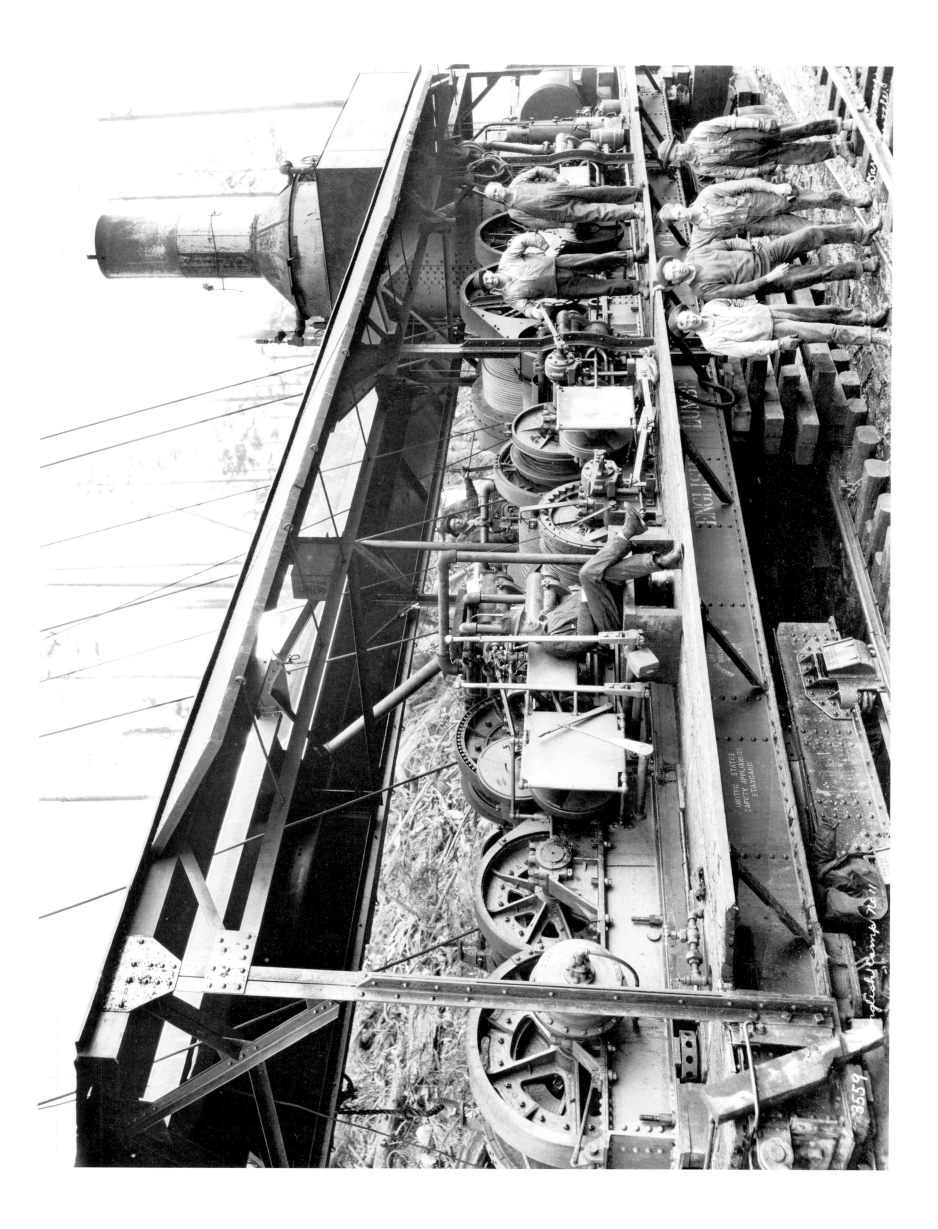

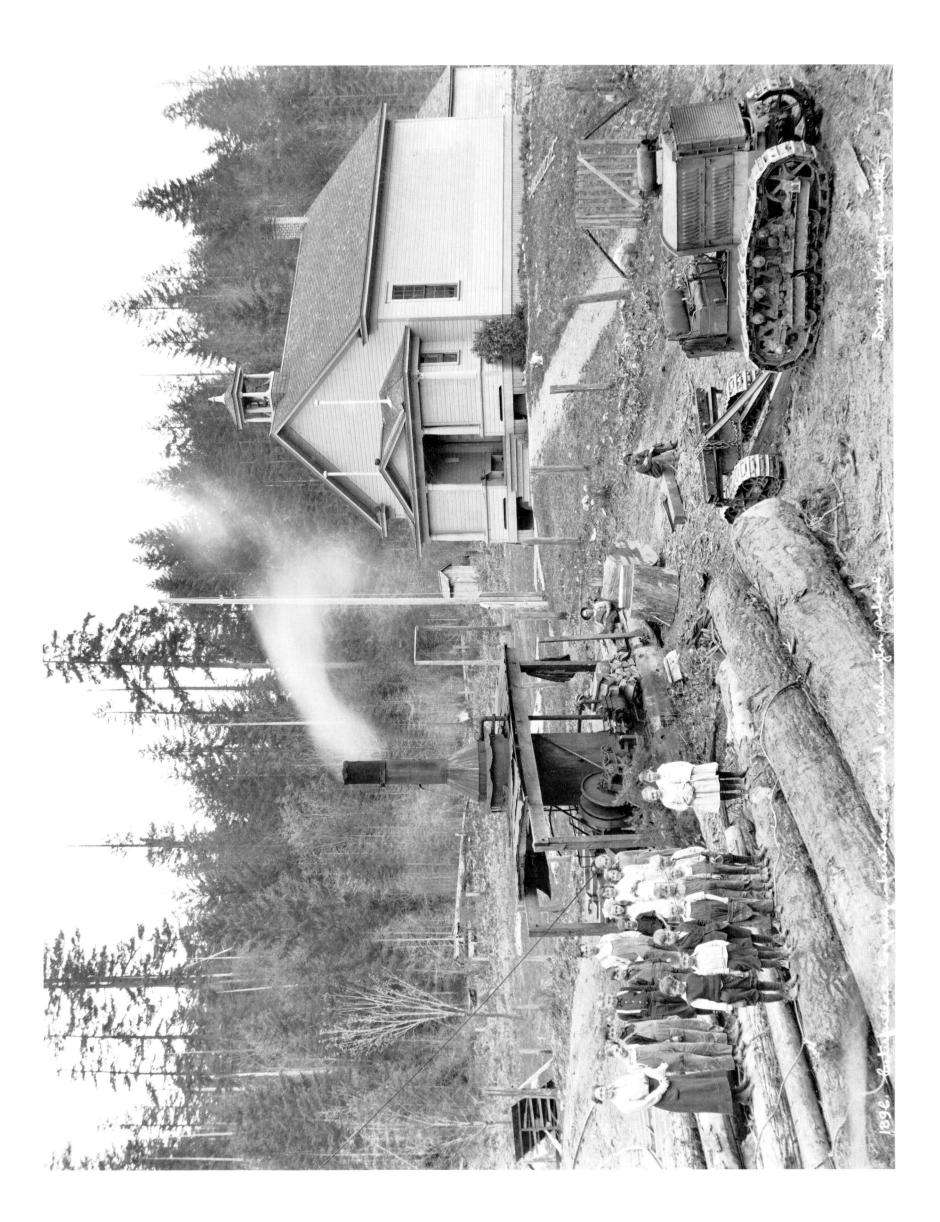

1896 [handwritten caption, illegible]

My first remembrance of Darius Kinsey was when I was four years old and that was sixty-five years ago. I lived with my parents in a one-room logging camp shack built of hand-split cedar boards. My hair was red and hung in braids tied with ribbons. Once, Darius picked me up and hugged me close to his heart and then sat me in my red rocking chair and took my very first picture. Pictures were treasures in those early days and Mother had mine enlarged and hung over her bed.

I think Darius was my first love. I was an only child at that time, and I wasn't allowed to wander around the logging community to play with other children. He always stopped at our home, sometimes had a meal with us, and until I was about six years old I was assured of that hug, close to Darius's heart.

Then there came the day when I began my first year of school — in a one-room, rough building that was situated so close to logging operations that the children would stop reading or spelling and count off whistles on their fingers. Once, when Darius was in camp, he lugged his photographic gear to the school and lined up the fourteen students on the porch and took their picture. A great day in the lives of logging camp youngsters!

I continued to see Darius over the years of my childhood and then, when I was fifteen years old, a tiny wisp of a girl, I went to a logging camp to wait tables. I hadn't been there very long until I saw Darius come riding into camp one day, in the cab of the "lokey." I ran down the hill to meet him, and he dropped all his gear and hugged me in the same old manner I hadn't forgotten from childhood. His procedure when arriving in a lumber camp was to find the camp bull cook and locate himself a bed. Then he'd get up early in the morning and have breakfast in the cookhouse with the guys, and ride out on the flatcar as they went to the woods. His picture-taking gear went right along with him and he would begin with the donkey engine crew and their operations, and move from there into the woods where he photographed the fallers and buckers and the rigging crew. Darius wore caulk shoes and jumped from log to log carrying a large tripod and square camera box — all the things that I never understood. And Darius wasn't afraid of anything. He went into the woods and took pictures of everything and everybody. I used to wonder about him: "Well, Darius, you'll get killed out there with those lines whipping and lashing, those falling trees and everything." But he had no fear of anything.

He wouldn't come in until supper time. On his return with the crew he would dash into the cookhouse and call out to me, "Hi redhead, how about a cup of coffee?" And I'd hurry and bring him some fresh pastry with his

coffee. After supper, he would line up the employees who kept the cookhouse and bunkhouses operating, for their picture. I always wore an apron, black lisle stockings and still the pigtails. He liked to get up a little higher than the people he was photographing. He would find a little slope and would put his people there. I remember in old Dempsey Camp, when he photographed the cookhouse crew. Darius finally found a slope and he put us down there. Then he told us, "Now all stand still. Gather together. Try to smile if you can." And then he'd get behind the black cloth and of course, being a little girl when I first went to the camp, I'd wonder. "Well, why in the world would Darius get behind that black thing. I wish I could see." What was behind that fascinating black cloth over the box that was perched on the tripod?

Darius was a rather small man, and he always wore a white shirt, black breeches, button shoes, stiff collar and a black derby hat. The derby I'll never forget as long as I live. I saw that hat grow old, then older. Soiled, but never replaced with a new one. And the starched collar. No necktie but just the starched white collar.

Darius Kinsey was a dedicated man and he had a way of making subjects of his beautiful photography feel as if they were special people. He seemingly had no fear of dizzy heights and with his caulk shoes gripping into the stringers of a bridge, he would photograph the crew at their work. He rejoiced when the highest single-pole bridge in the world was completed and then carefully pictured it. And he visited and wept with two widows when a bridge collapsed, and a locomotive fell to the bottom of a deep ravine. He wore his heart on his sleeve and could never hide the fact. He was a humble man, an earthy man, a logger's man, and a little redheaded girl's man.

But he didn't have much to say. Darius was just a quiet man. He probably didn't have time to talk. Maybe he was always thinking about what he was going to photograph the next day. Apparently he was so involved in his work, so dedicated to photography, that his mind just ran on that and nothing else. It is what I think that man was. They don't come up any finer than Darius Kinsey. There never will because the man behind the pictures was a fabulous man as far as I'm concerned. Many years ago I set aside an honored place in my heart for Darius Kinsey. After all these years it remains.

Mollie Dowdle
Sedro-Woolley
February 1975

3998A Bloedel-Donovan
Surbn Ca.

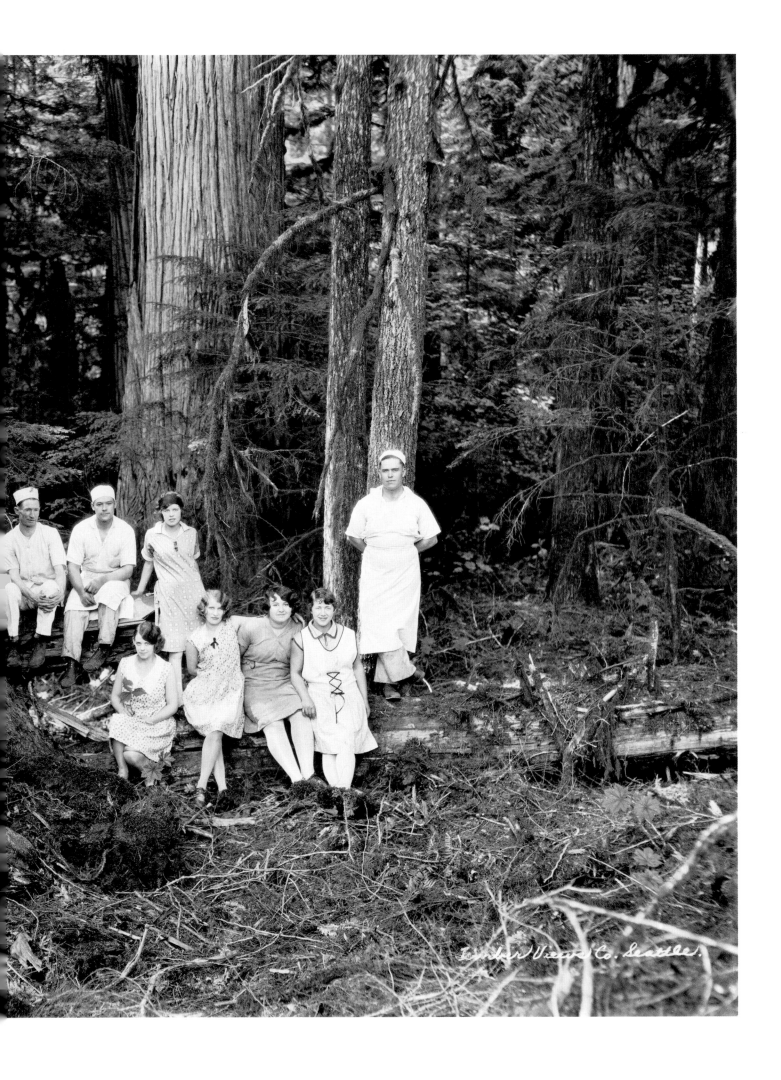

Timber Views Co. Seattle.

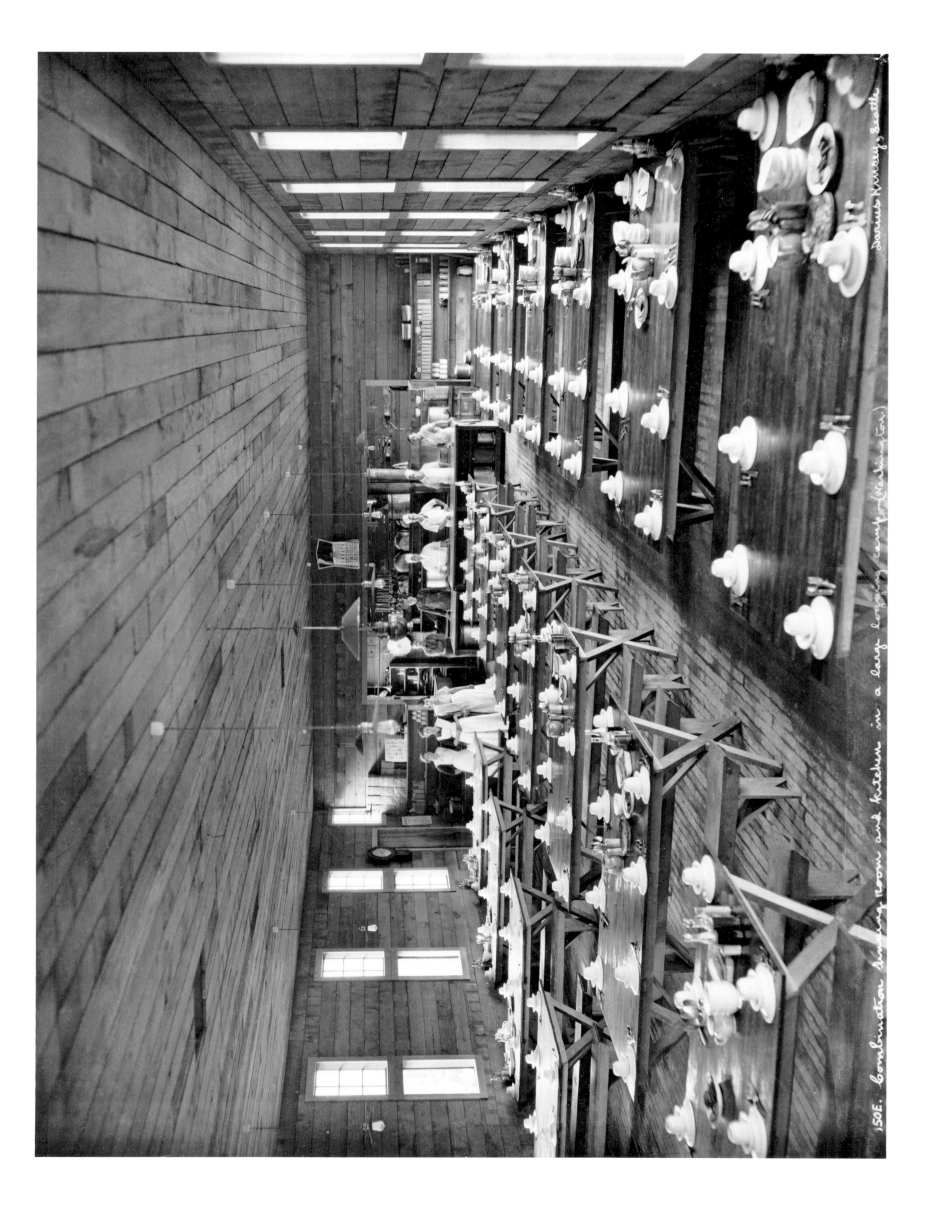

150E. Combination dining room and kitchen in a large logging camp (Washington). Darius Kinsey, Seattle

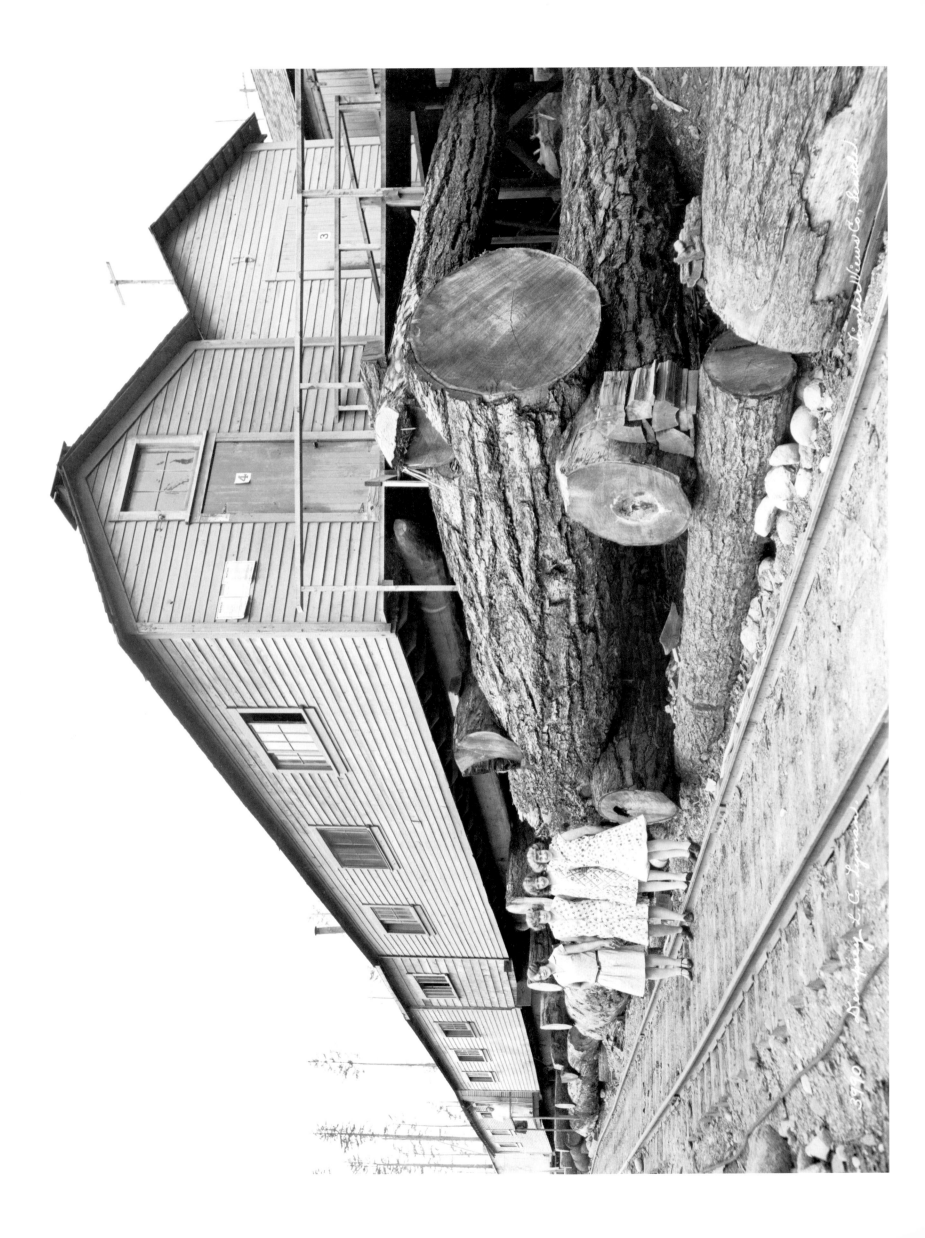

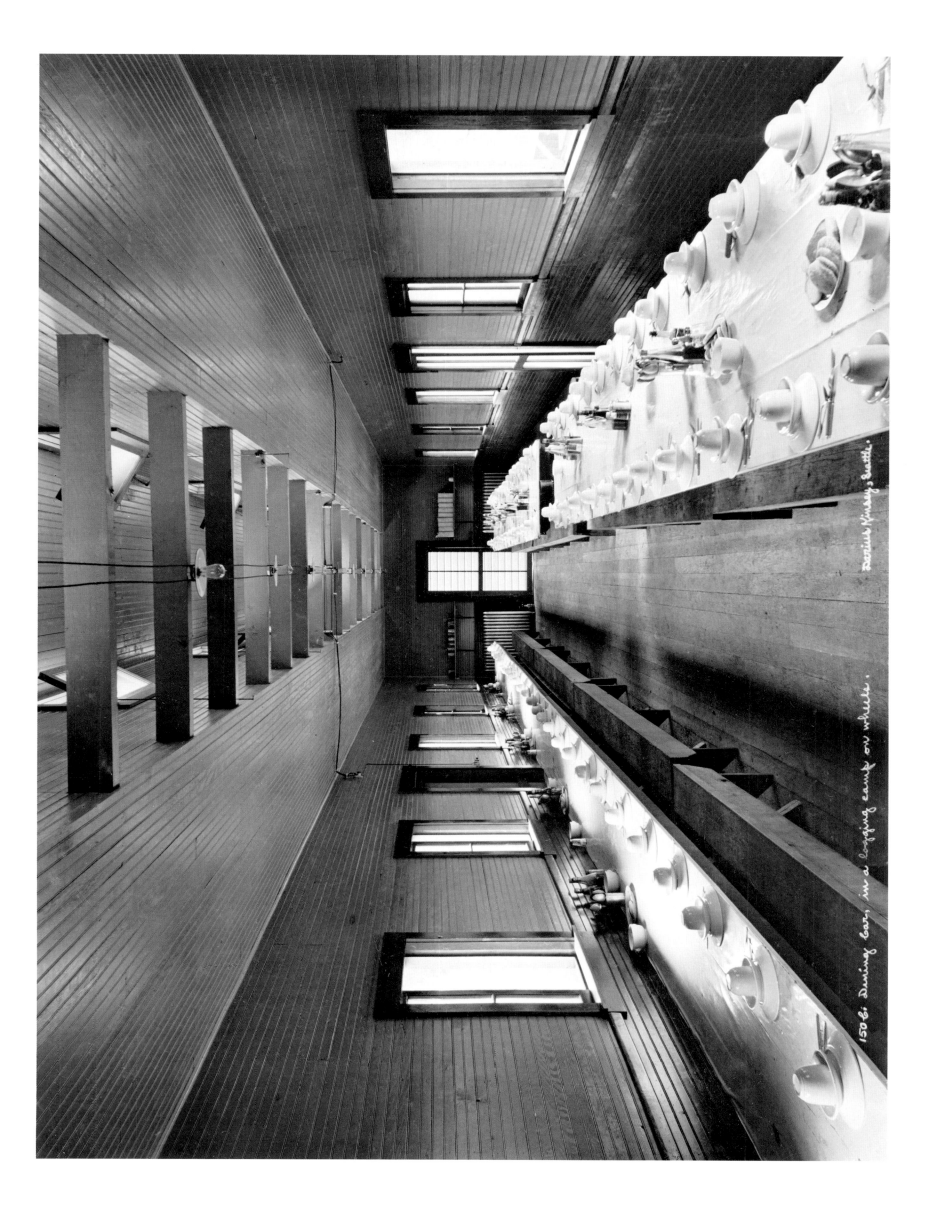

150 E; Dining car, in a logging camp on wheels.

Darius Kinsey, Seattle.

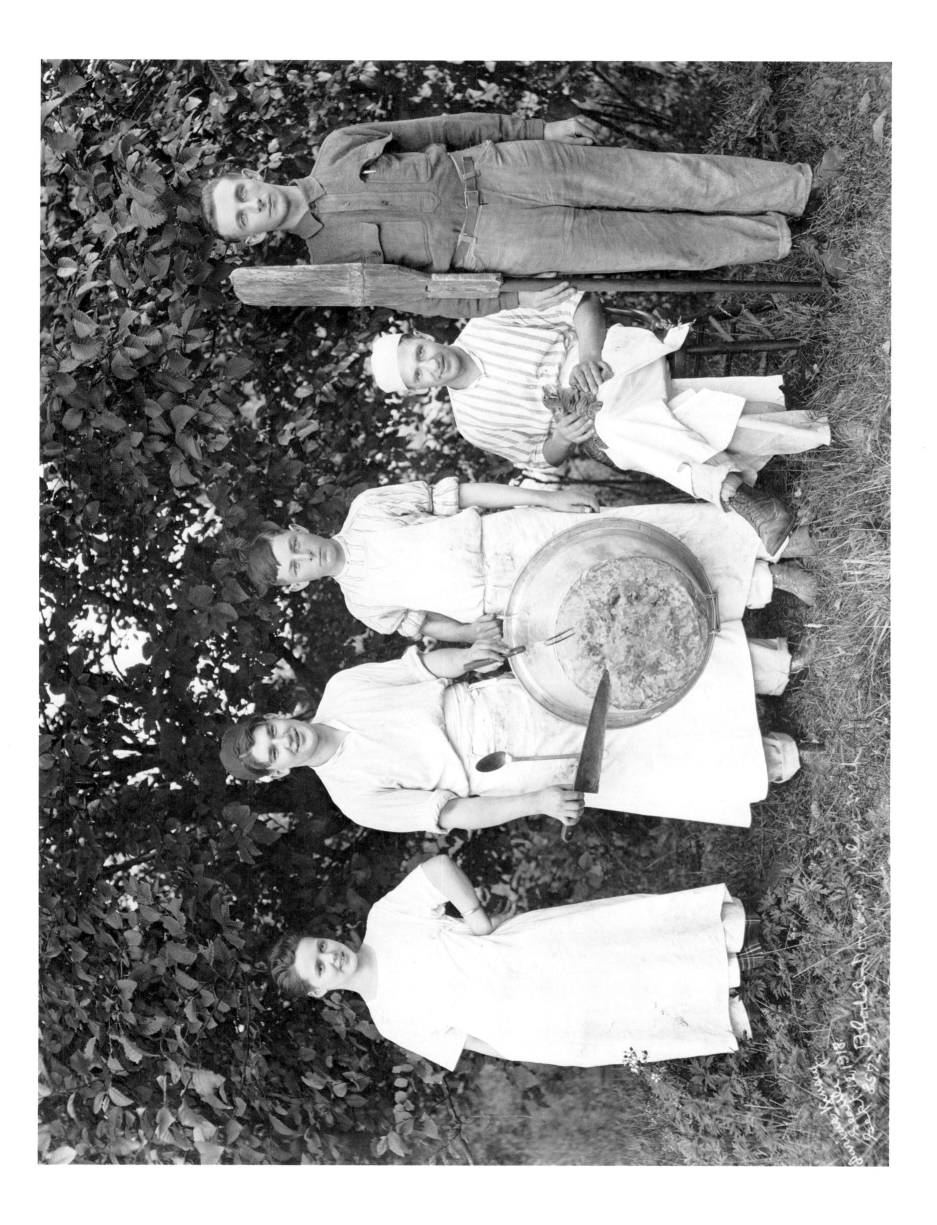

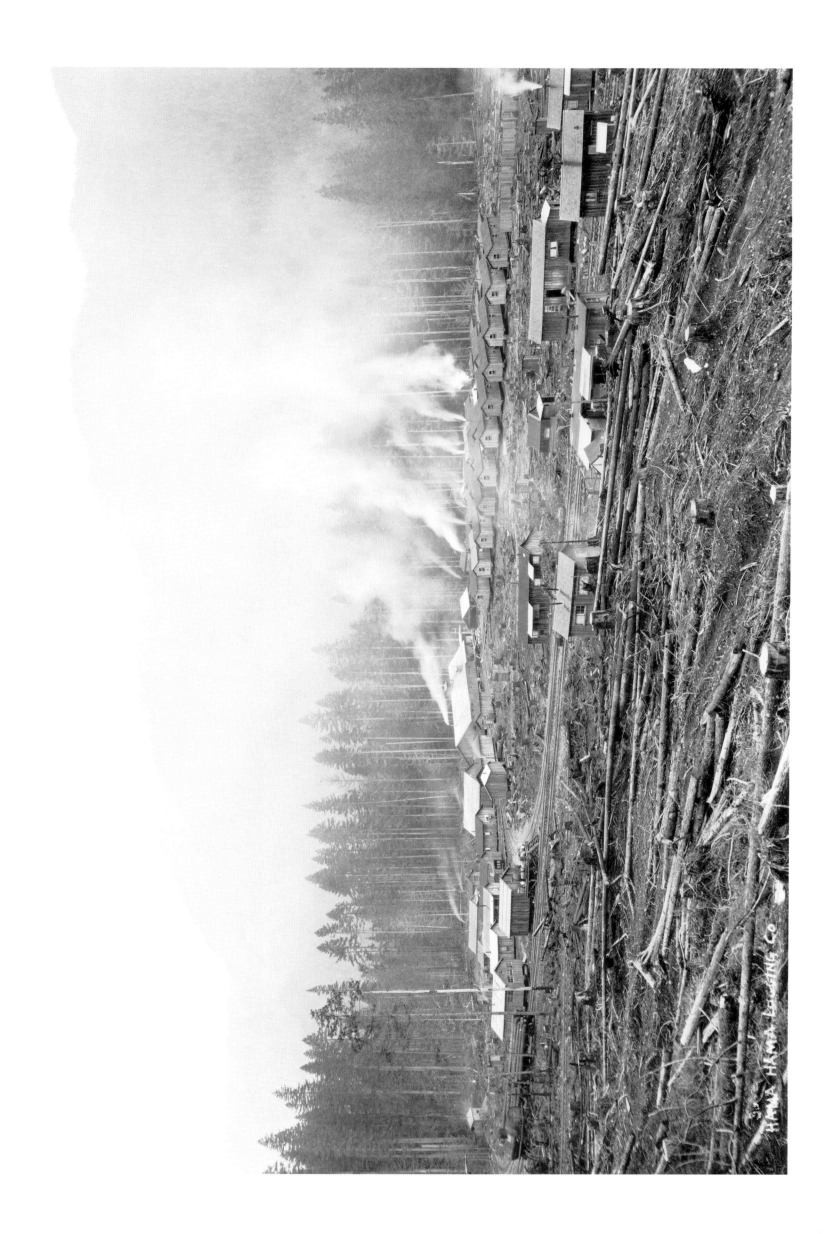

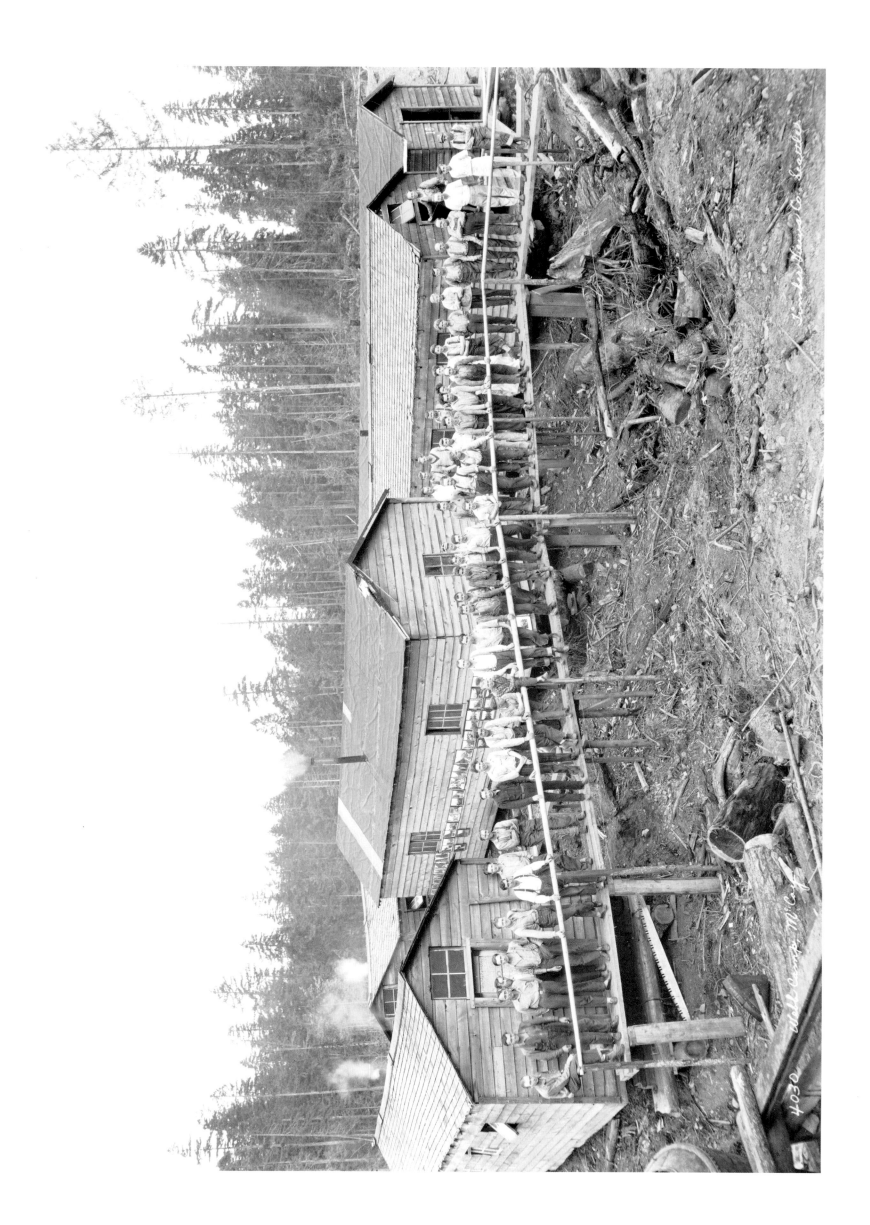

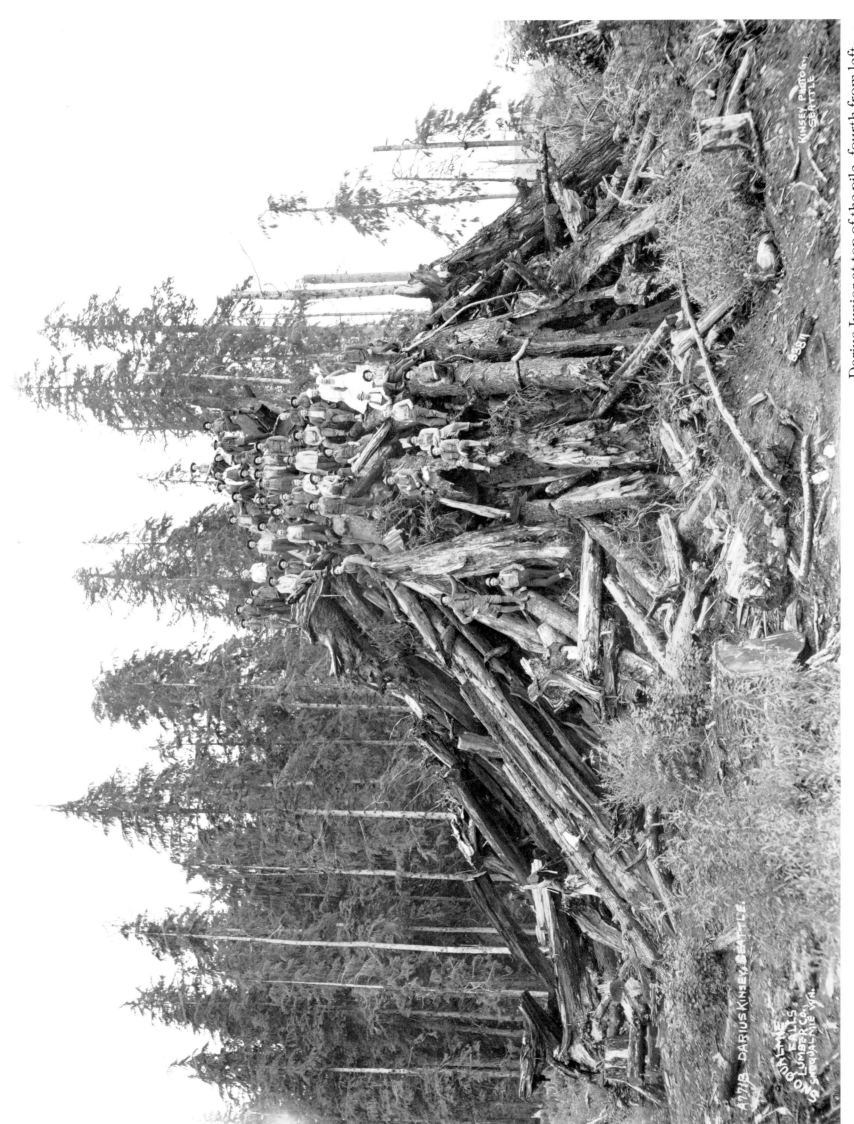

Darius Junior at top of the pile, fourth from left.

"Each pile of lumber is 56 feet high and contains 46053 board feet."

I remember him having those big deals he had to put in his camera (plate holders). And I remember when he came around. Because we just worked to beat the dickens, and they would yell and say who was there, so everybody would come around and take a little time out. They'd shut down the mill. It was a steam mill so they would shut off the steam engines. The old saws would come to a stop, and then we would go out and take time to have our picture taken, and then everybody would go back. Probably talk to him a little bit and everybody would go back to work. They'd start the mill going again and finish out the day.

You could order the pictures at the office and then have the price held out of your pay, the price of the picture. I guess that is how I got most of mine.

Ray Freeman
Interview
Woodinville, February 1973

Well, I think it was in '24 that I first met him. I was foreman with Campbell Lumber at that time. I was also with Siler Logging for years. But I usually knew a day or two before that he would be up at a certain time, and then I would meet him on the train. He was a pretty rugged individual. He wasn't very big, and I took him through some of the damndest places climbing those mountains—just like a goat. And I'd help him pack his stuff up there to get some of those pictures. He was quite thorough in his work and they were very beautiful pictures.

Lester Johnson
Interview
Seattle, November 1973

"157. Homesteader's shake cabin—a familiar landmark in the timbered wilderness of Washington. Copyrighted 1906 by Darius Kinsey, 1607 E. Alder St., Seattle, Wash." Glass plate.

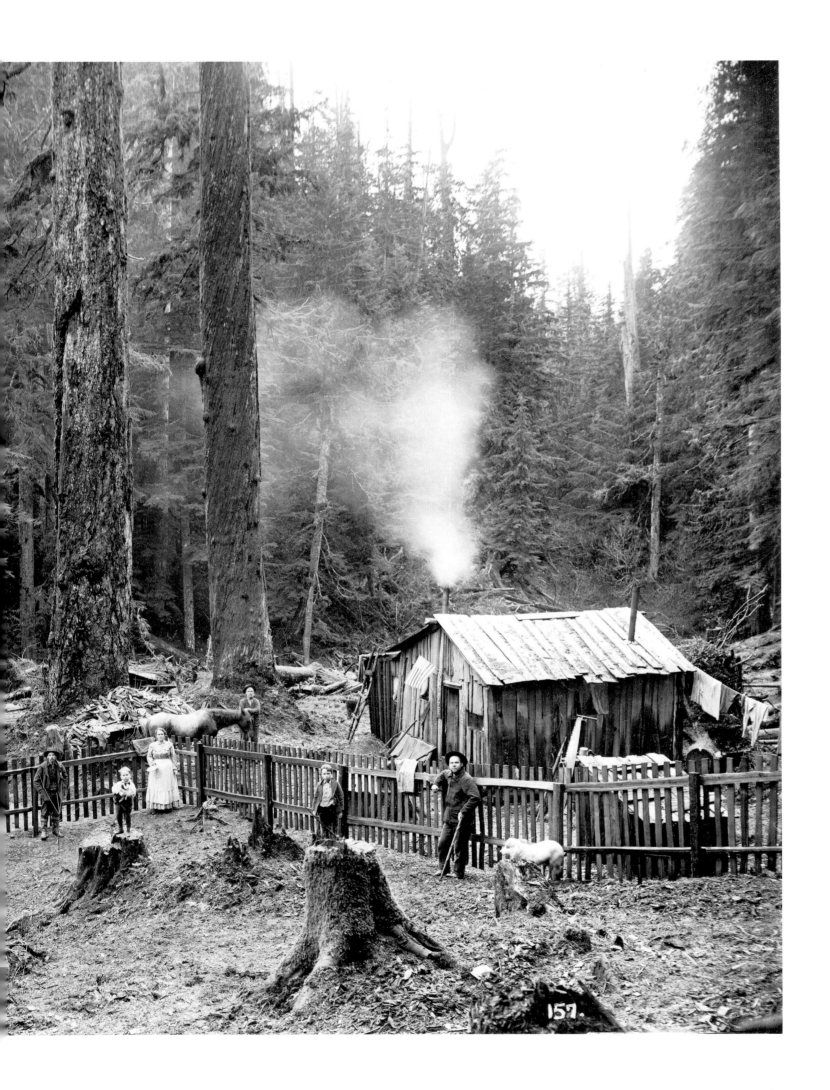

Everybody says, well, he probably wasn't the best. But now I tell you, those scenes, all the scenes he took, I haven't seen anybody who has got him beat on that. A tough job, you get out in these woods with an ordinary camera and sometimes you have to take two or three days before you can get light enough, and how he did all those remarkable things with that old equipment. But he would set there until things was the way he wanted it. Sometimes he would go clear up on a high stump, take a ladder to get up there. Stick around there for hours. Maybe sun would come down through a hole in the timber and he'd take it. Of course, if he was out in the open taking the crew or anything, why that would be easier.

Ray Jordan
Interview
Sedro-Woolley, November 1972

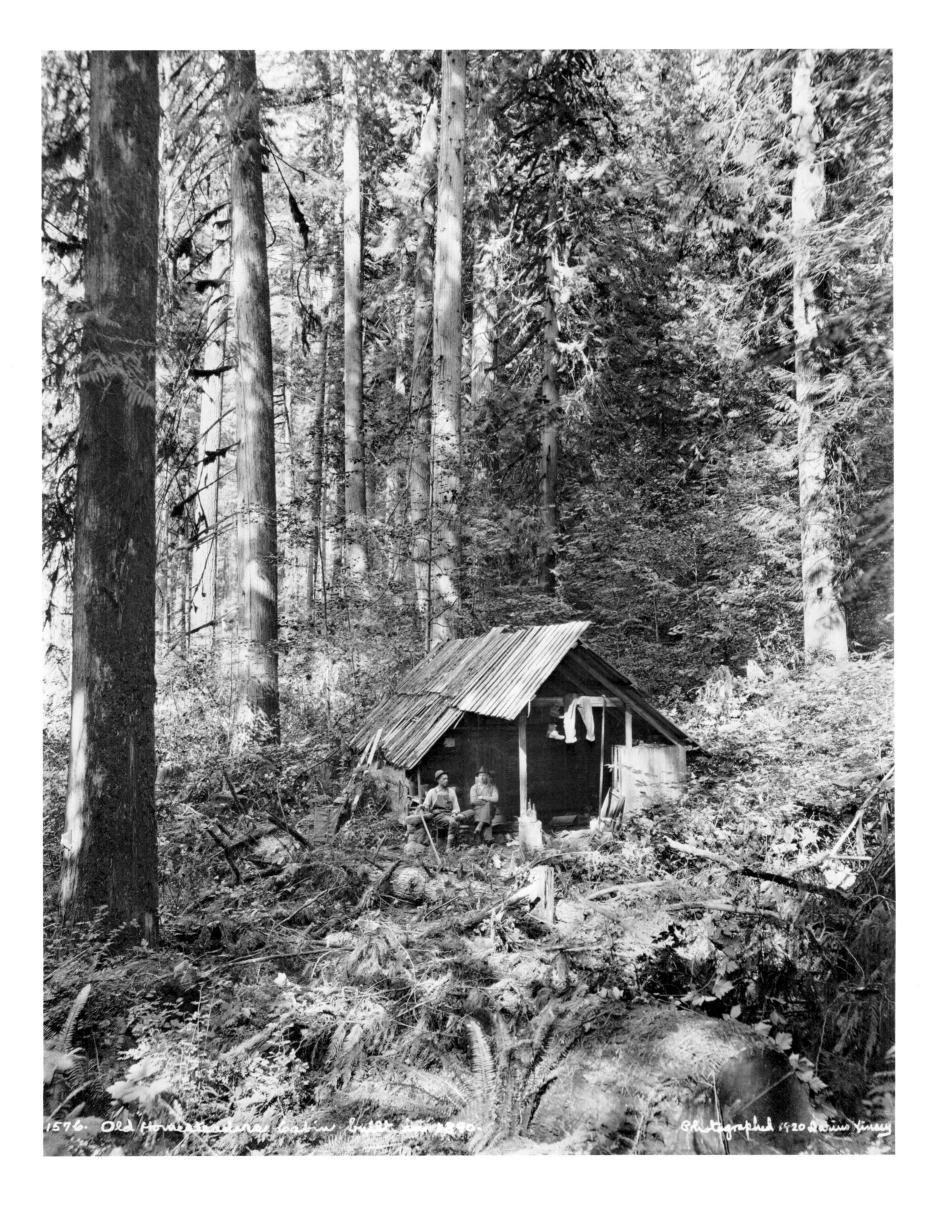

1576. Old Homesteaders' Cabin built in 1890. Photographed 1920 Darius Kinsey

No, I didn't work for them at their Alder Street house. Aunt Tib had a lot of nieces up in Nooksack and Sedro-Woolley, up that way, and of course those girls were always glad to get away from the small town and come to Seattle, and they had a big house over there on Alder. So she always had a couple of the girls, and one of them would do the housework for her. My Uncle Darius wouldn't let anyone else monkey with the films. That was up to Aunt Tib. She was the one who did the films and finished the prints.

I worked for them when they had that big old house up on Greenwood Avenue. They lived on the first floor and did the developing and printing on the second. And then, the whole next story up . . . well, that third floor was Uncle Darius' place, just like a recluse would live in. He was always going to put all those logging pictures together, you know. He'd make albums. He'd just fiddle around up there with those albums all the time. That was his work, and he would just sit up there for hours and monkey with those pictures. He would hardly come down for anything to eat, he was so wrapped up in it.

But he was a very quiet man, you know. He never liked to be out with people much, and my Dad (Alfred Kinsey) used to tell me that, when they were still in Missouri, Darius would like to go out with the sheep and go up in the hills. He liked that solitude. He was kind of a deep thinker. And then my Dad and Uncle Darius, they were the first ones to come out here.

Well, I worked for them when he was going around the logging camps, and he would send in the negatives and Aunt Tib would develop them. And I'd help her develop them. If I didn't happen to be there that day, she'd call and I'd have to dash up. When the negatives came in, we had to do them right now, and then probably get the prints out the next day or so. So I was always in there (the darkroom) with her, and she'd ask me things. She'd say, "Well, what do you think about this?" Then she'd get a little more developer, and she'd leave it in the tray and kind of look at it a little bit. And of course they had those wood doors over the windows and they kept those shut. And

when she'd get the negatives developed, why we'd start printing. And then I had to make up all the orders—put them in big envelopes that had all the things written on them, and put on the envelope the name of each person. And then she'd drag them downtown, carry all that big load downtown and mail them out that night, or whenever she could. She was really a workhorse. She really worked at it.

But Uncle Darius didn't trust anybody else with the films, and he didn't want to teach anybody else how to develop them or anything like that. If there was anything going on there, she was the one who really did it.

But on the hand coloring, it was getting to her eyes so bad that they wanted me to do it. She would tint one, and then I had to tint the rest to match. Because he never wanted the pictures very bright. She kept trying to get them a little brighter, because when she was out she always noticed colors. But he never wanted anything very bright, and I couldn't change anything because everybody always wanted Mrs. Kinsey's tinted pictures.

Uncle Darius would never go any place with her, either. He was too busy. He just didn't have time to go. But when the kids were married and gone and she was there by herself nearly all the time, she'd go downtown and order a bunch of desserts first, and maybe some other little thing in the cafeteria. Oh boy, she just had a good time. She was a wonderful person. You would have loved her. She was just a real good person. She never said anything about anybody or anything like that. But she used to talk to me—of course, I was young then—and she'd always say, "Well, now what'd you do last night, Alfreda, who'd you go out with, what did you do?" And she always wanted to know everything like that because she never got to have very much social life. She was always interested in what everybody else was doing.

Alfreda Kinsey Tiddens
Interview
Tacoma, March 1974

"This cedar stump near Lake Crescent was used for a U. S. Post Office in 1879."

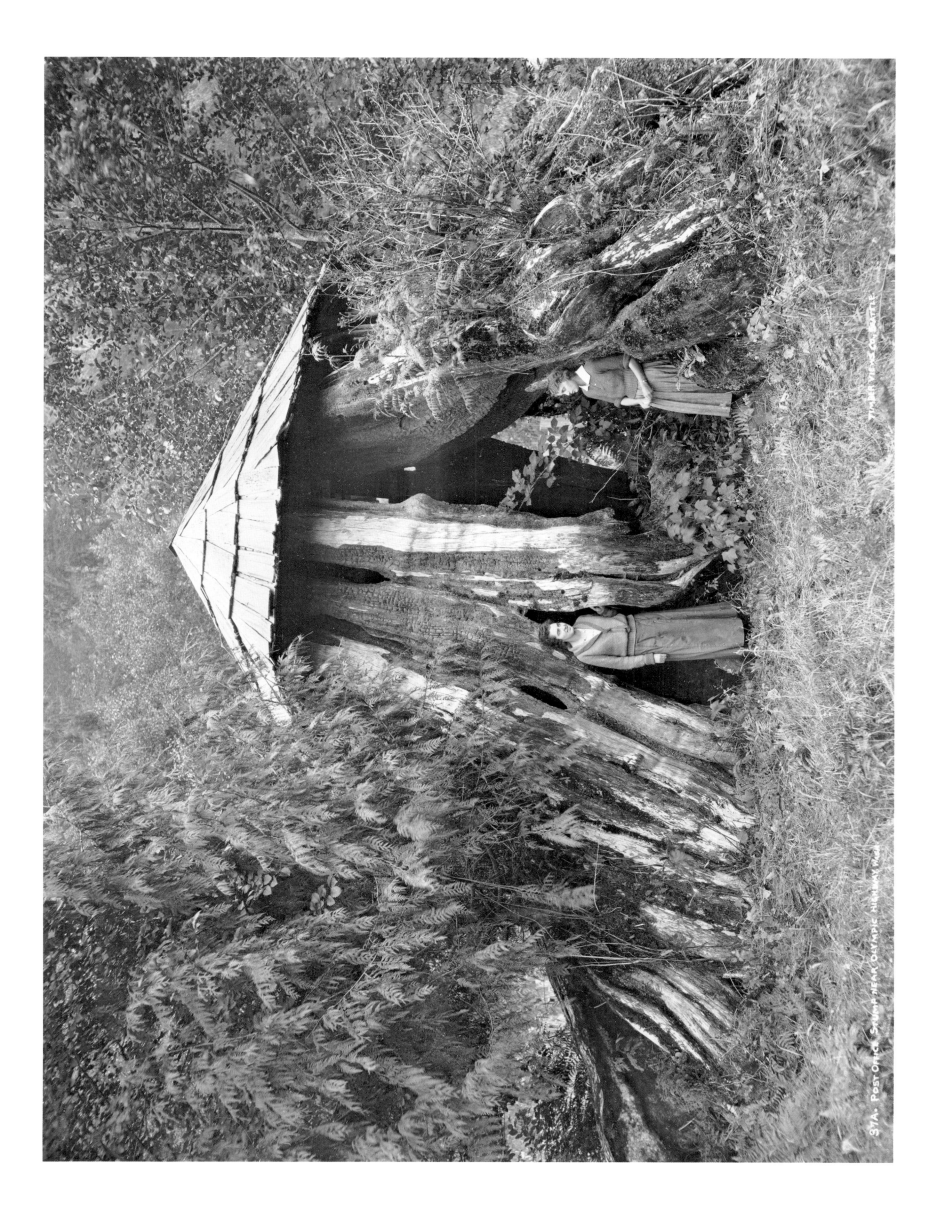

"X55. Ferry Boat on Skagit River at foot of Coal Mountain. Copyrighted 1907 by Darius Kinsey." Glass plate.

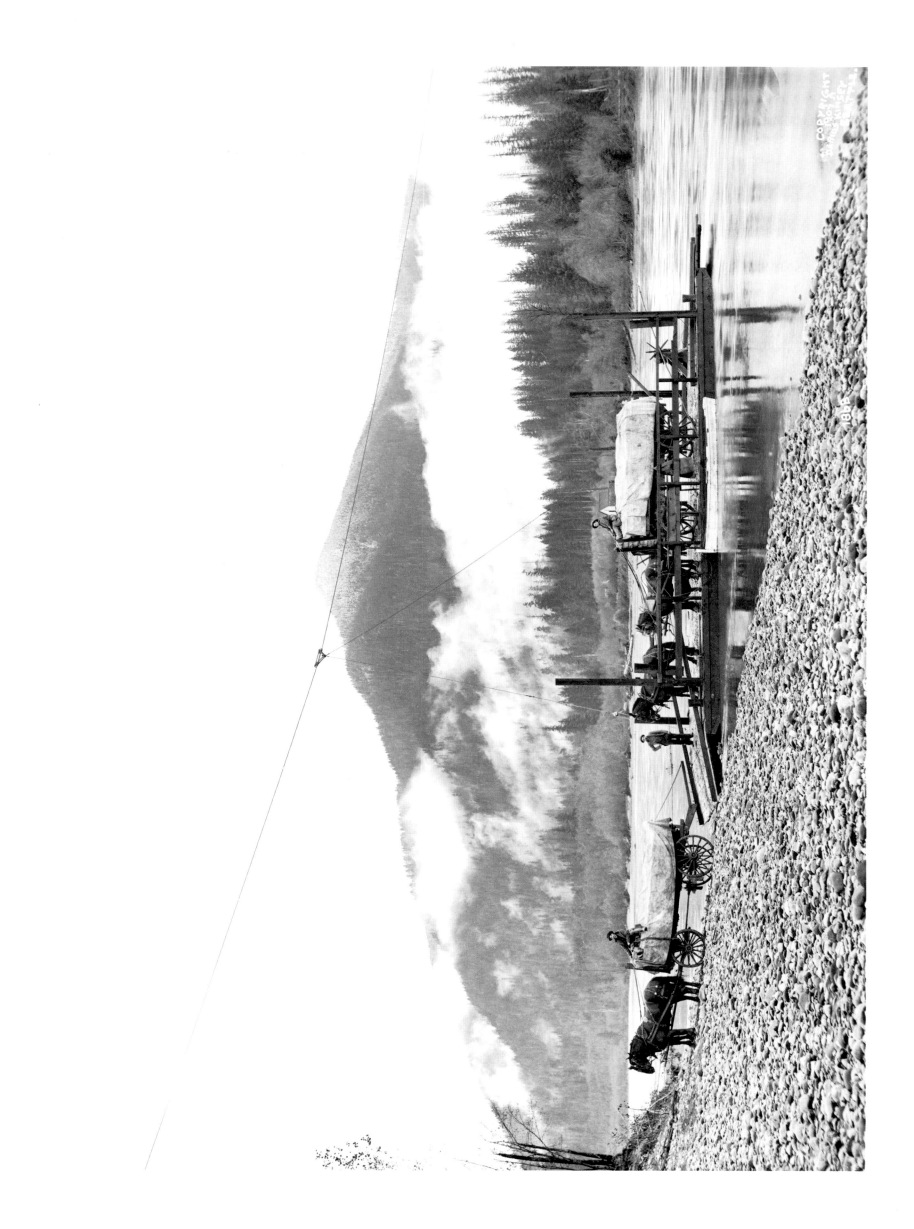

281-d. White Horse Mountain, near Darrington, Wash. 19©23 Darius Kinsey, Sanc

I was smiling after you called and asked if you could come out today (Sunday), and I was thinking, "Well, if that had been Uncle Darius here, he would have said 'No, you can't.' " Now, if anyone wanted to pay him some money on Sunday, he refused to take it. They'd leave it at my mother's (Emeline Kinsey Odell) and she would give it to him on Monday. You see, they were both religious and their religion meant something to them. He wouldn't accept one penny on the Lord's day, or do any business whatsoever. And that used to amuse me. You know how kids are. And this envelope we'd put up in the kitchen cupboard, and mother'd say, "Well, that goes to Uncle Darius when he comes tomorrow." She could take the money and give it to him on Monday and that was alright.

You know, I was thinking back. We loved to have him come (to Snoqualmie). He had this bum stomach, and I think of him so often because he would come up there, and you know what his diet was? Raw spinach, cottage cheese, and canned Italian prunes. We lived in a farming community and my mother had all this cottage cheese and she always made sure she had a lot of canned Italian prunes. And that's all he ate.

It was always a big deal when Uncle Darius came. Now, he was never one that would make over us. He had a beautiful smile, but he was not what you would call a smiling man. But he was . . . well, you had a feeling that he liked you. There was just something that he gave out, that he liked you. And you know, he stammered, he didn't talk very good. He stuttered.

As I understood it, the stuttering was even at a real early age, and he had trouble in school because . . . well, even now they don't have the patience with someone with a defect. And he would know it, and they would ask him to recite and he couldn't, and some of the teachers would get very impatient and angry, and of course it made him all the worse. I guess that's why he took up something where he didn't have to talk and he could be by himself and do what he wanted.

But I can remember him speaking up when there was a disagreement with regards to religion. He spoke up and gave that person chapter and

verse, because he knew that Bible, and he could really talk without any trouble then, because he knew that Bible and he was so disgusted and angry at the misinterpretation that he got it all out without too much stammering. Then, as he grew older, he learned to talk slower. Whenever he couldn't get the vowel or the letter out, why he'd just slow up a little. I think one of his troubles was that he thought much faster than he spoke.

Well, in 1916 when I was fifteen years old, Uncle Darius had been up in that country—the logging woods, you know—and we used to wonder what on earth he'd be doing. He was going to take a picture, say, up the Sunset Highway. He would go up there for two or three hours, maybe early in the morning, maybe late evening, maybe again at noon, figuring out the shadows. And when he took that picture he had something. That picture was the path on this log where it showed they had used the log for a footpath, and the sunbeams that filtered through . . . it is a marvelous picture. Well, I can remember the time he spent before he ever took it, figuring out the shadow deal. I didn't know what it was at the time, you know. I thought, "How can anyone go up there and spend so much time doing nothing?" But after I saw the picture, then I realized. That moss stands right up, the log shows where it has been used for a path, and up there in the sky coming through those great big, tall trees, is the sun and the most beautiful patterns of light. Oh yes. I think even as young as I was I could still realize that he was special.

You know, after you called me and I started thinking back—what I remembered about him . . . I just have no unpleasant memories of that man. And my mother, she evaluated him as a man, too, and a brother. And the sterling qualities that never changed. To her he was more or less the Rock of Gibraltar.

Edna Odell Oakes
Interview
Seattle, March 1974

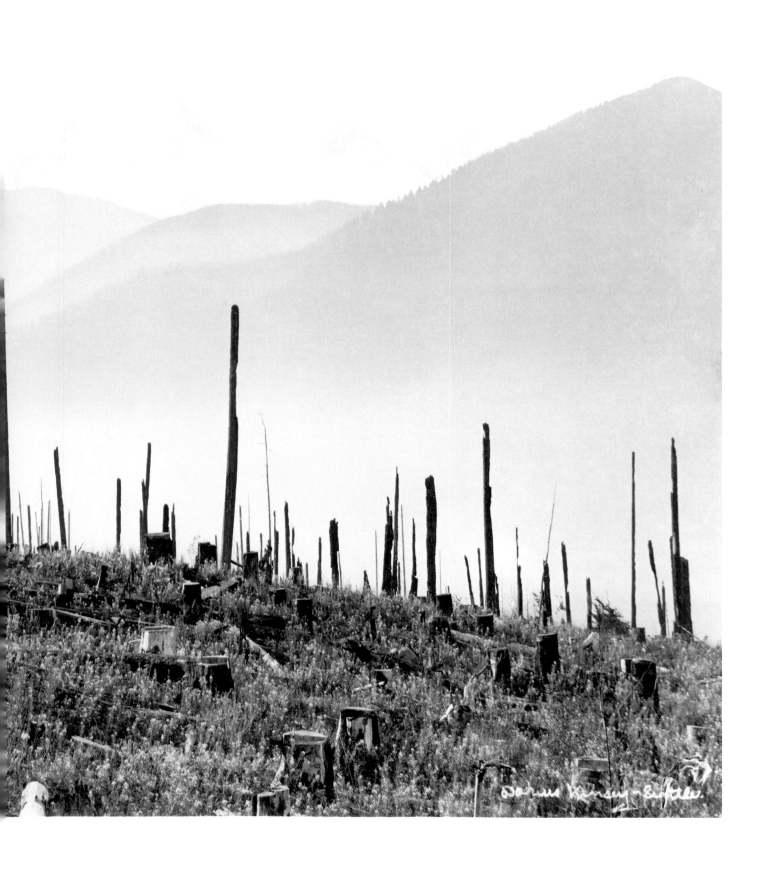

There was one thing I remember he liked to make. He would grind apples, fresh you know — grate them and then put in sugar and vanilla. Seemed like he grated them. He'd have that big bowl of raw apples and of course they'd get kind of brownish.

Well, another thing he fixed. He liked lamb and he would put a piece of the lamb down first, and then potatoes on top and then more lamb and more potatoes, and salt and pepper, and then put water over that. I can't remember what in the world it must have been. Some kind of a steamer-like thing, a dutch oven or that kind of thing. He'd fix it so that when he came home from church our dinner would be ready.

May Tucker Ploeg
Interview
Burlington, March 1974

From a glass plate.

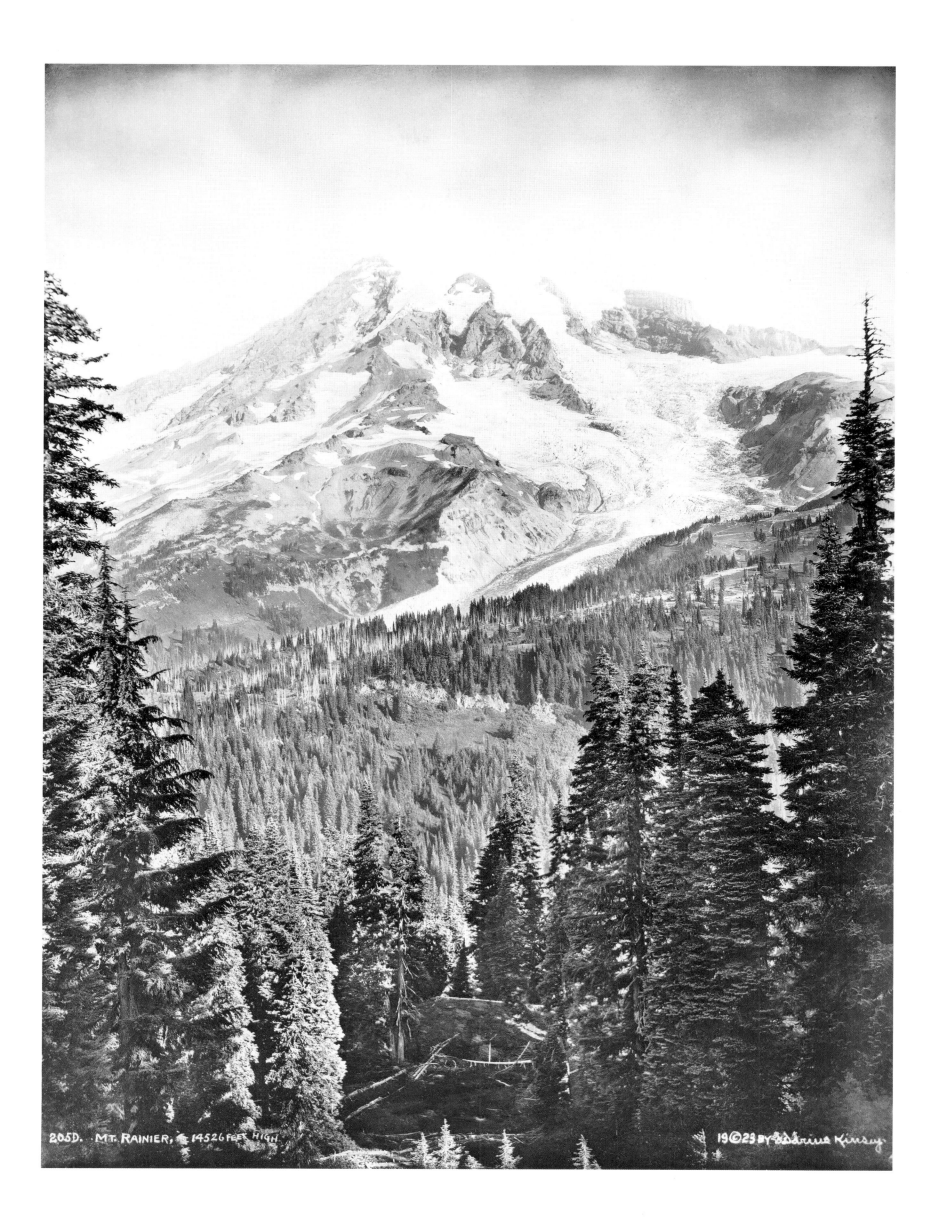

205D. · MT. RAINIER, 14526 FEET HIGH

Tabitha and Darius Junior on
the Yosemite trip of 1925.

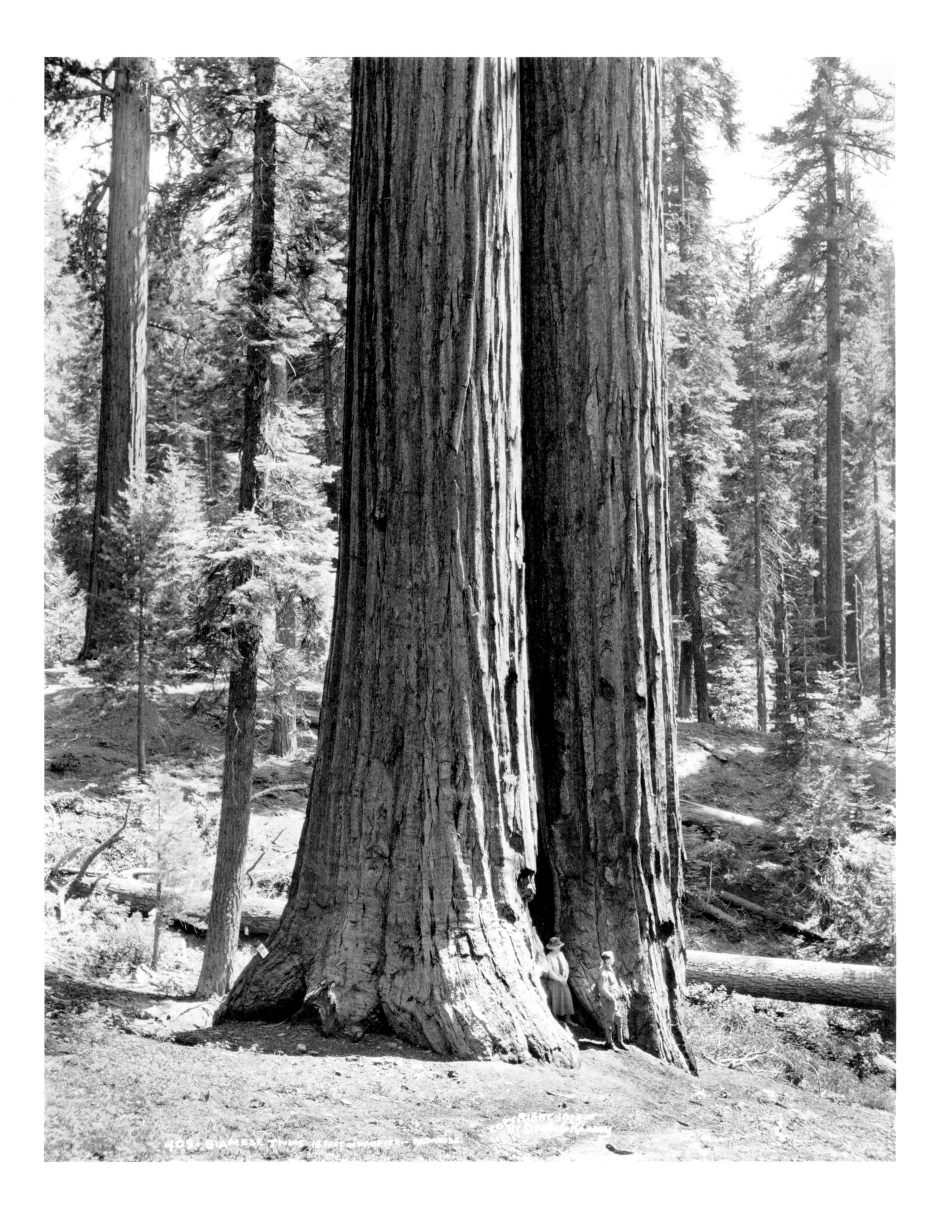

408 SIAMESE TWINS 18 FEET DIAMETER REDWOOD

I did the printing when I worked there (the summers of 1910, 1911, and part of 1912). You know, exposing the prints. My aunt did the developing. And then another girl did the washing of the pictures. It just depended on when my uncle was out taking the pictures. He would send them in and then there would be a big rush. And other times, why, we weren't so busy then. We got the orders ready and mailed them back to him and he delivered them to the men in the woods. He would usually try to be home on the weekends. He would go out during the week and then try to be home on the weekend.

<div align="right">
Laura Germain Massey

Interview

Bellingham, November 1972
</div>

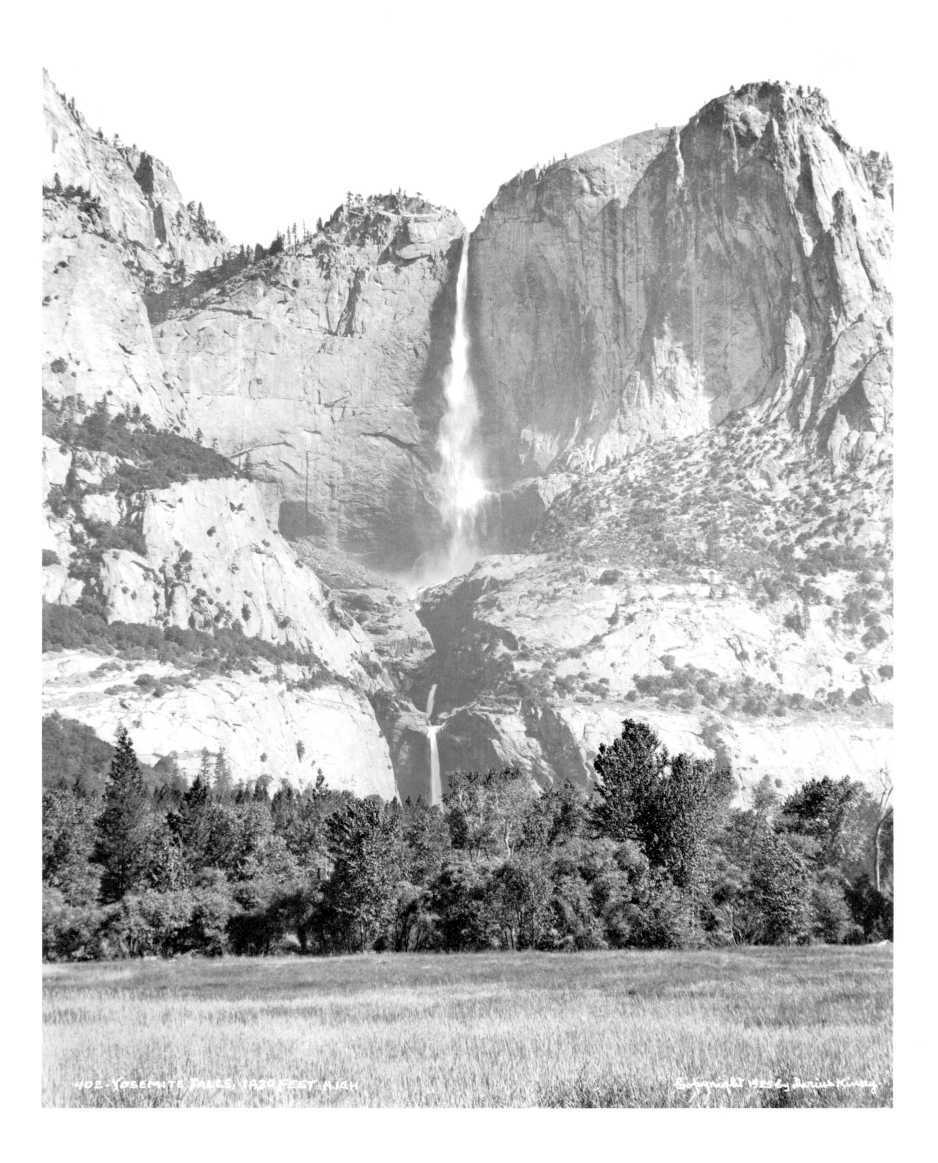

402 - YOSEMITE FALLS, 1430 FEET HIGH

Copyright 1925 by Darius Kinsey

Well, I worked there one summer (1607 E. Alder, in 1907) and I even printed some pictures, I learned to print. And I washed the pictures, 11x14" you know, those great big pictures. And I went with my aunt Tabitha to the depot to deliver the pictures, and oh they were heavy. They just about killed you off.

Well I do know that she spent an awful lot of time in the darkroom and she did a lot of the tinting. He never could have done the work he did if it hadn't been for her help, because really she did—you might say the main part of it after he took the picture—the main part of it getting them ready and finishing them.

He would have the glass plates delivered to the door and they would come sometimes quite late at night. We would hear the doorbell ring and we would say "Oh, that's more pictures." Well, it ruined Aunt Tabitha's back, so much lifting, made her a cripple. Just got her back all out of place.

Oh yes. She did a great deal of tinting. She sure was good at it, too. And she also did a lot of retouching. You know there would be a little flaw in the picture and if you retouched that, you would never know it. She was very good at it.

Ada Pritts Brown
Interview
Bellingham, November 1972

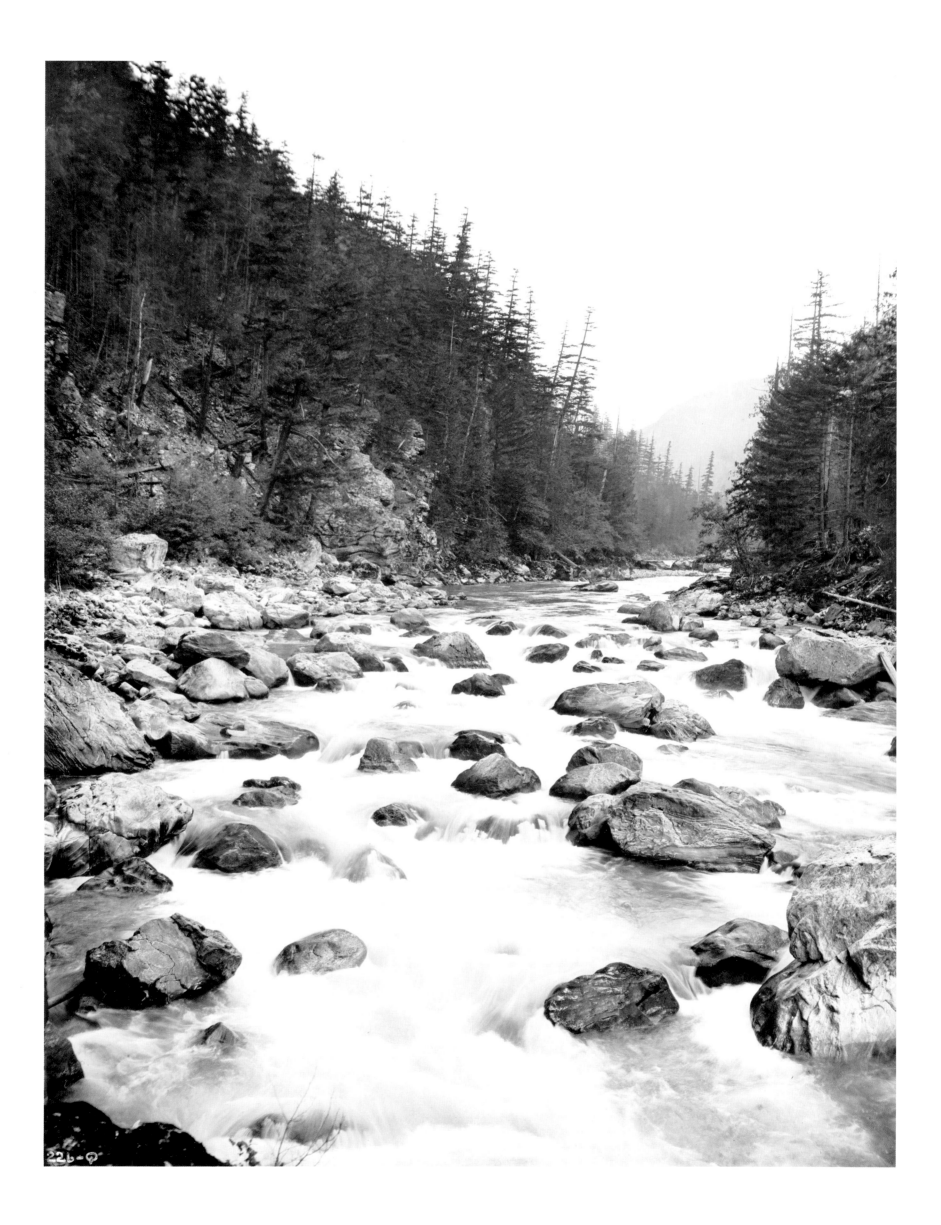

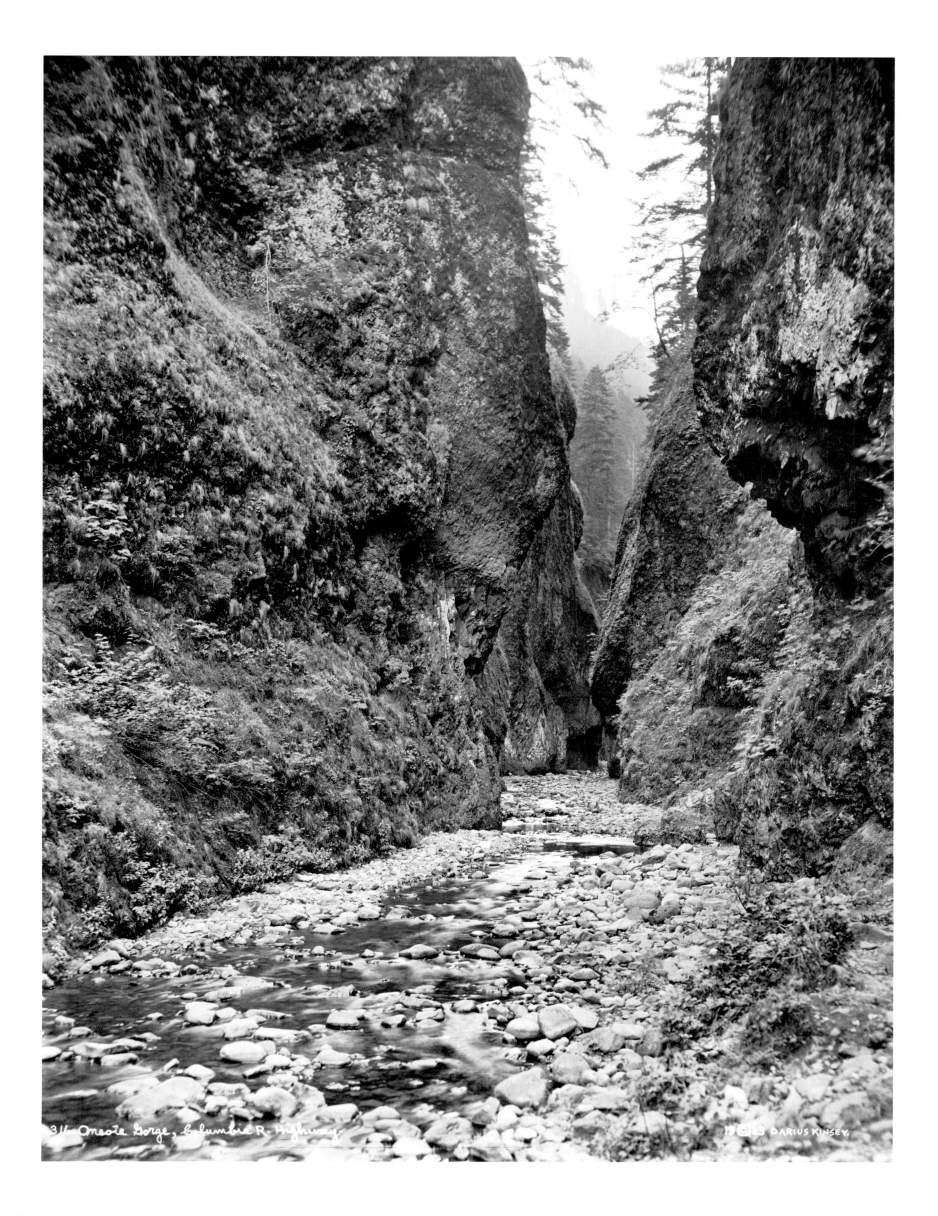

316 Oneota Gorge, Columbia R. Highway.

19©23 DARIUS KINSEY.

About 1950 I was interviewed and worked with the Editor of the newspaper in Concrete, Washington. He was getting out the fiftieth anniversary edition, and he said he had talked with several men who had helped Kinsey carry this great mass of photographic gear up the mountainside. Have you ever carried an 11x14" camera plus all the films and plates? Well, I haven't. But I know that the 8x10" that I had down here in the studio weighed the short side of a short ton, and an 11x14" was approximately fifty percent more than that. But Dwelley said the odd thing about it was that Kinsey could never hire the same kid twice, because they just didn't want to put up with that kind of labor for the money. Kinsey always wanted to get up on top of a high hill someplace, through the brush and stubs and downed timber and everything else. It's bad enough to carry yourself through that trash without lugging a big camera case. But he was a stickler for getting the right viewpoint and the right angle of view even though he was using a big view camera. And he was a master of it.

Jesse Ebert
Correspondence
October 1972

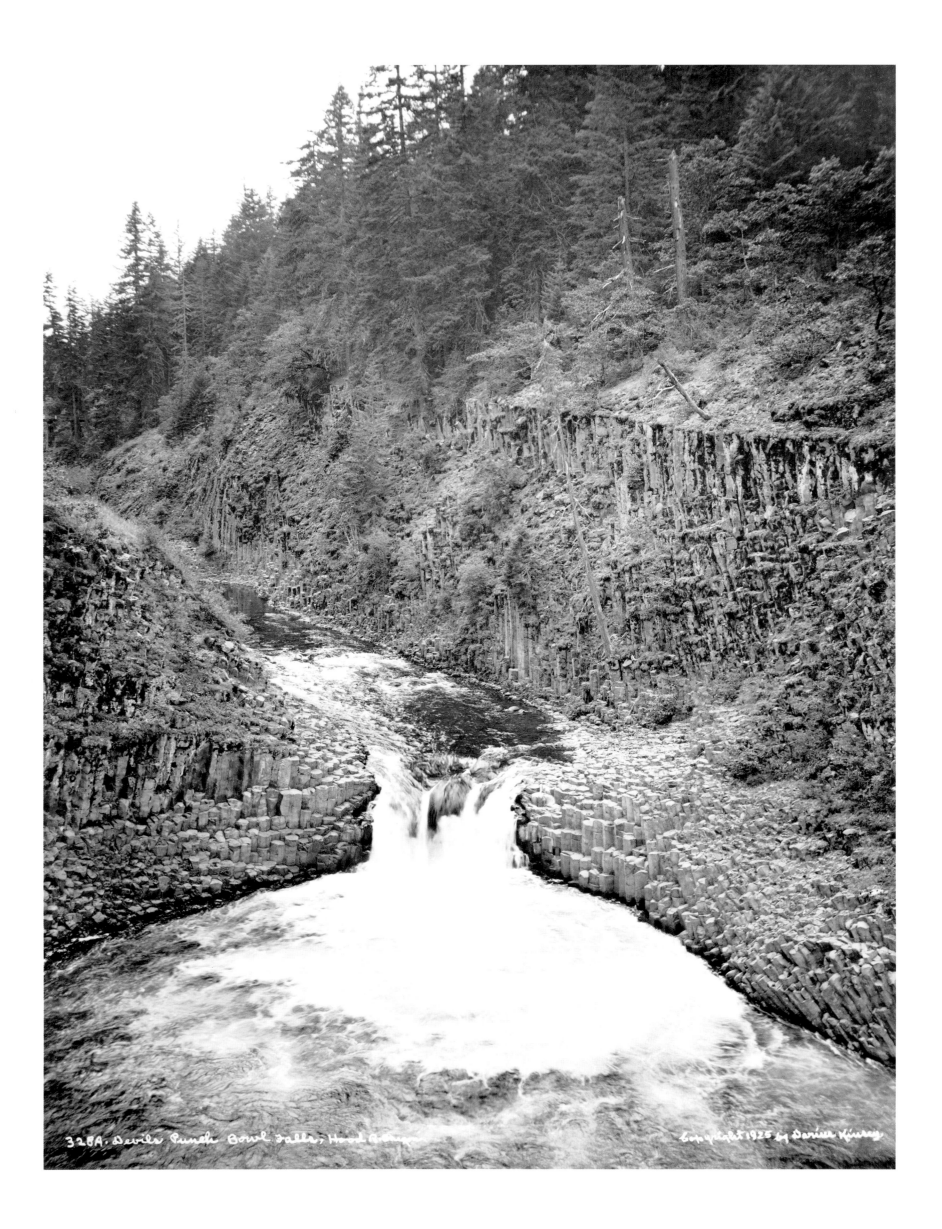

328A. Devils Punch Bowl Falls; Hood River Copyright 1925 by Darius Kinsey

He got very famous after he went to Seattle. We didn't appreciate him enough up here. She came from up around Nooksack. She helped with the studio. She worked hard. He took the pictures out in the woods and she finished them.

<div style="text-align: right">

Minnie Batey
Interview
Mt. Vernon, February 1973

</div>

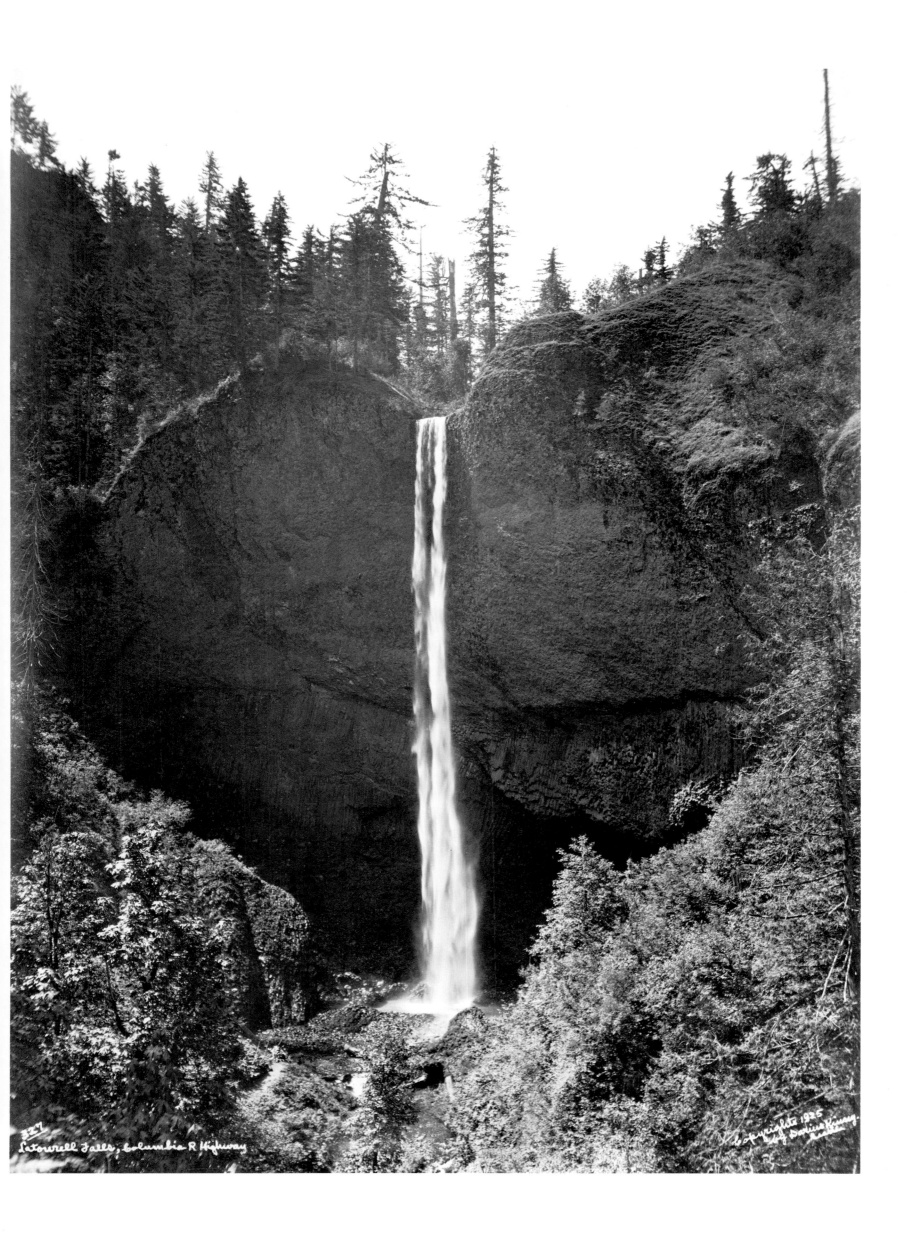

227
Latourell Falls, Columbia R Highway

Copyright 1925
by Sawyers Kirry

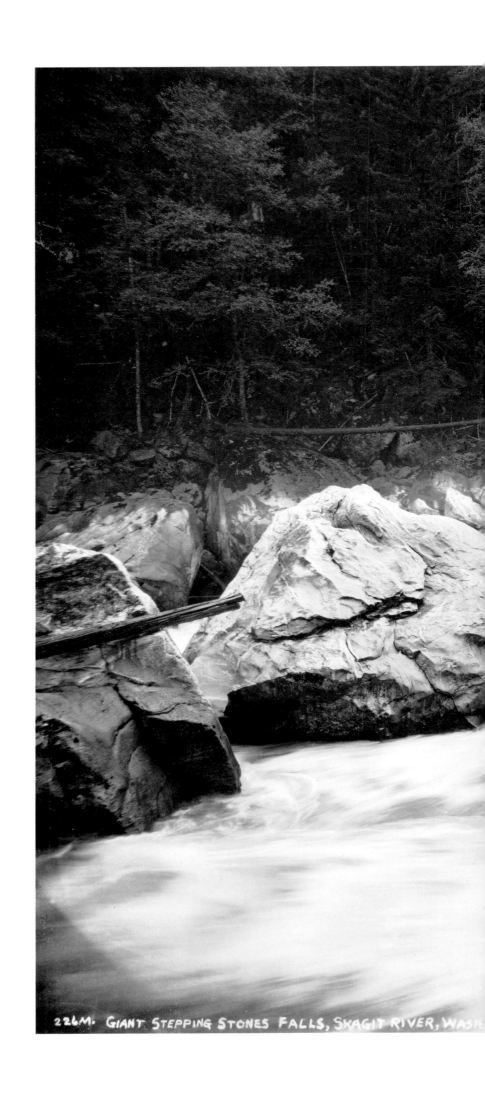

226M. GIANT STEPPING STONES FALLS, SKAGIT RIVER, WASH.

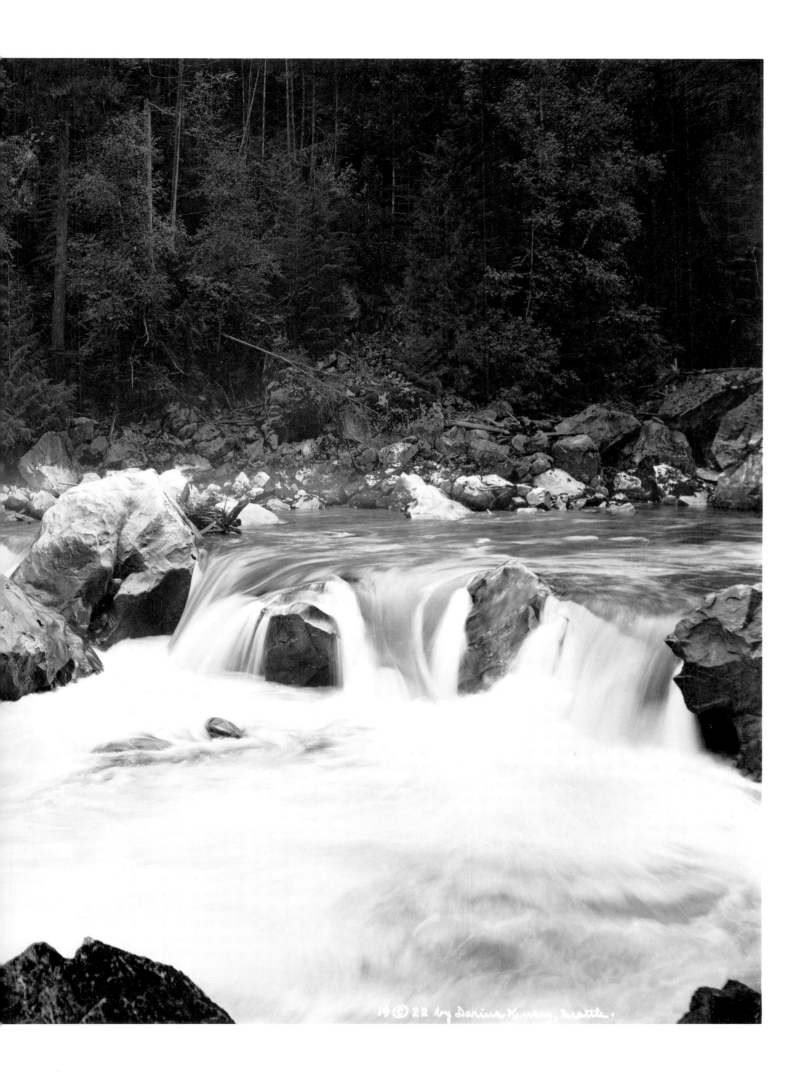

DARIUS AND TABITHA

Darius Reynolds Kinsey, second son of Louisa Elizabeth McBride and Edmund John Kinsey, arrived in Snoqualmie town of Washington Territory just before Christmas of 1889, at the age of twenty. This was the start of the Western venture for Darius, but as yet no evidence has surfaced to indicate that the trek across the plains — from Maryville, Missouri — was in any way connected with the specter of photography.

Darius had come to Snoqualmie with his older brother, Alfred, the two of them preceding the rest of the family — mother and father, three more brothers and a sister.[1] And the lot purchased on December 19, 1889, by A.F. and D.R. Kinsey from The Snoqualmie Land and Improvement Company[2] was presumably the site on which the Kinsey family built the Mt. Si Hotel. So Darius was going to be involved in the hotel business, and perhaps it was also assumed he would help his father with the buying and selling of horses. However, destiny had a few thoughts on the matter. Probably within two months of reaching Snoqualmie Darius came into contact with the instrument then and now known as camera. We will never know who first moved Darius and the black box into proximity, but the evidence we do have allows for speculation, an informed guess with a bit of intuition added: an explosion occurred. Affinity for every aspect of photography must have been within Darius'

genes, was so much a part of his chemistry that, once exposed to the realm of the silver halide and the ground glass, he literally exploded into it. The objective evidence for this rather subjective, almost mystical statement is overwhelming.

We know the first camera was the 6½x8½" and that Darius was photographing within the first year at Snoqualmie. Since the weather in those parts is usually lousy with rain until about the month of May, and since Darius supposedly contained himself long enough — once the explosion had occurred — to sit down and get a few instructions, either from the undocumented Mr. Reynolds at the Mt. Si Hotel or from the undocumented Mrs. Spaulding of Seattle,[3] let us guess that Darius was in the field by July of 1890 — roughly within six months of arrival in the West. By 1891 he had acquired, or at least had access to, an 8x10" camera,[4] and also by then he was working with a 4¼x6½". In 1892 he made perhaps his first great photograph — oxen on the Bryan and Reid skid road — which appears on page sixty-five. By 1894 at the latest he was traveling through the countryside taking family pictures,[5] and in that year he probably met Tabitha in Nooksack. By 1895 he was in partnership with brother Clark, the two of them utilizing both the 6½x8½" and 4¼x6½" formats, the former for logging and scenic photographs and the latter for studio

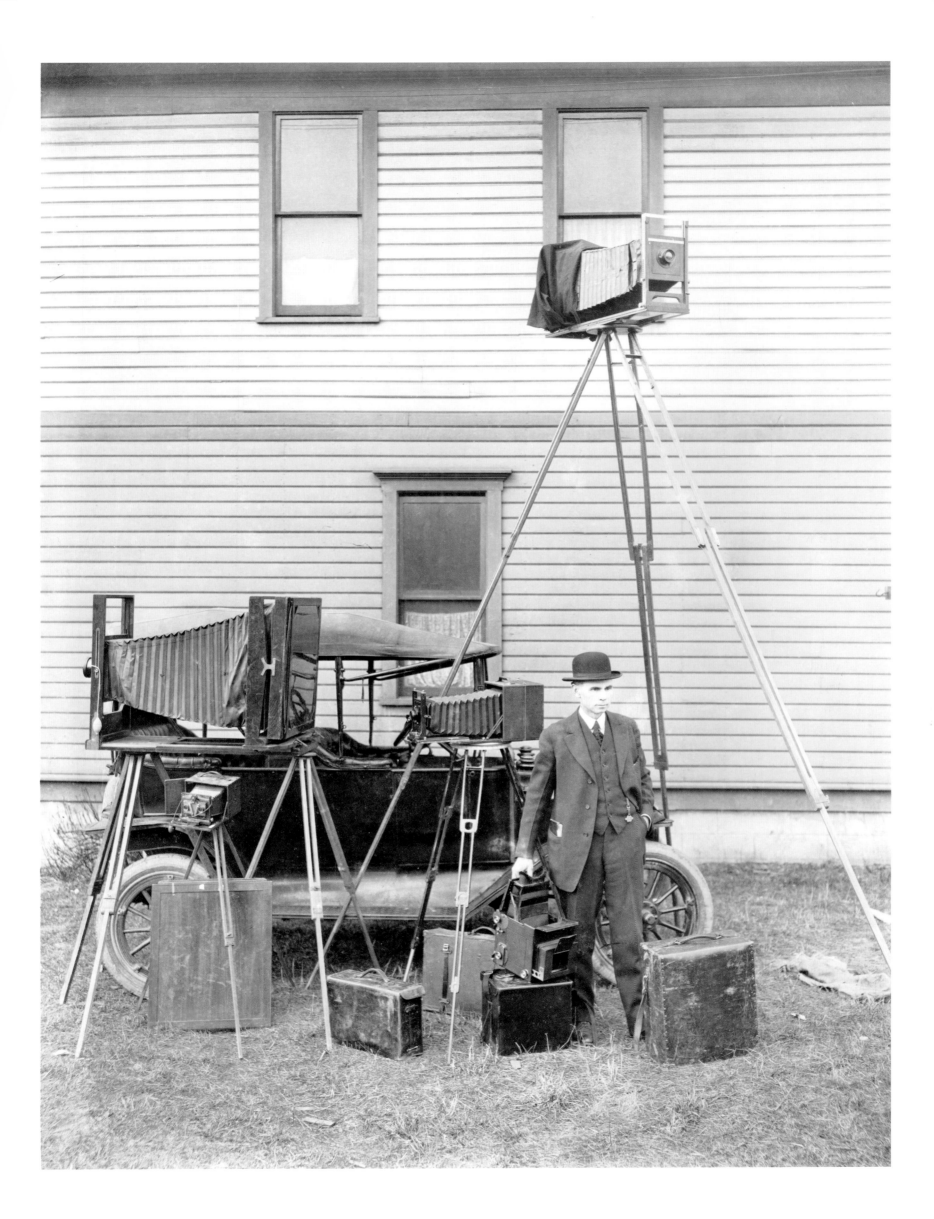

portraits. By 1897 he had purchased the stereo camera and was publishing stereo cards out of Sedro-Woolley, and by August of 1900 he had acquired the camera with which he would produce immortal work — the 11x14" Empire State.[6]

What road had Darius traveled prior to Snoqualmie, out of what background? We know very little. Edmund Kinsey, Darius' father, was the eighth of twelve children born to John and Emeline Kinsey, who were part of the large Kinsey clan — of German and English descent — centered in the Perth Amboy-Woodbridge area of New Jersey. And on February 6, 1867, Edmund married Louisa McBride of Scotch lineage and Boone County, Illinois. Edmund was a carpenter, cabinetmaker, and expert judge of horses. He was apparently restless, and even as the children were arriving he moved the family from Illinois to Missouri to New Jersey and back to Missouri. Nevertheless, four of the six children were born in Missouri. Darius arrived on July 23, 1869, at Maryville, Nodaway County, Missouri, following Alfred by a year and eight months. Then at roughly two-year intervals came Clarence, Emeline, Edmund, Jr., and Clark. As for Darius' boyhood and school years, virtually nothing is known. Based on his red velvet autograph album, he attended high school in Chetopa, Kansas, but he is not listed as having attended or graduated in records at the Chetopa School District. But the sentiments addressed to Darius throughout the month of October 1887, leave no doubt that school companions were doing the writing and that it was graduation time.

Somebody, somewhere, at some point — probably in high school — gave Darius painting and drawing lessons. Two of his watercolors appear in the photograph of the Sedro-Woolley parlor, and there is one glass negative that shows Darius sitting in skullcap, looking every bit the master draftsman, in contemplation of his drawing of the head of George Washington.[7] And that ends it. No watercolors or drawings seem to have survived, no one remembers them, and the school district back on the plains cannot tell us what classes Darius took, if any. We don't know if Edmund and Louisa encouraged the artistic abilities of their second son or if they viewed such endeavor as highly impractical, at a time when practicality was something the immediate family almost certainly needed. Maybe somebody somewhere will run onto a group of Darius Kinsey watercolors and drawings, and maybe Chetopa was not the high school he attended in spite of what the red velvet autograph album says, and the right high school will be dug out of the mist and come across with a list of classes that included painting and drawing. But I think not, and even if so we would not know much more than we do now about the sudden appearance of photographic genius in Darius Kinsey.

It was on one of those family picture-taking rambles through the upper Skagit Valley that Darius met Tabitha at the Pritts' homestead. And if not in 1894, then 1895 at the latest, since by December of that year he was calling her " 'Bitha" (p. 5). Of course, Darius was not the casual, itinerant photographer wandering through the countryside. He already had four or five years of photography behind him, was working officially out of Snoqualmie, was using a monogram on his mounts. And his file of 6½x8½" plates of timber industry scenes must have been growing rapidly, for he was combining the two kinds of photography as he traveled.

It would be nice to know whether or not Darius warned Tabitha May Pritts she might spend fifty years in the darkroom if she agreed to marry him, but warning or no, they took the vows on October 8, 1896, at Nooksack. Tabitha's father was Samuel A. Pritts, originally from Pennsylvania, and her mother was Elizabeth Berg, supposedly of Pennsylvania Dutch lineage. Samuel and

Elizabeth had six children of whom Tabitha was the youngest. With the possible exception of Mary, the oldest of the four Pritts girls, Tabitha was the one who wanted the least to do with farm life. She loved clothes, she emphatically did not like the homestead mud, and she wanted to live in the city. The city turned out to be Sedro, some thirty-five miles south of Nooksack. Hardly a metropolis at the time, nevertheless Sedro and Woolley served an area population of about fifteen hundred, and the two towns that were really one were growing fast. [8] As to why Darius chose Sedro-Woolley for a studio location, the probable answers seem obvious; he would have ready access to close-in logging operations, there was no photographer in town, and Tabitha would be near her family.

Without exception, surviving examples of photographs made by Darius during 1897 bear the placename "Woolley." This is confusing because the property deed for the new home was transferred to Darius on July 7, 1897, for "Lot 4 in Block 58 in Kelley's Plat of the Town of Sedro, Skagit County, Washington." Further, it looks as if Doctor M.B. Mattice, who purchased the same lot for $35.00 at public auction on May 7, 1897, signed the property to Darius without any money changing hands. Possibly the good Doctor needed some family portraits.

Regardless of Darius' preference for labeling himself as a photographer from Woolley, we now have the Kinseys on site at the 300-block of Talcott Street in the town of Sedro, and presumably by late summer of 1897 they had a house. The following year, on August 9, they added Lot Five to the holdings, although values were up a bit and Darius had to part with $65.00. [9]

From the two lots in Kelley's Plat, Darius and Tabitha established the working collaboration that would carry just short of half a century and produce some of the greatest photographs ever taken anywhere. Tabitha May wanted to go to the city because, among other things, she didn't want to cook for farmhands. But if she had known what she was getting into, the farm might have looked greener. What she was getting into was much more than fifty years in the darkroom. She would have to put up with a man who would think of nothing—almost literally—nothing but photography for the rest of his life.

There is today in Sedro-Woolley a newspaper known as the Courier-Times, published by a gentleman named Garry Evans. Eighteen months after the Darius Kinsey field research began, I reached Garry by phone. Which was one of the four or five most fortunate calls made in efforts aimed at reconstructing the lives of Darius and Tabitha. It seems that Garry had in his possession the only holdings in America on the turn-of-the-century Skagit County Times, and Courier, merged about 1920 into Courier-Times. Not only did Garry have the newspapers, he let us pore over them endlessly. Eight years of the Kinseys' decade in Sedro-Woolley were covered as their names appeared sporadically and unpredictably in the pages of both weekly papers, including the steady stream of ever-changing block ads which Darius paid for, some one hundred and twenty varieties at last count. There is no one who can remember any pertinent details of the Kinsey operation in Sedro-Woolley, 1897-1906; there is no correspondence, no published history of the Skagit Valley touches it, and there are no research papers. Therefore, in the absence of the Times and the Courier we would know nothing of the key decade in the establishment of the collaboration, except what could be inferred from the surviving glass negatives. But one cannot infer much from negatives to modus operandi. By itself, a snippet of five or six lines carries very little information. But read through almost two hundred of them plus a few long articles, then mix in the block ads . . . well, the Kinsey years in Skagit

County suddenly came to life. With unending thanks to Garry Evans.[10]

Darius was a superb businessman, and he and Tabitha ran a tight ship on the matter of a photographic portrait studio. In the block ads, Darius constantly hammered on the theme of quality versus cheap, sloppily done work. He would rewrite the ad week after week, always remembering the special occasions—Easter, Christmas, Fourth of July—and remembering also that everyone really needed a portrait of somebody. That is to say, the successful businessman needed a portrait of himself, Mother and Father needed a portrait of Baby or else the three of them together, and don't forget the Wife and don't forget the Sweetheart and there is nothing that would please the Relatives more than a portrait of yourself and don't forget to carefully consider what you will wear and we can handle the sitting rain or shine except that if it is overcast, and in the northwest it sometimes was that way, you had better come between 10:00 and 2:00 for best results, and we will get BEST RESULTS for you and if you aren't pleased bring it back, rain or shine every day of the year holidays included. But don't show up on Sunday. We will not be open on Sundays no matter what. Because on Sundays the cameras were put away and no money changed hands for photographs or anything else. But on any other day of the week Darius was behind the camera and proud of it, and Tabitha was in the darkroom sloshing in the chemicals.

Fortunately, a good number of the 4¼x6½" glass negatives from those studio days are intact, and we can make a firm judgement on Darius' ability under the dark cloth and Tabitha's skill in developing and properly fixing and washing the plates. Also, enough mounted portraits survive to add yet another dimension to the judgement. The prints are almost without exception in fine condition. They are good prints to begin with, some of them excellent, they have been carefully mounted within the borders of the card, and haven't faded in seventy-five years.

Not that Darius was involved only in portraiture during the Sedro-Woolley decade. Far from it. He was all over the map collecting "views" and his energy in this department is even more staggering to behold than the energy he and Tabitha put into the studio. He is off somewhere at every opportunity: to Nooksack on a picture-taking expedition where, among other things, he will put all the school children in the vicinity on the 100-foot-long log across Breckenridge Creek (p. 154); to Fairhaven to "secure some photographic views of fish traps and canneries"; to the Van Fleet place east of town, "a stump that had been hollowed out, on the inside of which were placed five horses and thirty-one people";[11] to Bremerton and Seattle to take stereoscopic views of the battleships and of the scenery around Lake Washington.

When contemplating the effort required to successfully carry out such field photography, it must be remembered that Darius' mode of travel at that time was either horse and buggy or train, and that he wasn't whipping around the countryside with a miniature camera in his pocket. He probably never had less than fifty pounds of paraphernalia along, and by the time he was taking the 11x14" into the woods, total weight was pushing one hundred pounds. And according to the evidence contained in the negatives, during the Sedro-Woolley years he never traveled with less than two cameras, usually the 6½x8½" and the stereo, and there are a few instances where the negatives show there were THREE cameras present—the 11x14" added to the other two.[12]

In addition to the portraiture, the administrative details of running the operation, the constant forays for view-collecting and the visits to the logging camps, Darius managed seven major photographic expeditions during the years 1897-1906. The first two were the expeditions of 1897 and 1900. Darius carried two cameras on the former and three

303

on the latter trip, and both efforts have been discussed in Volume One. Then, in July of 1902, both Darius and Tabitha went into the Monte Cristo-Silverton area of the upper Skagit Valley for two weeks, with the 20x24" and the 6½x8½". Miss Jennings held forth back at the studio, but we do not know any more about her than is in the snippet (p. 154). As for the "immense camera," first mention appears in the Courier in May. Since the sheer size of this instrument attracted a good deal of attention, it is probable that Darius did acquire the monster in mid-1902, else we would have heard about it sooner.

Late summer of 1903 witnessed two more expeditions—the Mt. Baker and Mt. Rainier extravaganzas, and some of the remarkable results from both of these trips have been presented in Volume One.

In August of 1904, Darius went to Yellowstone National Park for about two weeks, apparently only with the stereo camera in tow. The best of the Yellowstone plates are among the finest of his stereos, but otherwise we know nothing of the trip except for a snippet in each of the local newspapers. In September and October, Darius and Tabitha made a round-trip traverse of the U.S.A. with the express purpose—at least, Darius' purpose—of securing stereoscopic views (p. 155). They were gone seven weeks and Darius exposed some eight hundred plates. If we take the liberty of assuming that one week of the seven was not utilized behind the camera because Sunday comes once a week, that leaves us with forty-two days or very close to twenty glass plates exposed per day for six weeks.

Finally, in July of 1905, Darius left "in search of health," with at least one camera along. The Times snippet (p.155) is rather cryptic and very tantalizing. Where did Darius Kinsey go on this last of the expeditions out of Sedro-Woolley? He was apparently alone with his third eye and surely the state of his health must have improved as soon as he started looking at the mountains and the canyons and the streams and the trees. But if any of the glass plates from this seventh expedition are in the Collection, we cannot yet identify them.

By now we have a good idea of Darius' energy output during the Sedro-Woolley decade, but there are yet some miles to go. For example, he came up with the idea of a tent studio, complete with the classic backdrop. It is a miracle that exactly one plate of the tent itself and one plate of a group within the tent have survived. Earliest mention of this portable studio comes in August of 1899, and final mention of the peripatetic canvas comes in June of 1903 (pp. 58-59).

Then there was the matter of exhibiting. Darius did not rest content with displaying photographs in the local post offices. In the fall of 1899, the World's Fair Commission asked him to put together some prints for the State of Washington section of the Paris Exposition of 1900,[13] but this is another of those tantalizing items that so far have led nowhere. Darius may or may not have shown at the Exposition. As yet, no documentation has surfaced. When it comes to the St. Louis Exposition of 1904, we are in better shape. Darius not only exhibited, but he and Tabitha went through St. Louis to see for themselves, Darius no doubt concerned about lighting and whether or not the photographs were arranged properly on the wall. The Mattices, who lived a few doors from the Kinseys, also went to the Exposition that year, and in the Courier for July 7, the following paragraph appears: "Dr. and Mrs. Mattice returned last Friday from their eastern visit, very glad to again breathe the invigorating air of the Puget Sound country after the heat of the east. In conversation with a Courier reporter relative to the big fair and the attractions there, Dr. Mattice stated that D. Kinsey's photo exhibit was one of the attractions in the Washington State building. The views displayed comprised scenes in and around Sedro-

Woolley and largely represent the timber industry. The doctor said that the display was the cause of much favorable comment from those who visited the building."

Nor was the mounted print Darius' only method for getting his work afield in the State of Washington. As far back as 1899 he was taking advantage of the craze for the projected image, and had worked out a scheme in the Big City: "Sedro-Woolley is being advertised in Seattle in a novel and effective manner. A view of the city, taken by D.R. Kinsey recently at the moment when the three daily passenger trains were lying at the depot, is projected from a stereopticon upon a blank wall to the sight of thousands nightly . . ." If you are curious as to what Sedro-Woolley looked like at its "busiest moment" during that year, look at page eighty-five and visualize the photograph projected to a size of . . . ? Perhaps six feet across? Must have been impressive.

By the end of 1900, Darius' photographs were known throughout northwestern Washington. He had ordered a batch of "handsome easel frames . . . upon each of which he has mounted a number of his artistic photographic views, placing them on display in the various towns in the northwest part of the state. No handsomer works of art than these have ever been placed on exhibition in this section, and the Kinsey Photo Studio has reason for self-congratulation on the excellence of the work turned out. Copies of the photos are on sale at the several places where the exhibits are made." We know Darius was exhibiting in Seattle and in post offices in the immediate area—Hamilton, McMurray, and Clearlake—and from a later newspaper reference Whatcom gets into the act. Additional localities involve speculation, but he must have put those easel frames anywhere in proximity to his travels.

Though Darius made sure the work was seen afield, he did not forget he had become Sedro-Woolley's own, and in 1904 he made a presentation to the local Commercial Club.

It can be assumed that the "large views" he gave were from the 20x24" camera, impeccably mounted, of course, and combined with the quality and aesthetics he was achieving by that time, such a gift must have made the clubrooms seem like a gallery of the northwestern woods: "Photographer Kinsey has generously donated a dozen of his celebrated large views of Washington's scenery to the Commercial Club, and they are now being placed in position in the club rooms, in the Douglass block The views are very interesting, especially to strangers, and, being so, are especially fitted for club room furnishings."

All this enterprise required space. It will be remembered that Darius bought the lot adjoining the house in late 1898, presumably so that he could attach a studio to the residence (p. 56). Whether or not that addition was considered to have been the first enlargement of the studio, we do not know. But just into the new year of 1901, we learn that "For the second time since its establishment, it has been found necessary to enlarge the Kinsey Photo Studio. Mr. Kinsey has just made extensions and improvements to the studio which double its capacity, a fact which demonstrates that excellence of products is bound to create new demands. Mr. Kinsey is to be congratulated on the merit which has brought him his deserved success." Three years later, Darius added some more "extensive improvements" to the gallery and remodeled the house at the same time.

By the fall of 1902, Darius was thinking about moving the gallery, and he purchased a downtown lot ". . . on Woodworth Avenue directly back of Thompson's carriage shed, upon which it is his intention to at once erect a large building which he will occupy as a photograph gallery." But this plan was never carried through and two years later Darius sold the property.[14] Also in fall (and winter) of 1902, there is a flurry of snippets relating progress of the proposed Sumas branch gallery (p. 83). First mention, on August 14,

has him "contemplating" such an undertaking, on September 25 he is "considering the proposition," and on December 11 Darius is reported as the purchaser of the Simonds Building at Front and Second Streets, ". . . which he will fit up for a photograph gallery. Mr. Kinsey expects to take pictures." That last line may be the understatement of the entire Darius Kinsey career. However, there is no further mention of the proposed branch, nor any other evidence to suggest Darius followed through.

Darius' single-mindedness about the realm of photography precluded much socializing for the Kinseys. Without exception, reminiscences from those who remember point to the fact that he would not have been very social even without his cameras, but that Tabitha might have been happy with less time in the darkroom and a few more parties. But eight years of the Courier and Times give no indication that the Kinseys ever attended a social gathering in anybody's home, nor did they ever have a group of friends in for the evening. In those days the Sedro-Woolley papers were reporting such events and, for example, we learn that Mrs. C.E. Bingham, who lived a stone's throw from the Kinseys, would organize a party at the drop of a hat. Usually on Friday evening and sometimes for weeks in a row, and everyone who attended was accounted for in the columns. But Tabitha never showed up. Either she was not invited, which seems unlikely, or else Darius disapproved because there were things to be done in the darkroom, and maybe also because occasionally they played whist at those gatherings.

There was one exception to Darius' refusal to have the Kinseys involved in socialization—the Methodist Episcopal Church. Tabitha sang in the choir throughout the Sedro-Woolley years and Darius attended faithfully. Then, on the last Sunday of 1902, the Sunday School was "reorganized" with Darius elected as Superintendent and Tabitha as Chorister. Although it gets confusing when we read, a year and a half later, that ". . . Brother Kinsey has been at the head of our Sunday School for five years . . ." [15] Throughout all of 1903 and 1904 Darius is mentioned repeatedly in connection with the Sunday School, and he was evidently building attendance and enthusiasm. We don't know how many of his pupils had perfect records, but we do know of one. At the end of 1904 he indicated his pleasure with the gift of a Bible: "Presented to Katie Ledderly by Darius Kinsey for being neither absent or tardy for the year 1904 from M.E.S.S. Sedro-Woolley, Wash." [16]

So Darius relented and came out from behind the cameras when the Church was involved. Mostly the M.E. Church, but not always. On December 31, 1903, the Times closed out the year with: "Mr. and Mrs. D. Kinsey, Mr. and Mrs. Charles Mills, Miss Phronia Farnsworth, Miss Minnie Olin and Miss Dill, Mr. Baker and F. Lillie constituted a party that drove over to Burlington Tuesday evening to attend the revival services now being held there." It must have been a cold, wet ride.

There was one other area in the world of socializing where Darius relented, or at least did not interfere with Tabitha's wishes, and that was the well-known phenomenon of visits from relatives. The Kinsey and Pritts clans were large, and we already know from Dorothea's "Recollections . . ." how the early Seattle years saw numerous relatives passing through 1607 East Alder. Well, the Sedro-Woolley years were the same in that respect. There is a reasonably steady stream and we may guess that the newspapers now and then missed reporting a visit. Judging from later evidence we can also guess that the Kinseys started entertaining kinfolk almost as soon as the house had a foundation, but we cannot get any further back with documentation than March of 1899 when Tabitha was no doubt delighted and Darius inundated with a visit from

three of the Kinsey side of the family:

"Mrs. L.E. Kinsey of Snoqualmie, mother of our popular photographer, is in town on a visit. Clarence Kinsey and Clark Kinsey of Snoqualmie are also on a visit to their brother before they return to Alaska, whither they will go on an extended trip in a few days. These latter gentlemen are photographers of note and will take many views of Alaska life and scenery while away."

There were several other relatives visiting during the rest of 1899, and then in October of 1900 Clark is in from the Klondike again. In August of 1901 Dorothea was born, and this momentous Kinsey event must have attracted some visitors but for some reason the newspapers are silent. In June of 1904, Darius' mother is down from Grand Forks, Yukon Territory, where she has just spent three years with Clarence and Clark. This bit of news is important from other points of view. It documents Louisa's years in the wilds of the Yukon, where she supposedly ran a boarding house,[17] and it gives us a bit more insight on Darius' dedication to photographing the big trees. That is to say, he had a mother and two brothers in the Yukon and later on a third brother broke for the North.[18] But Darius held firm against the Fever and continued with the business at hand. In early summer of 1905 there was another flood tide of relatives as Tabitha's mother came down from Nooksack and Alfred Kinsey's wife came up from Snoqualmie. A week later Darius' mother came in from Snoqualmie. Three weeks after that, Darius left on the mysterious trip "in search of health." All of us can sympathize.

It was customary for Darius to consistently run his block advertisements in the local papers, week after week. Until 1902 they were placed almost without interruption, except when he was away on expeditions. By 1903, however, he was easing off a bit on promotion, and by 1905 several weeks would often go by with no advertisement from the Kinsey Studio. Presumably the quality of the portraiture had by then assured customers, but a more important reason for the decreased promotion may have been that Darius was getting less interested in studio work as he spent more time in the woods and worked increasingly with the 11x14" camera. The last block ad appeared in The Skagit County Times on July 12, 1906, and there is no further mention of the Kinseys until December of that year, when they were ready to leave for Seattle, permanently. Thus, Sedro-Woolley was losing two of its most revered and renowned citizens. Perhaps the sense of loss would have been tempered if anyone in town had suspected Darius would go on to produce immortal work with the big camera, but of course no one gave such a thing any thought, least of all Darius and Tabitha. They had to continue to make a living.

On January 9, 1906, Darius paid nine hundred and fifty dollars in gold coin for the lot in Squire Park Addition, Seattle.[19] However, the house that would become 1607 East Alder Street was perhaps not ready for the Kinseys when it should have been (construction delays?) and so, just before Christmas 1906, Darius and Tabitha finally said their official goodbyes to Sedro-Woolley, and a few days later Darius went south to see that they would have liveable quarters: "D. Kinsey went to Seattle Tuesday morning to make the final arrangements preparatory to moving there."[20] Meanwhile, just prior to the testimonial given the Kinseys at the M.E. Church, the well-known, locally famous house and studio changed hands, sold to one C.W. Michener for one thousand dollars: "Lots four (4) and five (5) of Block fifty-eight (58) of the First Addition to the Town of Sedro . . . ,"[21] in the 300-block of Talcott Street only a few doors from the corner of Third, between Dr. Mattice's office and the Presbyterian Church. From those two lots in Kelley's Plat the partnership moved on to the big city.

There would be no more portraiture, nor would there be respite for Tabitha from darkroom duties. The output that was to come during the Seattle years made the Sedro-Woolley decade look like a vacation.

When the Kinseys moved to Seattle at the end of 1906, Tabitha was expecting her second child. Darius Junior was born on April 3, and we can imagine the doting father waiting out the news at the hospital. If so, we imagine incorrectly. Not one piece of correspondence over Darius' hand has survived, and the consensus among the relations is that he did little, if any, personal letter-writing. But with the Collection came a copy negative of an envelope, the same Cedar Stump stationery mentioned on page 102. The envelope was addressed, by Darius, to Mrs. Darius Kinsey, 1607 East Alder St., Seattle. The postmark is Snoqualmie. And the date of the postmark? . . . April 3, 1907, 7:00 A.M. When Darius Junior was born, Darius Senior was with the 11x14" camera thirty miles away from Seattle.

The first months at 1607 must have been chaotic. Ada Pritts Brown, who worked for her Aunt Tib that year, remembered very well that there was an infant around the house: "Well, there were three of us girls there that summer. There was Lucy Marwood and Pearl Bayes and myself. And we were kept very busy. That was the summer Darius Junior was a baby and I took care of him a lot, too. But my main job was washing prints." During the early months in the new house, then, the Kinseys established the home-front work pattern that would hold throughout most of the Seattle years; always a few young people around — mostly nieces until they ran out of supply — to do the housework and help Tabitha with the processing. And what with the relatives who were constantly dropping by for a night or two, the East Alder Street enterprise shortly became known as the "Kinsey Hotel." [22]

And Darius? In the woods. Roaming the logging camps with the big camera, at first arriving via horse and buggy as far as the railhead, then via Model-T, and finally the Franklin. And remember that the paraphernalia during the early Seattle years included 11x14" glass negatives. Once at the railhead, via shortline (usually) to the camp where Darius Kinsey, Master Photographer of the Big Trees would climb down from the cab of the locomotive to pile one hundred pounds of equipment alongside the tracks, then head off to the bull cook shack to find his bunk. And the next morning, breakfast with the boys — then aboard the speeder heading out for where the action was. One hundred pounds of equipment, and how many hundreds of pounds of glass negatives went back to Tabitha? We need another zero. Thousands of pounds of glass were shipped to Tabitha who, almost literally, never stopped working. She developed by inspection, made the contact prints and sent the finished product back to the woods, where the loggers payed Darius fifty cents per picture. And Tabitha herself said that never once in all the years did she fail to get the package off on schedule. [23]

A number of those who remember certain aspects of the Kinseys' marketing procedure have commented on the manila print-delivery envelopes (they were really bags), in which Tabitha put the photographs for each individual who had placed an order. Since the main source of income for Darius and Tabitha was based on prints delivered to the logging camps, the envelopes took the place of the block ads which had figured so prominently at Sedro-Woolley — that is, the envelopes carried the promotional message. Three varieties survive and the earliest, a copy of which was found wrapped around one of Darius' stereopticon viewers, is the most fascinating. This 17x21" bag was printed during the East Alder Street years, when the Kinseys were still selling "views" from four different formats: 20x24", 11x14", 6½x8½", and stereo. Each of the formats is represented by a list, but the most

illuminating aspect of the envelope is the textual material. In writing his message, Darius really produced a short essay on the history of the partnership with not a small amount of philosophy thrown in. Minus the list, here is the essay, in order as it appears on the face of the envelope:

"The titles listed represent only a small part of our large collection of negatives. Have carefully gone over entire collection, selecting only those that were of the most interest.

"We are in the View business exclusively. Our negatives are all taken right on the spot where the scene is represented. Every view is finished from these original negatives.

"The reality and strength that is lost by copying and enlarging is retained by using the original negative. ORIGINAL NEGATIVES is our motto, which has much to do with the wide known popularity of our views. To secure original negatives it is necessary to visit personally all points where there is likely to be something of interest. While making these tours we photograph large groups, mills, farms, etc., but no portraits, as that is not in our line of work. We are always anxious to get negatives of logs that are being yarded out which are ten or more feet in diameter. Any items that may be of general interest to eastern people we are glad to hear about.

"The highest type of lens is used in making each negative. This part of the work I do personally, having travelled almost continuously with my camera since 1891. The vast amount of experience I have had is evident in the character and quality of negatives. These negatives are developed by Mrs. Darius Kinsey, who has had charge of the finishing department since 1899. Where a large business is handled it is necessary to employ help, who in some instances, get careless when washing or mounting a batch of pictures. The least trace of 'hypo'—which is used to fix the pictures—if not properly eliminated from pictures will cause them to fade after a time. Our pictures are all

washed through sixteen changes of water. If any trouble along this line occurs, it is from cause mentioned. All large studios have and always will have a little trouble from this source and are always glad to get back such pictures, replacing them with others.

"The question is frequently asked if we have such and such a negative taken by us several years ago. Some of the negatives taken as early as 1890 are still in my collection and ALL OF THEM since 1905. An order for one or more pictures can be finished at any time. Darius Kinsey, View Publisher, 1607 East Alder Street, Phone East 6778." [24]

In 1914, Tabitha finally got a respite—of sorts. Darius shifted to film.[25] Then, during 1915 he reviewed his glass negatives, and in 1916 published a catalogue with the following highly significant statement:

"At a considerable outlay of time I have carefully examined each negative in my large collection of Washington views, in which every phase of logging, lumber mills, and etc., are represented. From this large collection, 240 of the most interesting negatives were selected, which were then classified, all similar subjects being grouped together. These groups of negatives were then arranged in rotation according to their relation to each other, and then EACH NEGATIVE RENUMBERED. Two hundred and twenty-one of the subjects represent 11x14" negatives. Seventy-eight of the most interesting of these have been carefully selected and are to be known as our stock negatives. Preceding the number on each title of this set of seventy-eight, is the letter 'A' or star 'A'; star 'A' appearing only on thirty, which we consider of unusual interest and may well be termed as the cream of our collection" [26]

The statement is significant because it begs the question—what happened to the rest of the glass at the time, if anything? Jesse Ebert was asked that one, during one

of four long interviews. He had the answer: "Well, the rest of the glass was all destroyed. All of those that were taken down to Pacific Picture Frame, and there was a whole truckload full of them. It was during World War I, and Pemberton—I think that was his name, that owned the Pacific Picture Frame—told me that he was so anxious to get glass that he agreed to destroy the image on each plate, and they set up a hot tank and hired a couple of kids to scrub the gelatin off of the plates. He said a whole truckload."

About seventy percent of Darius' list of 1916 survives—glass and film negatives from the first thirteen years with the 11x14" camera.[27] But we will never know how many plates were destroyed at Pacific Picture Frame in Seattle. A reasonable estimate might be 10,000.

In the same year he shifted to film, Darius added the final variation to his arsenal of cameras and negative sizes. He purchased the Folmer and Schwing Cirkut Outfit and did a series of "panoramic subjects" eight inches wide by as long as fifty-three inches. Although some of these panoramas were listed in the 1916 catalogue, Darius apparently ceased making Cirkut negatives in late 1915. Following purchase of the Folmer and Schwing, either in late 1914 or early 1915, the Master Photographer set aside a morning—or maybe an entire day—and rolled the Model-T alongside the house at 1607 East Alder. He arranged the battery of cameras and cases,[28] donned his bowler, and proceeded to take a series of 11x14" self-portraits (or was Tabitha behind the camera?). One variation of this magnificent photograph appears at the beginning of the catalogue, titled "Darius Kinsey and Equipment." On the same page, under the heading "Preparedness," Darius talks about the picture:

"This picture emphasizes the fact that I am well prepared to do any kind of work in my line. The ELEVEN by FOURTEEN CAMERA and HIGH TRIPOD, form a combination that is hard to beat. The striking and unusual results secured by the use of this camera cannot be equaled with any smaller size instrument. Prints from original 11x14" negatives of the big trees and logs, have in them characteristics which give one a decided impression that the trees and logs are really large. In some subjects (in order to secure results which will be a credit to the scene) camera should be elevated higher than is possible with an ordinary tripod. The HIGH TRIPOD permits the camera to be quickly adjusted to any height desired, up to twelve feet . . ."

From the dramatic point of view, Darius Kinsey's self-portrait-with-equipment hardly matches the nonpareil of such photographs— F. Jay Haynes at the Great Falls of the Missouri, six-shooter and sheath knife in belt, knee boots, and rakish hat above the supremely confident, casual pose. But Darius was not given to overstatement. In his classic presentation of himself with precious cameras, he is suggesting versatility in his line, as he calls it, and the wonderfully low-key aspect of that presentation fits the personality we have been looking at for more than three hundred pages. Yet, we now have enough understanding of Darius' photography to more fully appreciate just how superbly the photograph sums up his career, even though taken in 1914, twenty-six years before the last negative. That quiet man under the bowler, with starched collar, accomplished miracles in the woods—quietly.

On November 11, 1918, Darius Junior was shingling the roof at 5811 Greenwood Avenue when news of the Armistice came.[29] Greenwood Avenue was to be the new location for the "View Publishing House," and the Kinseys moved there in the first part of 1919. Darius Senior proceeded to give his growing enterprise a name—Timber Views Company—and thereafter most negatives were signed with that legend. A letterhead was printed, using the famous 1892 Bryan and Reid ox team photograph, Darius Junior was listed as Secretary, Darius Senior was

mentioned as ". . . behind the camera when all our films are exposed," the phone was SUnset 1197, and there was no letup in the prodigious flow of negatives from the logging camps. Further, Darius now added the realm of industrial photography to his repertoire, in some cases utilizing the 11x14", but also returning to one of his earliest formats — the 8x10" — for an extensive series on the Lake Cle Elum project in the late twenties and early thirties. Darius seemed especially interested in the construction of dams, and in addition to Cle Elum, photographed at Diablo Canyon and Baker Lake, and on the Tacoma-Cushman and Skagit River projects. At least some of the industrial photography may have been done on assignment, as perhaps with Winston Brothers (Cle Elum), Ivanoff Machine Shop, Hollywood Farms, and Carnation.

As the years sped by, Darius spent less time in the woods and increasingly photographed large groups of men in the shingle mills and lumber yards, in situations where he did not have to drag the equipment any distance from the Franklin. But he still went out to the camps, and Tabitha became more and more fearful he would get injured. Which is what happened, because in the fall of 1940 Darius slipped and fell while climbing a stump, or at least that is the undocumented story. He was probably not seriously injured but he never photographed again.[30] The magnificent odyssey was finished. By that time he was famous throughout the State of Washington, but mainly within the timber industry, where his efforts were seen as excellent history and fine documentation. Indeed, the efforts were all of that, for Darius did not stop with the loggers in the woods, where he photographed every aspect of the scene, but followed the timber all the way through the mills to the docks, where the schooners waited for the finished boards. Yet the camera work of Darius Kinsey was really a gigantic concentration of vision that clearly

transcended the mere documentation of logging and became greatness.

And let us not forget that across the fifty-year career, in spite of his preoccupation with the photography of logging, Darius returned again and again to the foothills, the snow peaks, rushing water — especially Snoqualmie Falls and the Skagit River. The landscape. Both Dorothea and Darius, Jr. have commented on the endless waiting the family endured as the indefatigable photographer dragged his equipment over the hills to look at the natural scene. By the time he was setting up the big camera for the waterfalls of the Columbia River Gorge and Yosemite — in the mid-twenties — Darius Kinsey had three decades of landscape photography behind him, and of course that included the big trees. But it is fascinating to take the glass and scrutinize a print, on which we will see that Darius has tacked on the side of the cookhouse a large number of sample 11x14's for the men to choose from. And usually, regardless of the number, seventy-five percent of those pictures [31] are pure landscape. Rather eloquent testimony as to what Darius thought of his "scenic" work.

And Tabitha? Well, she finally got out from under the yellow lights, apparently not really aware of the enormity of her contribution. In 1953, when Darius had been gone for eight years,[32] the Reverend Erle Howell of the First Methodist Church interviewed her at 5811 Greenwood, where Tabitha had her own apartment even though the house had been sold. The subsequent article appeared as "Fifty Years in a Darkroom," in The Seattle Times of June 14. The final paragraph reads as follows:

"Asked to comment upon her work in the darkroom, Mrs. Kinsey calmly observed, 'There isn't much to say. I only did my duty. Any good wife would have done as much. Photography was my husband's business, and it was my job to help. I tried never to let him down. I can see nothing especially noteworthy about that.' "

NOTES AND REFERENCES

1. Darius' arrival date based on his autograph album (see p. 16), according to which he was definitely not in Snoqualmie prior to the month of December. Statements regarding lineage and birth dates are based on various family Bibles, and the 1880 Soundex (see p. 37). Additional family biographical information appears in An Illustrated History . . . (1906, p. 683), The Snoqualmie Valley Record, June 25, 1953, and was also gathered from interviews with relatives.

2. Vol. 94, Deeds, REC #47362, King County. Also Vol. 65, Mortgages, REC #73349 (Dec. 1890), King County. The Improvement Co. advertised lots in the Seattle Daily Press, June 7, 1889.

3. Undocumented family stories.

4. Kinsey solar print owned by D. Reinig.

5. Portrait of Ada Brown (at age four) and parents, dated 1894.

6. The dates are based on existing negatives, stereo cards, and mounted prints. By this time, Darius was also advertising himself (with Clark) as official artist for Seattle and International Railway, and Seattle, Lake Shore and Eastern Railway. We do not yet know what this meant, but probably no assignments were involved.

7. Reproduced in This Was Logging!.

8. An Illustrated History . . . (1906, pp. 219-227) is an excellent source on Sedro-Woolley at that time. See also our pp. 82-89.

9. Deeds, Filing #28855 (1897) and #49245 (1898), Skagit County.

10. The Skagit County Times, March 1899-April 1907; The Skagit County Courier, June 1901-March 1904. Month and year of

the quotation is usually given in the essay, but these newspapers have been treated as a discrete unit in order to avoid additional footnoting. Unquoted commentary on the Sedro-Woolley years is also based on the numerous snippets, unless otherwise documented.

11. This 6½x8½" glass negative has survived, and was reproduced in the Golden Jubilee edition, The Courier-Times, Oct. 20, 1949 (p. 7), with all participants named. According to the caption, the photograph took first prize at the Portland (Oregon) fair in 1905.

12. The Cedar Stump Residence (pp. 102-105) was photographed with four cameras.

13. Pp. 83 and 94, snippets.

14. P. 83. The Woodworth Ave. transactions are in Deeds, Filing #41644 and #49247, Skagit County.

15. P. 155. No mention of Darius in this position appears prior to Jan. 1, 1903.

16. Courtesy of Ray Jordan.

17. Surviving family members cannot provide information on this matter. Clark Kinsey (or Clarence?) photographed the building, according to an identification by Dionis Reinig.

18. Alfred Kinsey, in 1905, according to Alfreda Kinsey Tiddens, interview.

19. Vol. 454, Deeds, REC #371949, King County.

20. The Skagit County Times, Dec. 20, 1906.

21. Deeds, Filing #59962, Skagit County.

22. Darius Kinsey, Jr., interview.

23. Reverend Erle Howell, "Fifty Years in a Darkroom," The Seattle Times, June 14, 1953. Based on an interview with Tabitha.

24. The other two surviving envelopes are 13x18", both published out of 5811 Greenwood Ave.

25. The latest glass negative is dated 1913, with a few exceptions, such as Mt. Rainier 1923 (p. 283). The earliest film negative so far located is Sept. 24, 1914.

26. Catalogue of Washington Timber and Scenic Views. Darius used several numbering systems. They are not reliable for chronology, nor are his copyright dates, some of which he changed periodically.

27. The Catalogue also offered Panoramic Subjects (both Cirkut and 11x14" doubles and triples), prints from 20x24" negatives, Lantern Slides, and Enlargements to 40x60"!

28. The cameras have been identified with reasonable certainty by Eastman Kodak, Patent Dep't. Museum (correspondence) as the 20x24" Empire State, the 11x14" Empire State, the 5x7" Stereoscopic Premo, the 5x7" Press Graflex, and the Folmer and Schwing Cirkut Outfit No. 8. In addition to which Darius worked in 3¼x4¼", 4x5", Stamp Photo, 4¼x6½", 6½x8½", 8x10".

29. Dorothea Kinsey Parcheski, correspondence.

30. Latest date on a negative is October 1940.

31. Sometimes as many as eighty-five prints were displayed.

32. Darius died in Sedro-Woolley on May 13, 1945, obituary in The Seattle Times, May 14, 1945. Tabitha died in Bellingham on Nov. 23, 1963, obituary in the Bellingham Herald, Nov. 24, 1963.

Books

Adams, Kramer: **Logging Railroads of the West,** Superior Publishing Co., Seattle 1961 (locomotive photographs).

Andrews, Ralph W.: **This Was Logging!,** 1954 (text and photographs); **Glory Days of Logging,** 1956 (photographs); **This Was Sawmilling,** 1957 (photographs); **Photographers of the Frontier West,** 1965 (text and photographs); Superior Publishing Co., Seattle.

An Illustrated History of Skagit and Snohomish Counties, The Interstate Publishing Co., 1906 (biographical sketch).

Clark, Donald H.: **18 Men and a Horse,** The Metropolitan Press, Seattle 1949. Reprinted by Whatcom Museum of History and Art, Bellingham 1969 (uncredited photographs).

Holbrook, Stewart H.: **Down on the Farm,** Crown Publishers, N.Y. 1954 (photograph).

Jensen, Oliver, and Joan Kerr: **American Album,** American Heritage Publishing Co. Inc., N.Y. 1968 (photograph).

Koch, Michael: **The Shay Locomotive; Titan of the Timber,** World Press Inc., Denver 1971 (locomotive photographs).

Ranger, Dan Jr.: **Pacific Coast Shay; Strong Man of the Woods,** Pacific Railroad Publications Inc., San Marino 1964 (locomotive photographs).

Szarkowski, John: **The Photographer's Eye,** Museum of Modern Art, N.Y. 1966 (photograph).

Taber, Thomas III, and Walter Casler: **Climax — An Unusual Steam Locomotive,** Railroadians of America, Rahway 1960 (locomotive photographs).

The Way Life Was, Praeger Publishers, N.Y. 1974 (text and photographs).

Willis, Margaret (ed.): **Chechacos All; The Pioneering of Skagit,** Skagit County Historical Society, Mount Vernon 1973 (photographs).

Magazine Articles

Bohn, Dave: "Kinsey, Photographer," **The American West,** May 1975 (with photographs).

"Dempsey Logging Camp at Hamilton Has Unique Features," **West Coast Lumberman,** October 1, 1918 (with photographs).

Denman, Frank: "The Enduring Legacy of Darius Kinsey," **Seattle,** January 1970 (with photographs).

Holbrook, Stewart H.: "Daylight in the Swamp," **American Heritage,** October 1958 (with photographs).

Life: "Speaking of Pictures: Work of Forgotten Photographers...," September 10, 1951 (photograph).

Ripley, Thomas Emerson: "Shakespeare in the Logging Camp," **The American West,** May 1967 (with photographs).

Willey, D. A.: "Logging in the Northwest," **Scientific American,** December 29, 1900 (with photographs).

The Yellow Strand: November and December 1915, January-March 1916 (photographs).

Newspaper Articles

The **Argus:** "Darius Kinsey and Paul Bunyan," July 10, 17, 24, 31, and August 7, 1954, Seattle (photographs).

Dowdle, Mollie: "Photographer Leaves his Fond Visual Memories Behind," Skagit Valley **Herald,** November 15, 1962.

Fish, Byron: The Seattle **Times,** January 15 and 16, 1953.

Golden Jubilee: The **Courier-Times,** Sedro-Woolley, October 20, 1949 (photographs).

Holbrook, Stewart H.: "Darius Kinsey," The **Oregonian;** Northwest Roto Magazine, November 28, 1954 (with photographs).

Howell, Reverend Erle: "Fifty Years in a Darkroom," The Seattle **Times,** June 14, 1953.

Jordan, Ray: "Ace of the Picture Men," Skagit Valley **Herald,** September 25, 1969.

_____: "Kinsey, Davis and Ketchum," Skagit Valley **Herald,** October 17, 1973.

Nooksack **Reporter,** October 9, 1896.

The Seattle **Post-Intelligencer:** "Almost to the Summit of Mt. Baker," September 13, 1903 (with photographs).

_____: "Have Narrow Escapes...," July 21, 1903 (Mt. Rainier).

The Skagit County **Courier.** The Skagit County **Times,** 1899-1907.

The Snoqualmie Valley **Record,** June 25, 1953 (interview with Emeline Kinsey Odell).

Exhibition Catalogues

Barrow, Susan H. L., and J. Allan Evans: **Green Gold Harvest; A History of Logging and Its Products,** Whatcom Museum of History and Art, Bellingham 1969 (text and photographs).

Szarkowski, John: **The Photographer and the American Landscape,** Museum of Modern Art, N.Y. 1963 (photographs).

THE DARIUS KINSEY COLLECTION

In February of 1970, Cicely Berglund forwarded a copy of the January issue of Seattle. On the cover was a photograph of a 103-year-old Northwest Indian, by Darius Kinsey. One of the feature articles, "The Enduring Legacy of Darius Kinsey" by Frank Denman, included seven more Kinsey photographs.

Cicely asked if I had ever seen Kinsey's work, and did I want her to talk to Jesse Ebert, the gentleman who owned Kinsey's negatives? I replied that, indeed I had seen a little of Darius Kinsey's work, but very little — probably no more than five reproductions. Nevertheless, what I had seen was outstanding. And sure, why not? Why not see Jesse Ebert and find out if he was interested in selling the Collection. But Cicely never found Jesse and the rest of the year 1970 slipped by quickly. Seattle magazine stayed on the shelf, although I knew it was there.

A year later, while browsing Shorey's Western Catalog Number 24, I noticed six Darius Kinsey prints for sale. That random observance reopened the matter, and by March of 1971 I was in touch with Jesse Ebert, by telephone from Berkeley. He still had the negatives, and ten days later I headed north on a breakfast flight. Jesse met me at the airport and filled me in as we drove to West Seattle. He had bought the Collection in 1946 direct from Tabitha Kinsey, a year after Darius' death. Over the years he had been adamant against fragmenting the Collection through partial

sale, and then Jesse delivered a few nice stories about the "cheapskates" who had never wanted to buy because of the price. On arrival at Jesse's aerial photography enterprise, we entered at the basement door and walked through the darkroom and preparatory areas, up the stairs past a Darius Kinsey locomotive mural, through the studio into the negative storage area. In the righthand corner was a huge, four-drawer X-ray file cabinet. Piled on top were many yellow Kodak boxes and some 11x14" glass negative crates.

This was the Darius Kinsey Collection, which Ebert had tended for twenty-five years. I was mentally prepared for viewing superb photographs, but it would have been impossible to understand in advance the quality and scope of Kinsey's lifework. The sheer quantity — almost three thousand 11x14" negatives — was staggering, but the Collection represented a great deal more than quantity. After looking at some twenty negatives on Jesse's very large light table, it was obvious that Darius Kinsey at his best nudged genius. But the immense additional factor was the remarkable consistency of the work — the smooth tonal range and tight control of contrast, the delicacy of so many of the pictures. Considering the difficulty of photographing in the woods, the technical achievement was hardly believable.

It was not necessary to see more to realize the magnitude of the collection Ebert had preserved. So Jesse and I had a long lunch. He was looking me over, because it

was obvious those negatives were not going to move to someone he didn't like. And I was doing some mental arithmetic and getting tenacious. But we got along famously. After another long meeting the next day, I told Jesse I would return for the Collection in two months, and headed south on a dinner flight.

Three months passed before I could get back to Seattle. There was some additional mental arithmetic to do, but more important was to find someone who could and would collaborate with me on what I suspected would be a large undertaking. Eventually I called Rodolfo Petschek, friend of ten years or so, and we had lunch at the Heidelberg on Telegraph Avenue. I told Rudi what I had been up to and suggested we purchase the Collection jointly. By the time we finished our knockwurst with red cabbage, we were partners in the Darius Kinsey Collection—with a handshake over dessert.

When I finally took another breakfast flight north, Ebert met me at the airport again. The following day it took us two hours to pack the negatives for transport. I felt genuinely sad as we shook hands at the curb in West Seattle. Jesse had preserved the Kinsey legacy for a quarter century, and preserved it intact. The Collection had, in its own way, become part of him. Nevertheless, he felt the negatives had found a proper home and I had a similar suspicion. We waved goodbye and I drove off with the monumental photographs.

Following Ebert's purchase of the negatives in March of 1946 (at first with a partner, whom Ebert bought out nine months later), the Collection developed a unique life of its own. Ebert occasionally sold mounted Kinsey prints at a nominal price, but he was not overwhelmed with orders. Then in 1953, Ralph Andrews, the Superior Publishing Company author, approached Jesse and asked if he could utilize some of Kinsey's photographs for a book. Permission was granted and that project became This Was Logging!, published in 1954 in Seattle. Naturally there were the usual requests from the calendar and textbook interests (they can never afford to pay very much for black and whites), and the logging and railroad museums (they can never afford to pay anything). A railway museum in New York, for instance, while not able to offer cash, nevertheless trusted that Ebert would favor them with a print from every Kinsey locomotive negative he had (well over one hundred), allowing that Ebert would be given courtesy credit in the displays.

Meanwhile, on September 19, 1952, Ebert, Sam Emmanuel, and Paul Sirlin signed an agreement whereby Emmanuel and Sirlin took an option on the Collection. From that day forward, for just under twenty years, Emmanuel made efforts to sell the Collection on behalf of Ebert. Fortunately a complete record was maintained and preserved by Emmanuel, and more than a year after the Collection left Ebert's hands the existence of the correspondence became known to the authors.

In November of 1952 Emmanuel first offered the Collection for sale. The final attempt was made in a letter of March 30, 1970. Across those eighteen years Emmanuel corresponded coast to coast. The Collection was offered to, among others, the University of Washington, the Washington State Historical Society, Whitman College, Weyerhaeuser Company, Rayonier, Crown Zellerbach, West Coast Lumbermen's Association, The Bancroft Library at University of California, Yale University, Clemson University, Forest Products History Foundation (later known as the Forest History Society, Inc.). Early in the correspondence Emmanuel even went after some of the advertisers: The Kemper-Thomas Co. ("Advertising That Lives"), Shaw-Barton ("Calendar and Specialty Advertising"), and Brown & Bigelow ("Basic Advertising Ideas through Remembrance Advertising").

Most of the Institutions mentioned did

not have budgets for purchase of such a collection. So Emmanuel approached various individuals in the timber industry, and also the Forest History Society, which was qualified to act as liaison but also had no budget of its own. Without exception potential donors and recipients haggled over price, which was in the neighborhood of five dollars per 11x14" negative. Further, the Collection was seen only as a source on the history of logging in northwestern Washington. The Collection was very definitely a documentation of logging in that area, from 1900 to 1940. But not just any documentation—an unprecedented, superb documentation. And throughout the correspondence, only Herbert Winer, Professor of Lumbering at Yale, understood that Kinsey had also depicted a lifestyle—by just as carefully photographing the homesteaders, the school in the wilderness, the kitchen help in the logging camp. Finally, all potential donors and recipients missed the major point: Darius Kinsey had created a gigantic, historical work of art.

At the University of Washington, Robert Monroe (Special Collections) made attempts to see that the Collection was secured for that University, but he was voted down. However, in the myopic approach to the Darius Kinsey negatives, Yale University headed the list with quite a bit to spare, as representatives of that august repository debated endlessly with Emmanuel and Ebert over the greatest intact collection of logging photographs in existence. In May of 1962, George Garratt, then Dean of the School of Forestry at Yale, spent two hours at Ebert's studio looking at Kinsey's negatives and prints. Thirty prints were then shipped east by Emmanuel, and in July Garratt referred the matter to the aforementioned Herbert Winer. Meanwhile, so that Winer would have more information on which to base his eventual recommendation to Librarian James Babb, four more visitors were sent to

inspect the Collection, including a logger/photographer, a commercial marine photographer, and Mrs. Iva Hopkins, who was to provide a detailed list of the negatives. The list subsequently ran to forty typewritten pages of captions, when such appeared on the negative; otherwise, a one-line description of the photograph.

Winer's recommendation to Babb (a copy of which was sent to Emmanuel) was essentially affirmative, his major point being that if the unpublished part of the Collection partly resembled the published (in Ralph Andrews' books), the value of the Collection to Yale would be large. But Yale and Jesse Ebert were too far apart on price, and apparently no one acting on behalf of Yale had the slightest understanding that they were looking at the work of a genius photographer. For example, Emmanuel noted that two of the four visitors mentioned above ". . . kept stressing the fact that many of the photos did not have historical significance."

In late 1964, negotiations with Yale were reopened when Ebert dropped his price to about $3.00 per negative, and the Forest History Society (by then housed at Yale) became involved in an advisory capacity. Two more Yale alumni visited the Collection, but Dean Garratt and Elwood Maunder (Director of the Forest History Society) both thought the price was still too high. And there rested matters with Yale. Except that there was a final letter from Elwood Maunder to Sam Emmanuel. Maunder had done what he could to act as liaison between Yale and the Collection but, although he certainly wanted to see the negatives placed, he understood them as nothing more than an excellent source of timber industry history. He felt Ebert should reduce the price further, and suggested a figure which rounded out to $1.47 per negative.

A very interesting comparison can be made between the myopia of Yale University and the understanding shown by John Szarkowski at The Museum of Modern Art in

New York. Szarkowski was not a potential donor or recipient, but in 1962 he was organizing the exhibit which would be known as "The Photographer and the American Landscape." In November of that year Szarkowski wrote Ebert, noting that he had recently come across Kinsey's work as reproduced in This Was Logging!, that he was impressed, and that he wanted to obtain prints for the permanent collection at MOMA. And further, if Ebert thought Kinsey had done outstanding work in pure landscape, Szarkowski might include Kinsey in the budding exhibit. Kinsey was eventually included in that great exhibition, as one of nineteen landscape photographers active from 1867 to 1962. Of the nineteen, only six were practicing prior to the turn of the century, and Darius Kinsey—who took his first photograph in 1890—was thus to be found in esteemed company. The other five were Timothy H. O'Sullivan, William Henry Jackson, Henry Hamilton Bennett, Edward Steichen, and Alfred Stieglitz.

As for representatives of the timber industry, contacted by Emmanuel as potential donors—well, they are hardly worth mentioning, so dull was the response. Without exception they yawned, even the one or two who made the effort to visit the negatives. And of course they grumbled about the price. But we are indebted to the industry for the greatest line to come out of Sam Emmanuel's eighteen years of correspondence. A representative of one of the largest timber companies in the world thanked Emmanuel for his letter, but opined that the Darius Kinsey Collection would not really add much to that company's public relations program nor their corporate image-building.

Field research on the lives of Darius and Tabitha Kinsey began in the fall of 1972 with the first of four extended trips to the Seattle area—west as far as Port Angeles, east as far as Snoqualmie, south to Tacoma, and north to Nooksack, with a good many stops in between. With the exception of the old newspapers which illuminated the Sedro-Woolley decade, knowledge about the double career came mostly from interviews with those who remember one or both of the Kinseys. Virtually all those interviewed had material they were willing to loan for copying, and freely shared the reminiscences which helped immeasurably in getting a subjective feeling for the Kinsey operation. Objective items—such as dates and property deeds—were gathered in usual places, as mentioned in notes to the Essay. Finally, the negatives themselves played a silent but enormous role. Two years after purchasing the 11x14" negatives from Jesse Ebert, the surviving pre-1900 work came to light. Thus, as we came to know more about the Kinseys, so we came to know more about the photographs, and were able to understand clues which had been there all along.

The list of those who have helped us with the Kinsey story is long, and the Volumes would have been no more than a bound portfolio of photographs without that help. In addition to those whose signed interviews appear, I am indebted to the many others who were willing to sit down and talk, loan original material, or provide other kinds of information: Garfield Green, Reverend Erle Howell, Evelyn Loop, Lottie Robinson, John Wahl, Art Bacon, Galen Biery, Ed Case, Mrs. Harlan Cavender, Pastor Earl Dean, Frank Denman, Stanley Dexter, Charles Dwelley, Edward H. Kinsey, Mr. and Mrs. Paul Leonard, Jack Macdonald, Harry Majors, Mr. and Mrs. Elmer Matilla, Donita Robertson, and Arvilla Sheeder; Ruth Scherr at The State Historical Society of Missouri, Hazel Bush at the Chetopa District Schools in Chetopa, Kansas, Irene Schumaker and Barbara Bashaw at the Skagit County Historical Society, Mrs. Jack Ferrell and Mrs. Mary Lou McKibben at the Snoqualmie Valley Historical Society, and Margaret Yeoman at the Skagit County Auditor's Office, Mt. Vernon.

With reference to the Skagit County Times and Courier—those early-day Sedro-Woolley newspapers, gratitude to Garry Evans, Publisher of the present day Courier-Times, for his generosity in making available to us what turned out to be a gold mine of information on the Kinseys.

And to those who took an exceptional personal interest in the project during the three years of research: Ralph Keaton, for supplying leads toward additional interviews; Allison Belcher, who conducted the remarkable six-week search in Portland for the Great Glass Plate, and Gordon Miles who subsequently allowed that Plate to return to the Collection; Peter Parcheski for digging in the King County Deeds and Trusts; Jesse Ebert, for cooperation and moral support from the first day we met; Sam Emmanuel, for the meticulous file and continuing interest; Robert Monroe, at Special Collections, the University of Washington, for voluminous correspondence and sustained cooperation; Doris Gilpin, for the handwork on the slipcase design; Richard Schuettge, for critical commentary and production assistance; and Mary Millman for her precise and ornery critical commentary.

An enormous debt is owed to son and daughter Darius Kinsey, Jr., and Dorothea Kinsey Parcheski. Their contributions were markedly different and remarkably complementary. Dorothea was indefatigable in providing leads and making sure I saw every scrap of material she held. Her essay speaks for itself. Darius, Jr., who spent so much time with his father in the woods, preferred the interview approach, and we had several long talks. And without the cooperation of Mr. and Mrs. Darius Kinsey, Jr., most of the photographs in Volume One could not have been published.

Finally, my colleague in this four-year project, Rodolfo Petschek. Volumes One and Two resulted from a fifty-fifty collaboration —a remarkable example of a combined effort to share the work of the Kinseys.

However, as I think back over the four years and visualize just one aspect of Rudi's contributions—his twelve months in the darkroom, to make prints for Volume One from the extremely difficult early plates, for example—I know that, short of writing a monograph on our partnership, there is no way I can really thank him for his part.

Field research ended on March 29, 1974. The previous day I went to the northern end of the Skagit Valley. I don't know whether or not the drive was a pilgrimage, but I do know I had deferred this particular trip for more than a year after learning there was a headstone. Just before noon I reached Nooksack, and about forty-five minutes later I sat in the car and spoke the following into the tape recorder:

"I am now up on the hill at the Nooksack cemetery. It is extremely cold. Blustery wind, raining on and off lightly. Dark grey storm sky and the black mountains to the east partly shrouded by clouds. This is a very beautiful open spot, surrounded by farm land, with few buildings to be seen in the vicinity. Tabitha Kinsey's relatives are here, and that includes the Germains, the Tuckers, and Samuel and Elizabeth Pritts. Over there by itself, although in the general vicinity of the family graves, is a small reddish headstone, facing west. A single headstone for one of the greatest photographers in the history of American photography, and his wife—who spent fifty years in the darkroom."

As I shut down the little machine a squall came in. And the wind. I got out of the car and walked back to the reddish headstone, stood alongside for a little while, and finally murmured something to the Kinseys about their work now belonging to the ages. Then I headed south through torrential downpour.

Dave Bohn
Berkeley
March 1975

KINSEY

DARIUS
1869 — 1945

TABITHA M.
1875 — 1963